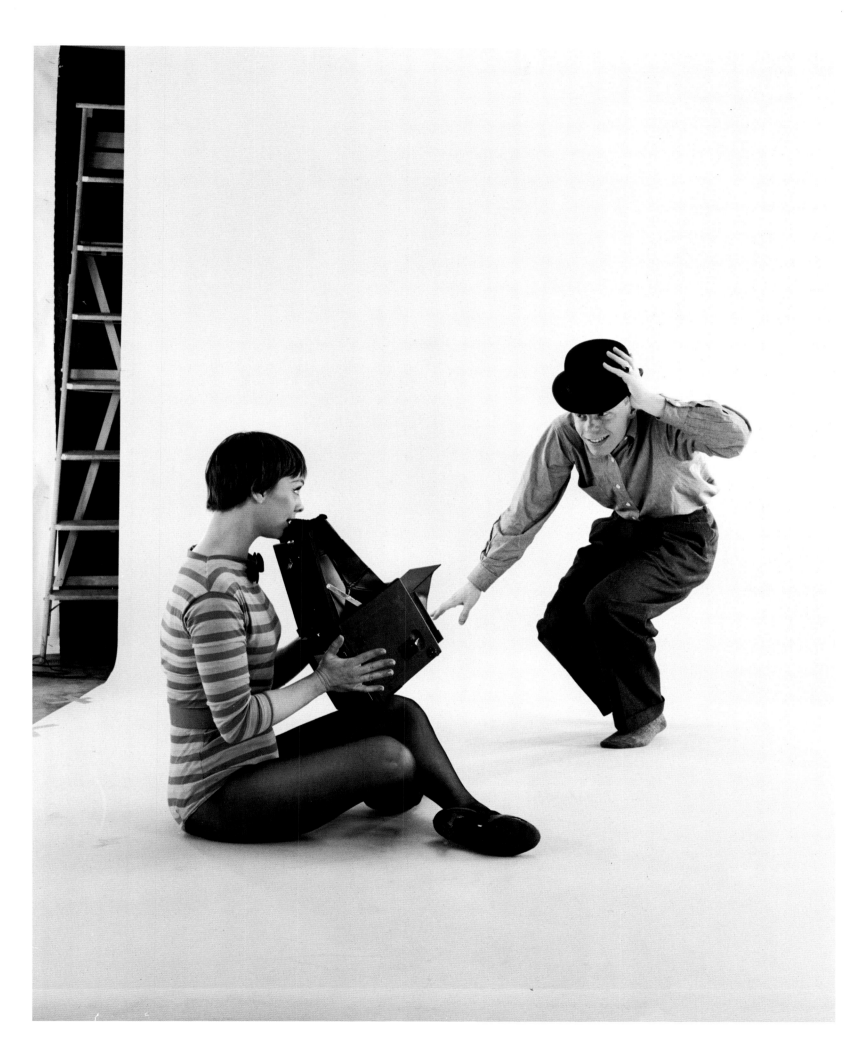

CAROL HANEY AND ORMOND GIGLI, 1954

GIRLS IN THE WINDOWS:
AND OTHER STORIES

Photographs & text © 2013 Ormond Gigli
Introduction © 2013 Christopher Sweet
Afterword © 2013 Marla Hamburg Kennedy

Published in the United States by
powerHouse Books, a division of powerHouse
Cultural Entertainment, Inc.
37 Main Street, Brooklyn, NY 11201-1021
telephone 212.604.9074, fax 212.366.5247
e-mail: info@powerHouseBooks.com
website: www.powerHouseBooks.com

First edition, 2013

Library of Congress Control Number:
2013944045

ISBN 978-1-57687-660-2

Printed and bound in China through
Asia Pacific Offset

Book design by Triboro

10 9 8 7 6 5 4 3 2 1

powerHouse Books
BROOKLYN, NEW YORK

NEXT SPREAD: GIRL IN THE LIGHT, 1967

ORMOND GIGLI
GIRLS IN THE WINDOWS
AND OTHER STORIES

–
–

Gigli

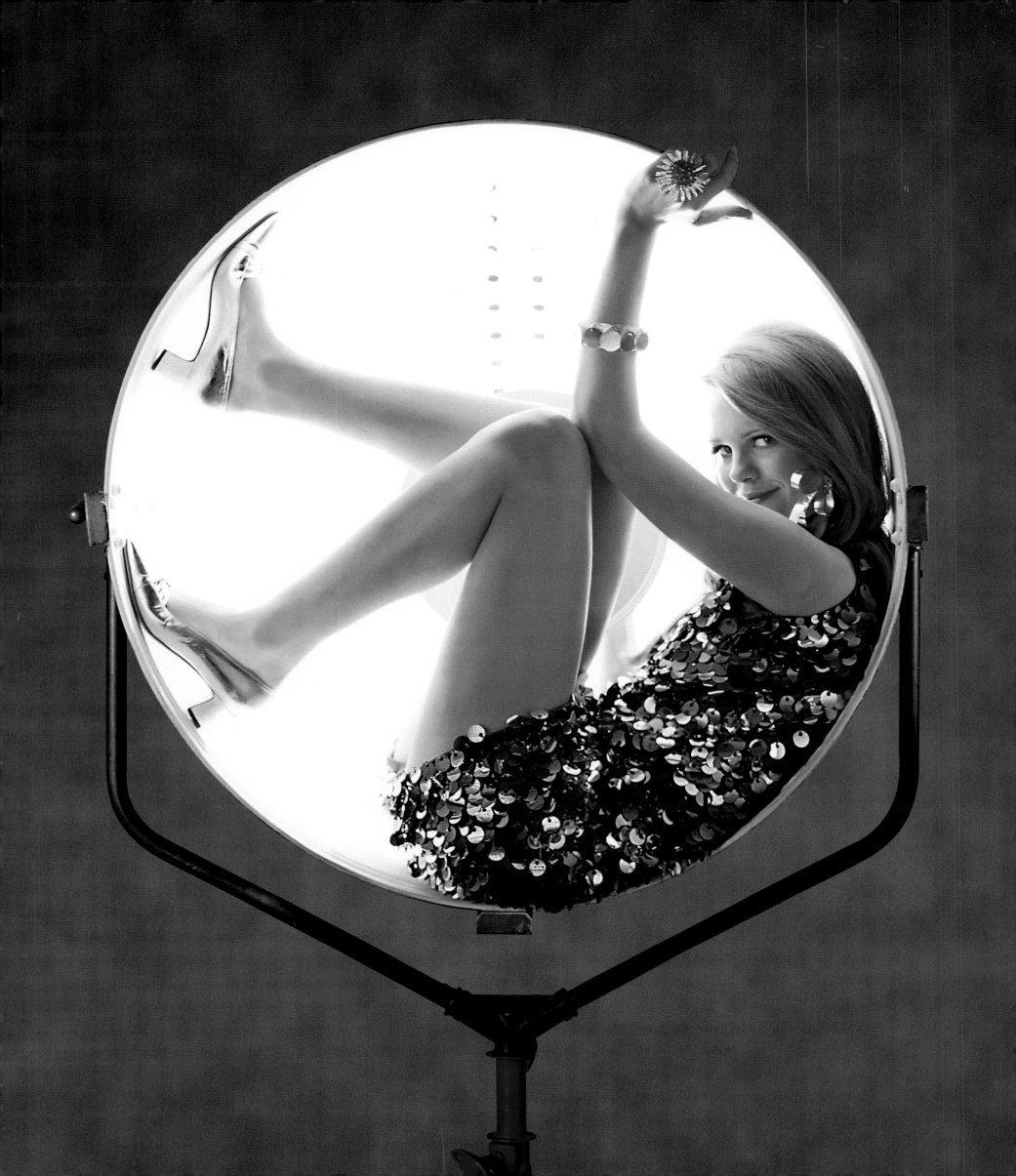

ORMOND GIGLI
GIRLS IN THE WINDOWS
AND OTHER STORIES

Introduction by Christopher Sweet
Afterword by Marla Hamburg Kennedy

POWERHOUSE BOOKS, BROOKLYN, NEW YORK

—

—

INTRODUCTION BY
CHRISTOPHER SWEET

—
—

Ormond Gigli had an illustrious career as a commercial photographer and photojournalist over the course of some forty years and took many magnificent photographs, but one photograph has eclipsed all the others. It was a photograph he conceived for himself, without an editorial assignment. It is the incomparable *Girls in the Windows* of 1960. This photograph is his signature image and has become an icon of postwar photography and of postwar New York. It is a powerful image made at the height of the Mad Men era, at a moment when New York City was in the midst of dynamic changes and on the verge of social upheaval, and occurring relatively early in Gigli's career, at the point when he comes fully into his own as a photographer.

Ormond Gigli was born and raised in New York City and came from a hard-working family of modest means. Through hard work and talent and focus he would earn his way through life. He discovered photography as a young teenager. His father had borrowed money to give him his first camera. Upon developing his first photographs he discovered his métier, his vocation in life, and he would devote himself to photography thereafter. In high school he worked as a photography assistant after school and then as a Navy photographer during the war. Upon his return to civilian life, he would launch his career as a freelance photographer. By the early 1950s he had published his first assignment in *Life* magazine and his photographs would soon become a regular presence in the pages and on the cover of *Life* as well as *Time* magazine. He would also be a frequent contributor to *Collier's*, *The Saturday Evening Post*, and many other publications. He would enjoy the special status and perks that were showered on photographers, writers, and editors of Time-Life in the postwar heyday of that company.

In 1960 Gigli bought a brownstone on East 58th Street, between Second and First Avenues, just to the east of one of the entry ramps to the Queensboro Bridge. He would build his studio on the garden and street level, and he and his family would live on the second floor. There were three apartments on the top three floors and he planned to divide each of them into two, and rent out the apartments to help pay the mortgage. When he bought the building the tenant on the top floor just happened to be Marcel Duchamp, the doyen of Dada and Modernist master. Duchamp did not want to leave the apartment, saying that climbing the stairs kept him young, but when the renovations began on the floors below his, he changed his mind and moved elsewhere.

Across the street from Gigli's house stood a row of brownstones from the previous century. The original residents had long since moved on and the houses had fallen into decline and been carved up into warrens of apartments to let. By 1960, however, New York's postwar building boom was on in earnest and the shabby brownstones were primed for destruction. With the grand thoroughfare of East 57th Street one block south, the landlord scheduled the buildings for demolition to make way for an apartment building. These brownstones filled the view from Gigli's house. At one point he was looking across the street at the desolate brownstones, emptied of the former tenants, and in that curious intermediate state, poignant as an ancient ruin, he was moved to somehow memorialize the doomed, empty houses. He saw all of a sudden what he would do. He envisioned glamorous women filling the windows. The façade would be an elaborate frame, from cornice to curb, for a dazzling array of fashionable ladies. He would add the flourish of a Rolls Royce pulled up onto the sidewalk before the center building for an additional note of old-world glamour. It was a photograph without commission or assignment but pure inspiration.

Gigli sought to preserve for posterity a slice of old New York that had formed the view from the front of his house. However briefly he had lived there, it was a façade in many permutations that would be well known to a New Yorker, the backdrop to many memories. His insight was to turn the empty façade of the buildings into a set piece for living figures, its windows into multiple stages for his model-collaborators to present themselves. It is an entirely staged composition, its structure dependent upon the brief state between gutting and final demolition of the building. It pretends to no narrative, but to document its own reality, it is a picture of an "event" that occurred entirely for the purpose of the photograph. It is a sort of modernist theater, a kind of "happening," as Gigli's wife suggested. All the participants came as themselves.

Looking at the photograph, *Girls in the Windows*, the old brownstones fill the image. The sky is cropped out. The cornice contains the upward motion. The space before the building, of sidewalk and gutter, forms a shallow stage to heighten the sense of the façade as a kind of bas relief. The doorways themselves are off center with respect to the buildings, set to the left of the base of each building with two windows to the side and then four uniform windows on each of the four floors above the ground floor. To achieve the general symmetry, the composition is centered on the doorway of the middle building. And the doorways of the buildings on either side anchor the lower left and lower right corners. And so we see the full façades of two buildings and half the façade of the building to the right. The fenestration seems as if it would stretch to the left and right beyond the picture frame as far as a city block. The upper story windows, a grid of forty windows, are each filled with a model, a woman dressed formally in colorful, elegant attire. As a base to the dominant grid and to balance the off center element of the lamppost and the slightly distorted line of the curb, the photographer positioned one model in the only ground floor window to be filled, just to left of center, and two models on the sidewalk along with the limousine (and driver). A model in a black gown drapes the lamppost while another in a white gown adorns the Rolls Royce—as if a hood ornament come to life. This grouping activates the foreground and leads to the rhythms above. It reminds us of the essential linkage of the sidewalk and street to the buildings that line those streets.

The photograph is Gigli's *Broadway Boogie-Woogie*, alluding to Piet Mondrian's masterpiece of 1943. And from there one thinks of Ellsworth Kelly's *Colors for a Large Wall* of 1951, and onto Andy Warhol's grids of Marilyns and Jackies in the early 1960s—or perhaps more aptly his *Ethel Scull 36 Times* of 1963. Given the fact of Duchamp's tenancy, his *Fresh Widow* of 1920 also comes to mind. The photograph resonates in powerful ways. Aside from the rhythms and energy of the colorful figures arranged across the façade, the window itself has long been a motif of art, indeed, the very premise of pictorial art since Leon Battista Alberti wrote in 1435: "Let me tell you what I do when I am painting...on the surface I draw a rectangle of whatever size I want, which I regard as an open window through which the subject to be painted is seen." For the Romantics in the early nineteenth century the theme of figures in windows, framed by windows, became a compelling subject. However, the viewer was invariably inside, behind the figure, looking out over the shoulder to the world beyond. The room is the realm of intimacy and familiarity, safety and convention, perhaps entrapment, while the vista suggests the unfulfilled longings of poetry, manifold possibilities, a realm of freedom. In any case the window offers communication—spiritual, intellectual, emotional—to something greater, something desirable on the outside, in the world beyond.

In Gigli's photograph we look to the windows from outside. The interior has been rendered opaque, unreadable, uninhabitable, as with Duchamp's *Fresh Widow*, where the panes of the facsimile French window are blacked out with leather sections. The gutted rooms behind the women in the windows are in essence blacked out, closed off, almost menacing in their obscurity. The windowed façade is the margin between interior and exterior, it is the zone between past and future–the window sills are thresholds. Interestingly, Gigli has in a sense put into practice Duchamp's statement: "I used the idea of the window to take a point of departure... I could have made twenty windows with a different idea in each one." Gigli brings forty-one ideas to the widowed windows. The interior behind the women represents a past which cannot be regained, though perhaps wistfully remembered. They are poised on the threshold, on the brink of no return. They look and open their arms to the future. The past is void, the moment and the future are everything.

Girls in the Windows is an image made at a decisive moment in the life of New York City. It is the moment when the waning values of the nineteenth century at last gave way to Modernism and indeed contemporaneity. The conservative, conformist 1950s period is the last gasp before the revolutionary social changes of the 1960s and beyond. Imbued with a sense of promise and pathos, *Girls in the Windows* is an image of that threshold, the transitional state of urban and social transformation that is New York City. The wrecking balls are all over the city, and the promise of the future is great, but the consequences cannot all be foreseen and some are inevitable. Within a few days of the taking of the photograph, the site was a rubble-strewn lot. The buildings and the people who lived there are long gone, the building that replaced them is now in middle age. Those who gathered for an hour or so for the photograph dispersed and never reunited. In recent years the photographer sold his house across the street and retired to his farm in the Berkshires. Brownstones which had once been symbols of middle class prosperity and then became emblematic of urban decay have now circled back to become once again proud symbols of wealth and status. We live in a state of constant change, but the photograph *Girls in the Windows* is forever.

BEHIND
THE SCENES

—

—

I was given an assignment by *The Saturday Evening Post* to illustrate an article on the training of astronauts in zero gravity and docking procedures. The editors told me to see what I could come up with over at General Electric. Once there, I saw what had to be done and I enlisted the help of the scientists. A dull-looking space capsule was painted white and we placed orange tape around the outside, a light with a green gel inside, and motorcycle tail lights on each side of the "space ship." A space suit was borrowed from NASA, nearby. One of the scientists played astronaut. The air-jet-powered capsule moved through the laboratory simulating docking in space. It was fun to be creative and make the situation work. The photograph ran in a two-page story called "Space Spectacles."

I did a very nice cover photograph for *Newsweek* for an article called "Danger in the Sun: A Good Tan May Be Hazardous to Your Health." It was a bust-length shot of a girl in a bathing suit, all wet, as if she had just gotten out of the pool, turning her face to the sun, with eyes closed and a half smile. The image was shot from below so there was only blue sky behind her. Everything with Newsweek, it seemed, was sort of last-minute, a rush. You'd get the assignment, cast it, and shoot it all very quickly. And then they would have their meeting on Friday afternoon, and either you had a cover on Monday or they threw it in the garbage can. It also depended on which cover editor was there and fighting for it. So I shot this assignment in the studio and it looked great. My lighting was no different from sunlight, in fact it was better. Then at the last minute the editor says that we have to shoot it outside. So, the next day, Friday morning, we pack into a huge motor home and head out to the beach and we shoot the model and then rush back to town and get the film to the photo lab and then to the magazine. Okay, they picked one of the model on the beach for the cover, but you couldn't tell the difference from the others. All kinds of situations and adventures. – O.G.

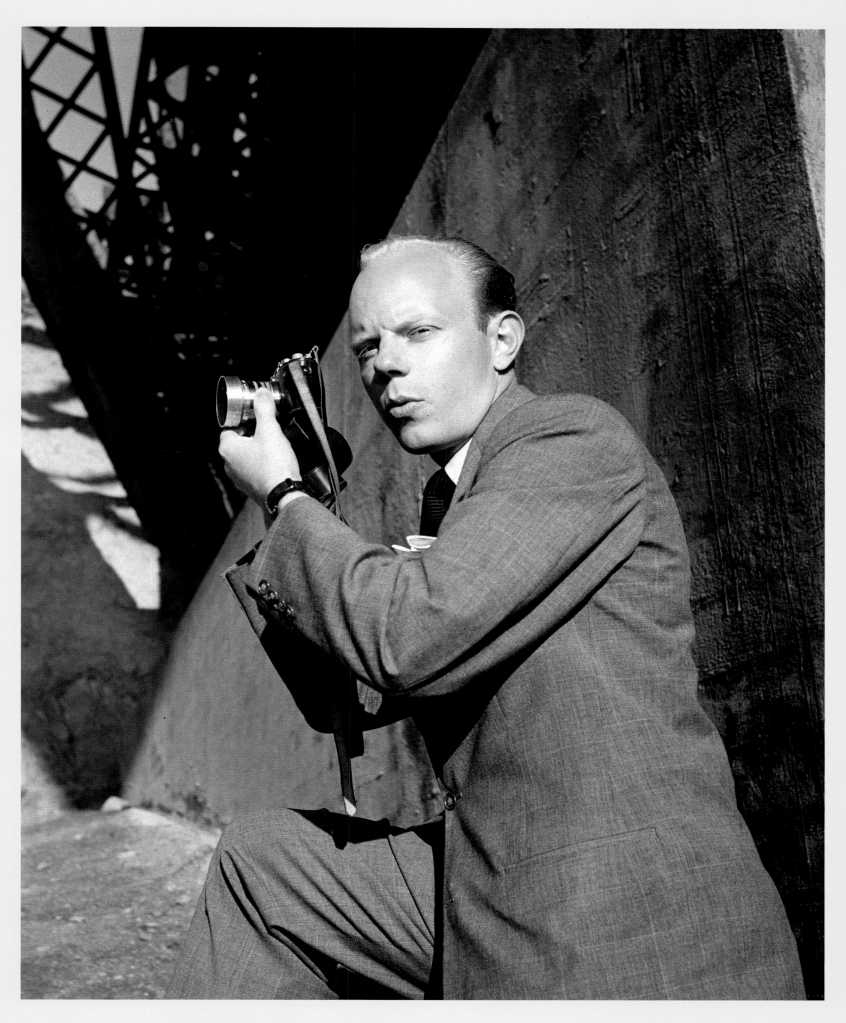

SCOUTING LOCATIONS UNDER THE QUEENSBORO BRIDGE, NEW YORK, 1960s

The text on the sign reads:

JUST $15 95
FED. TAX $1.92
SIZE 700/6.50-13
BFG TRAILMAKER

PREPARING A MINIATURE SET IN THE STUDIO FOR A TELEVISION COMMERCIAL FOR NEW ENGLAND TELEPHONE, 1972

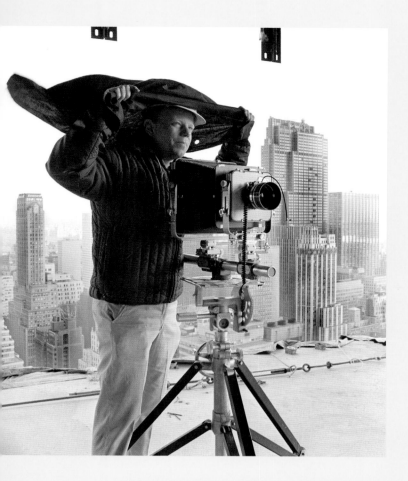

IN THE UNFINISHED PAN AM BUILDING, 1962

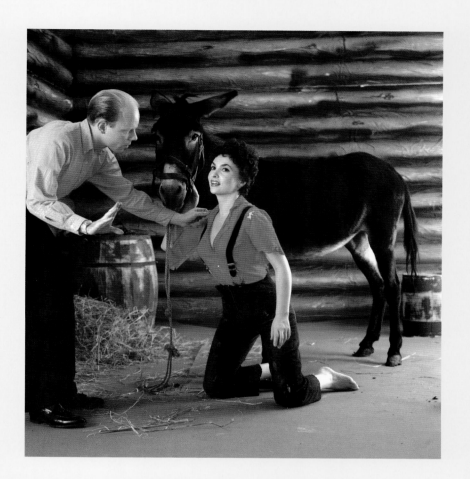

WITH GINA LOLLOBRIGIDA, 1955

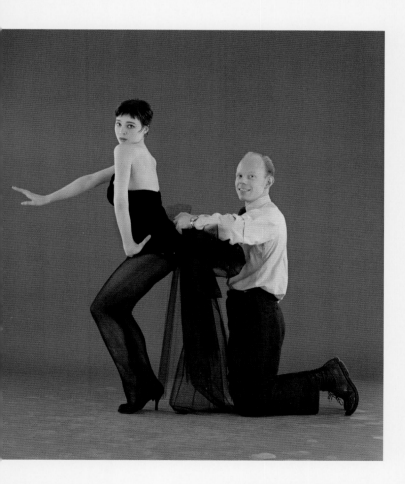

WITH LESLIE CARON, 1954

AFTER A SHOOT FOR *THE SATURDAY EVENING POST*, 1959

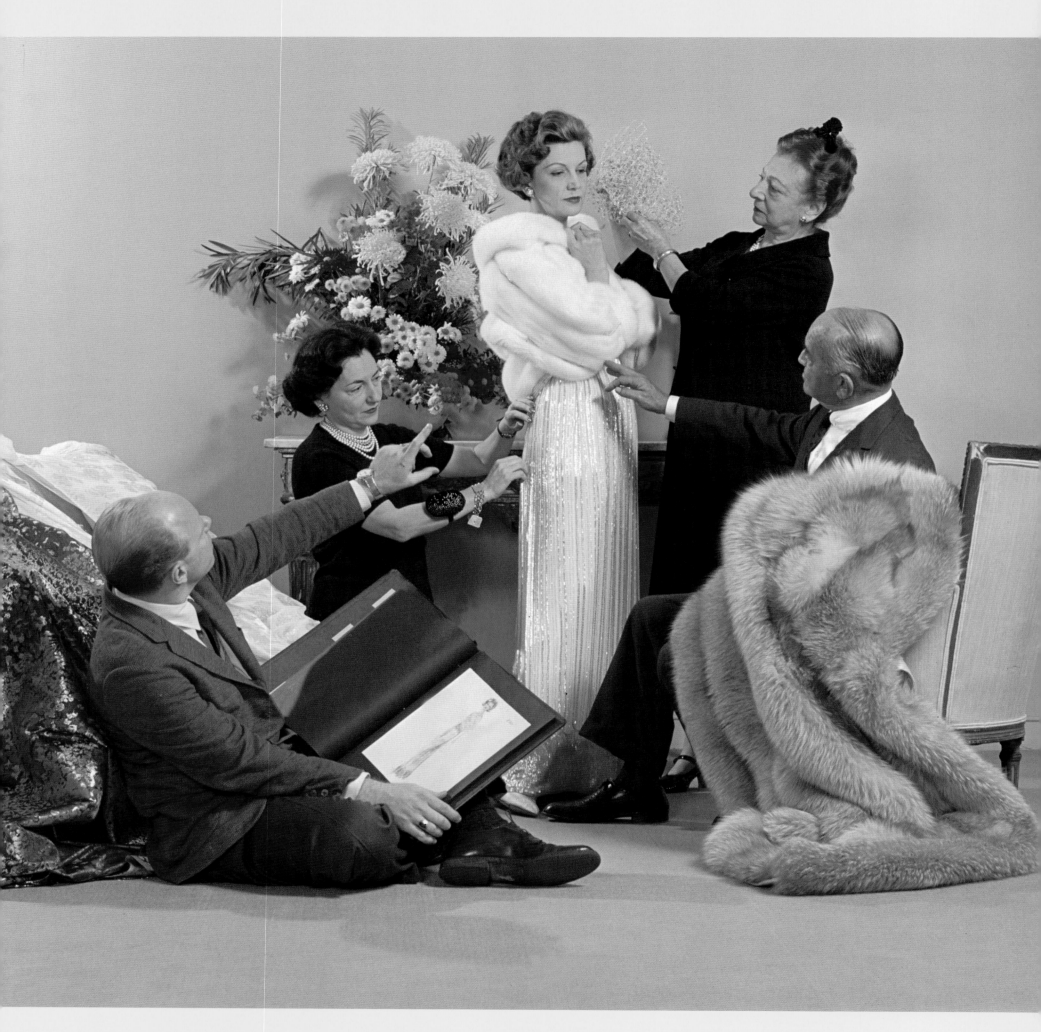

AT BERGDORF GOODMAN, FOR "POSH PLACE FOR FASHION," *THE SATURDAY EVENING POST*, 1962

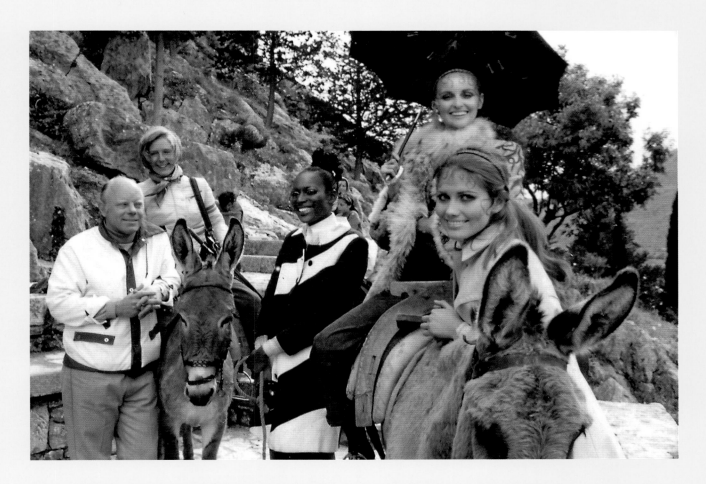

STARTING OUT FOR A DAY'S SHOOT IN GREECE, FOR "SUN, SKIN & A HINT OF SIN,"
TIME, 1969. FROM LEFT TO RIGHT, MYSELF, THE EDITOR ANDREA SVEDBERG, NAOMI SIMS,
SAMANTHA JONES, AND MAUD ADAMS.

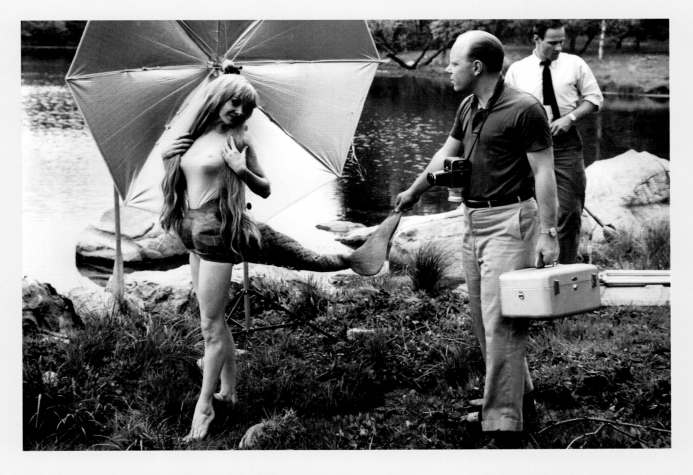

PREPARING A MERMAID FOR AN ADVERTISEMENT, 1970s

DIRECTING A MODEL FOR A TELEVISION COMMERCIAL, 1970s

AROUND THE WORLD, FOR U.S. ARMY ADVERTISING, 1974

WORKING ON A STORY ON FIRE PATROL,
FOR *COLLIER'S*, 1954

DIRECTING IN A U.S. ARMY AIR CONTROL TOWER, FOR U.S. ARMY ADVERTISING, 1970s

SHOOTING AT SCHAEFER 500, POCONO RACEWAY, PENNSYLVANIA, FOR WINSTON CIGARETTES, 1970s

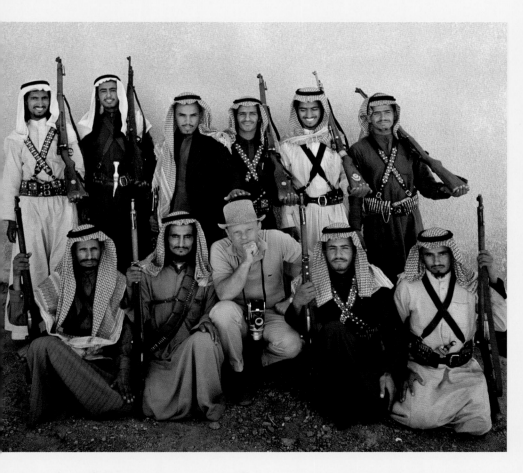

IN SAUDI ARABIA, 1964

ARMY DOCTORS AD CAMPAIGN, FOR U.S. ARMY, 1976

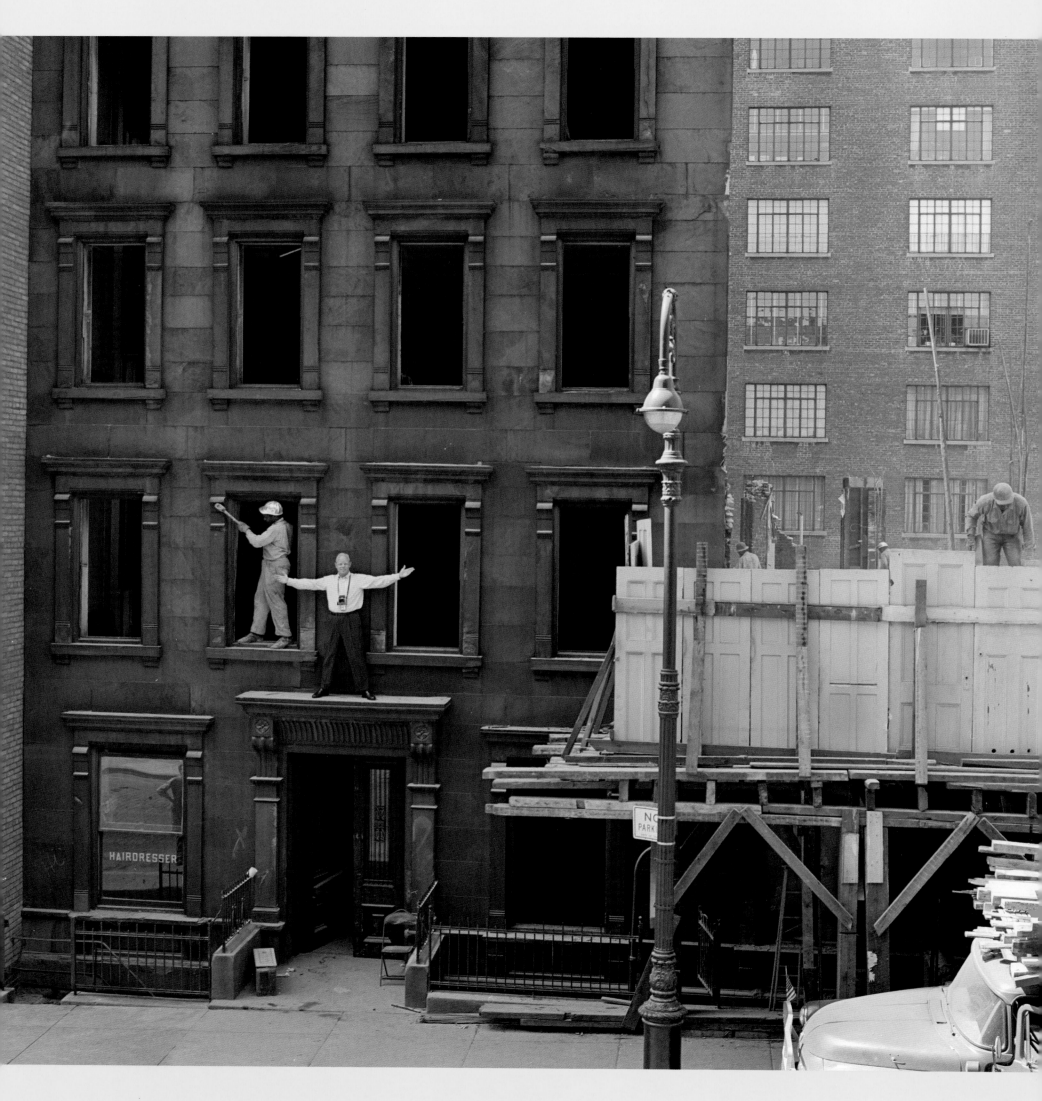

DEMOLITION BEGINS AT WHAT IS NOW 320 EAST 58TH STREET, NEW YORK, 1960

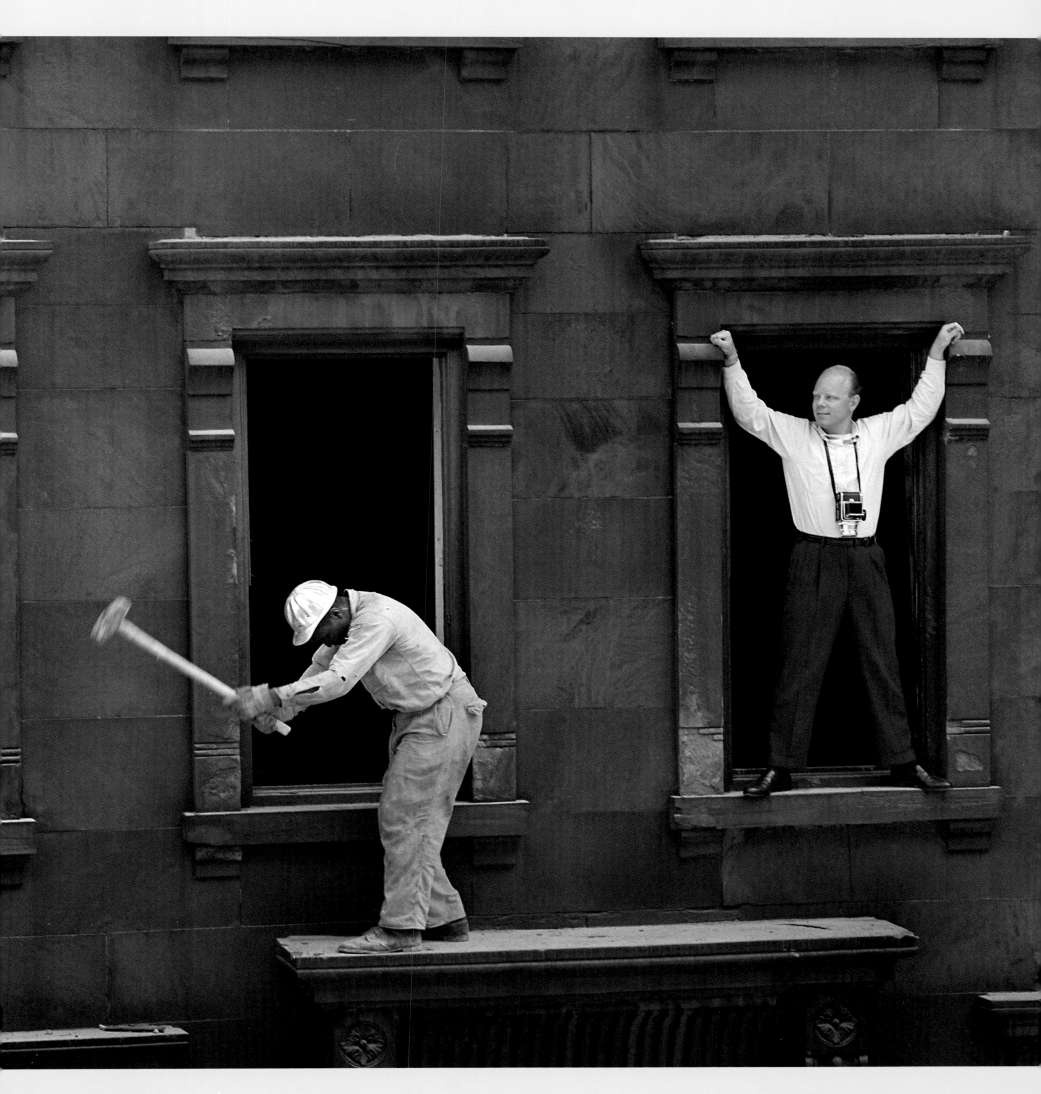

GIRLS IN
THE WINDOWS

—
—

In 1960, while a construction crew dismantled a row of brownstones right across from my own brownstone studio on East 58th Street, I was inspired to somehow immortalize those buildings. I had the vision of 43 women in formal dress adorning the windows of the skeletal facade.

We had to work quickly to secure City permissions, arrange for models who included celebrities, the demolition supervisor's wife (third floor, third from left), my own wife, Sue (second floor, far right), and also secure a Rolls Royce to be parked on the sidewalk. Careful planning was a necessity as the photography had to be accomplished during the workers' lunch time!

The day before the buildings were razed, the 43 women appeared in their finest attire, went into the buildings, climbed the old stairs, and took their places in the windows. I was set up on my fire escape across the street, directing the scene, with bullhorn in hand. Of course I was concerned for the models' safety, as some were daring enough to pose out on the crumbling sills.

Then, the morning of the shoot, I woke up to discover that Con Edison had dug a huge hole in the sidewalk where the Rolls Royce was supposed to go. I was in distress, but the Con Edison crew which was still on site was unfazed and after we spoke they proceeded to fill up the hole and cement it over again. Of course, they would dig it up again after they feasted their eyes on all the beautiful models.

The photography came off as planned. What had seemed to some as too dangerous or difficult to accomplish, became my fantasy fulfilled, and my most memorable self-assigned photograph. It has been an international award winner ever since.

Most professional photographers dream of having one signature picture they are known for. *Girls in the Windows* is mine. – O.G.

GIRLS IN THE WINDOWS, 1960

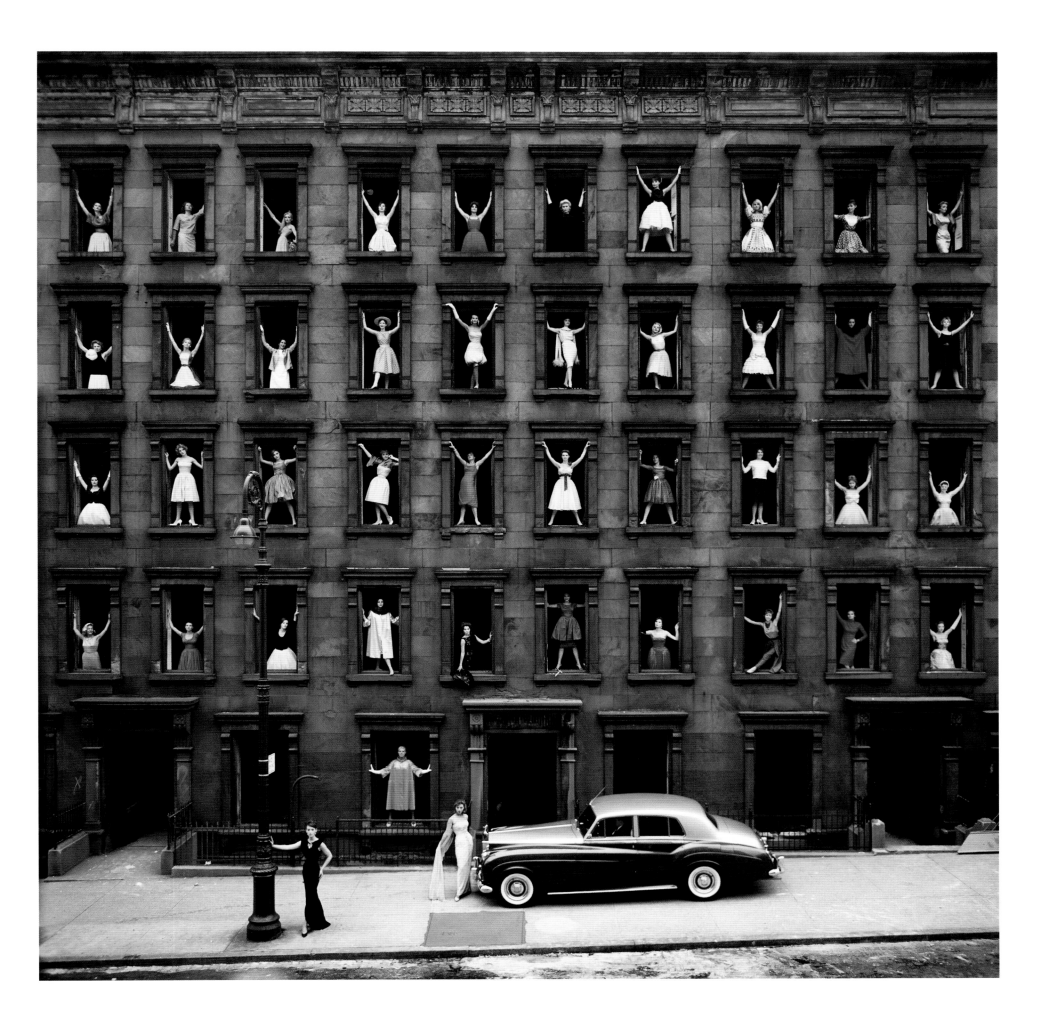

HOME
& ABROAD

—
—

I was living in Paris in the early 1950s when my career got under way with my first published assignment in *Life* magazine. From then on, I was like a night watchman, going out every evening, sometimes returning home at dawn. And I began to work for *Paris Match* and other French and German magazines. A year into my stay in Paris my father died and so I grabbed my cameras and some photographs and headed home to stay with my mother for a while, as I was an only child. I thought it would be for a couple of months, but my career blossomed in New York. A French photographic agency that I worked with in Paris, Rapho, had a New York office called Rapho Guillumette and they agreed to represent me. I continued working for *Life* in New York and then also for *Time, The Saturday Evening Post*, and *Collier's*, and many others. My shooting schedule was so full, I decided that though Paris was tempting, success in New York was too great to ignore. One of the first jobs I got when back was to photograph Williston Basin for *Time*. It was quite a change to go from the City of Light to an oil town on the Great Plains as winter is coming on. *Time* wanted to see what I could accomplish, and I wanted to deliver the goods. One day I was going to drive out into the boondocks to shoot a cattle ranch or something. I was told that in the back of the rental car were a blanket, a metal pipe, and a can of Sterno. If it started snowing and I got stuck, I was to stay in the car, and someone would find me in a day or two, according to the rental agent. I understood what the blanket was for and the Sterno, but what about the pipe? He told me I should open the window and stick the pipe out through the snow so the Sterno would have oxygen to burn. I was a little nervous after that, but I needed it to be a successful assignment and did what I had to do. Fortunately, I didn't get snowed in. – O.G.

SHOOTING FROM A HELICOPTER, EMPIRE STATE BUILDING, 1971

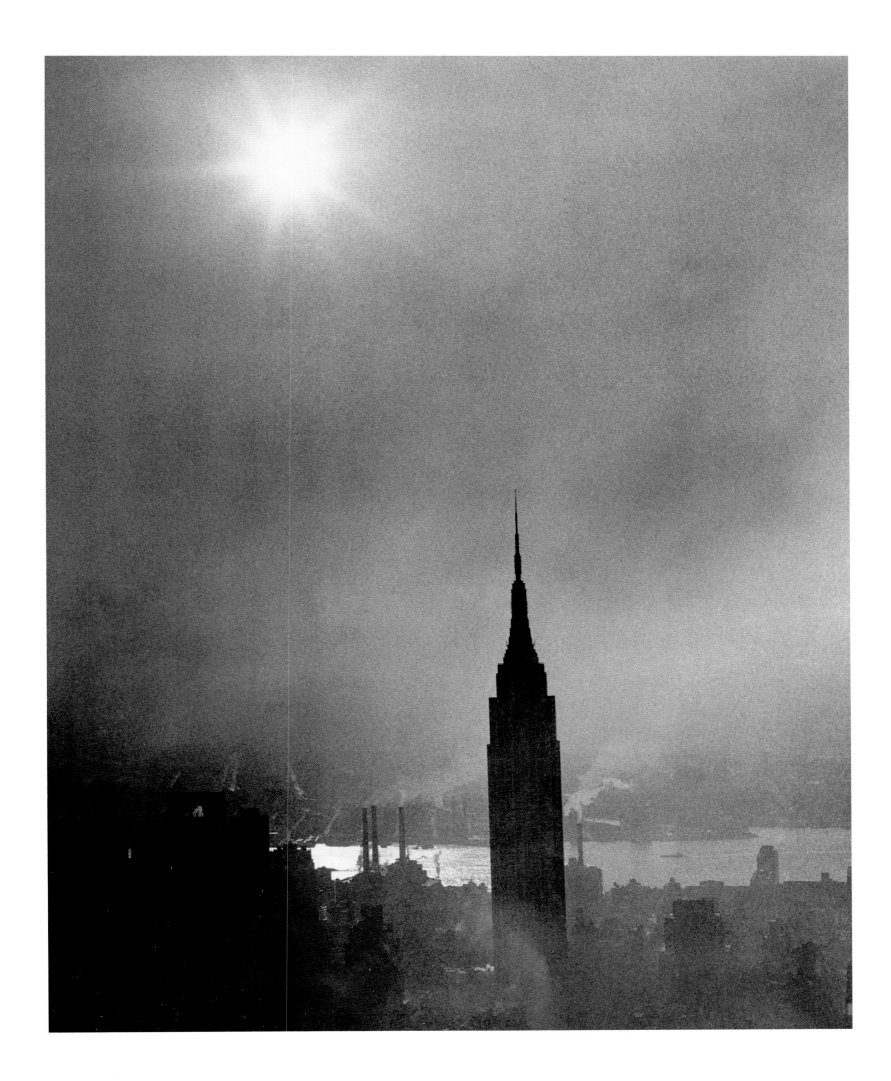

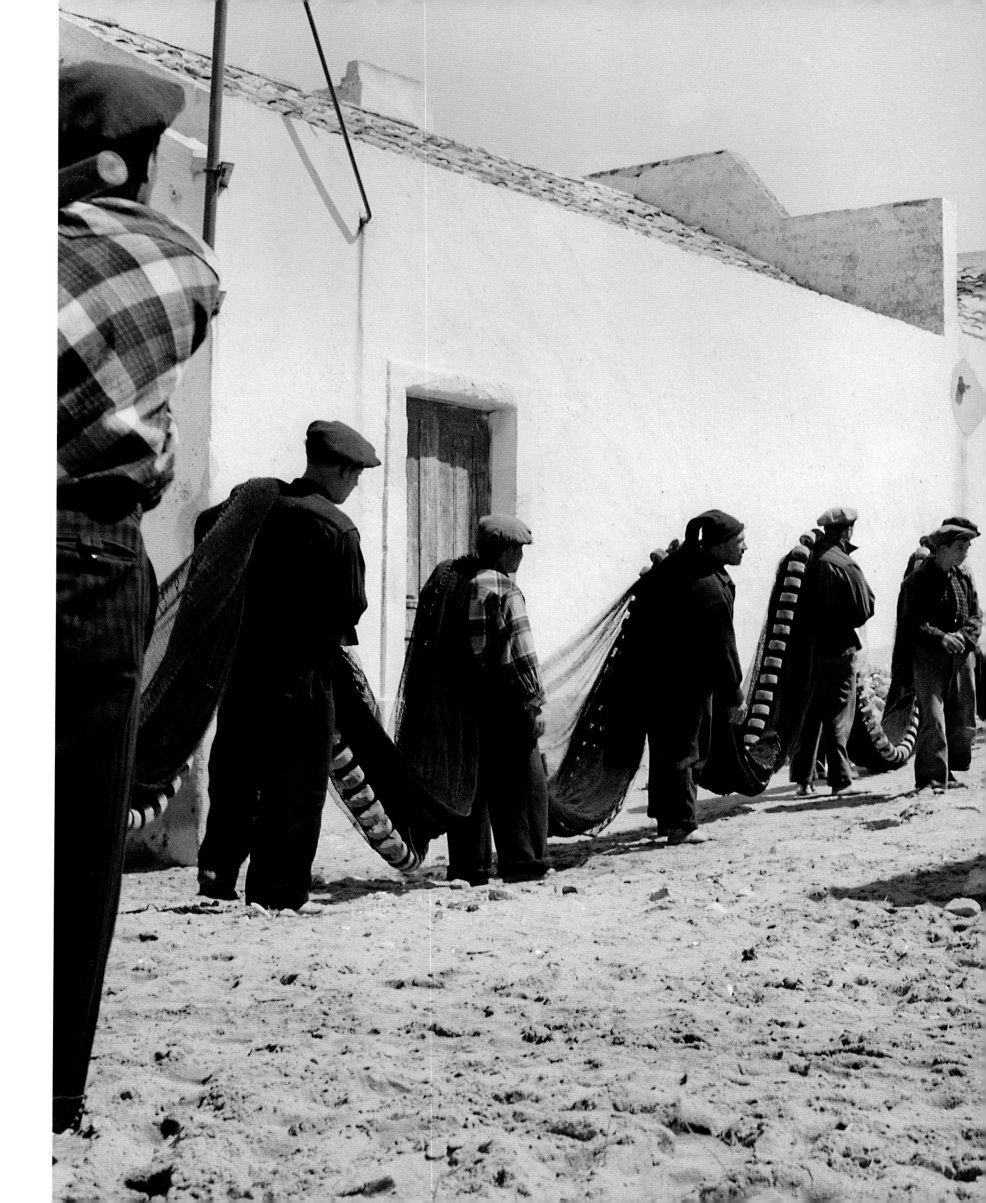

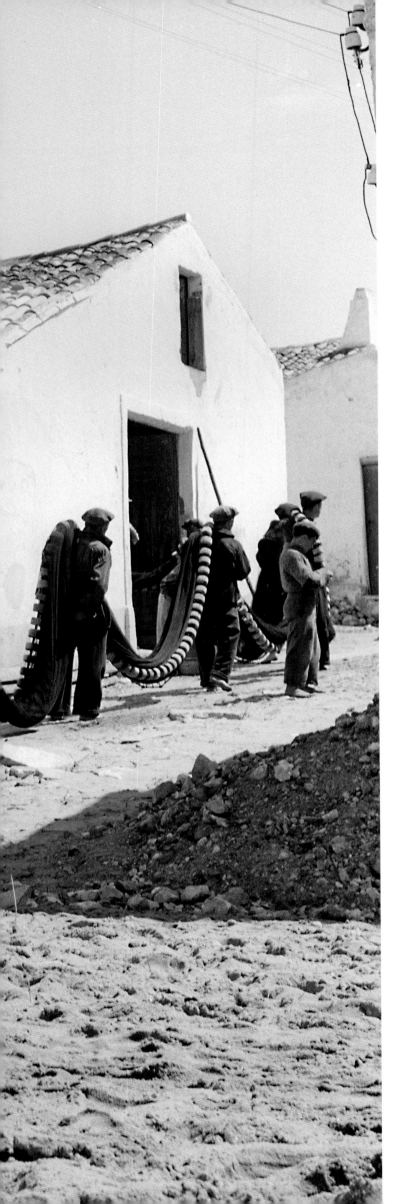

FISHERMEN, NAZARÉ, PORTUGAL, 1952

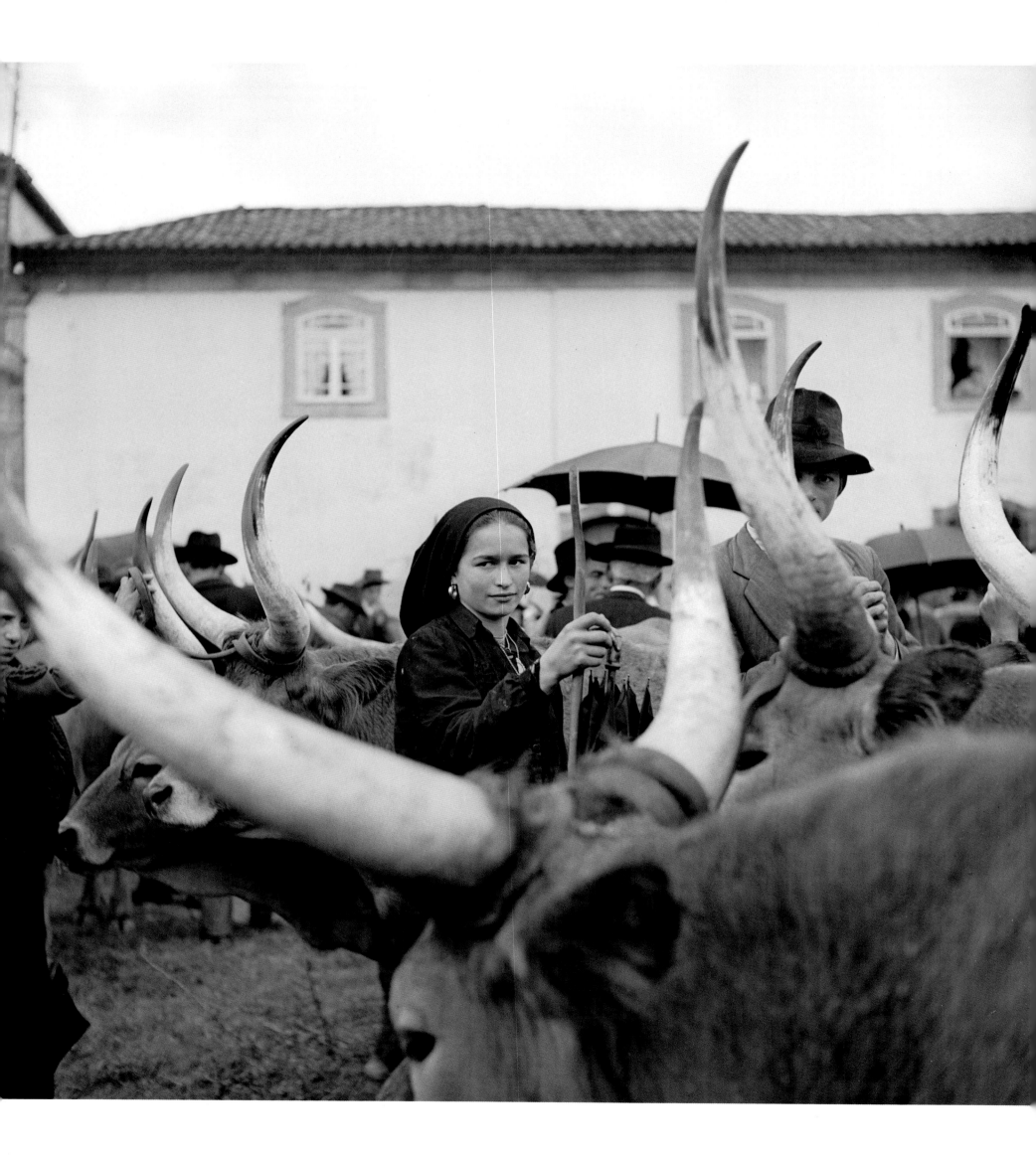

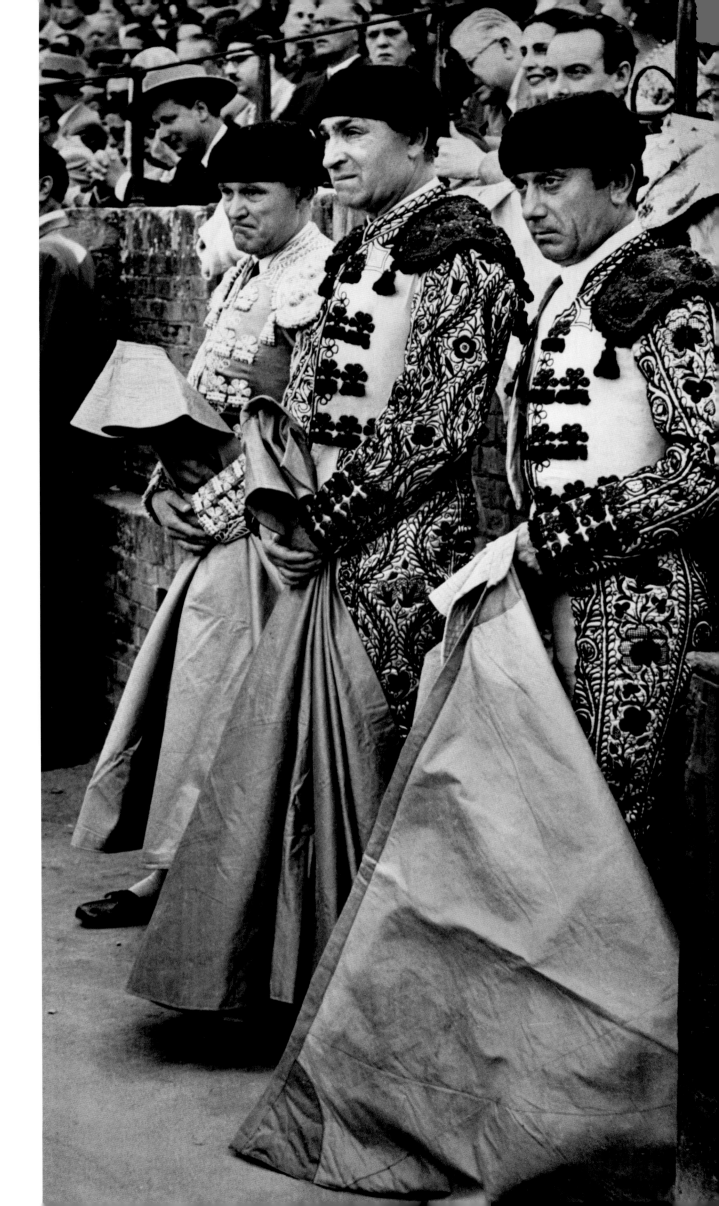

LEFT:
PORTUGAL,
1952

RIGHT:
MATADORS,
SEVILLE,
SPAIN, 1952

31

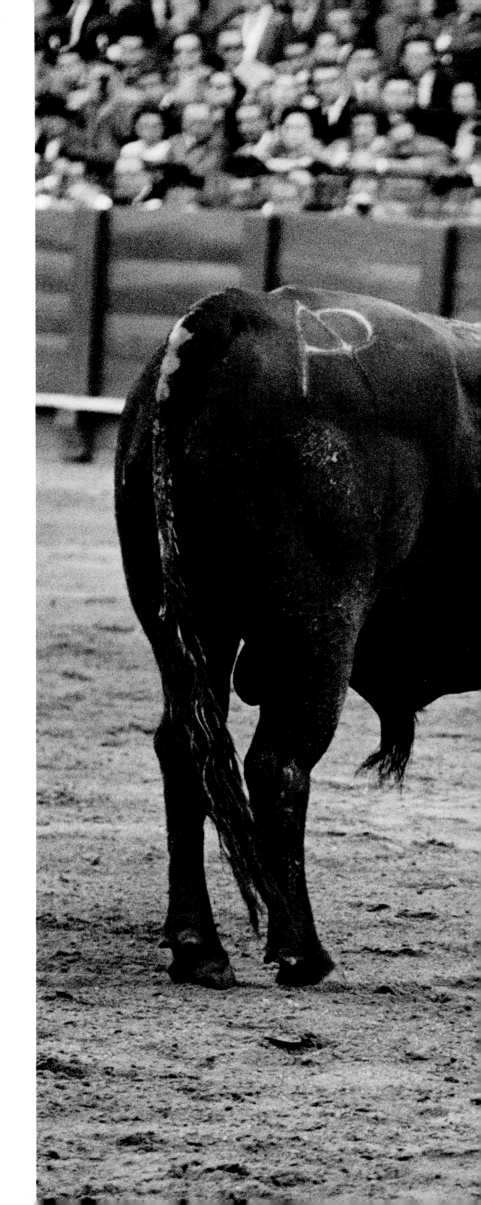

SEVILLE, SPAIN, 1952

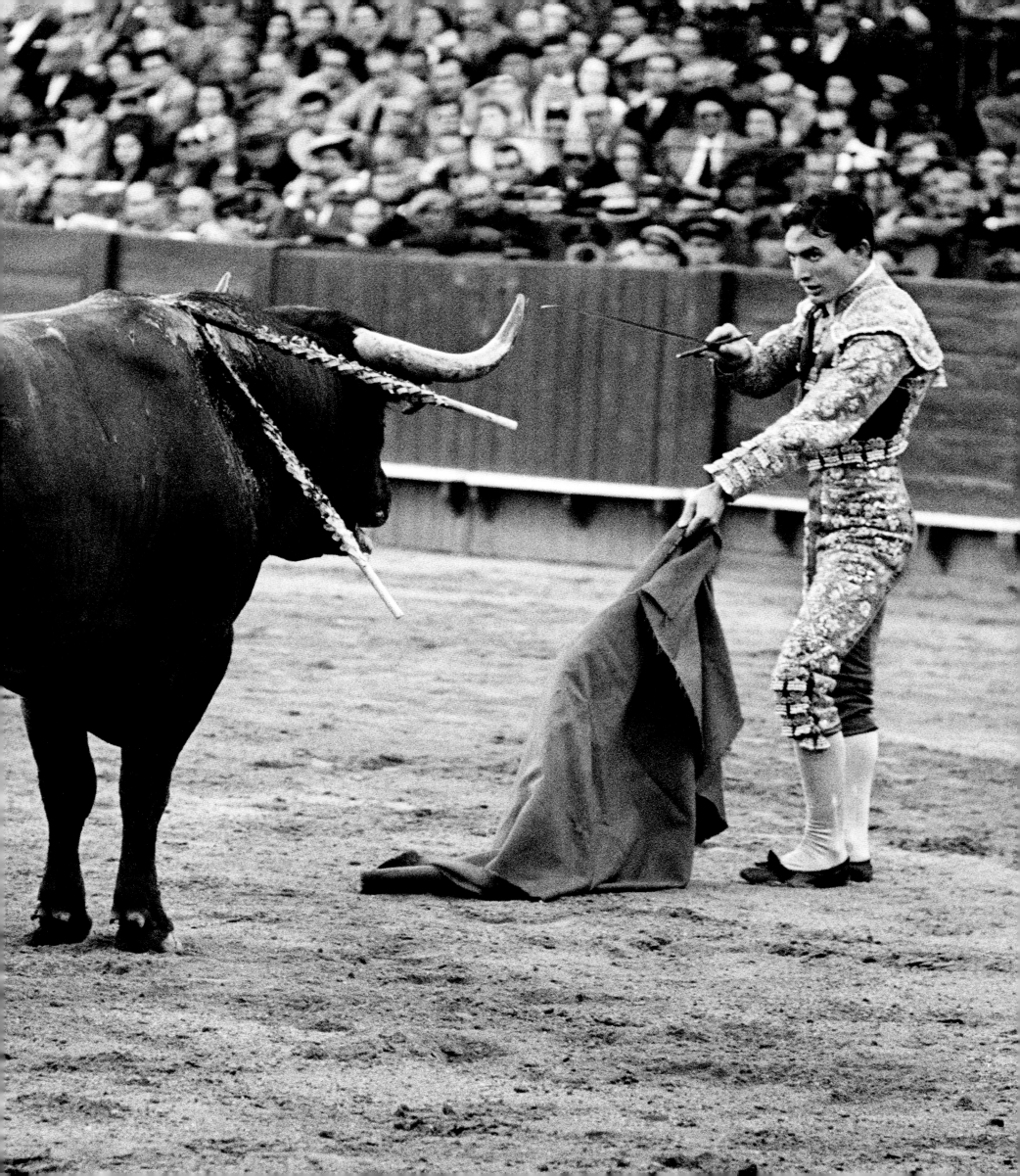

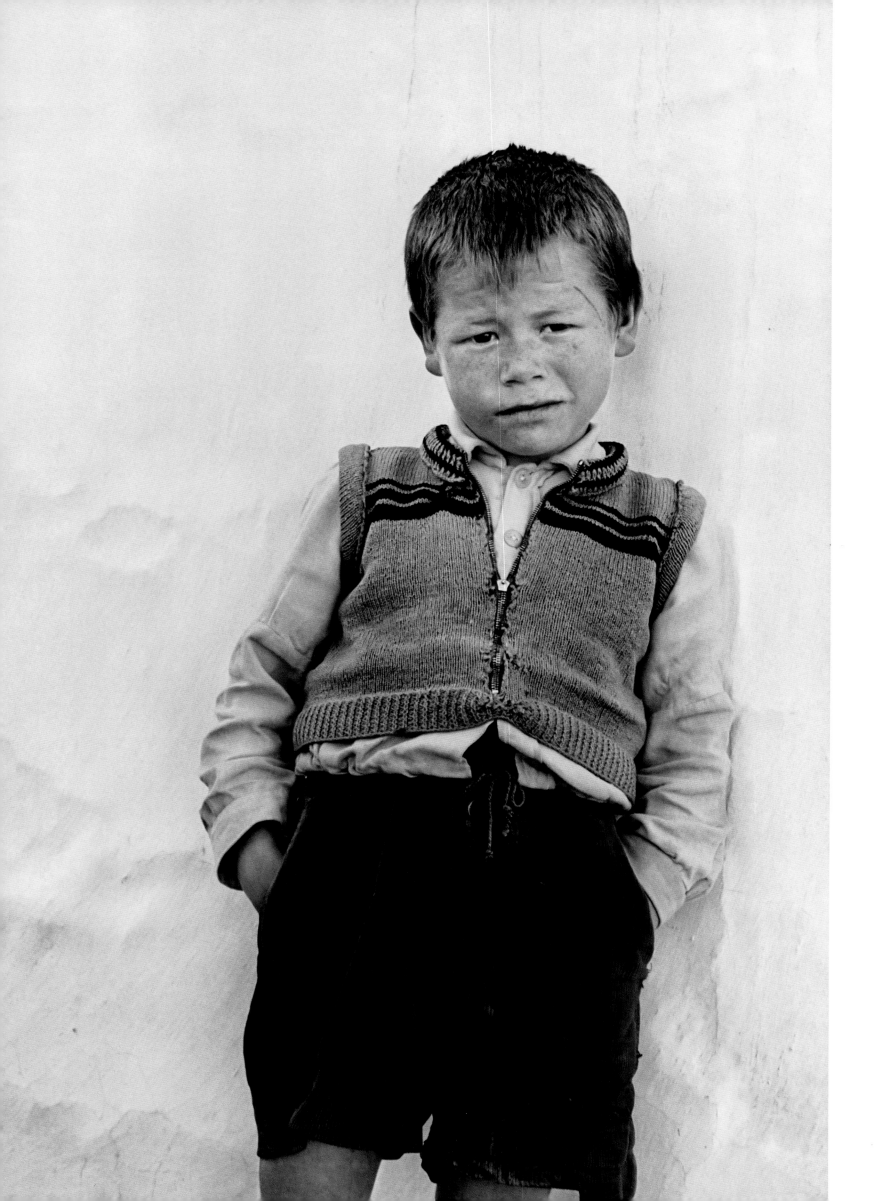

SPANISH BOY,
1952

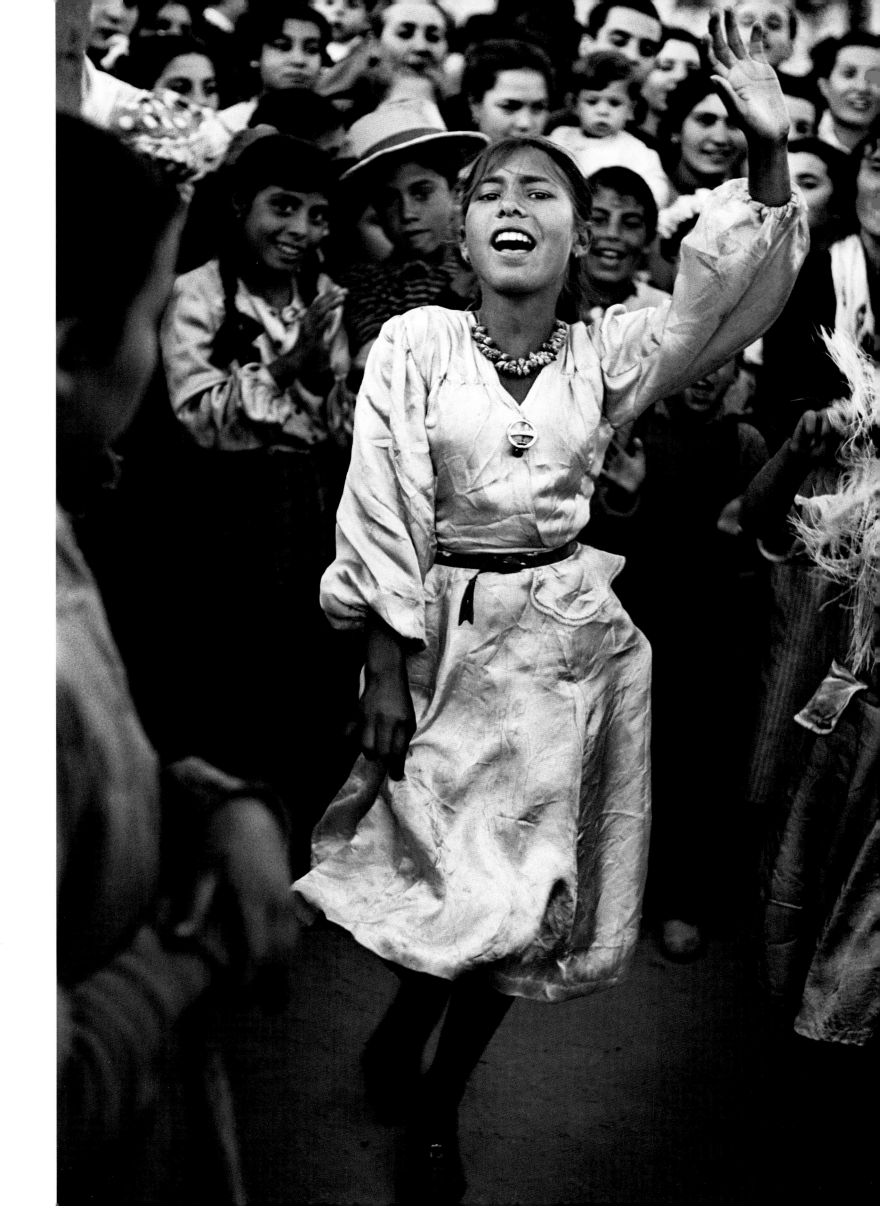

SEVILLE,
SPAIN, 1952

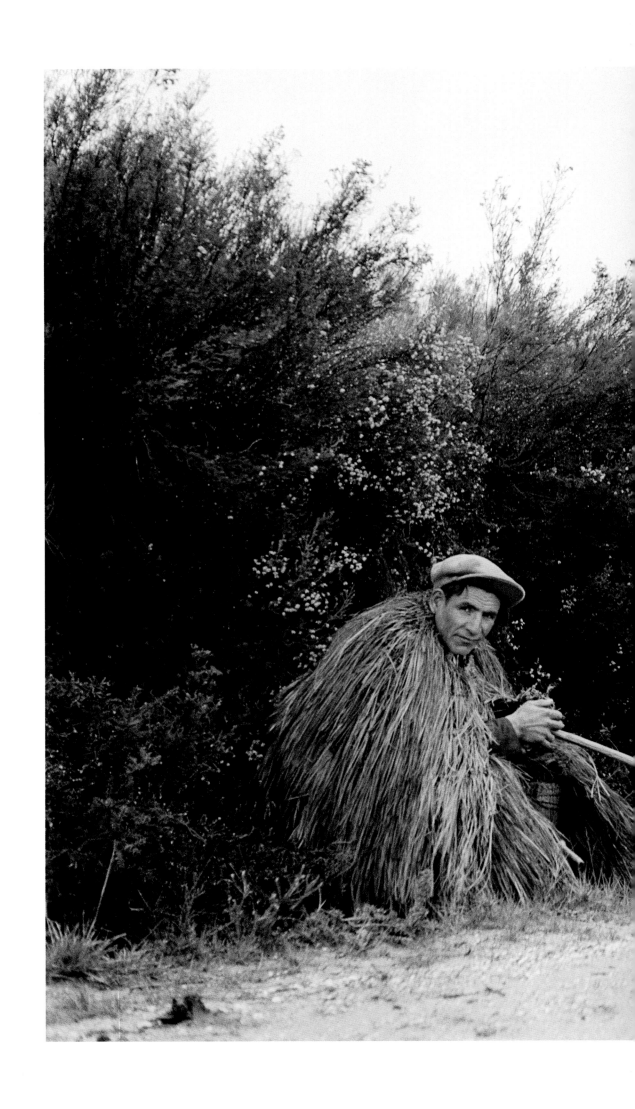

SOMEWHERE ON
THE FRONTIER
BETWEEN PORTUGAL
AND SPAIN, 1952

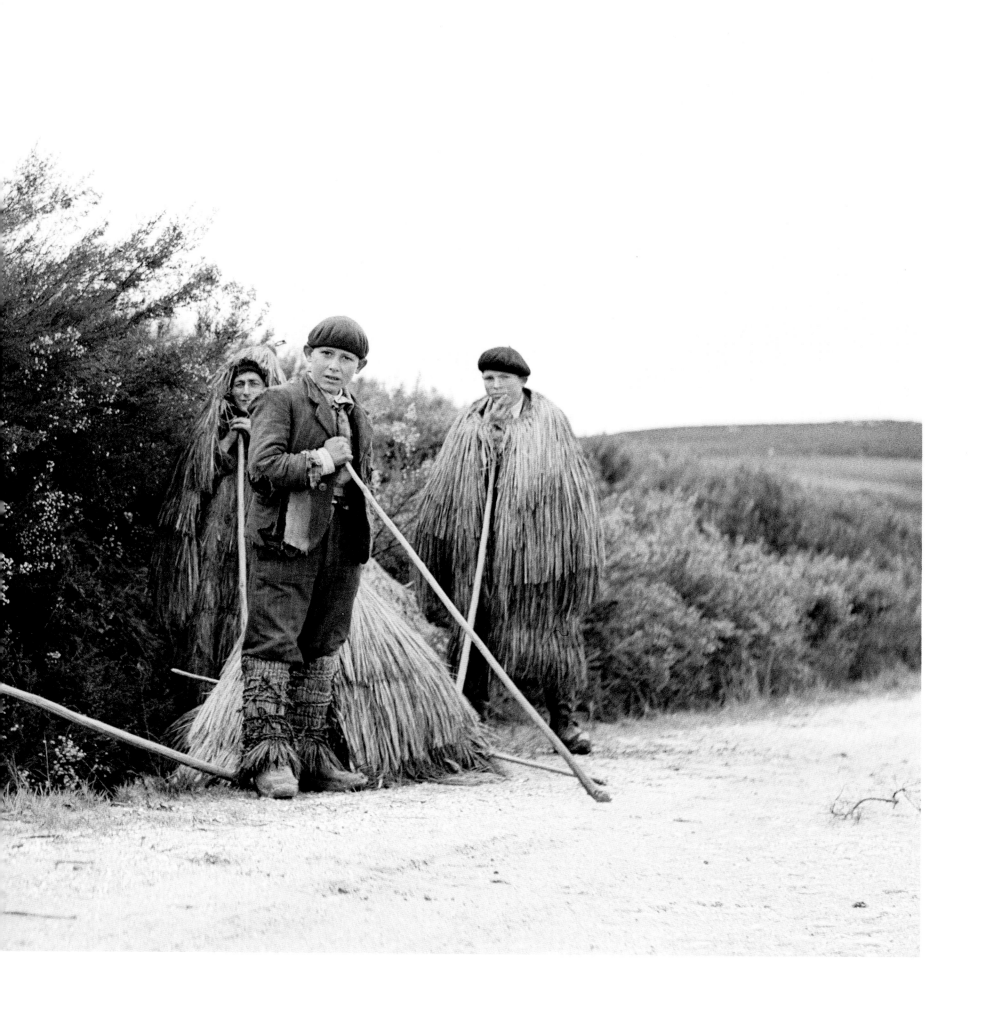

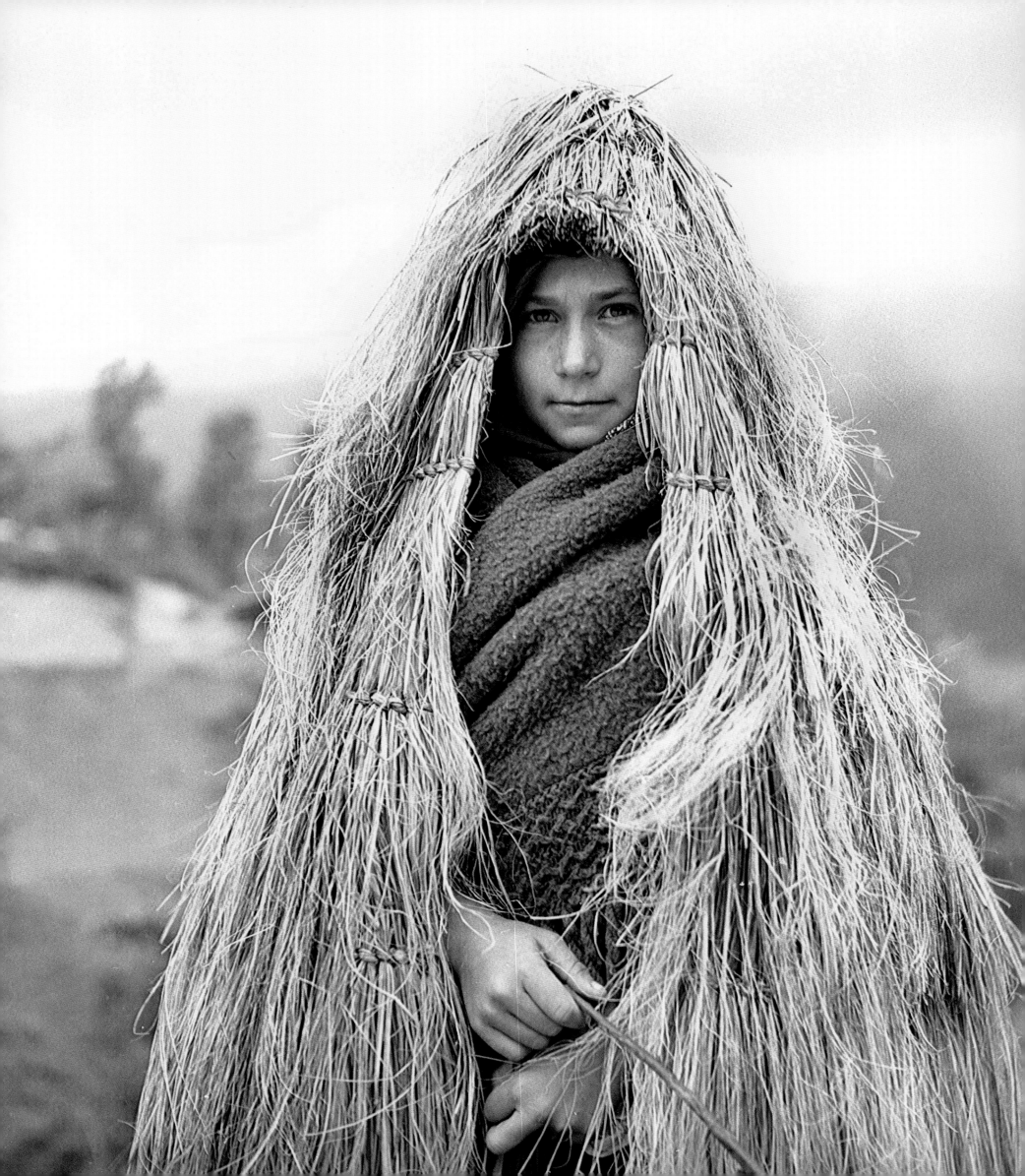

PORTUGAL/SPAIN, 1952

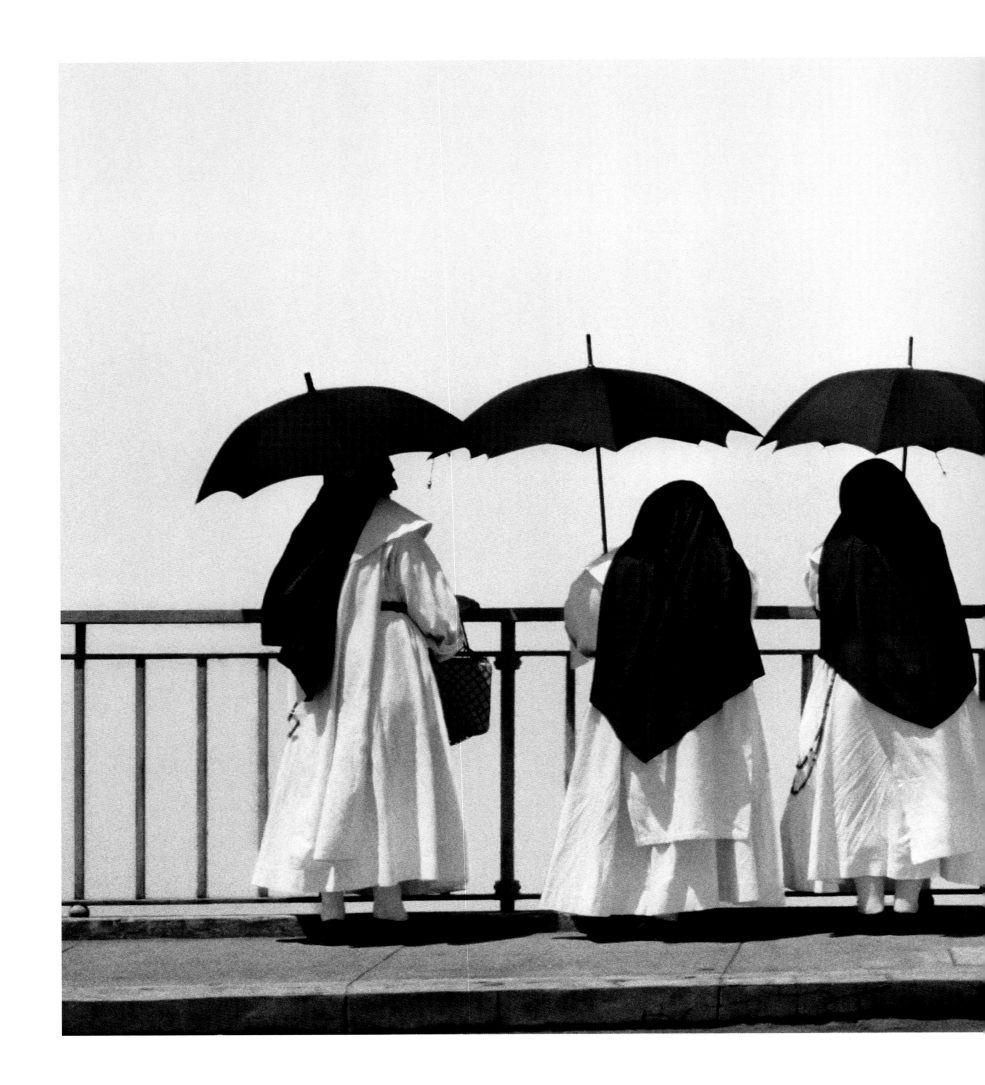

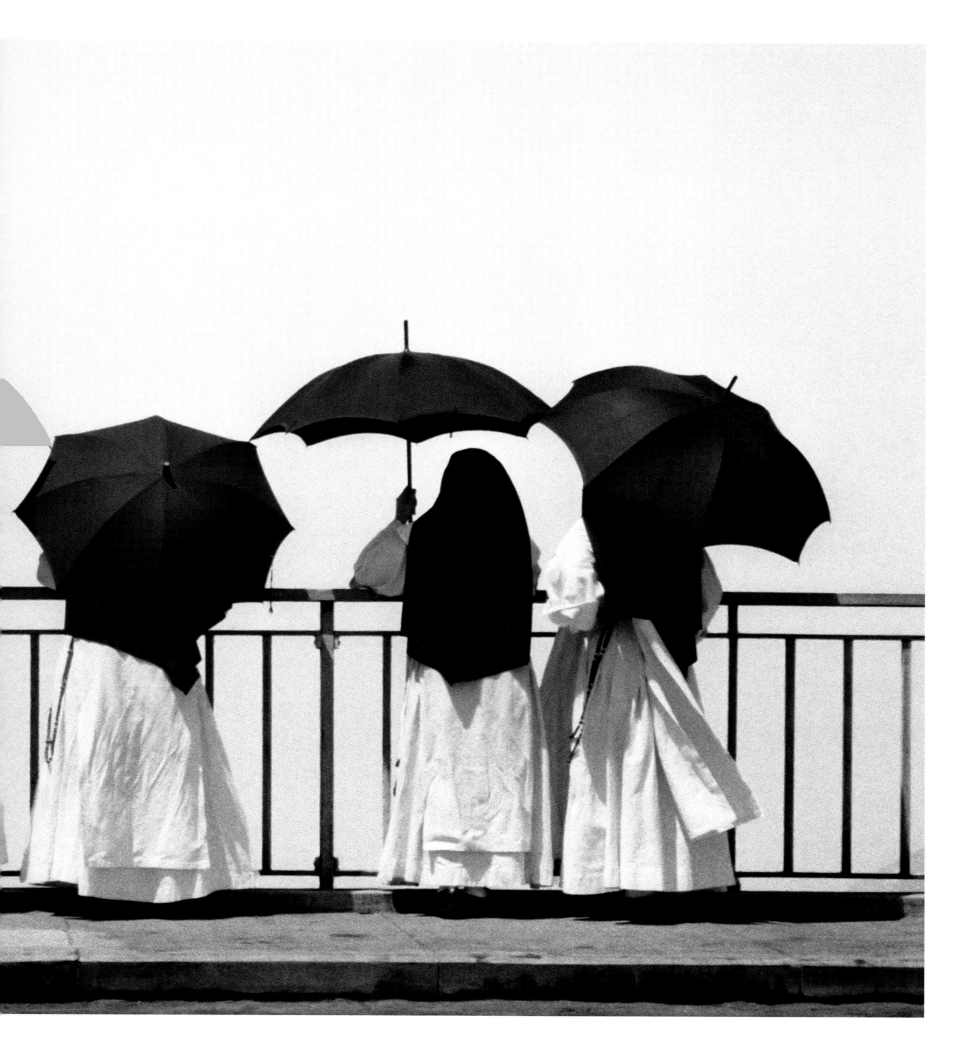

NUNS, RIO DE JANEIRO, BRAZIL, 1955

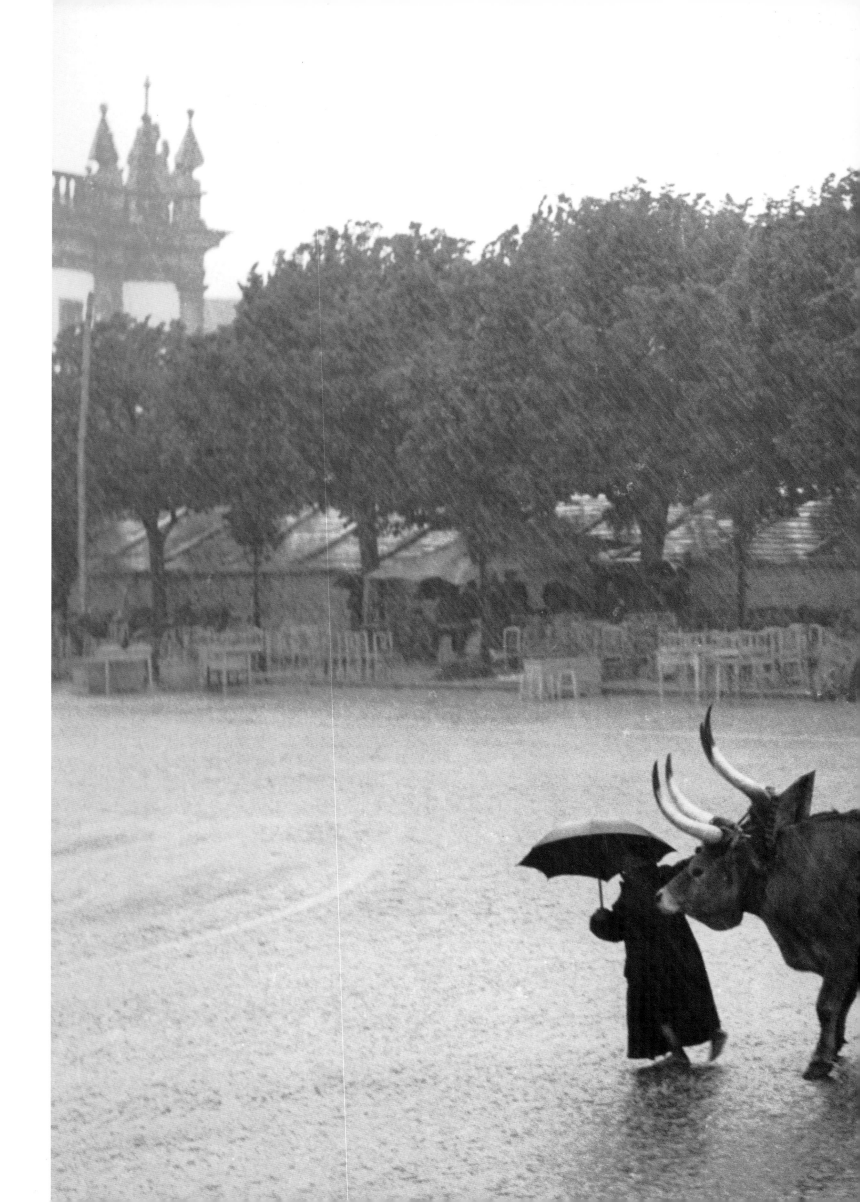

BARCELOS,
PORTUGAL,
1952

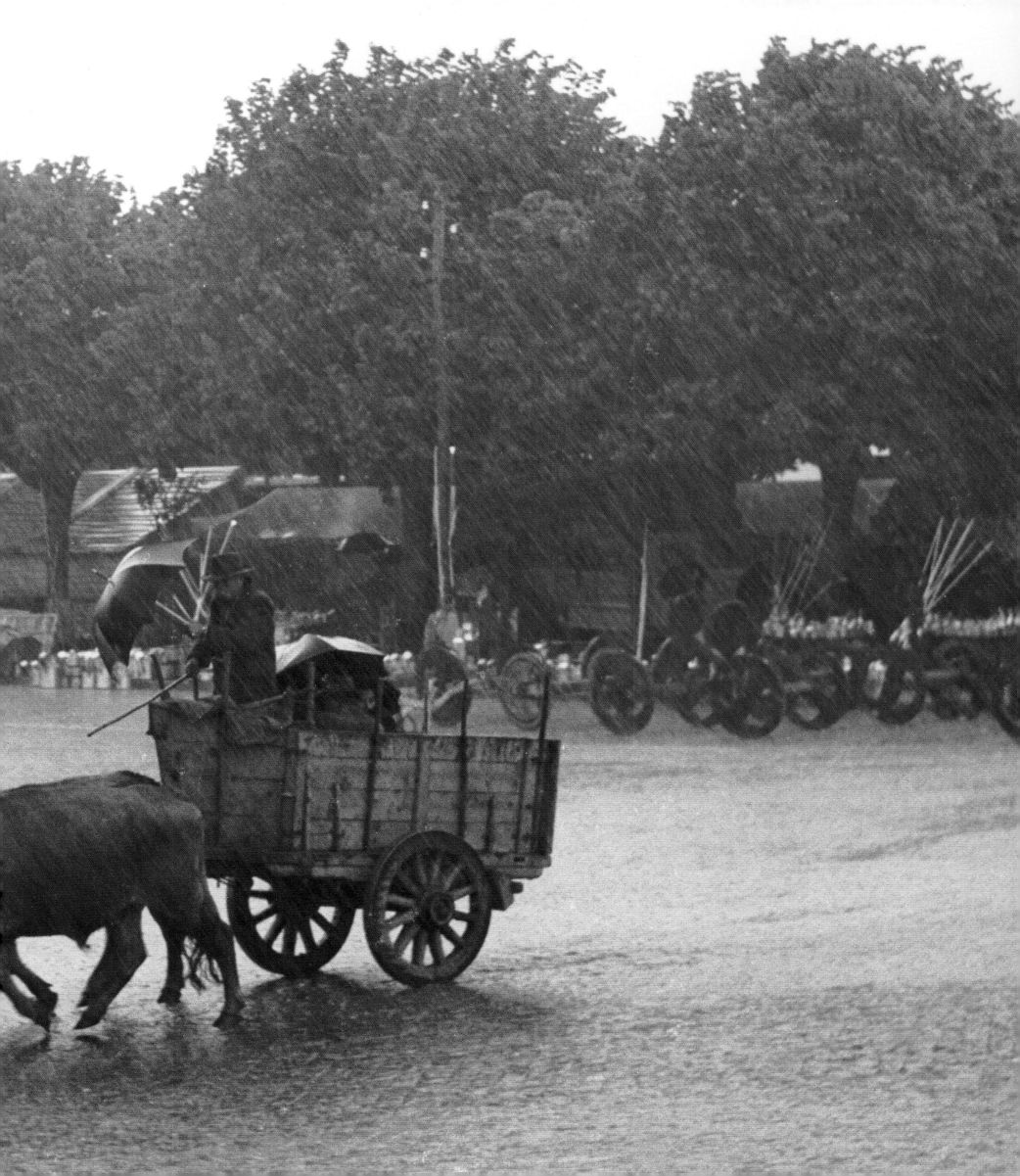

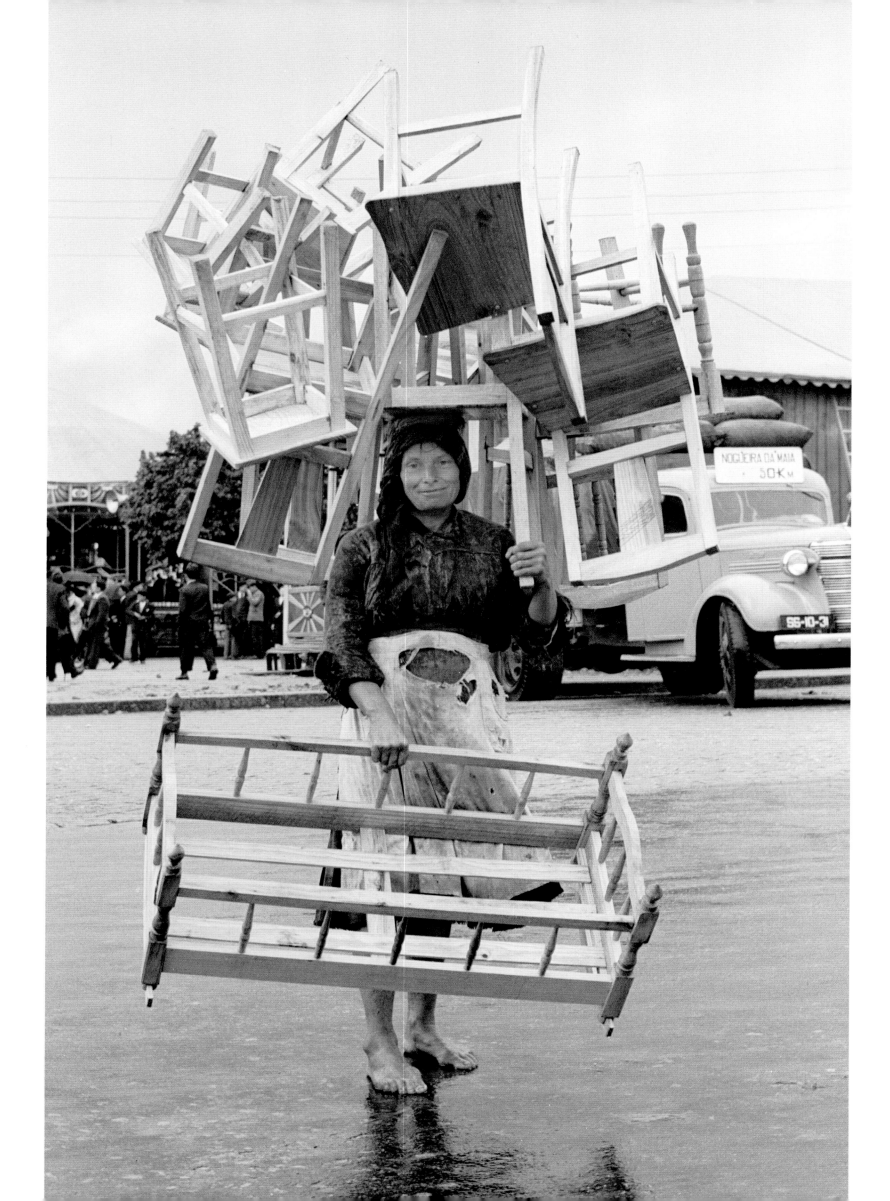

BARCELOS, PORTUGAL, 1952

WILLISTON BASIN, NORTH DAKOTA, 1952

I photographed Williston Basin for a black-
and-white story about oil, farmers, and the
community. By the time I got there, everything
on my shooting schedule had already taken
place. I would have to recreate whatever I
needed. I corralled lots of people and had them
waiting on line to get into the bank, to make it
look like people were making lots of money. I
had people go into stores to buy cowboy hats.
One night I was in a combination bar, gambling
joint, steak house about thirty-five miles out of
town on the state line between North and South
Dakota. Gambling was illegal but the *Time*
stringer who was accompanying me thought it
would make a good shot if I could get one of the
gambling tables surrounded by bettors. I put my
little Leica under my coat. When we walked into
the area where the craps tables were located,
there were huge cowboys with guns keeping
an eye on things, making sure everything was
kosher. I was determined to get a shot.
I pre-focused, opened my coat, and pushed the
button, and it sounded like a cannon going
off in my ear. I didn't dare take another shot
because I would have had to wind the film.
I didn't know if I had anything, but felt extremely
uncomfortable. The stringer and I started to
walk out when the manager came over to us and
said I couldn't photograph in there. Oh yeah,
I said, and slung my camera over my shoulder
and started to walk out, when he stepped in
front of us again, smiled and offered us a thick
steak and beer. We accepted. He asked that I not
publish the photograph of the gambling as it was
illegal. I had nothing else on the roll and handed
him the film. Afterward, the stringer said we
would never have made it back to town safely if
I hadn't given up the film. The next day, I was
photographing at the bank, making it look like
Boomtown, USA. When I finished, the bank
president came out and said he was glad we had
enjoyed the meal at his place the night before.
"Your place?" I said. "Yeah, my place. I own it.
I appreciate what you did."

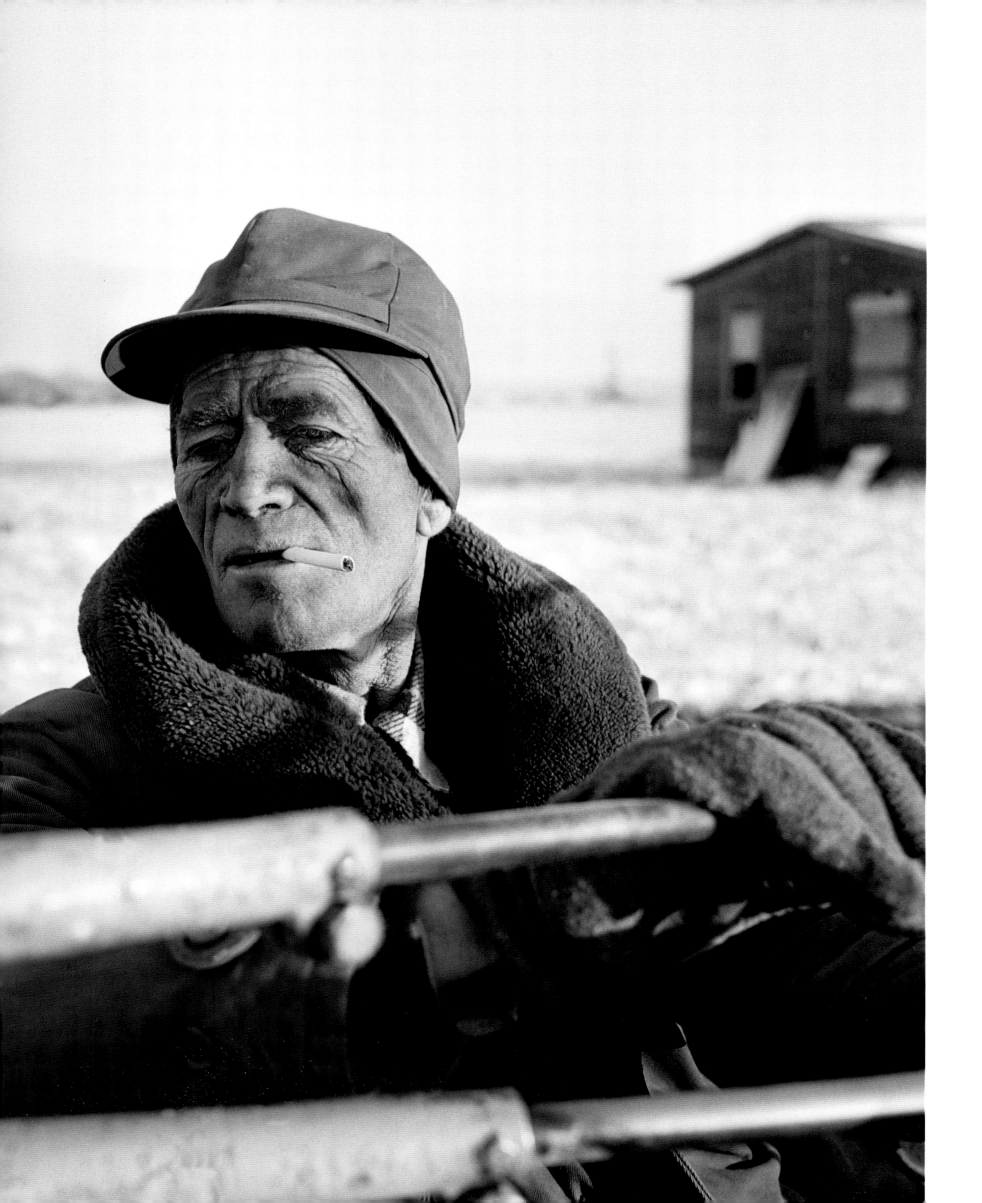

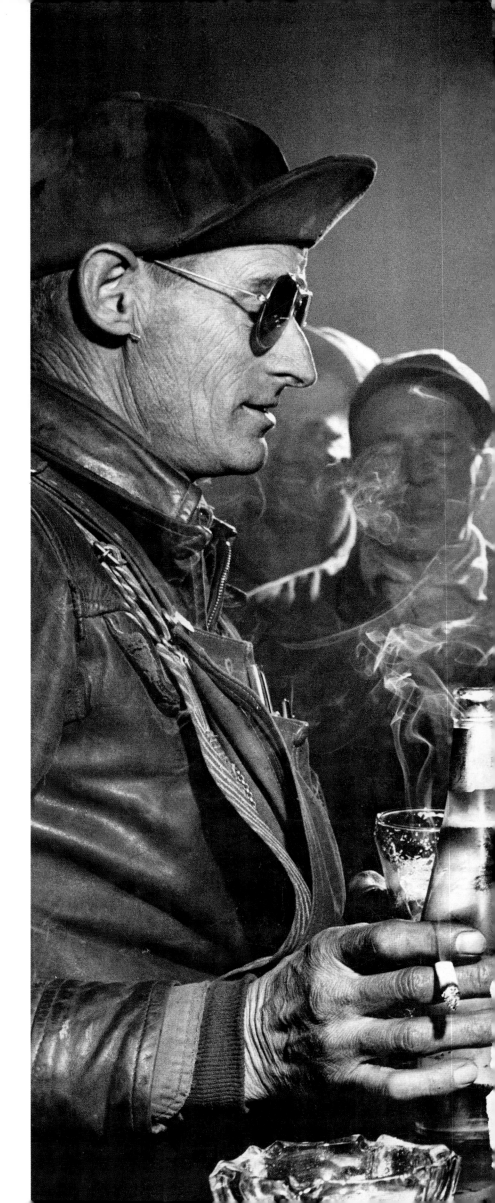

WILLISTON BASIN, NORTH DAKOTA, 1952

48

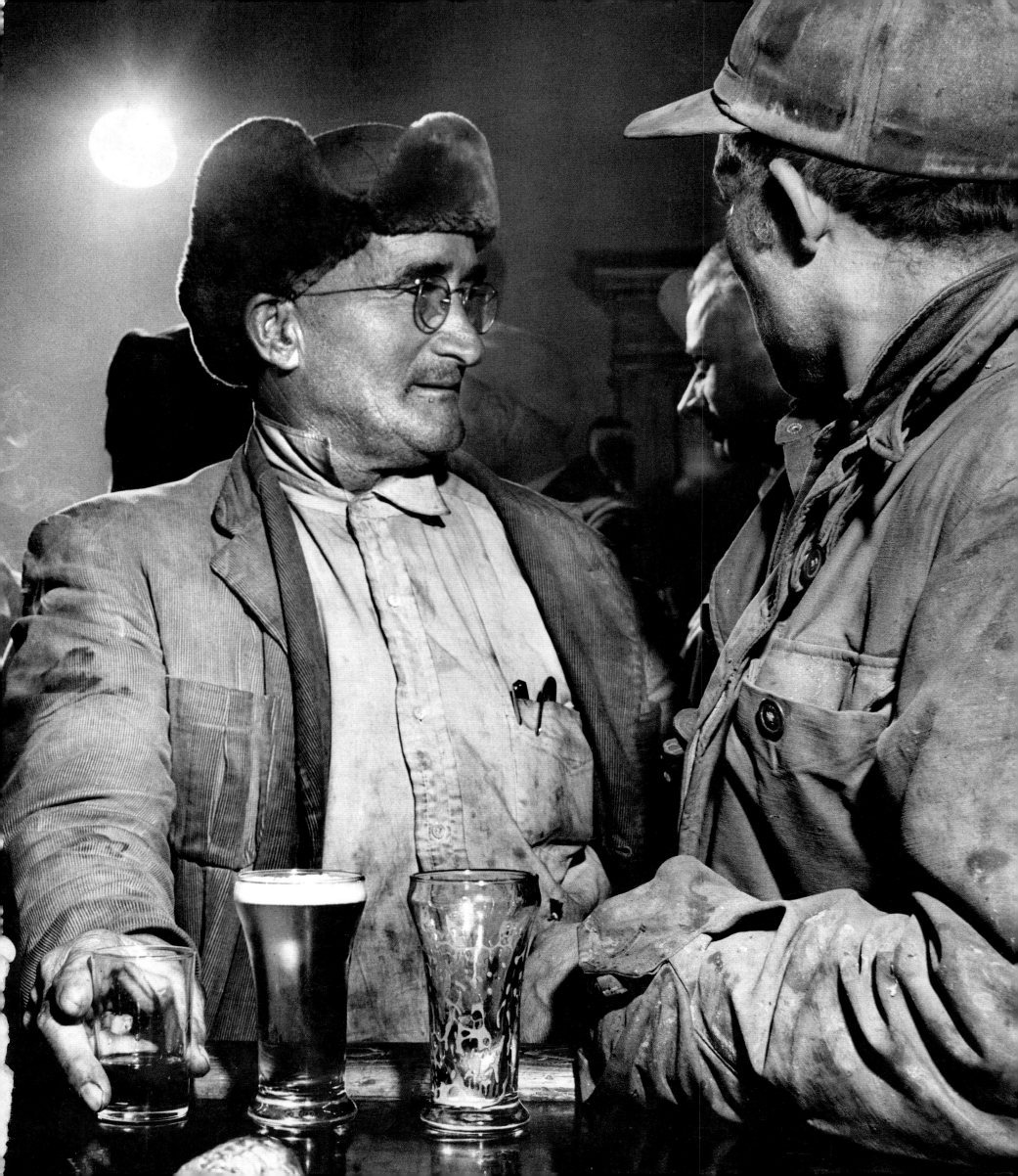

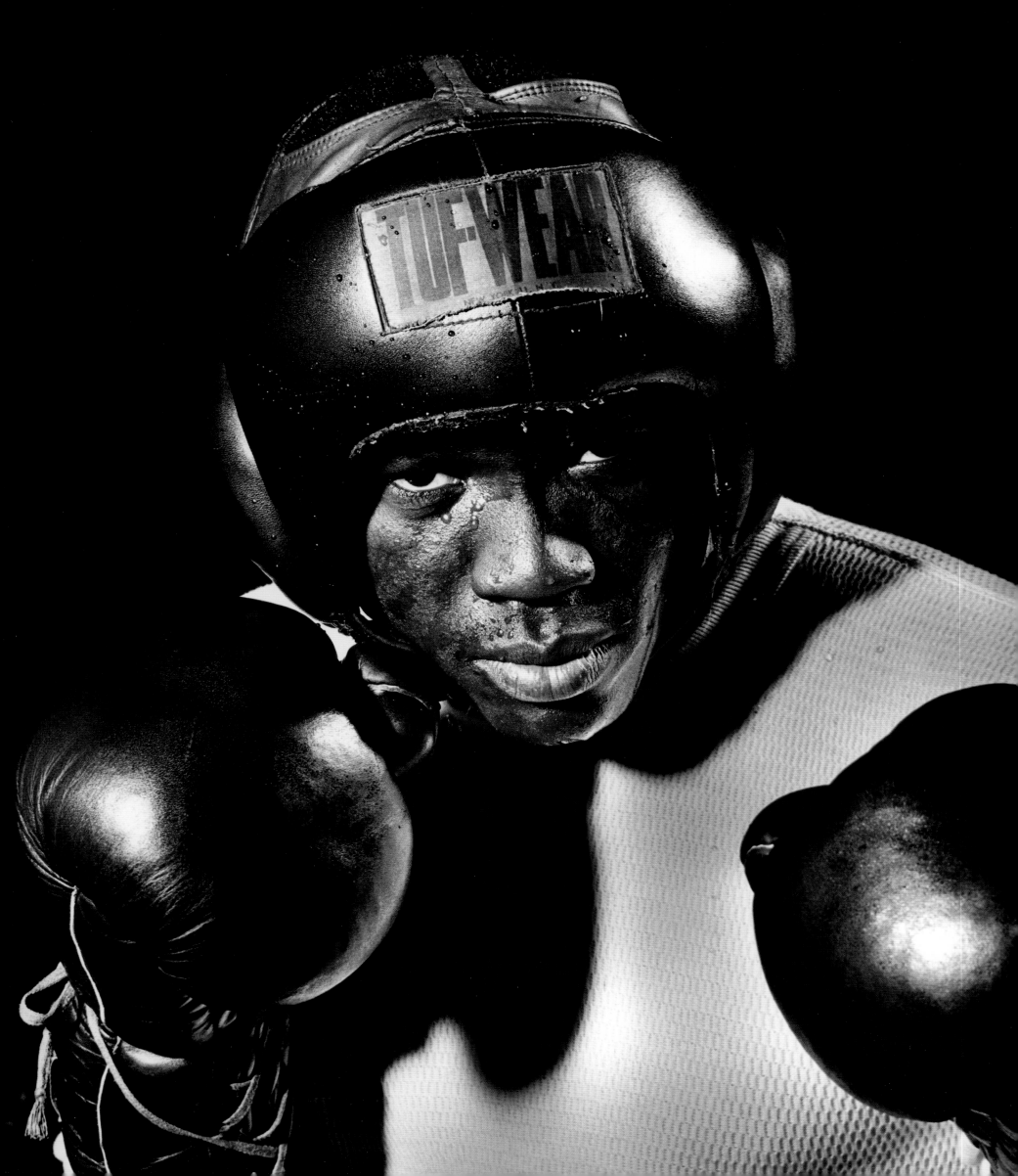

EUROPEAN JUDO CHAMPIONSHIP, PARIS, 1951

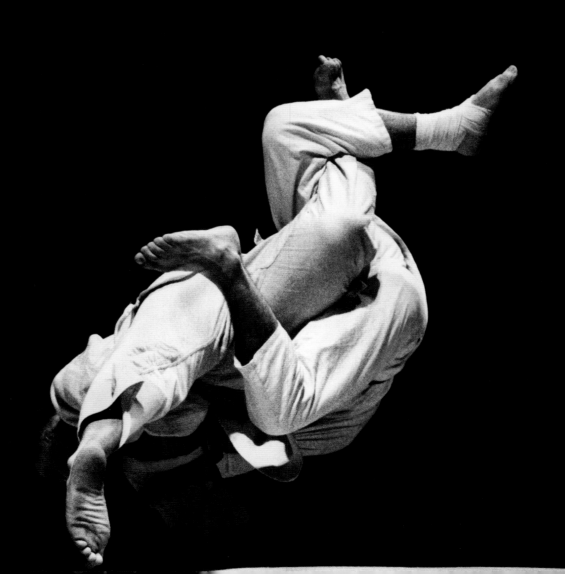

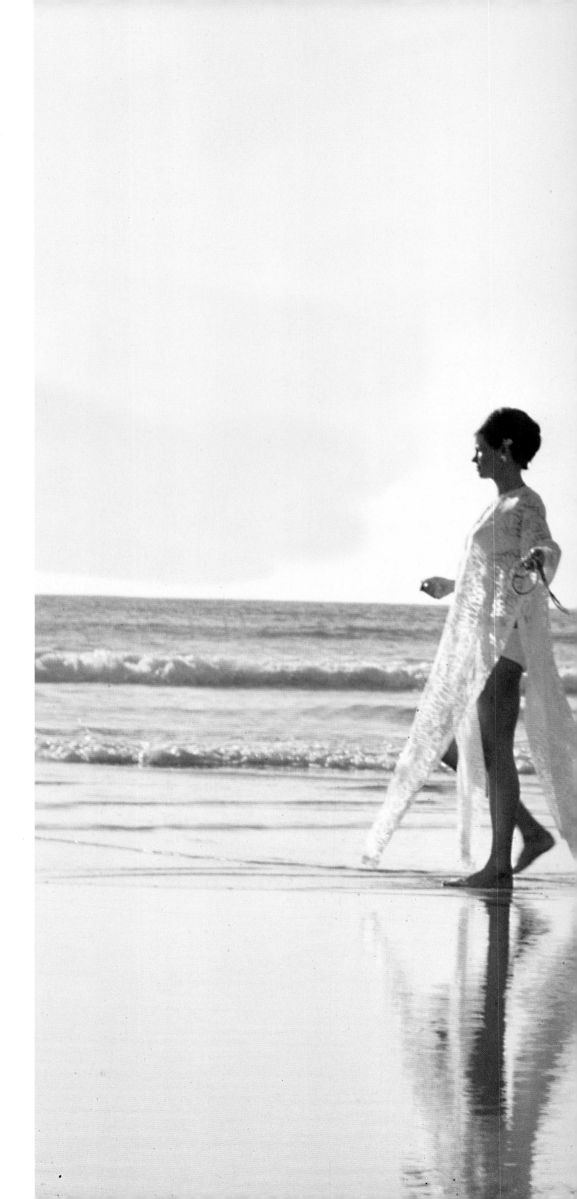

MOROCCO, FOR *TIME*, 1968

Time magazine called me up one day and asked
if I would like to go to Morocco and photograph
it as the new "in" place in the world to go. Or
they said I could go on a safari. I said forget the
safari, I want to go to Morocco. They wanted
me to take someone along who could take notes
and suggested I bring my wife, Sue. So off
we go to Morocco where we meet a reporter who
lived there, a stringer for *Time*. He had done
all the research on the best hotels, best
restaurants, the best of everything, and that's
where we stayed, where we ate, and where we
photographed. We started out in Rabat and
went all over. We had a wonderful time. I got
six pages in the magazine.

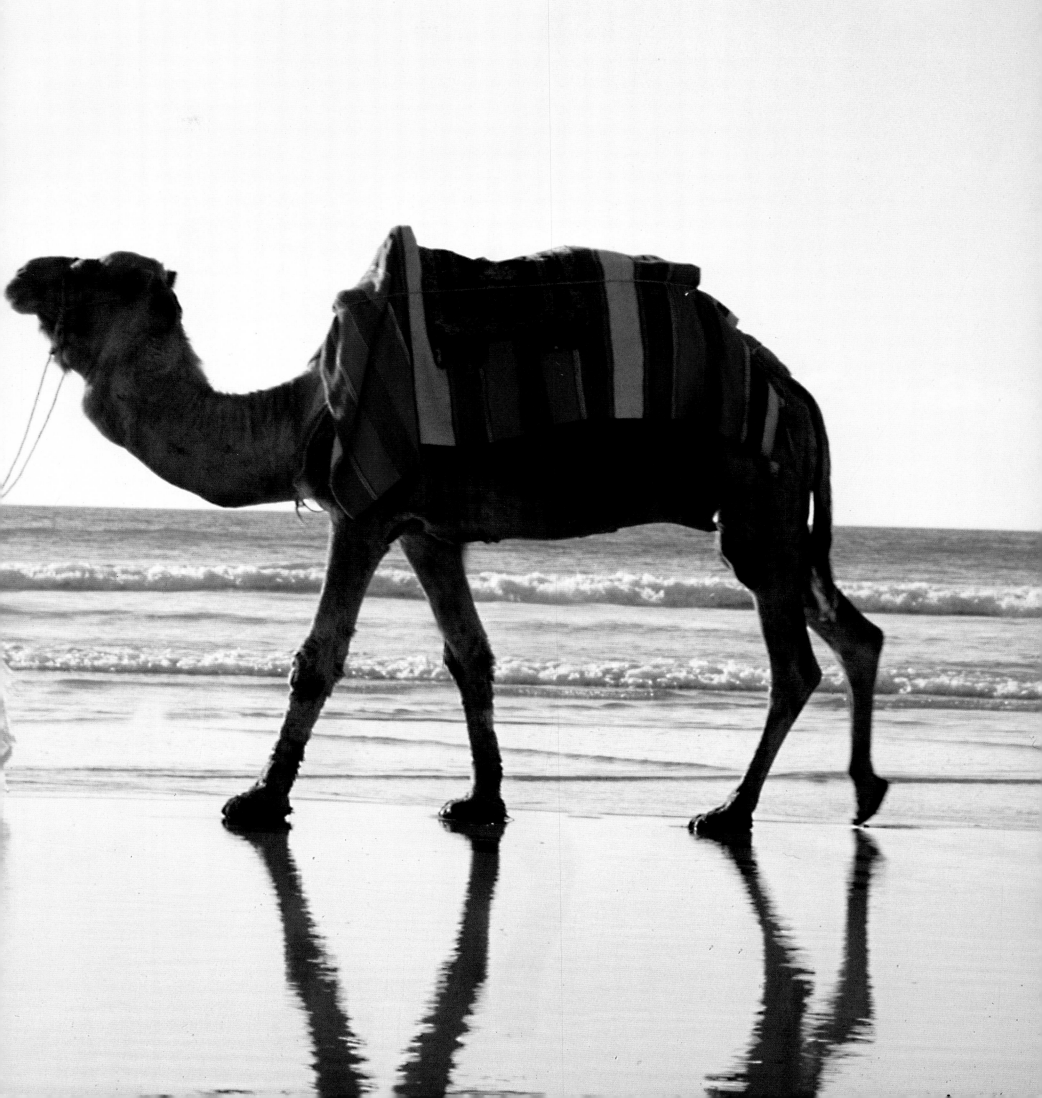

MOROCCO, 1968

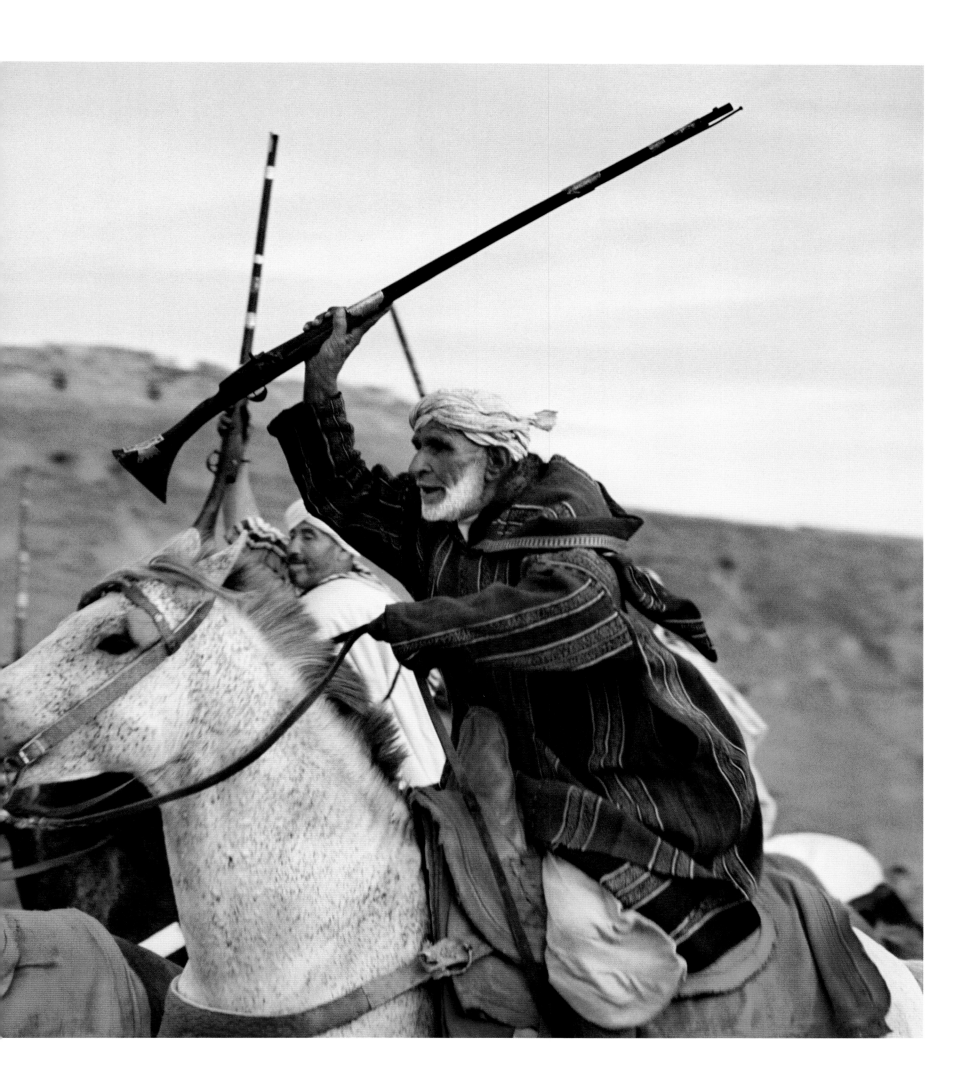

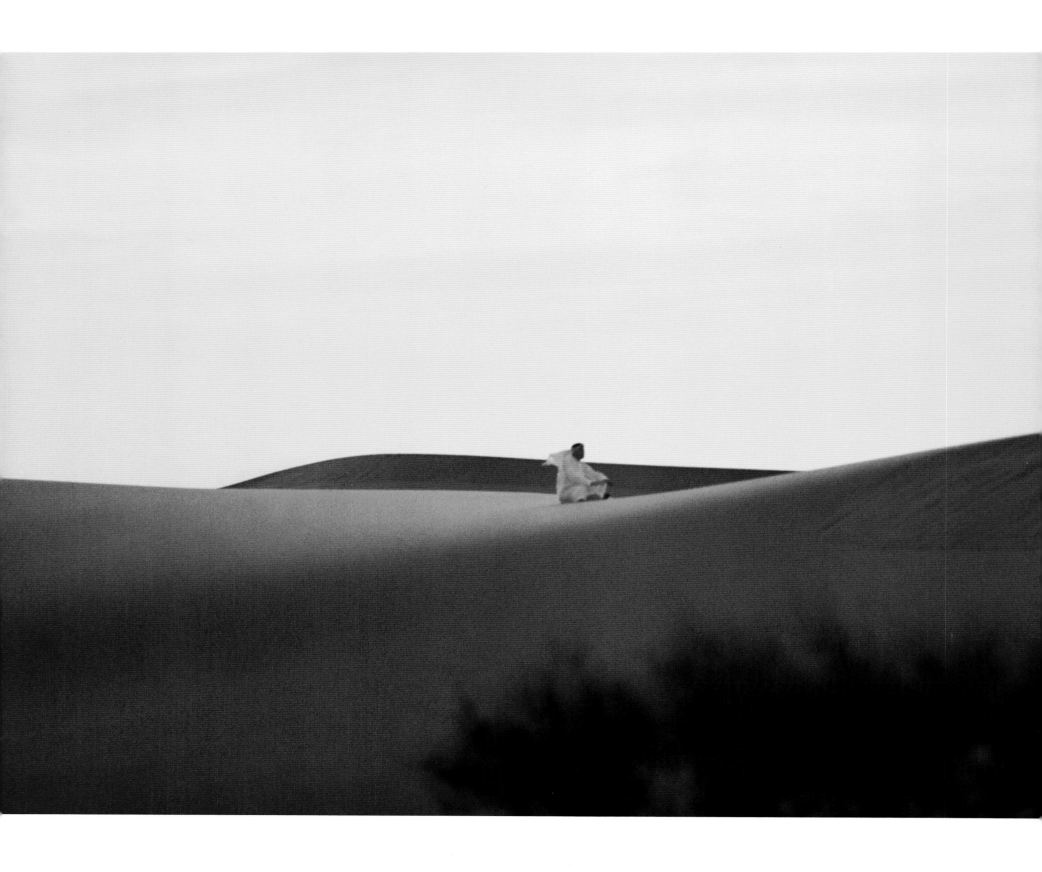

SAUDI ARABIA, 1964

I got an assignment from the Saudi Arabian government to photograph farming, irrigation, schools, and airports. At the same time, *Time* assigned me to photograph a feature story on the lack of water in the Middle East, including Saudi Arabia, Kuwait, Israel, Ethiopia, and Egypt. And it was to include King Faisal. The King actually invited me to lunch while I was there.

Arriving in Jeddah, I was given my own Beaver aircraft with an American pilot. This would be my means of transportation for the whole assignment, with a Saudi guide. My first day there we flew out into the middle of the desert to photograph King Solomon's mines. We had to land several miles from the mine where we met some geologists who guided us

there. Still tired from traveling, I fell behind the group. I noticed two large dogs nearby. I tried to be friendly but they kept their distance. When I got caught up with the group, they asked me, "Did the wolves bother you?"—a learning experience. And King Solomon's mines turned out to be a small hole in the ground. No photograph.

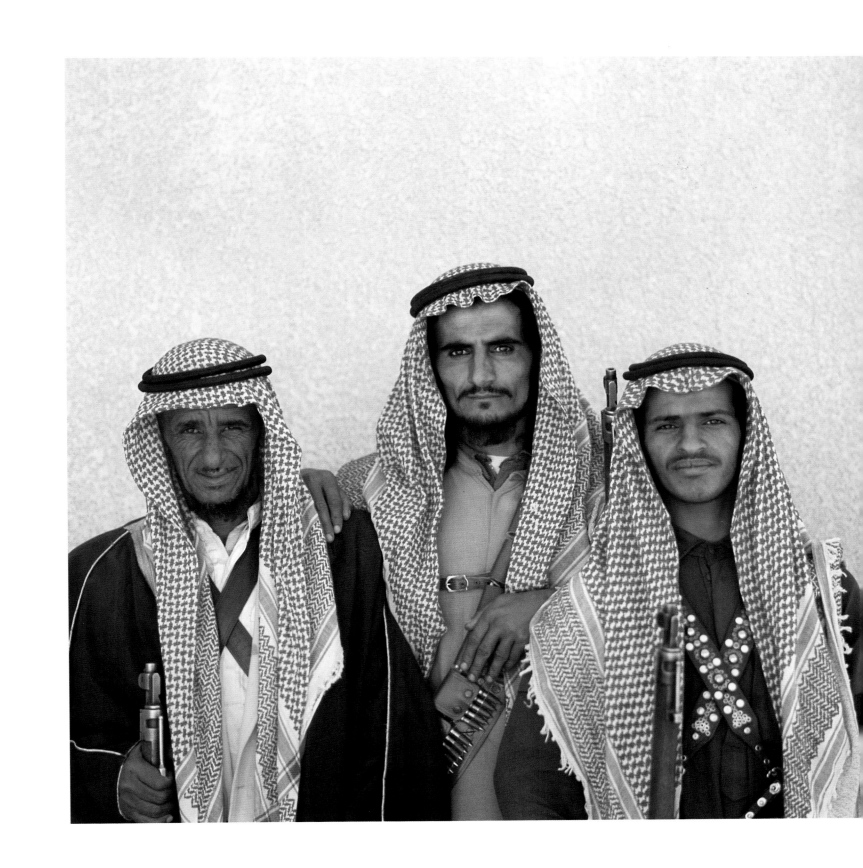

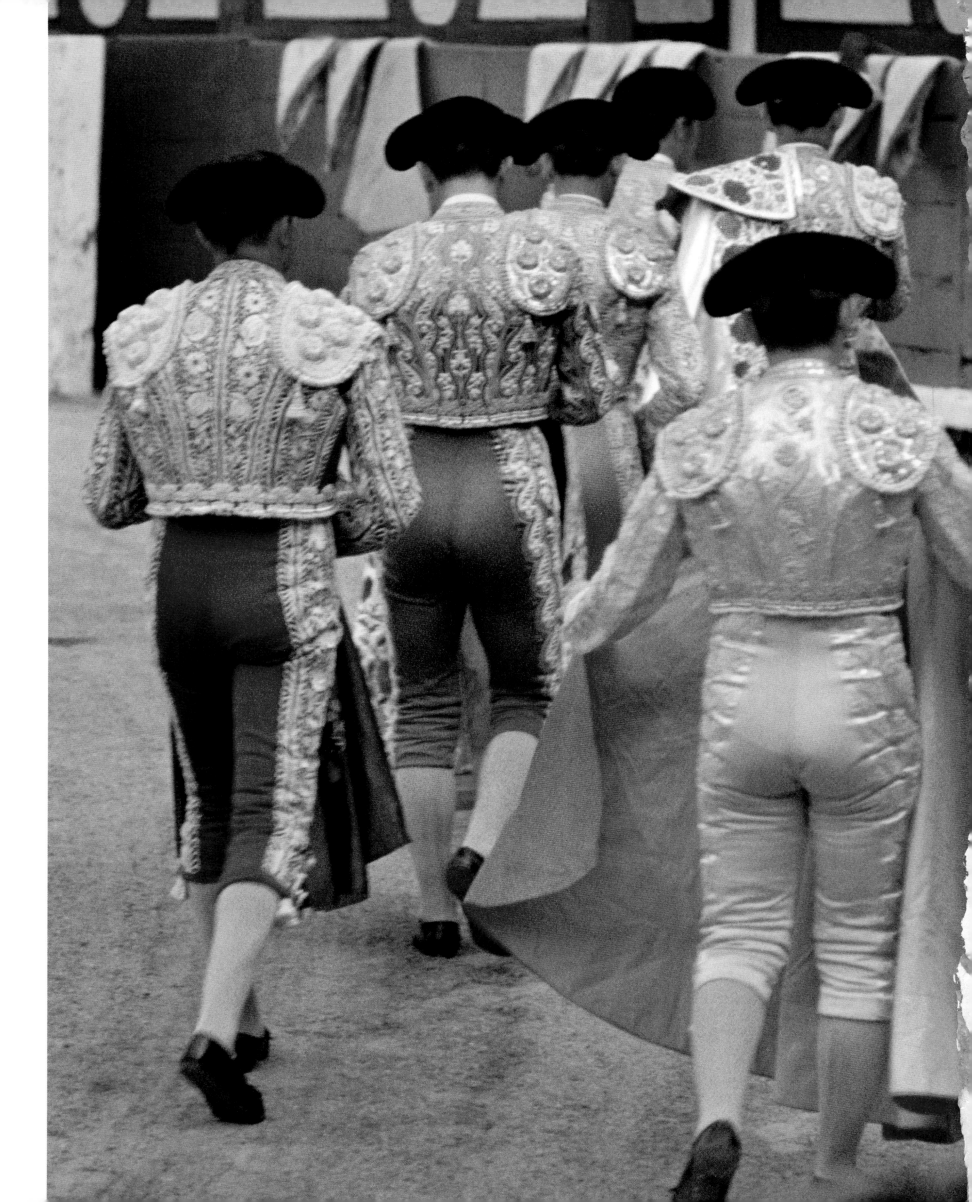

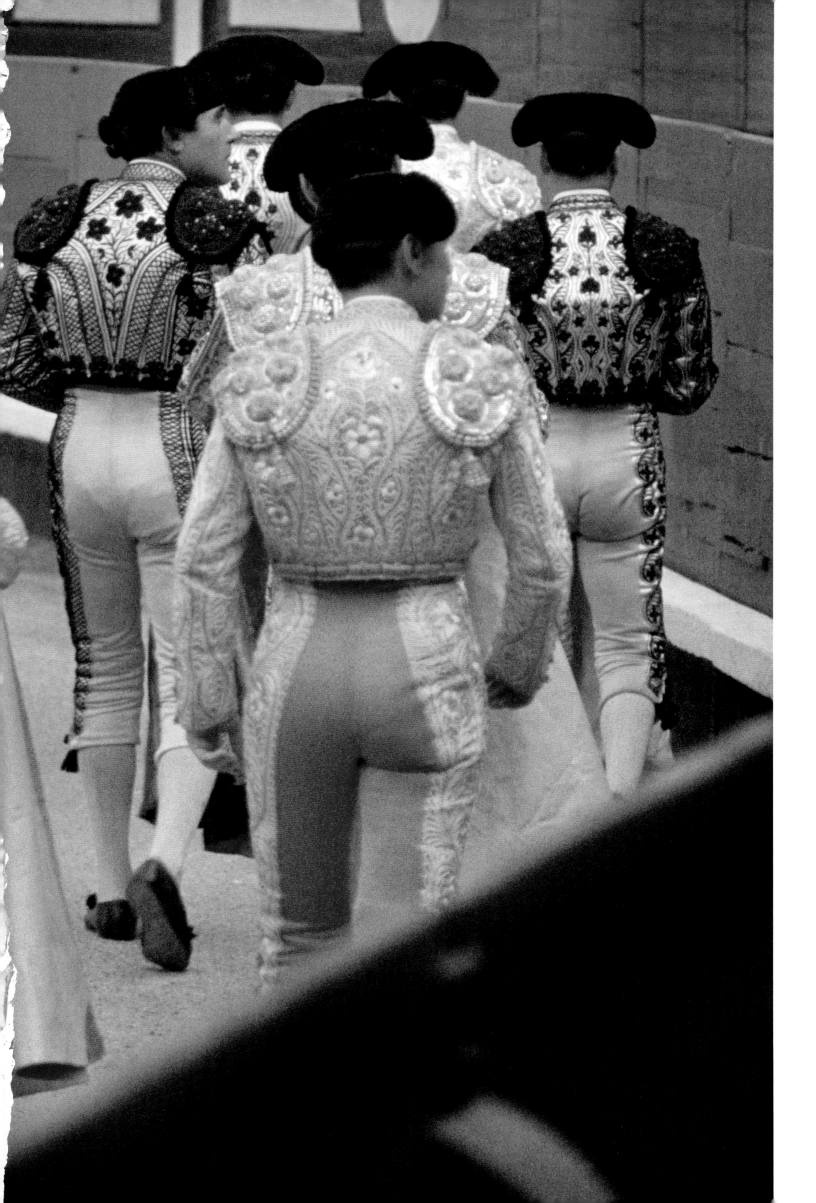

BULLFIGHTER
PROCESSION,
SEVILLE, SPAIN, 1952

SAUDI ARABIA, 1964

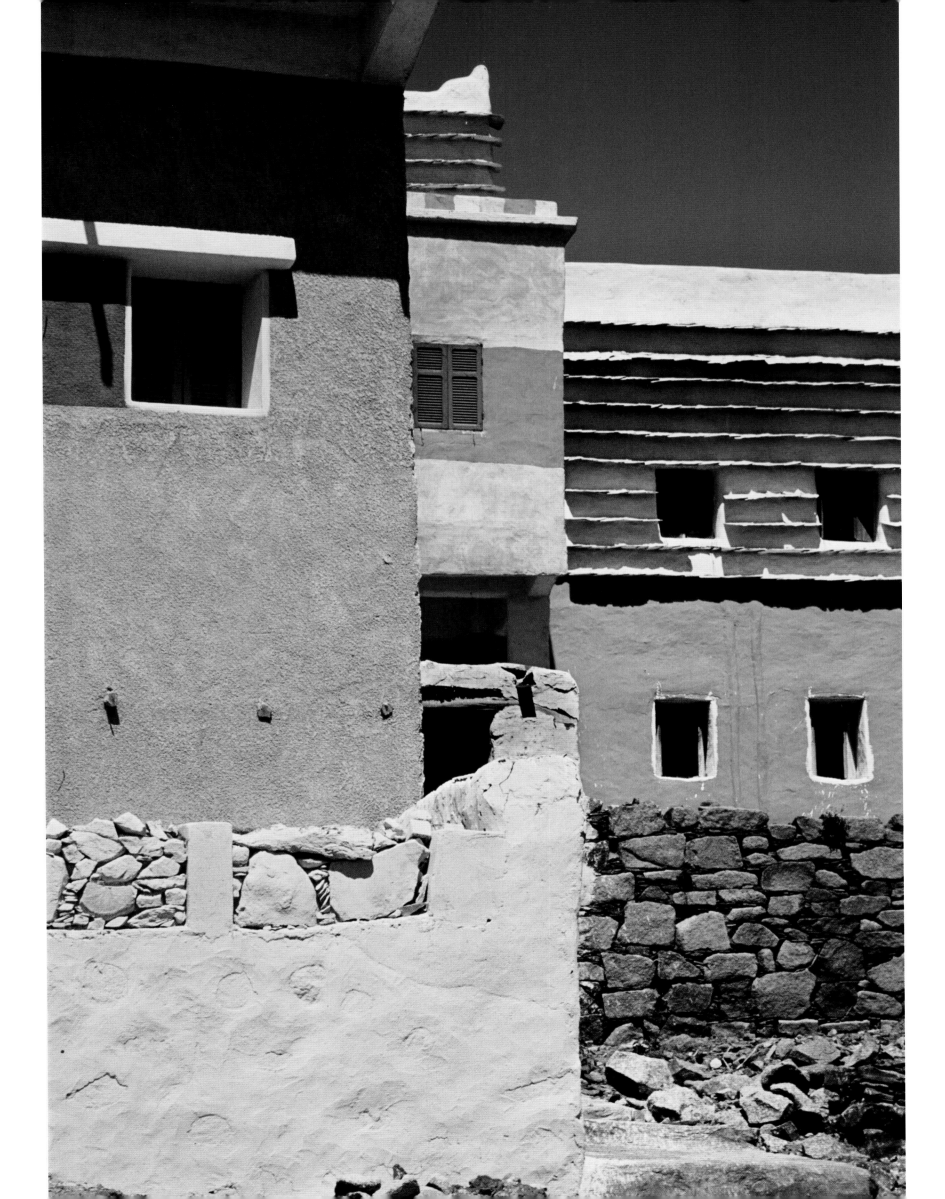

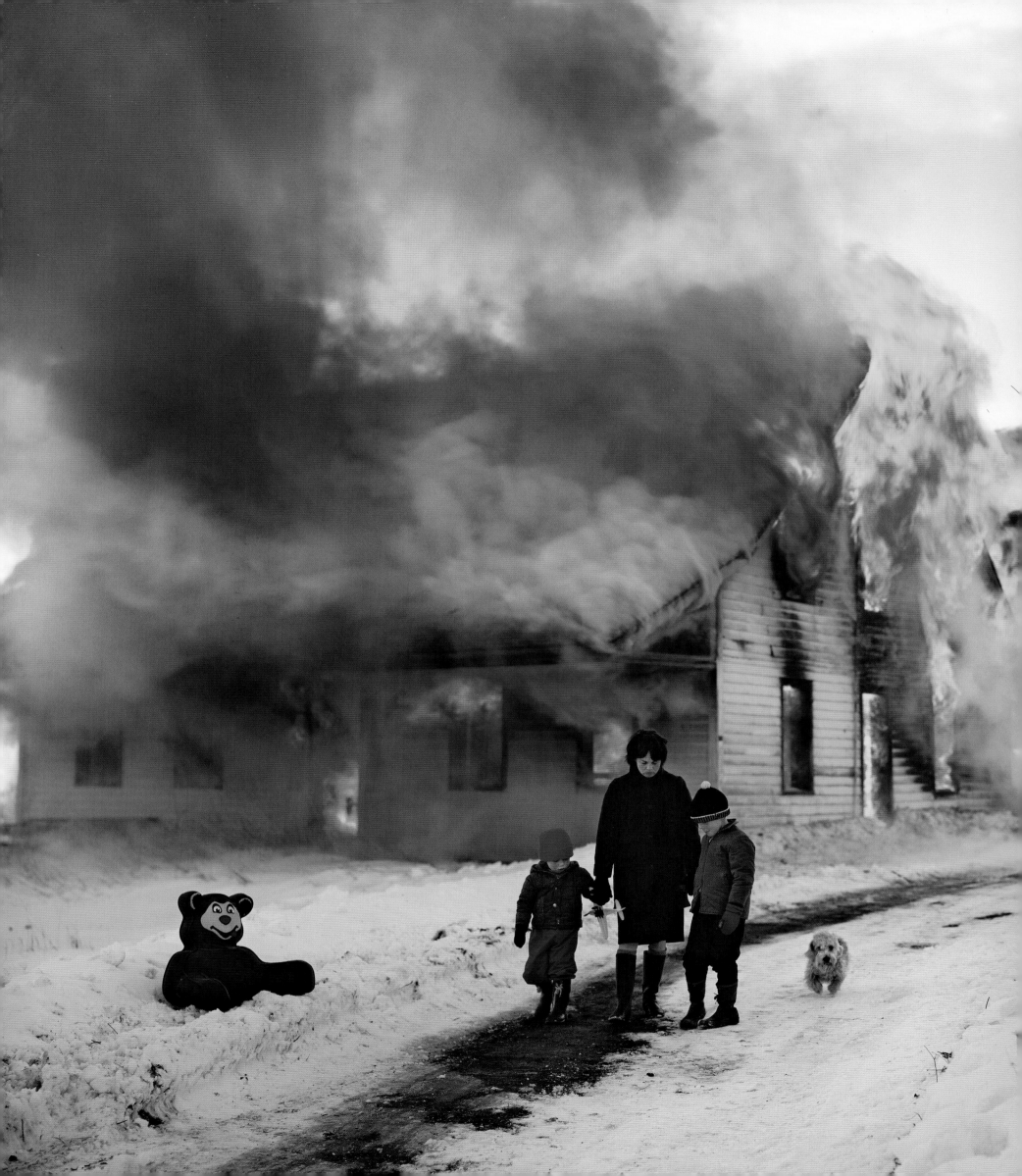

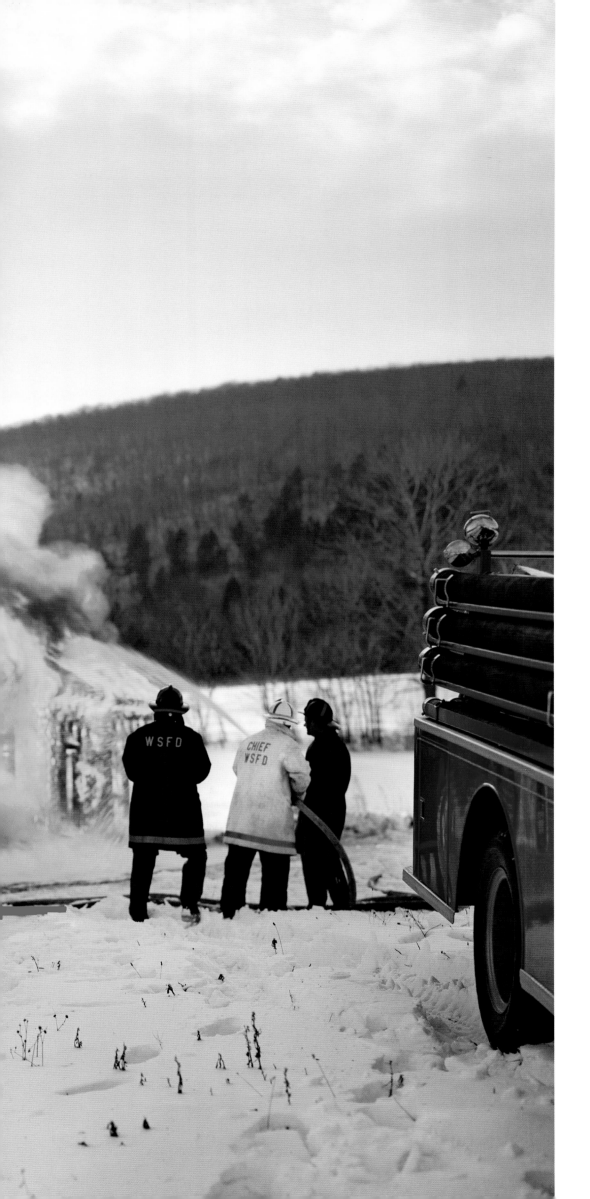

HOUSE ON FIRE, BERKSHIRES,
MASSACHUSETTS, 1963

We bought a farm in the country with a
dilapidated farmhouse, in Massachusetts, and
built a modern home up on the hill. The old
farmhouse was an eye sore, even the old boards
couldn't be saved. We had to get rid of it. I had
the idea to invite the local fire department over
to burn it down, while acting like they were
trying to save the house. I had my two small
boys, Ogden and Blake, on the scene, along
with their mother Sue, the former actress. The
house was on fire in the background and the
firemen were fighting the flames. I shot pictures
of Sue walking away from the house holding
the hands of four-year old Ogden and
seven-year-old Blake. Everyone played their
part, even Dudley the dog.

FORM
& FASHION

—
—

My earliest professional work as a photographer involved fashion. In 1941, at the age of seventeen, I got a job in the afternoons, after school was out, working for the *Ladies' Home Journal*. I worked as a photo assistant to Wilhela Cushman who was the fashion editor there. We used an apartment on East 79th Street, which I had located for the purpose, as our studio. Some of the top models of the day would be sitting around in that apartment waiting for their turn to be photographed. We usually wouldn't get started until around six o'clock and sometimes we would go to eleven o'clock or even one o'clock at night. Sometimes Mrs. Cushman would get carried away and say, "Ormond, call Mr. Goldfarb, I want hundreds of sunflowers." I would say, it's one o'clock in the morning, and she'd say she didn't care, call him at home. If nothing else, it taught me that if you needed something, you go after it, there is no time to be shy. The work also exposed me to good taste and a sense of quality. Quite a few times we would be driving along in her limousine and she would see a girl on the street who looked attractive, and we would stop and she would tell me to go get the girl. I would rush out after the girl and explain the situation and bring her to Mrs. Cushman in the car. Mrs. Cushman would usually say, "No, you won't do."

The war intervened and I ended up as a navy photographer. When I got back to New York in 1945, the *Ladies' Home Journal* somehow learned I was out of the service and let me know that they would like me to come work for them again. But I knew I would have a problem with Mrs. Cushman again about credit. I had been doing all the lighting, setting up the shoots, the cameras, and handing Mrs. Cushman the cable release, then she would snap the picture. Then I would change the film and reset everything. I stayed with them for about six months and never got credit, so I moved on.

I was living the life of a starving artist in Paris in the early 1950s and it was a beautiful place to be. I was staying in a cheap hotel in Porte de Saint-Cloud. At one point I was up in the attic developing pictures I had taken on a trip to Spain and Portugal and it was freezing cold. Finally, I felt I had to give it a try and so I went to *Life* magazine's Paris bureau. I saw the bureau chief there, John Jenkisson, and showed him my work. He said to me, "When I send Robert Capa on an assignment he never does what I ask him to. If I say I want a straight portrait, I get a profile. I don't mind getting profiles, if I'd also get a straight portrait. If I give you an assignment, will you give me what I ask for?" I said yes as long as I could inject my own thoughts into the picture. He tells me he will see what he can dig up for me. So I get on the Métro and head back to my hotel, and as I walk in, the concierge tells me that *Life* magazine just telephoned. I call them back and they have an assignment for me. I get on the Métro and head back to *Life* and they ask me to photograph the French fashion openings and the "new look" for the season. Schiaparelli, Dior, Fath, and all. I had four photographs published in *Life* magazine, in the "centerfold," in March 1952. And that was really the beginning of my career. – O.G.

PREVIOUS SPREAD: LIPS, FOR *TIME*, 1960 NUDE, FOR *LEAR'S*, 1988

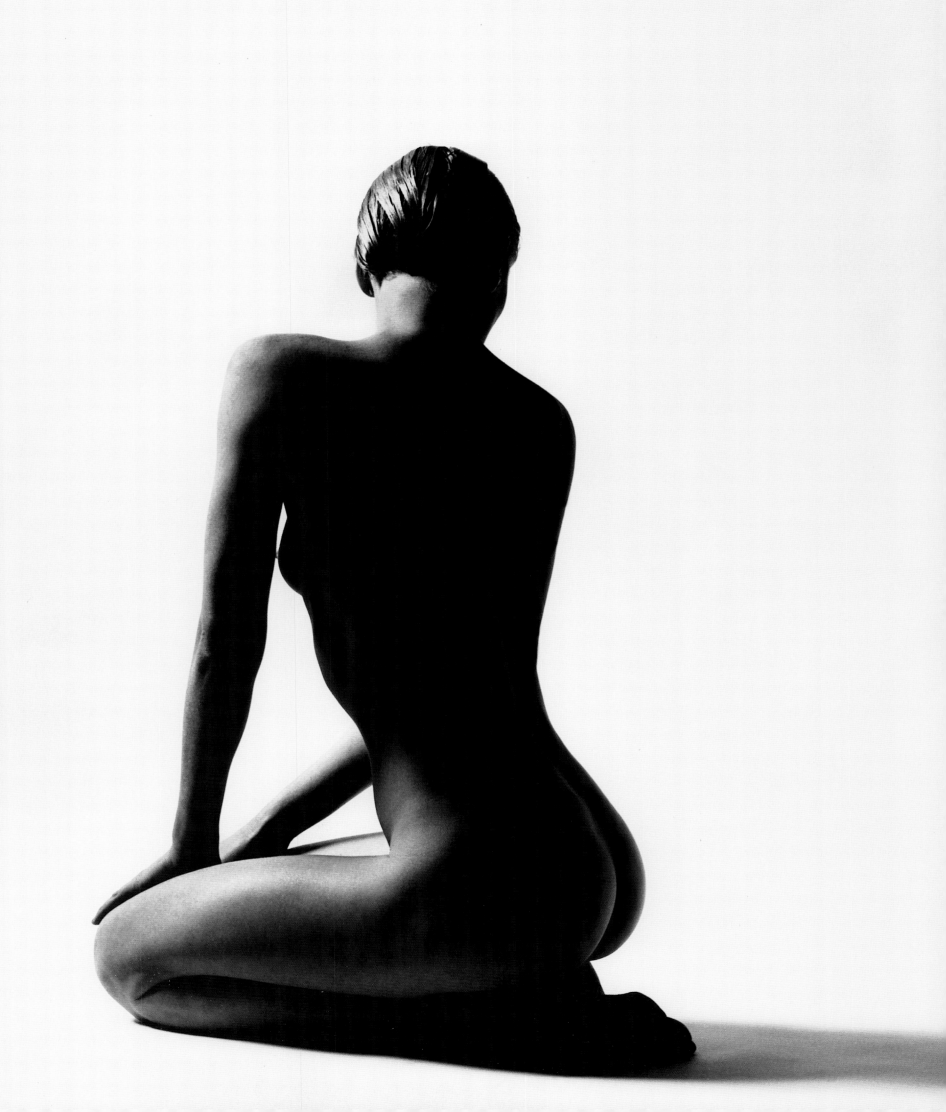

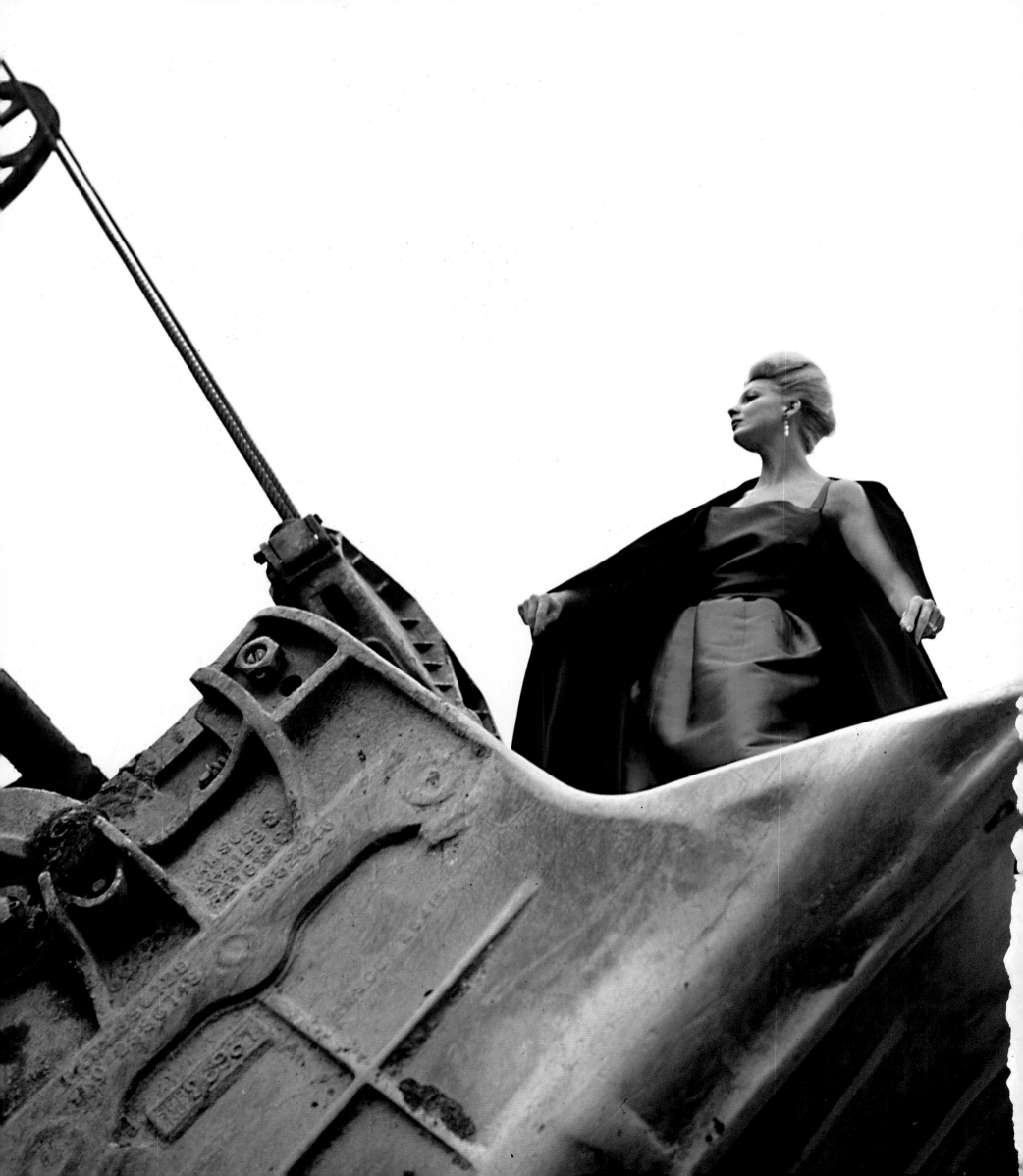

WOMAN IN STEAM SHOVEL, 1965

I was photographing a model in my studio for
a fashion story when I noticed this huge steam
shovel parked outside on the street. I went
out and asked the operator if he would let me
photograph a model in the shovel and he
agreed. He raised the shovel up so I could
photograph her from below and not show the
buildings that surrounded us.

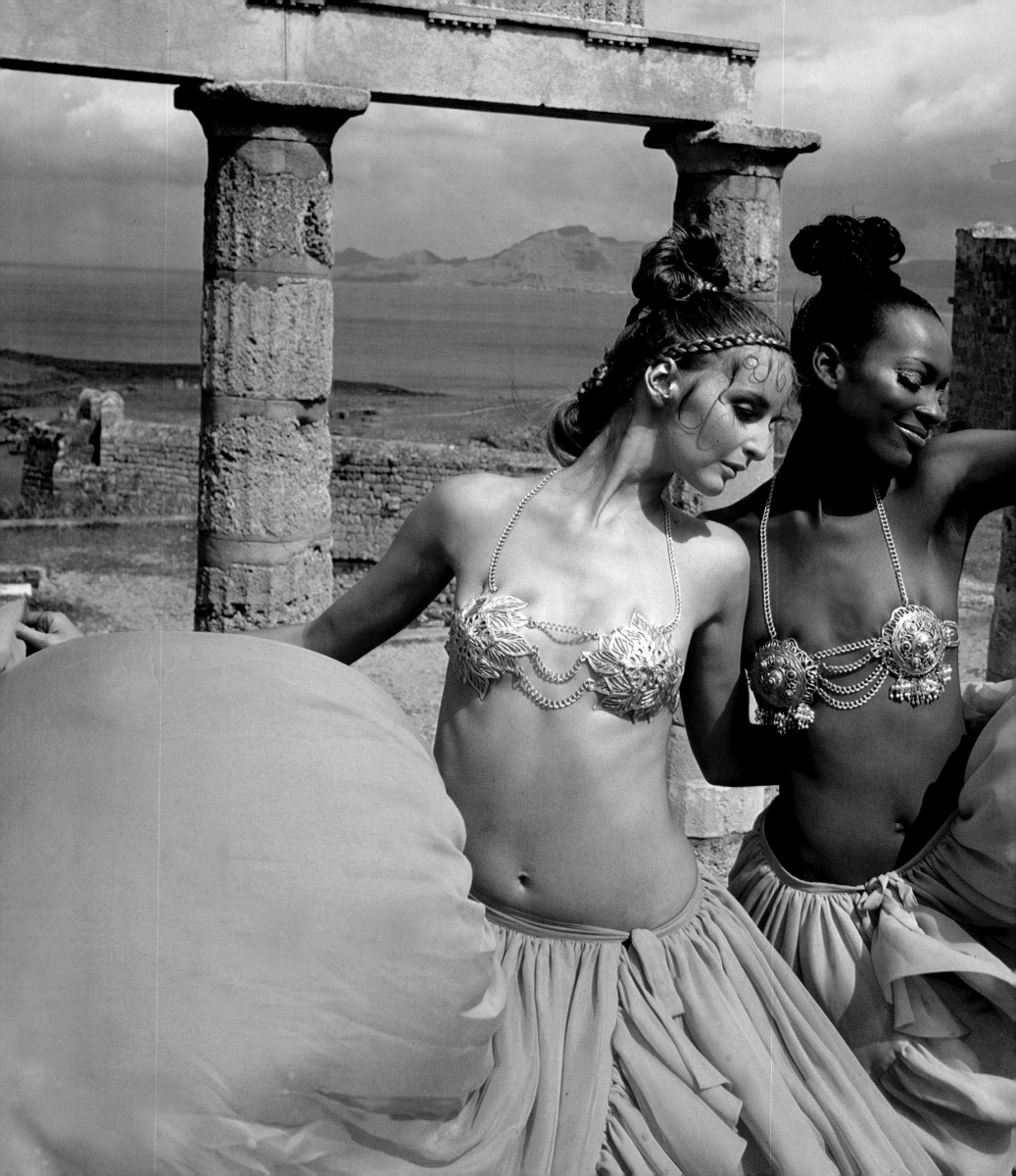

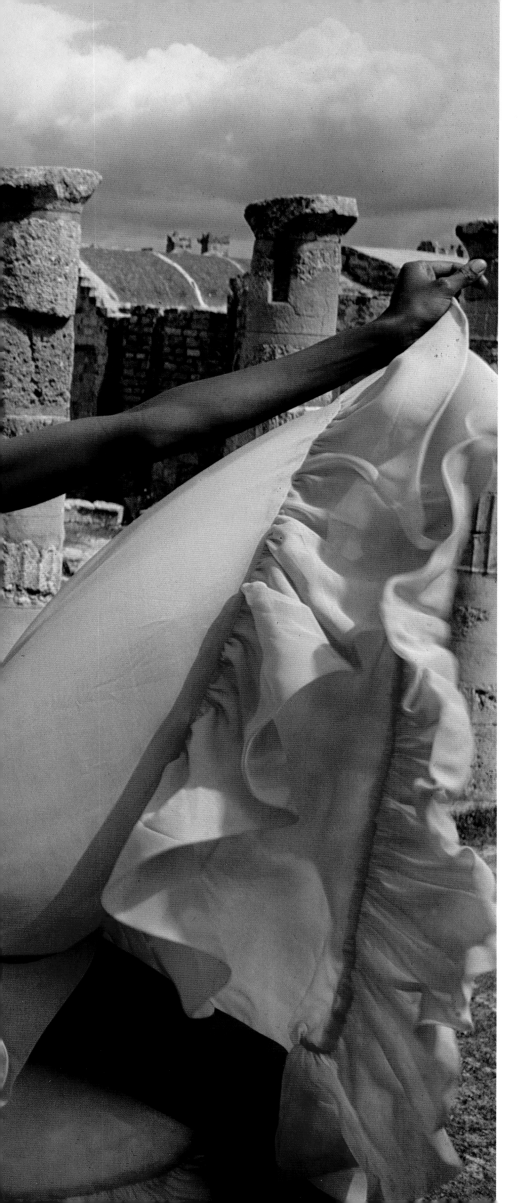

NAOMI SIMS, SAMANTHA JONES, GREECE,
FOR *TIME*, 1969

I was assigned by *Time* to do the photographs
for an article called "Sun, Skin, and a Hint of
Sin," and selected the models with the editor
Andrea Svedberg. We settled on Samantha Jones,
Naomi Sims, and Maud Adams. The story was
about fashion that was bare or transparent in
various ways, showing a lot of flesh. We
were headed to the Mediterranean for the shoot.
The first stop was Rome and then Greece and
Sardinia. In Rome, we stayed at the Excelsior
hotel, where I usually stayed. I got the king's
suite because they knew me and I showed up
with three incredible beauties. Andrea, the
editor, arranged for a big limousine to take us
around town to our shoots, because we needed
a lot of room in the car with all the clothes.
In Rome, however, the limousine we rented just
happened to be the pope's limousine the year
before, so people thought we were the pope
out and about and the car was being blessed
many times over until we spilled out of the car
and they saw me and the models in their
see-through outfits.

In the mornings we would leave the hotel early
to catch the good light, and the girls would come
down from their rooms all made-up and dressed
to shoot. There were no makeup artists or stylists
with us. The porters would be swooning,
"Mama mia, che bella!" And sometimes looking
at me thinking, what kind of night did he just
have. Naomi Sims was the first black supermodel,
Maud Adams became famous as a Bond girl,
but Samantha Jones was the greatest model I ever
worked with. She understood the clothes, the
situation. She was amazing.

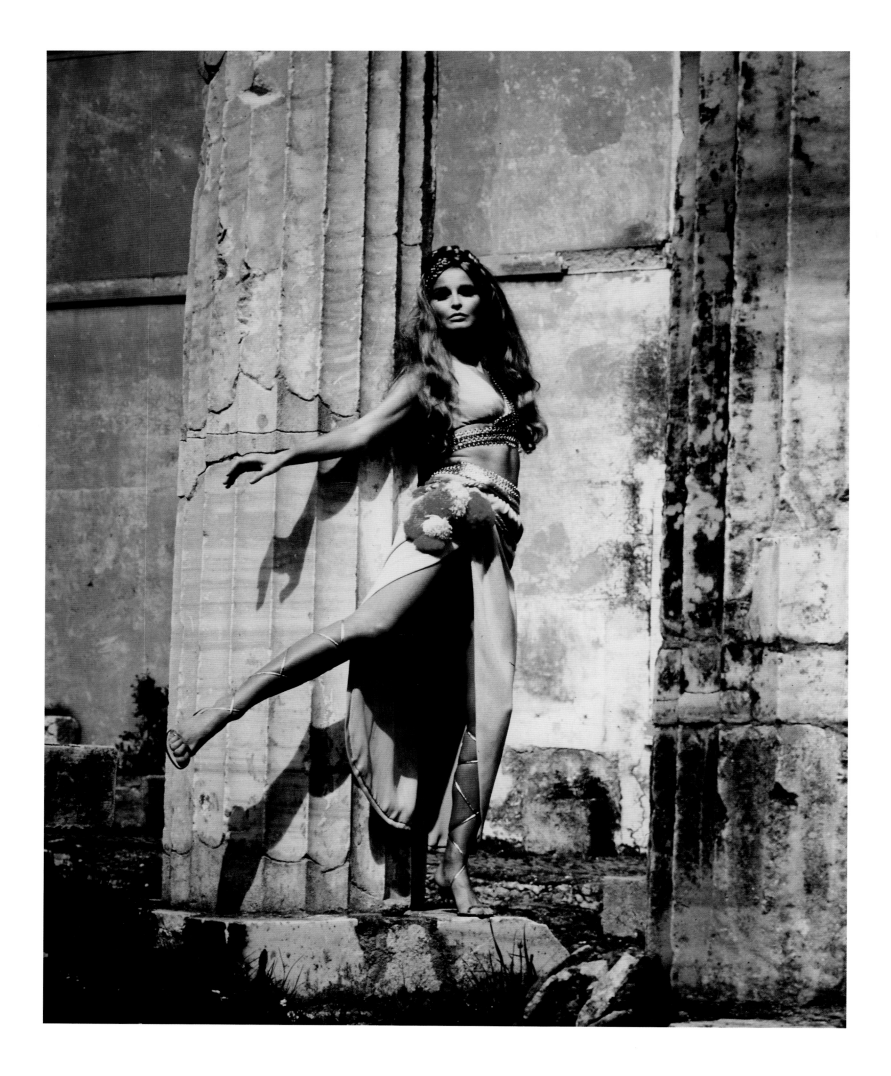

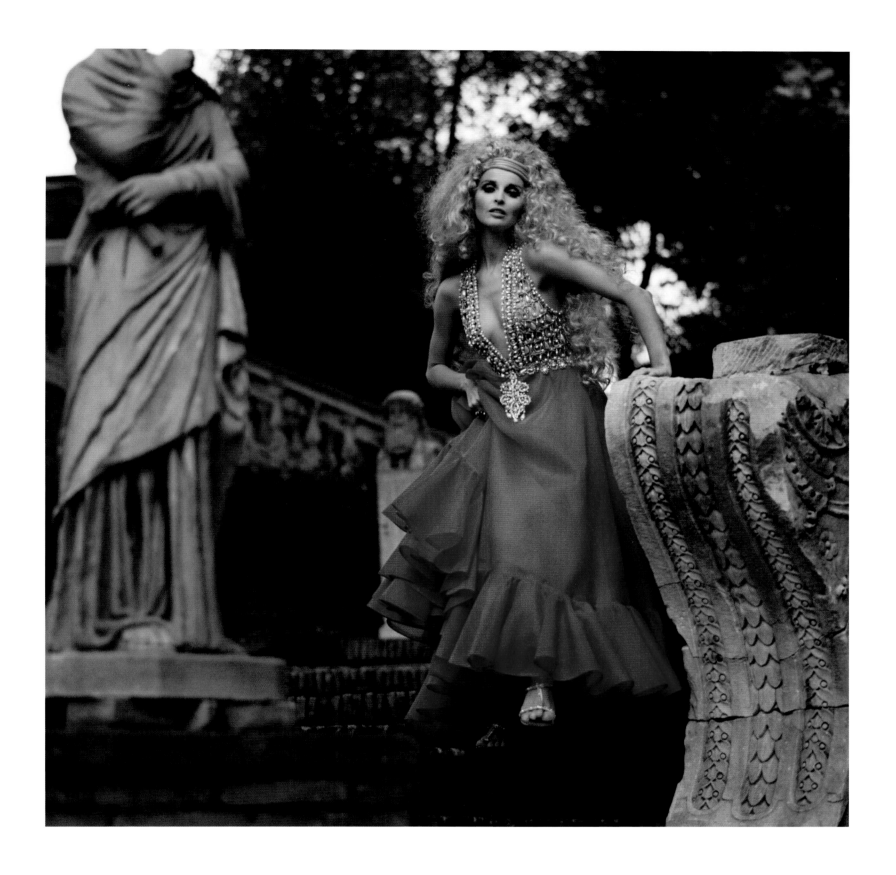

SAMANTHA JONES, ROME, FOR *TIME*, 1969

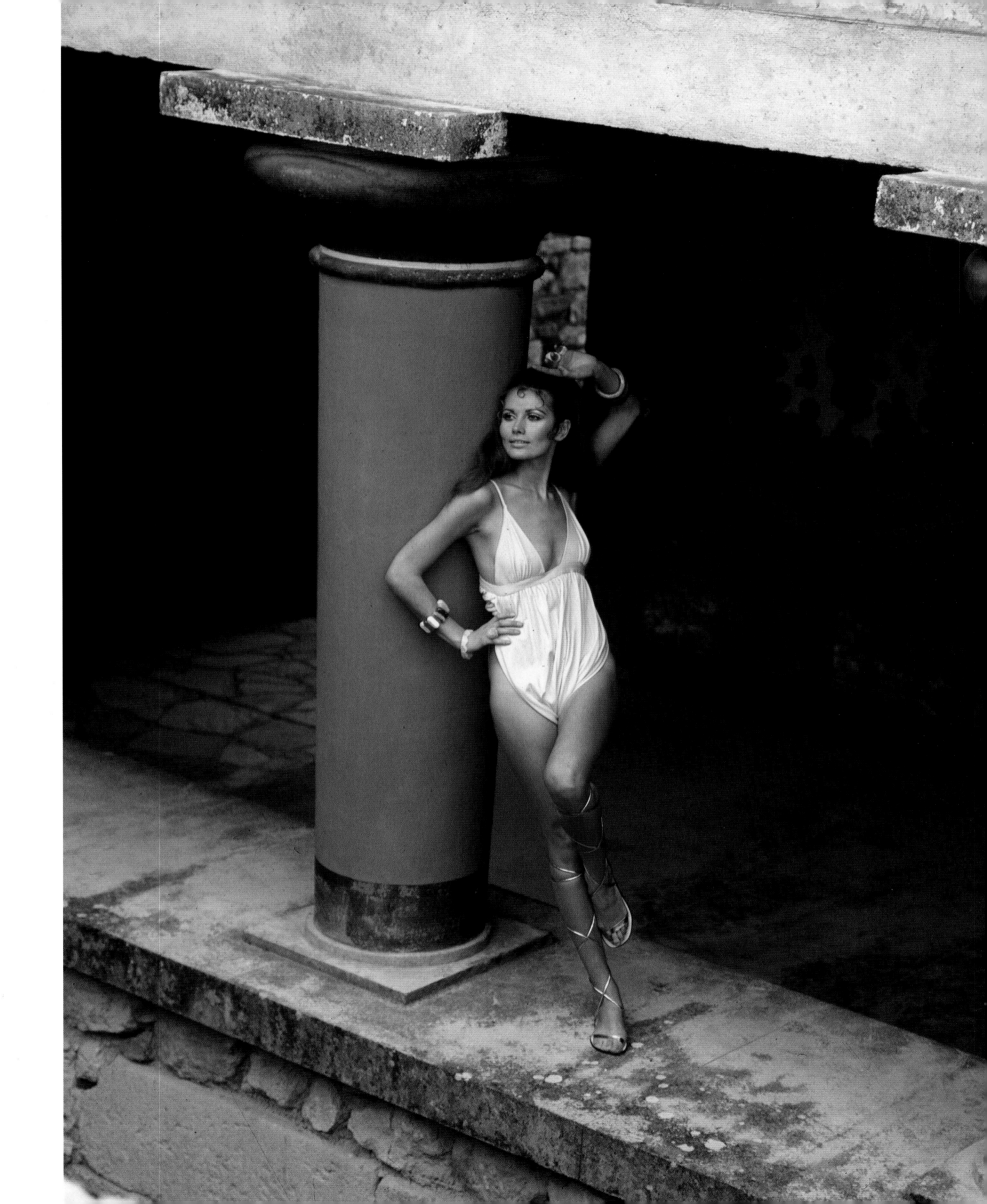

MAUD ADAMS, GREECE, FOR *TIME*, 1969

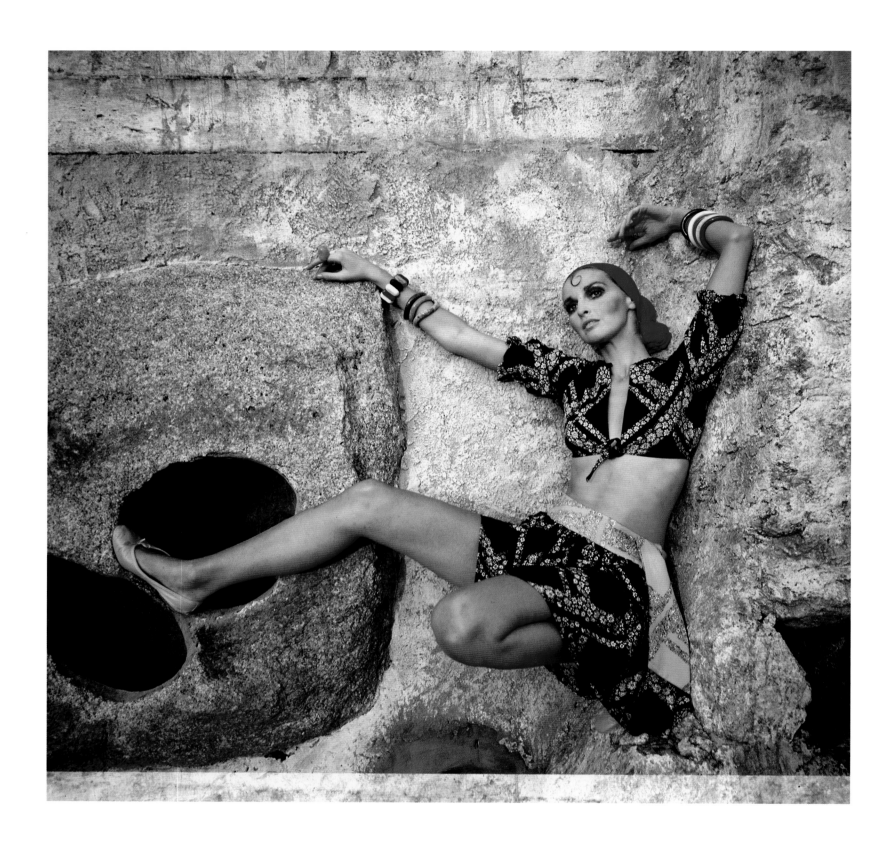

SAMANTHA JONES, SARDINIA, FOR *TIME*, 1969

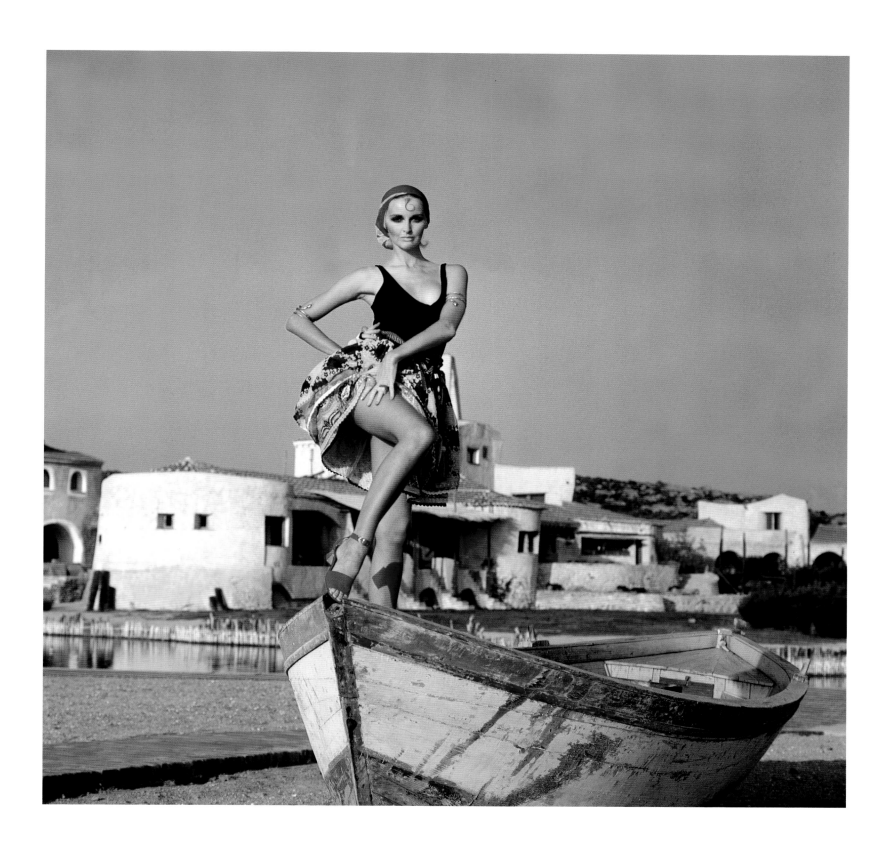

MAUD ADAMS, GREECE, FOR *TIME*, 1969

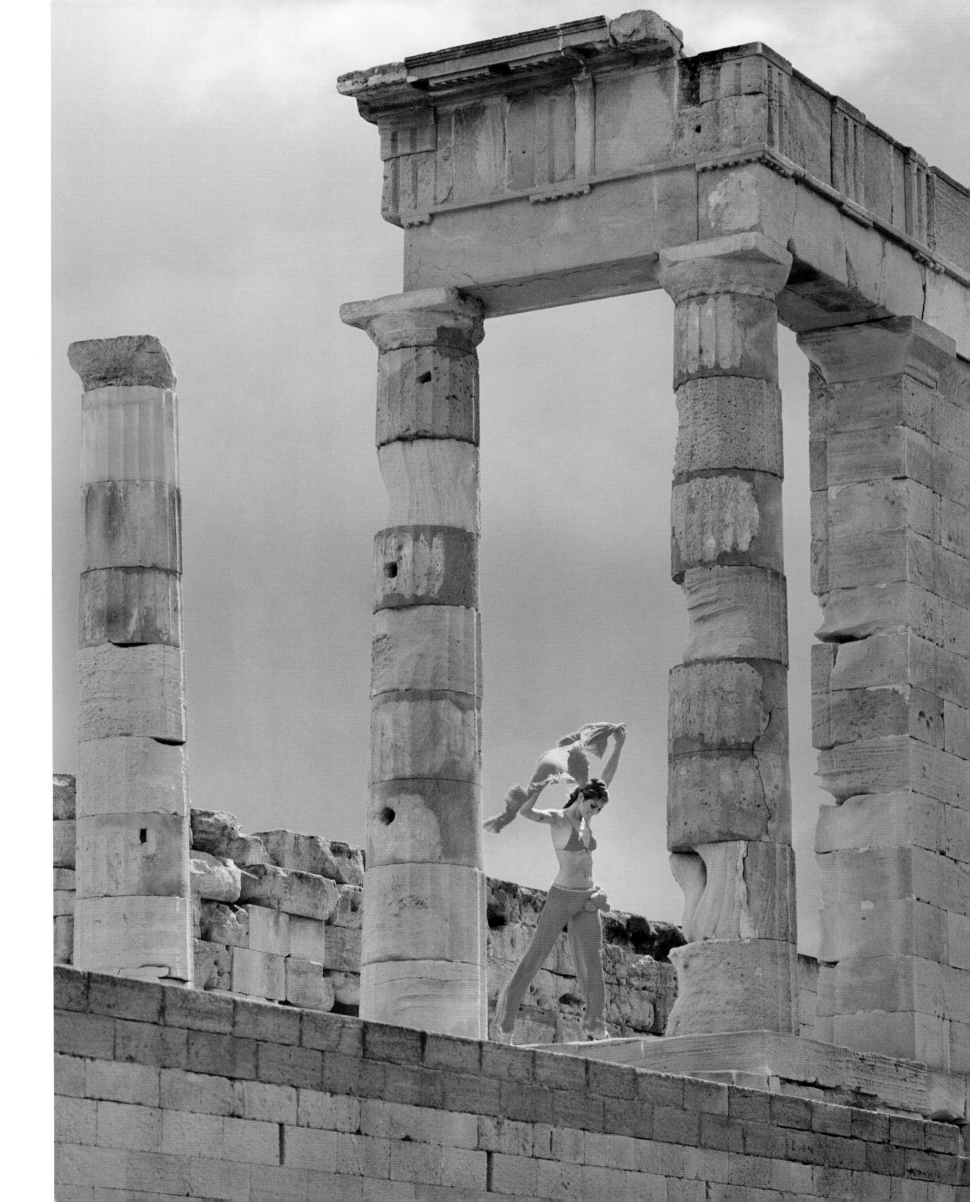

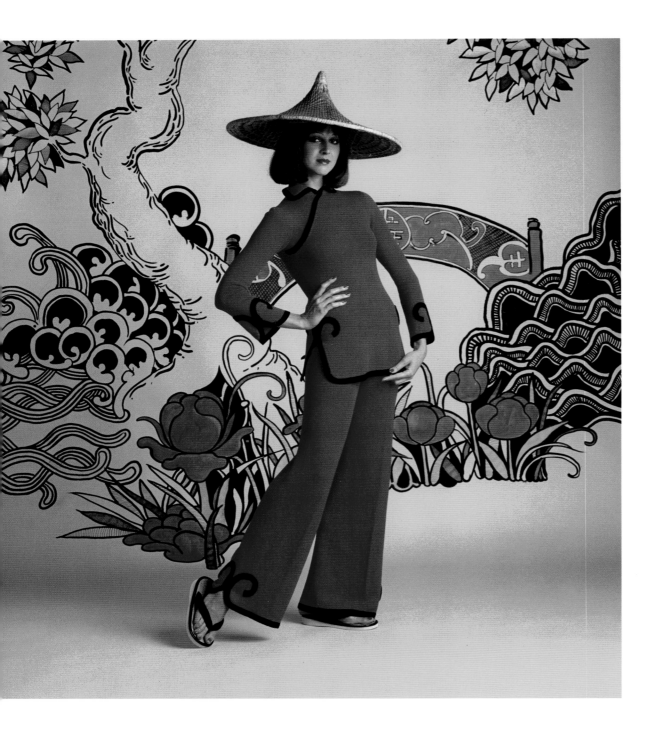

THE CHINESE LOOK, FOR *TIME*, 1975

These shots were done for an article called
"The Chinese Look: Mao à la Mode" which
explored how Chinese-inspired fashions
were sweeping through the European and
American fashion houses at the time.

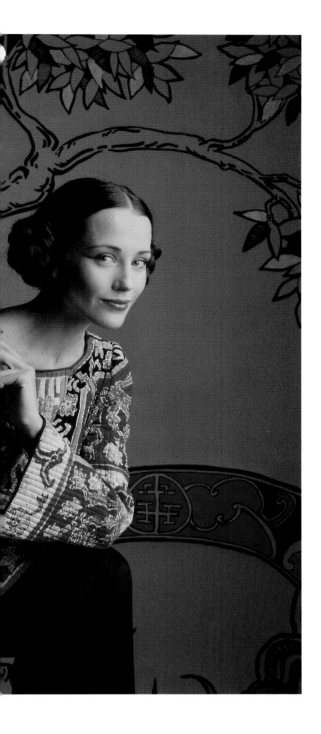
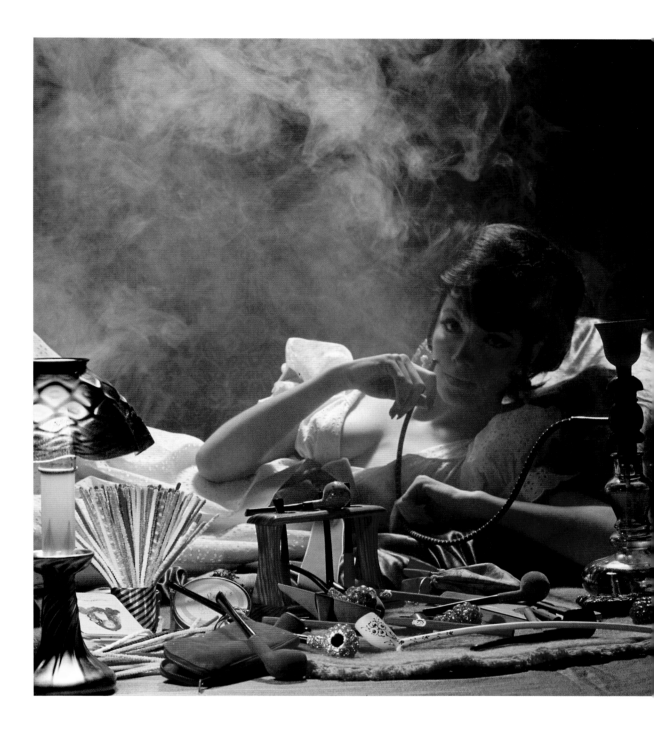

PIPES, FOR *THE SATURDAY EVENING POST*, 1959

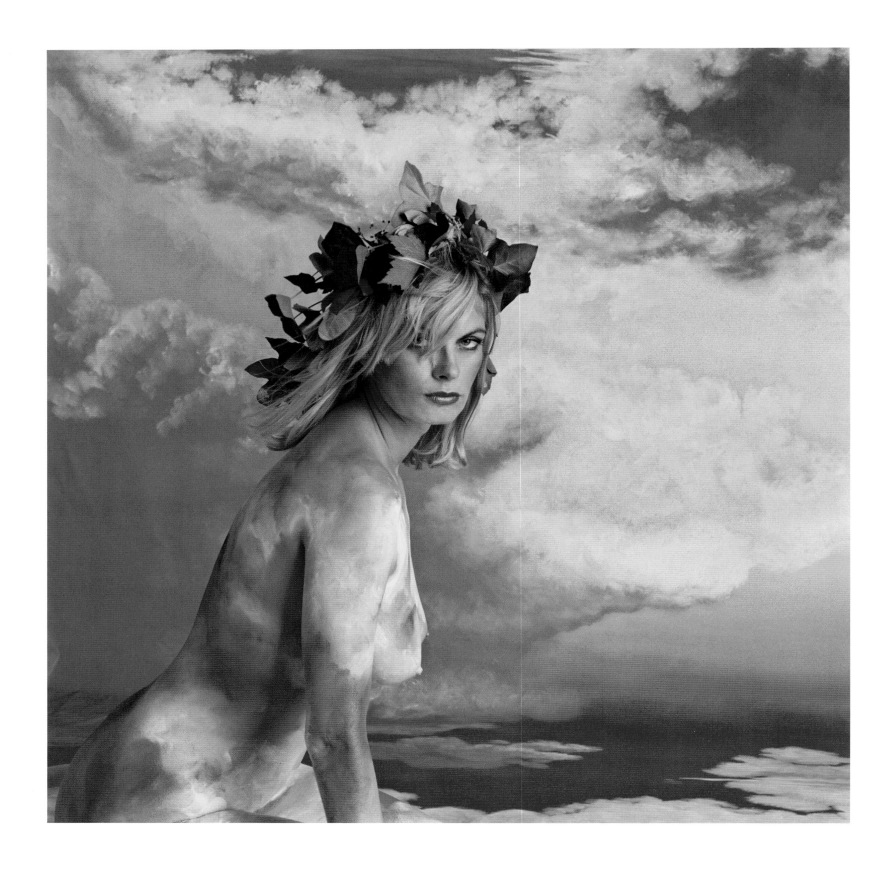

GIRL IN THE CLOUDS, SUMMER, 1975

In 1975 I decided to work on a new type of calendar with graphic designer, Tony Palladino. On the front would be four new photographs, and on the back four photographs from my archives. We designed a long, slim 7 ½ x 36 inch calendar representing the four seasons. The models would be shot in front of four different backgrounds and they would be scantily dressed, if at all. I always felt that if we just took the nude body, it really wasn't sexy. You had to put some clothes on or use some fabrics. I was casting for some models who would work only for the photographs that I would give them for their portfolios. Since I had a stellar reputation, it was very easy for

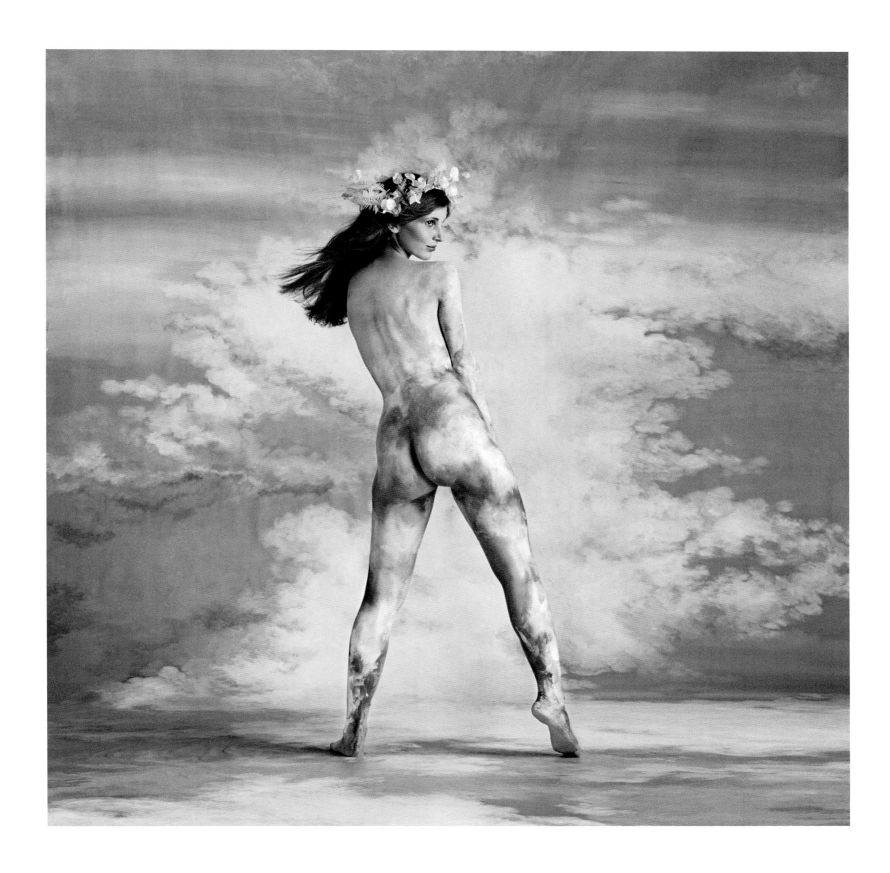

me to get models. They would be happy to do it because I would try to use them on paying jobs in fashion. I picked my four models with sensational figures. The most difficult part of my job was to not have them show all of themselves. I wanted to show just a little. My idea was to make it very feminine, beautiful, and tasteful. Below the photographs were printed the months of the year. My philosophy was spelled out on the calendar: "Whether I am shooting in the studio or on location around the world, I try to bring a different dimension to what I am photographing, so people see it in a new way. Everything in the world has its own beauty, its own energy; and that's what I want my pictures to convey."

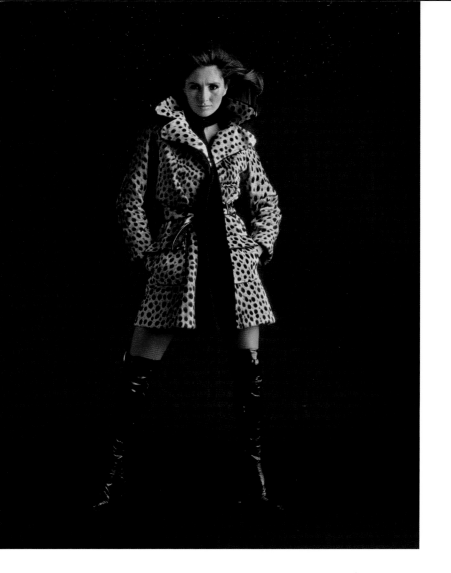

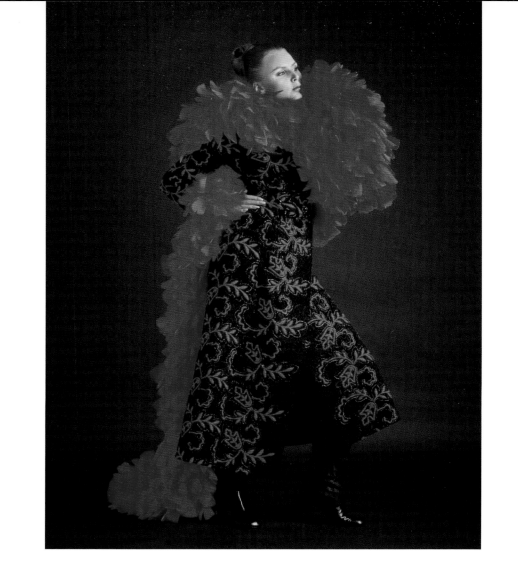

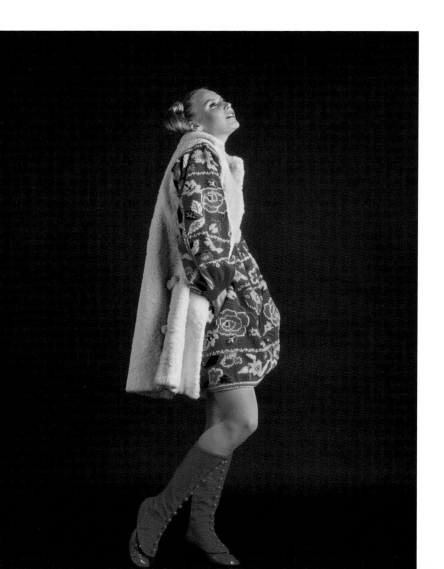

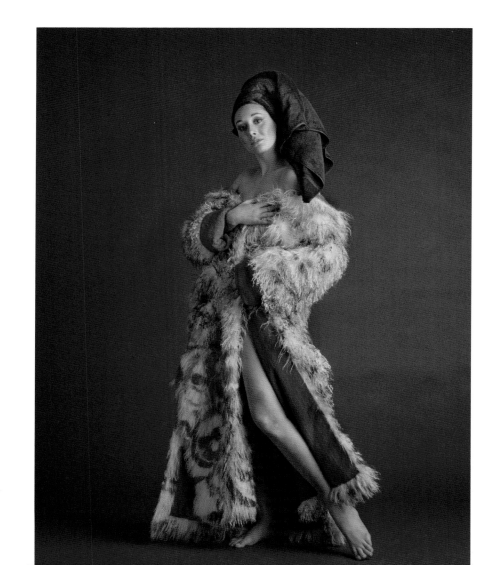

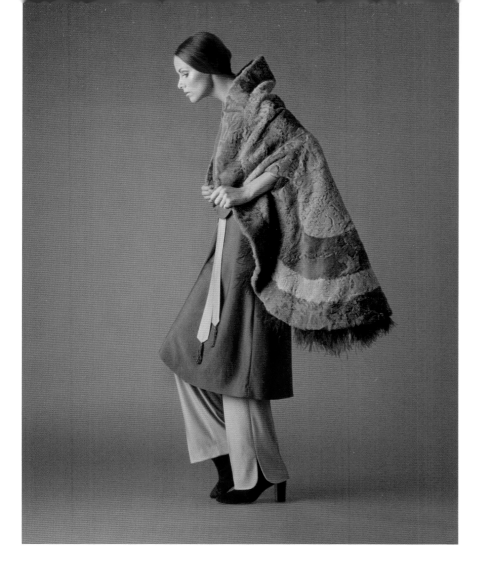

FUR FASHIONS, FOR *TIME*, 1969

These photographs were shot for an article about contemporary fur fashions, "The Skin Game," that showed how mink and sable were being joined on the racks by chinchilla, ermine, and fox, as well as wolf, monkey, weasel, bull, and yak. Not only that, the furs were often styled in patterns as well as dyed in multi-colors and also cut in various shapes.

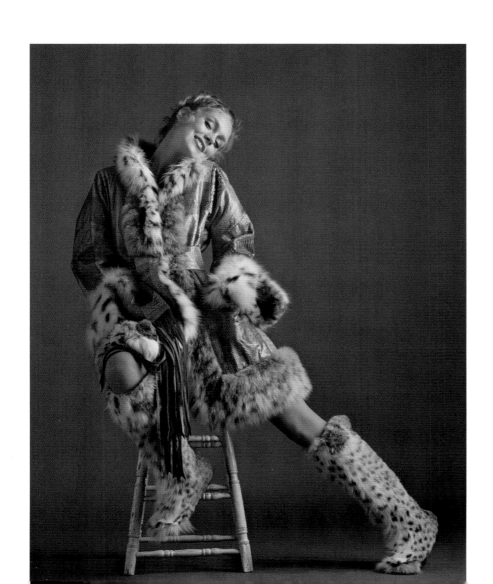

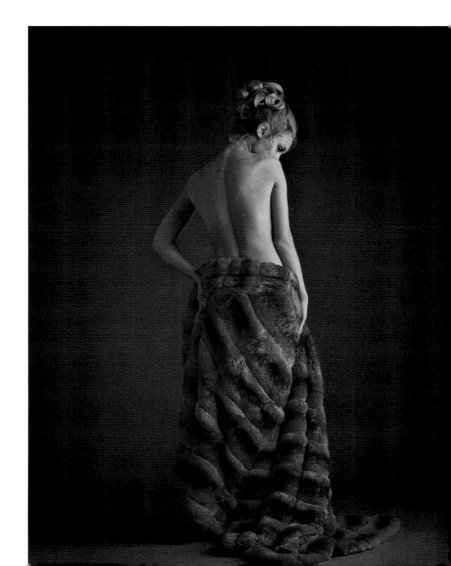

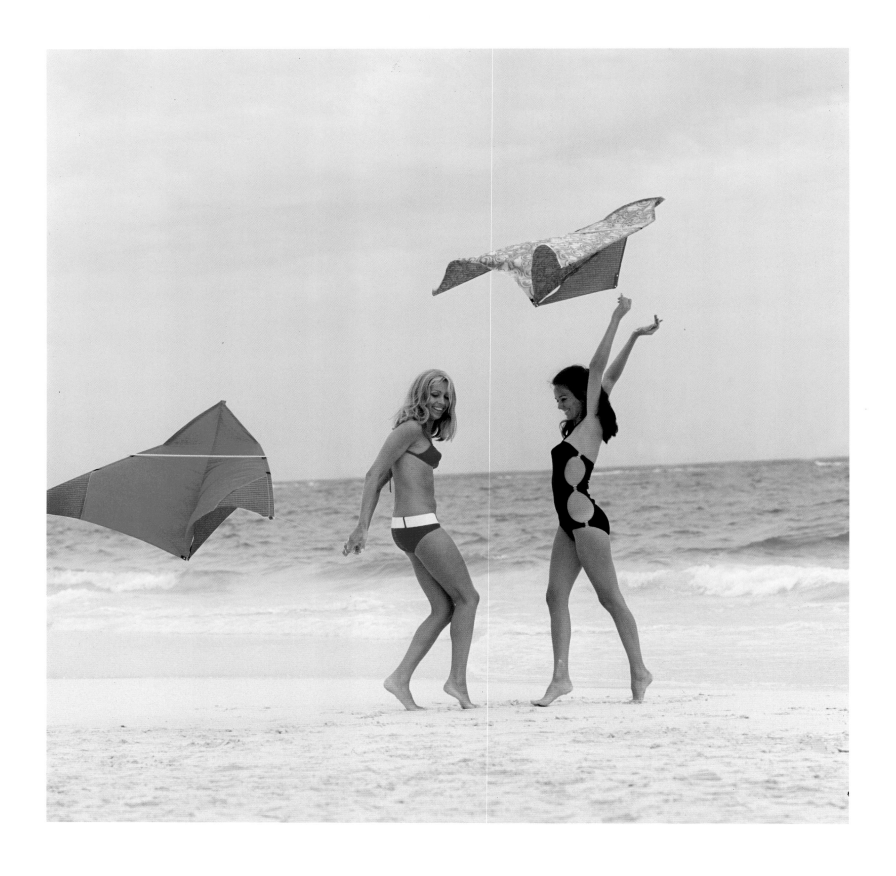

SWIMSUITS, FOR *TIME*, 1968

Time magazine wanted me to do a bathing suit story using models with very skimpy, sexy bathing suits. They wanted to know where I would like to do this. Not hesitating, I said Bermuda. It was perfect, only an hour and forty-five minutes from New York, with a hotel right on the beach. I picked some models and

we flew down to Bermuda. I shot a lot of pictures which *Time* was very happy with and they ran four pages of my photographs. *Life* International, *Life* Español, and *Life* in various countries picked it up for covers, though *Life* in the United States wouldn't run it on the cover since it had been in *Time*.

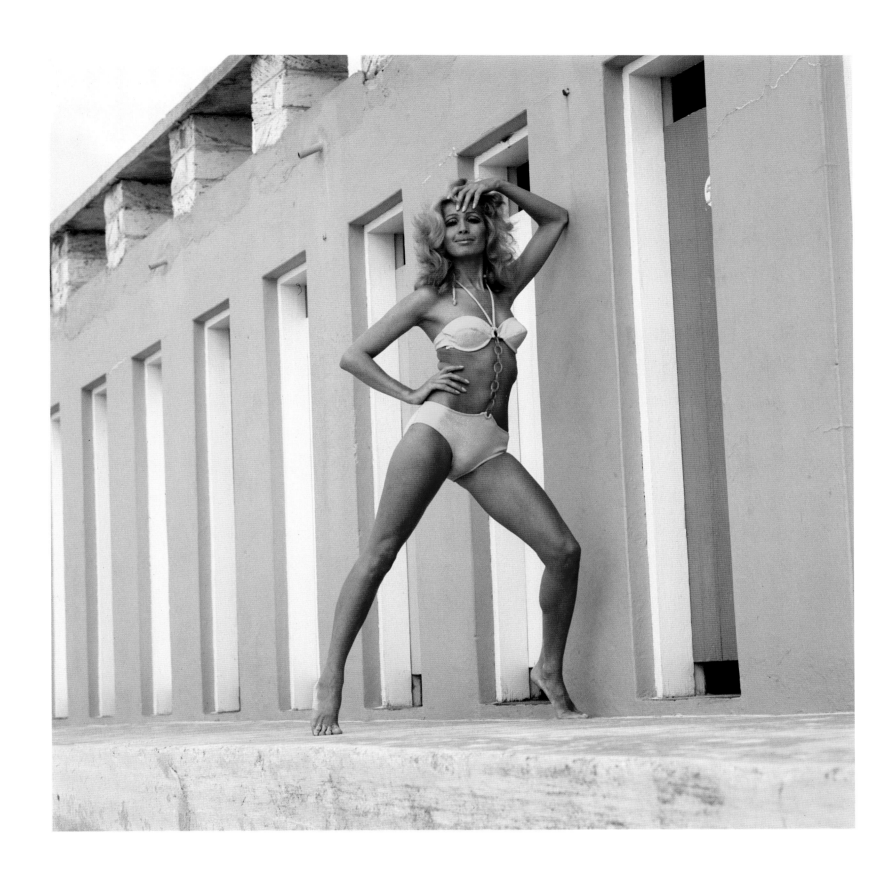

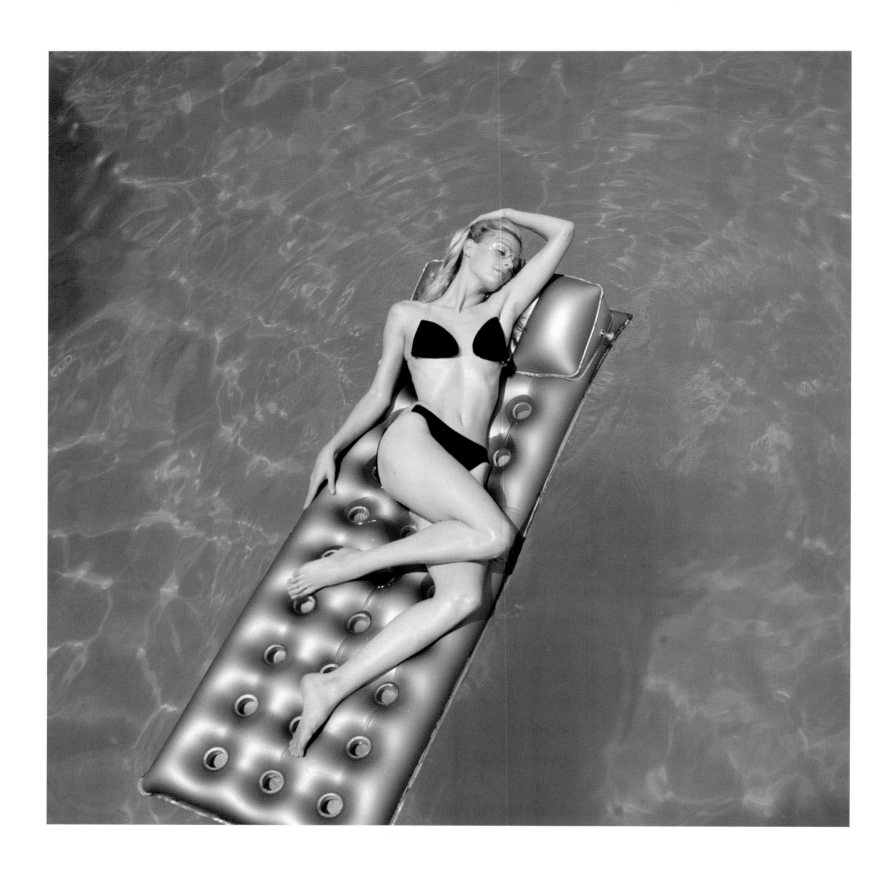

SWIMSUITS, FOR *TIME*, 1968

92

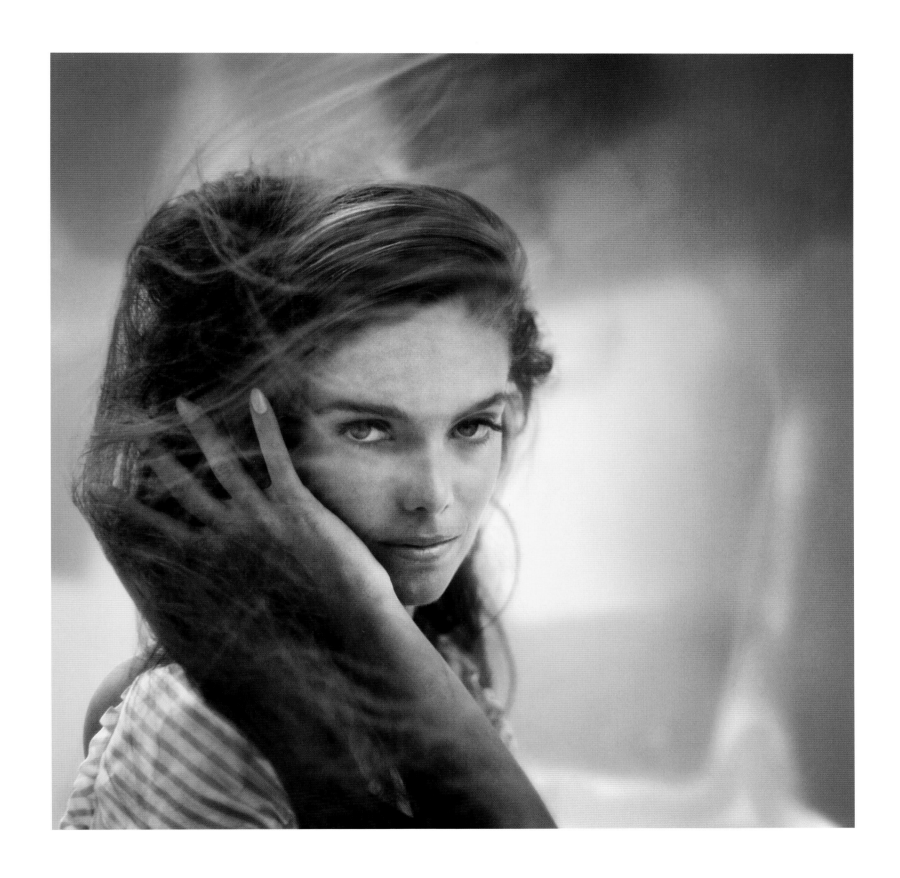

LYNNE LEONARD, FOR *TIME*, 1966

NORMA KAMALI, FOR *NEWSWEEK*, 1978

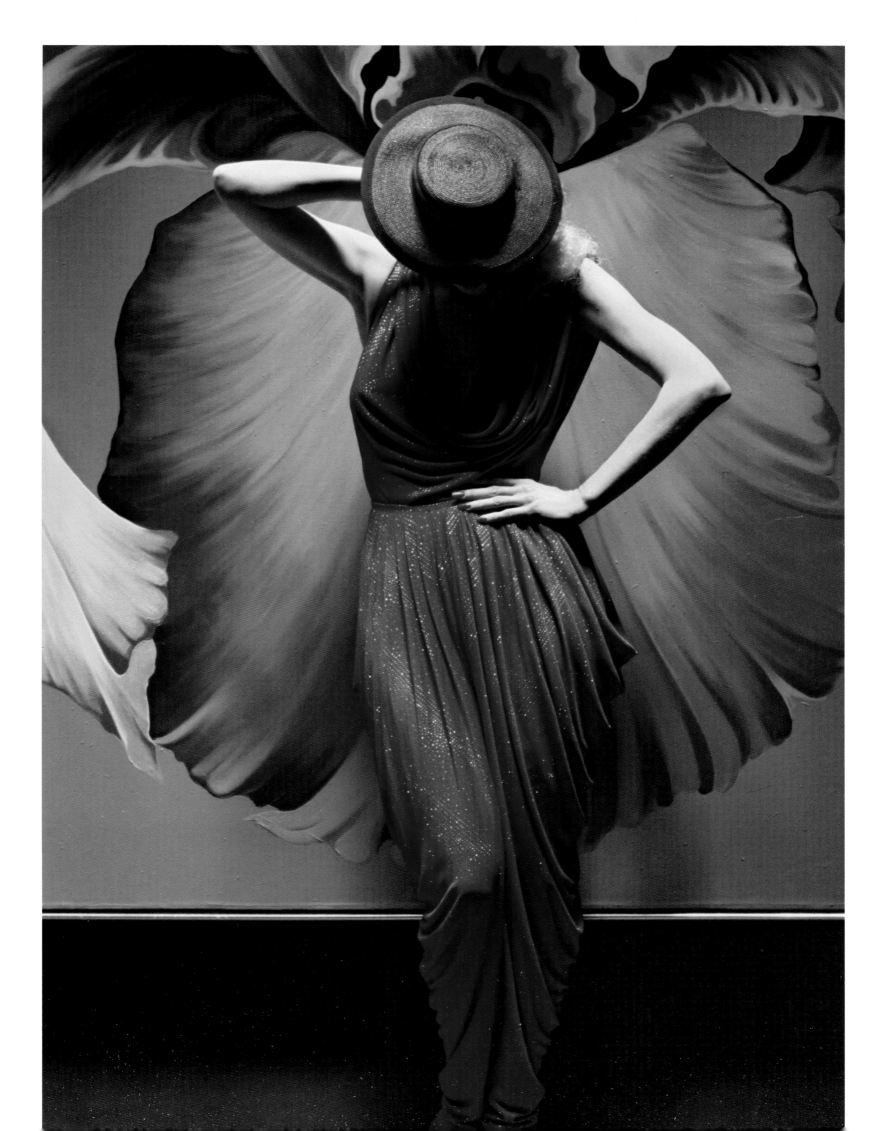

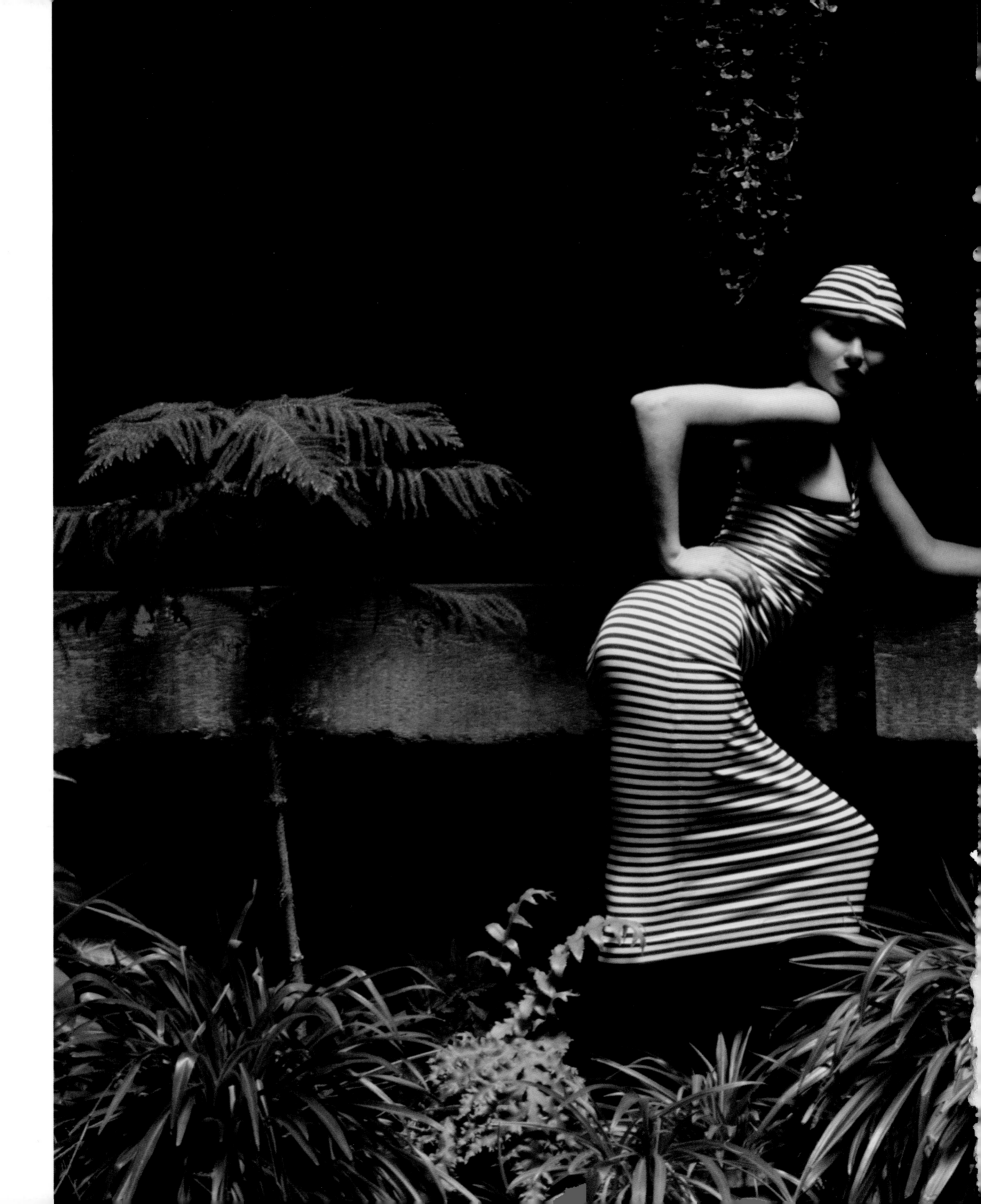

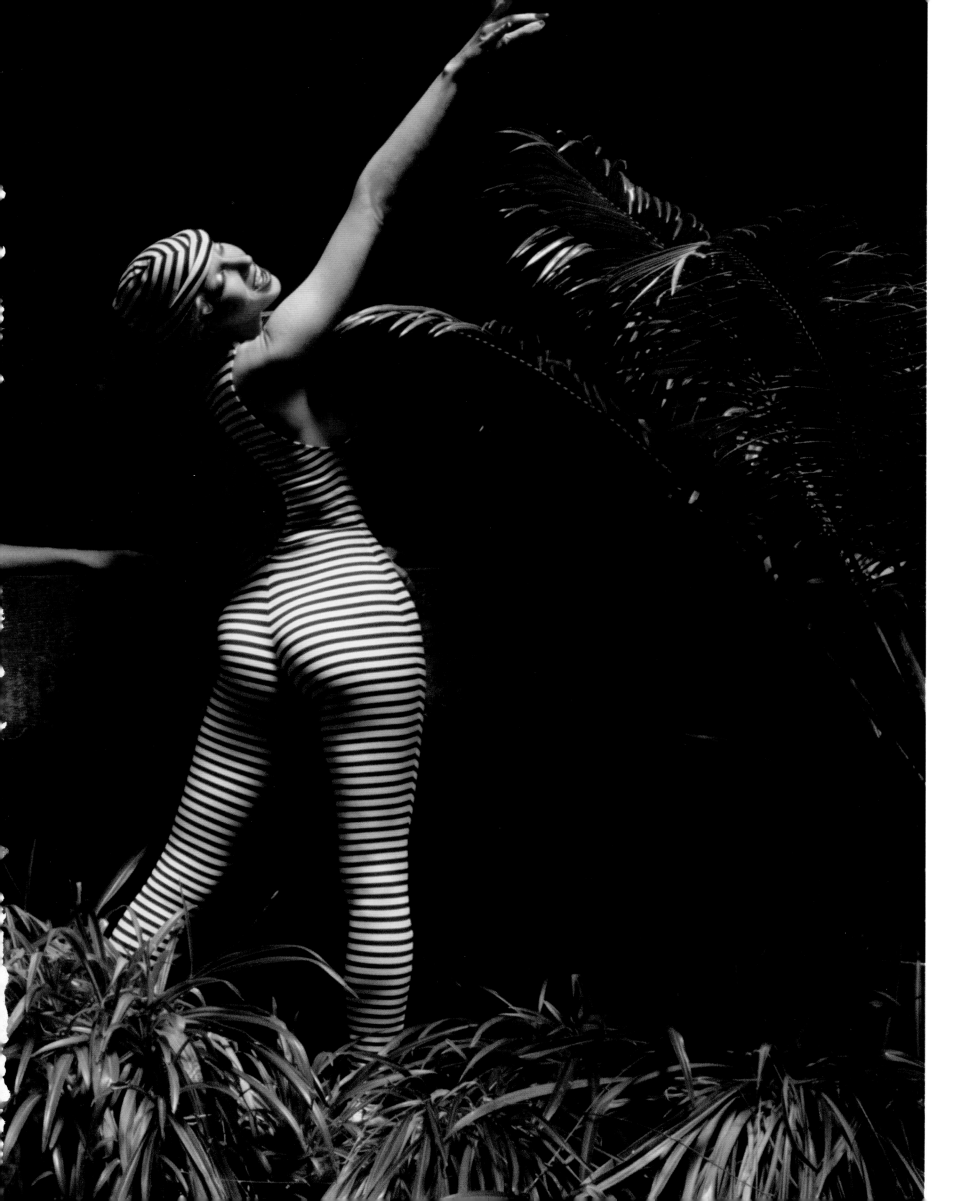

PREVIOUS SPREAD AND OPPOSITE:
NORMA KAMALI, FOR *NEWSWEEK*, 1978

Norma didn't want to be photographed
herself, but I thought she looked pretty good.

98

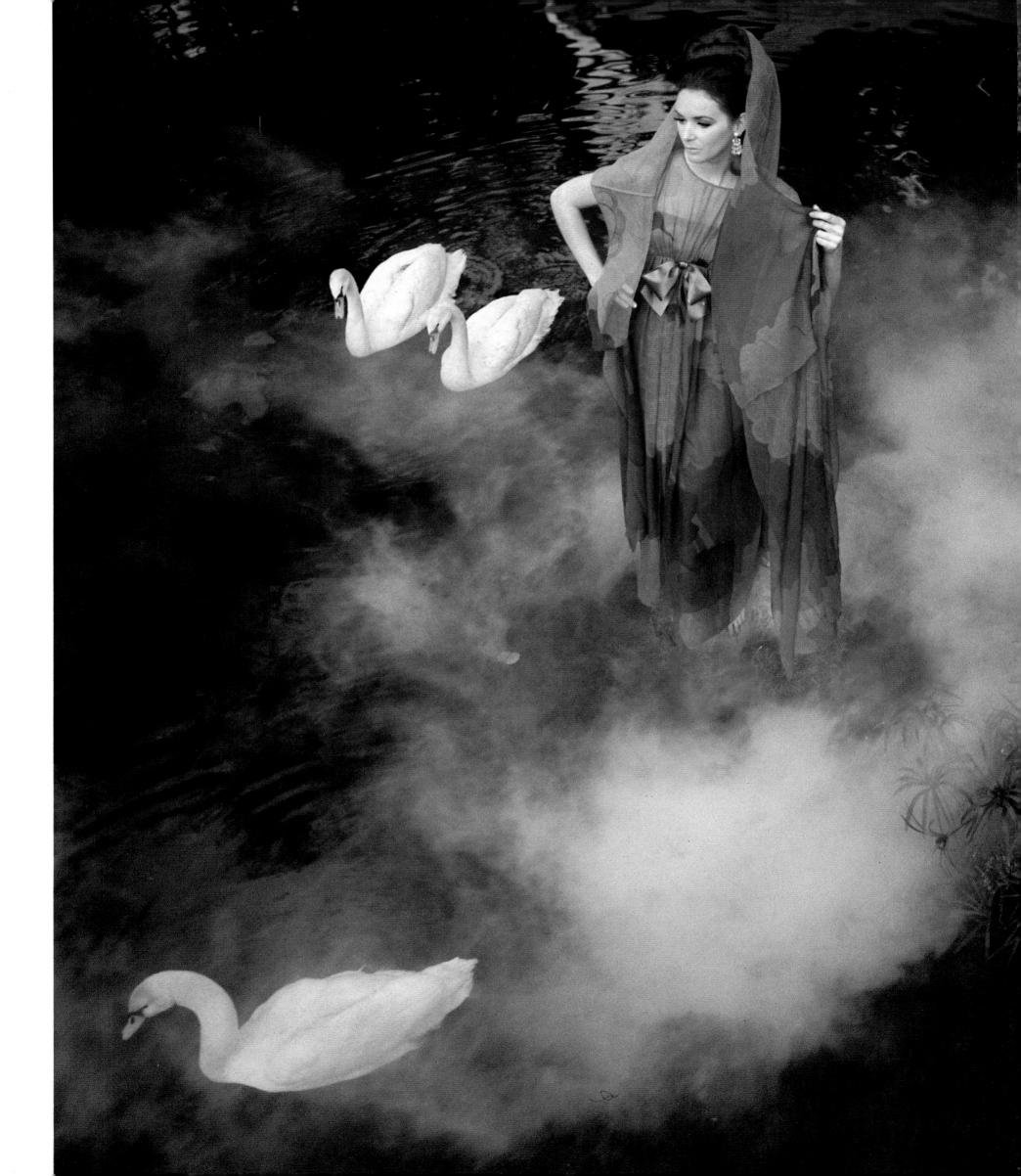

WOMAN WITH SWANS, 1960

This was an outtake from a car advertising
campaign I was working on. The shoot took
place near Fort Lauderdale. The model
is wearing a very expensive Pauline Trigère
dress I had borrowed from the designer.
She is walking across the pond on submerged
cinder blocks and the swans were tied so
they couldn't swim away or ripple the surface
of the water, which was supposed to show
the car reflected. The swans didn't move,
the model didn't fall in the water, everything
went well.

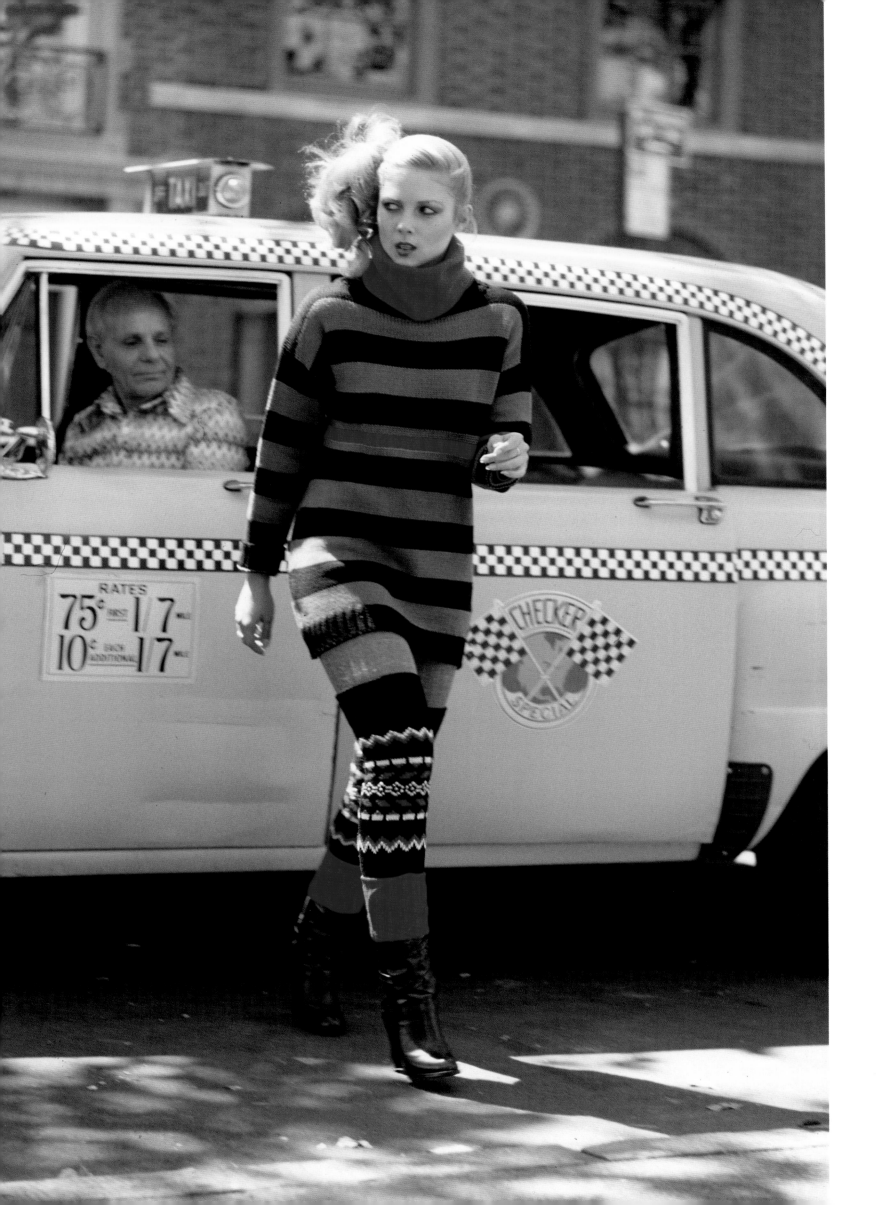

KNITWEAR
FASHION,
NEW YORK,
1982

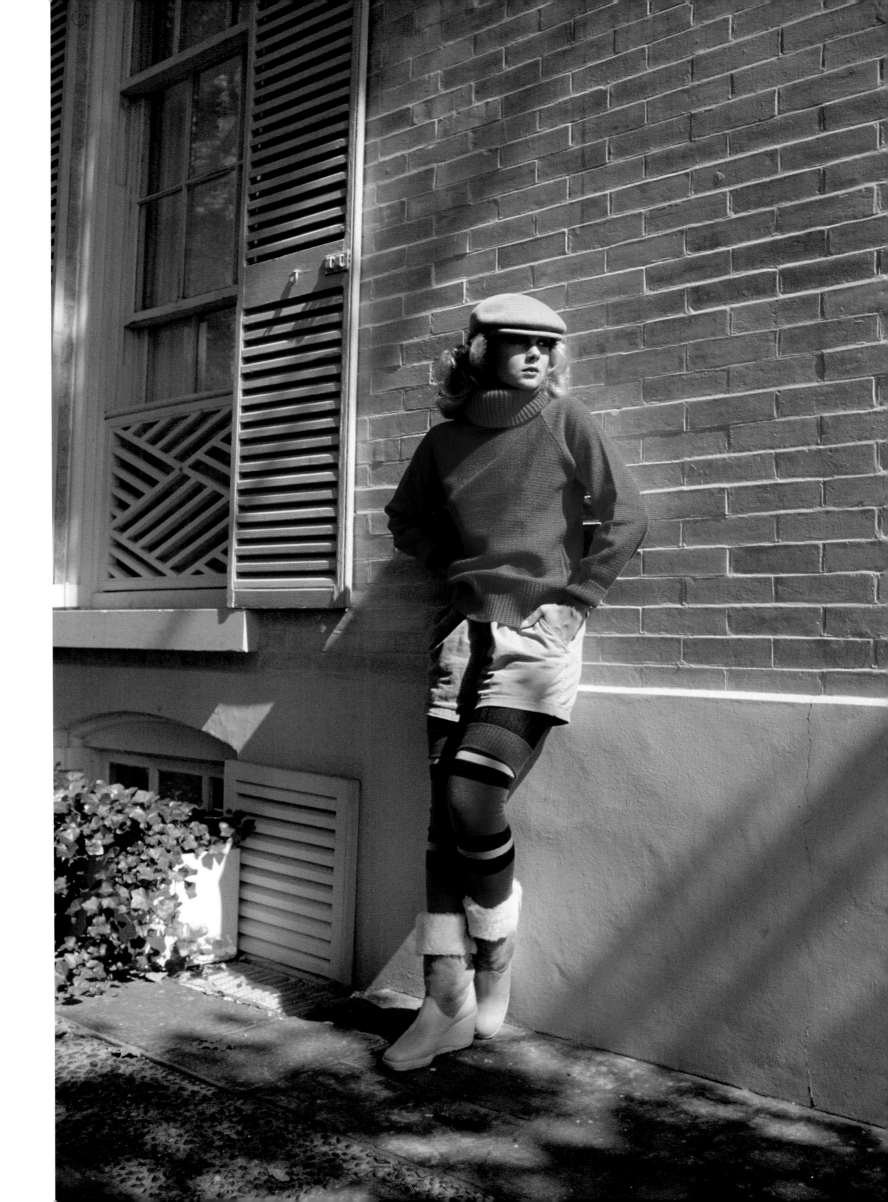

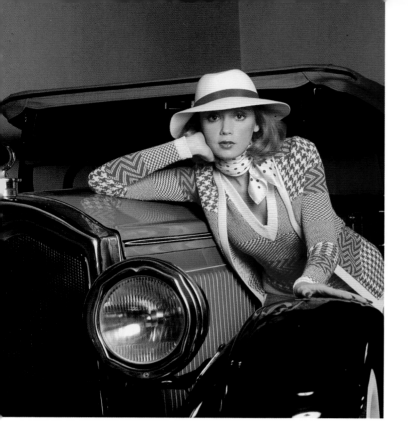

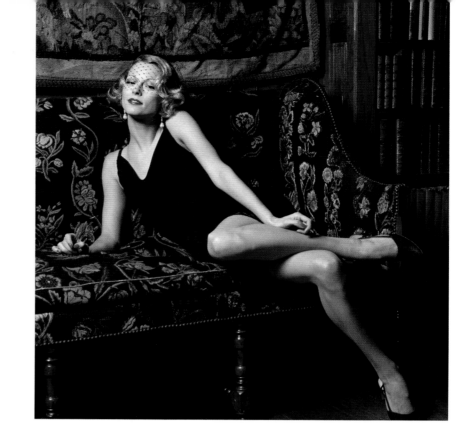

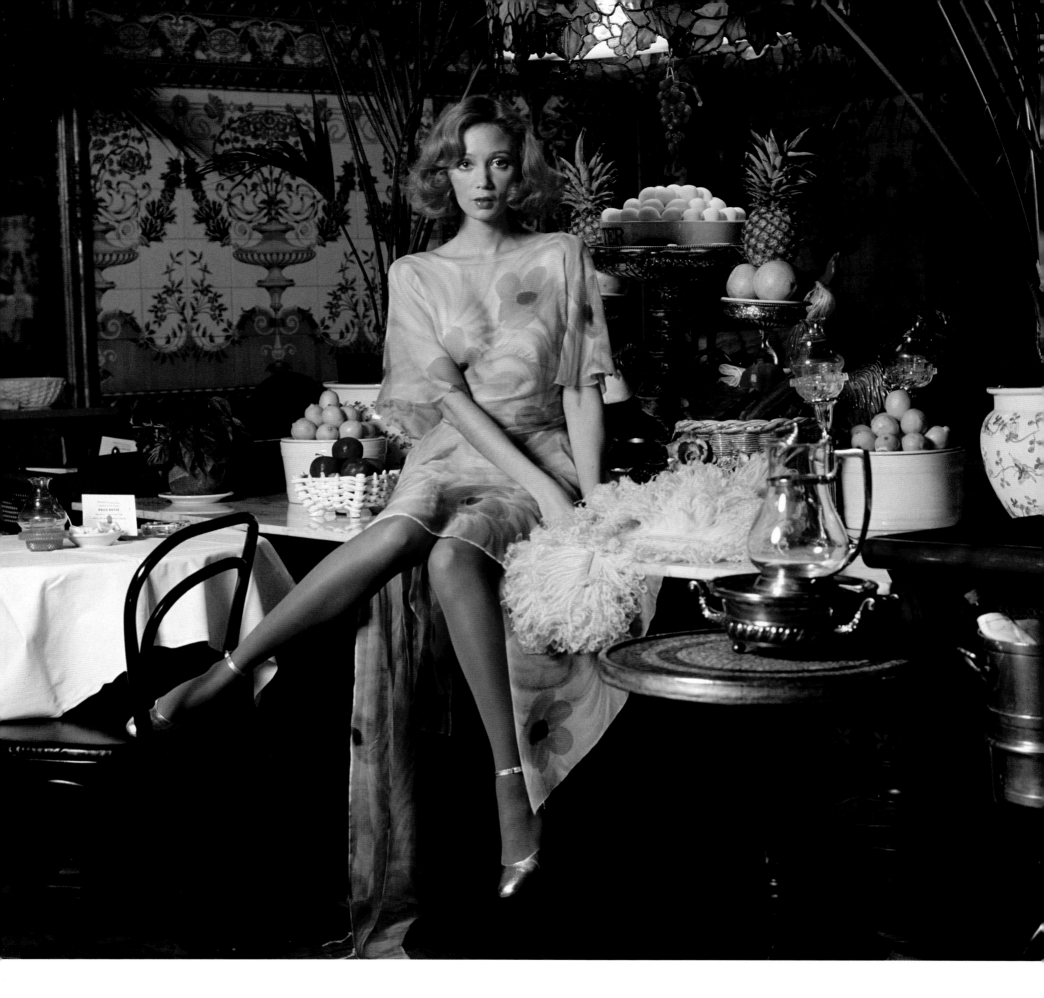

THE GATSBY LOOK, FOR *TIME*, 1973

The Gatsby Look was for an article called
"The New Old Sports," on fashion that is elegant
but also casual and sporty.

FACTS
& FANCIES

—
—

Working as a photographer, I did everything–fashion, celebrity, portraits, travel, dance and theater, publicity and advertising–a lot of work. If you sat around waiting for assignments, you didn't work very much. Of course, I received assignments from *Time* and *Life* and other American and European magazines, but I was also generating ideas for stories and pictures and subjects all the time. I had lots of ideas as to how to make images that would appeal to the magazines and fit into their program.

One day the wife of the editor of *Life* asked me out to lunch. I was shocked when the charming woman offered me a staff position on the magazine. Unfortunately, by the time she made the enticing offer, I had imbibed two Scotch and sodas–which was unusual for me–and my immediate response was, "No. You can't afford me." I had fantasized about working on staff for *Life*, and would have welcomed the security it offered, and here I was being offered this incredibly rewarding job. I didn't even ask the salary and benefits. I was getting lots of exposure and the cream of assignments from any number of magazines. So, I guess, instinctively, I didn't really want the job. I had worked hard my whole life for everything I had gained and I was independent and productive and doing well. My response to the offer fortunately did not negatively affect me with them. I continued to work for *Life* and *Time*. And I made the right decision. In the 1960s, *Collier's*, *Look*, and *The Saturday Evening Post* all went under, with *Life* following in 1972. Many excellent staff photographers were suddenly thrown out of work, and didn't know what to do, but I continued shooting for *Time*, for ad agencies, public relations firms, theater, and film. Still, the world was changing and eventually it catches up with you. – O.G.

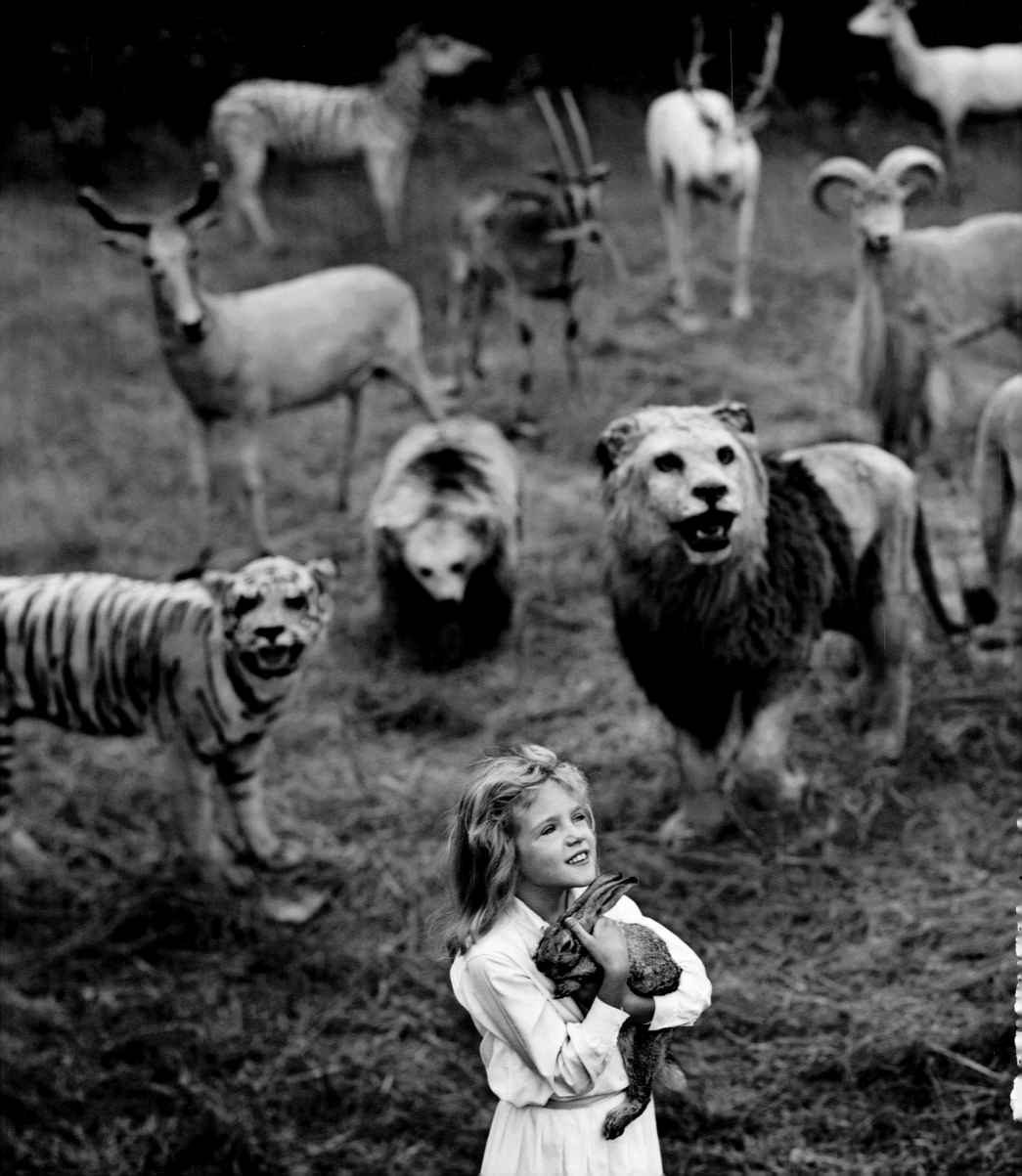

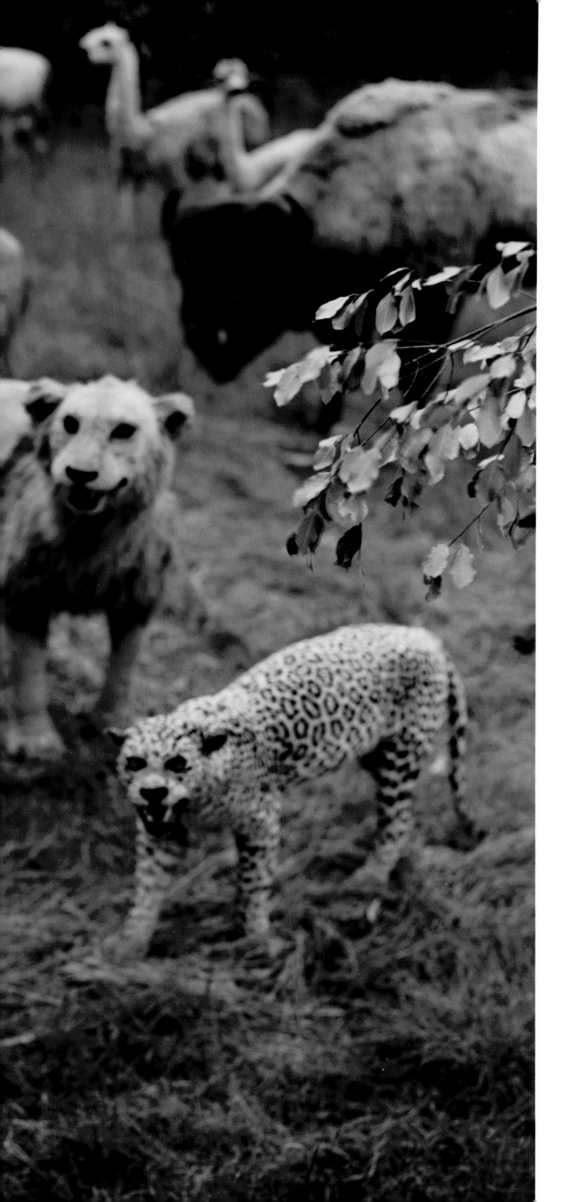

PEACEABLE KINGDOM, 1961

I was intrigued with the famous *Peaceable Kingdom* paintings and set out to do my own version as a photograph, for *The Saturday Evening Post*. The magazine ran one of them as a double page spread for their "Face of America" feature.

FAMOUS FORD MODELS, 1966

I asked Eileen Ford to photograph her top
models in a group portrait. I had to set up very
carefully in advance as I had to do it quickly,
since the girls were doing Eileen a favor and
were anxious to get it done and go. I spread
a huge cloth, painted like the sky, on the floor
and up the rear wall, and then pre-lit the
studio for six in the evening when they all
showed up. Thirty-five of the most beautiful
women in the world suddenly walk into the
studio. I had their places marked and they
took their positions. I had boxes and cushions
and such to even out the distribution of
figures, so no one was blocked. It all took
place in less than an hour. The girls were from
all over the world and the photograph was
picked up by a lot of magazines—in Germany,
Italy, everywhere. It was a very successful
picture. It stands out for me as one of my best,
along with *Girls in the Windows*.

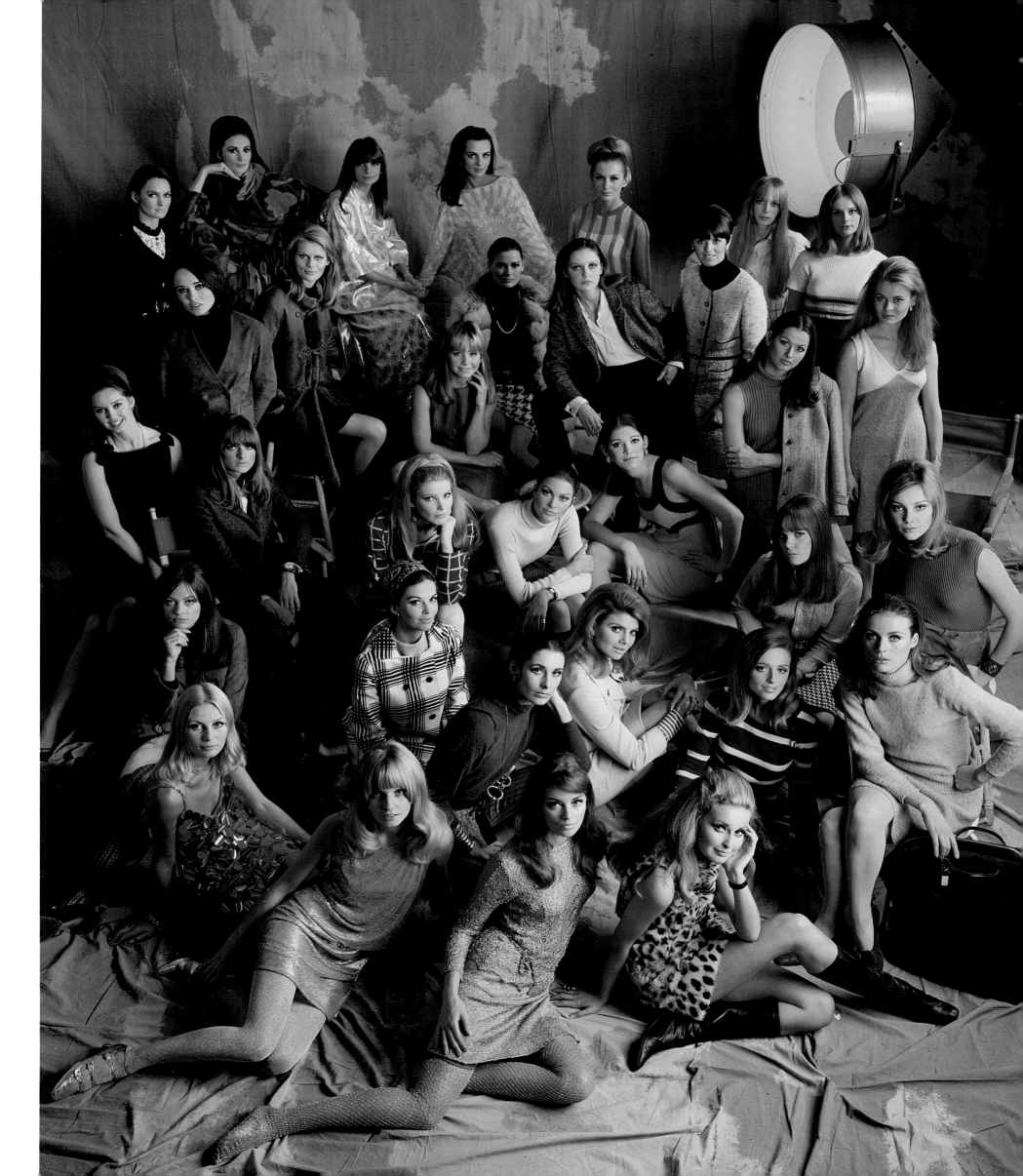

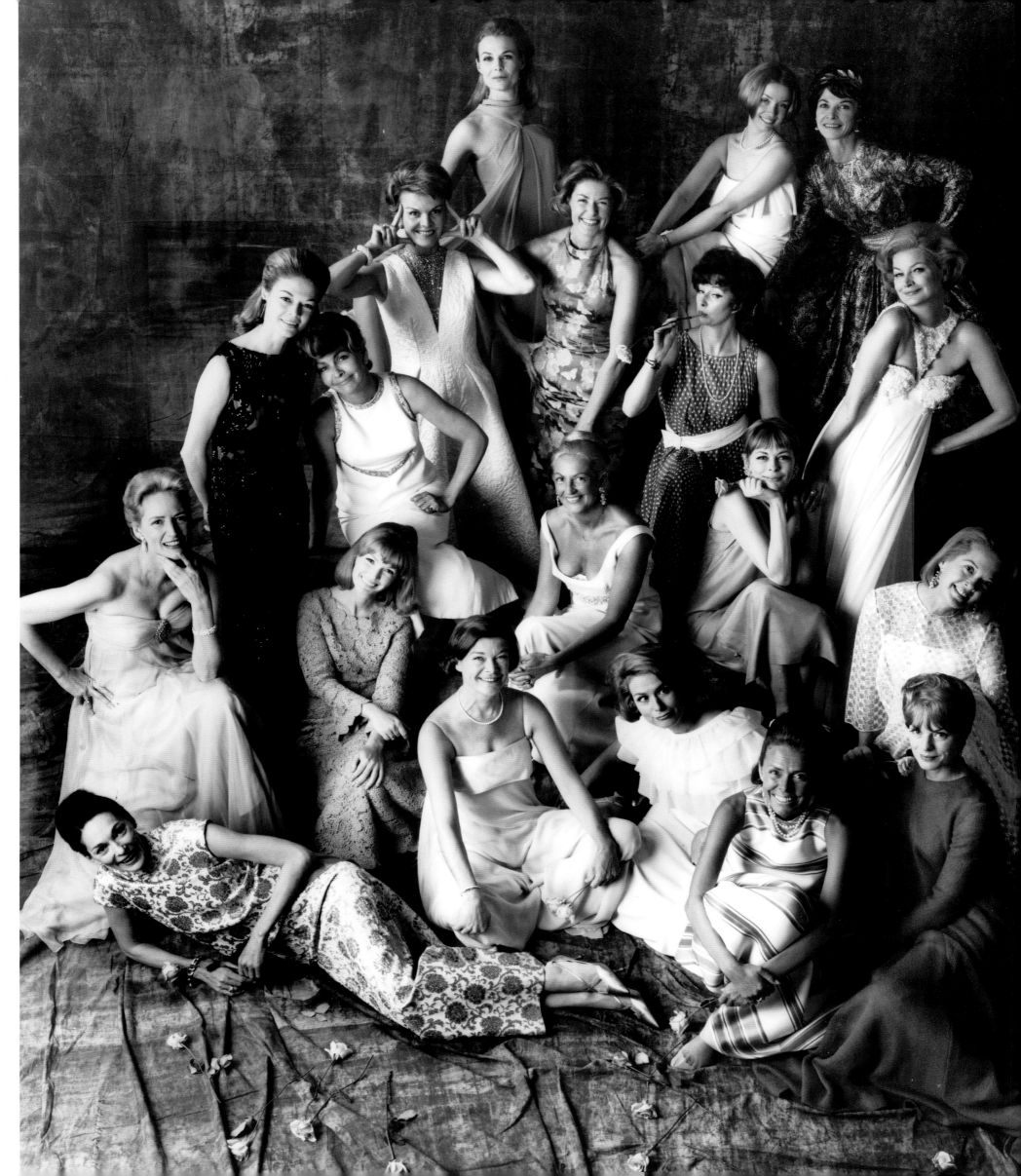

FORMER FORD MODELS WITH
EILEEN FORD, 1967

Eileen Ford is in the front row, second from
the right. These ladies were top models
in their time, years before, during the early
years of Eileen's agency. They were retired
and got together with Eileen at her request.
They really had a good time.

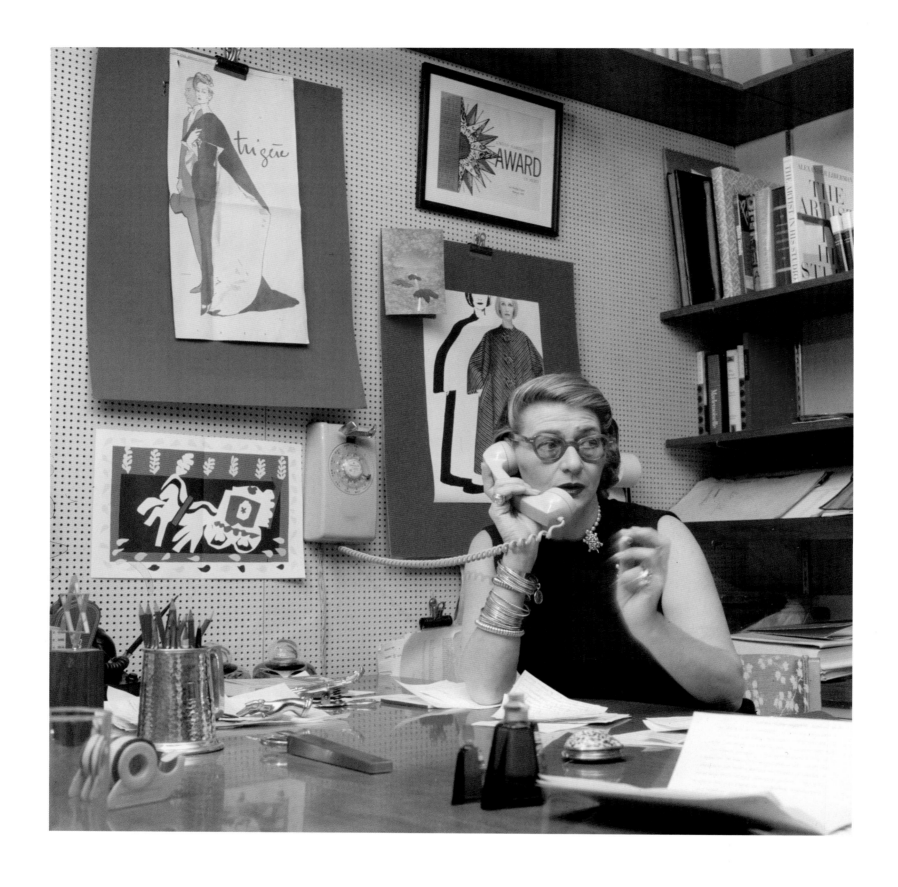

PAULINE TRIGÈRE IN HER STUDIO,
NEW YORK, 1962

My wife loved her clothes and looked
great in them.

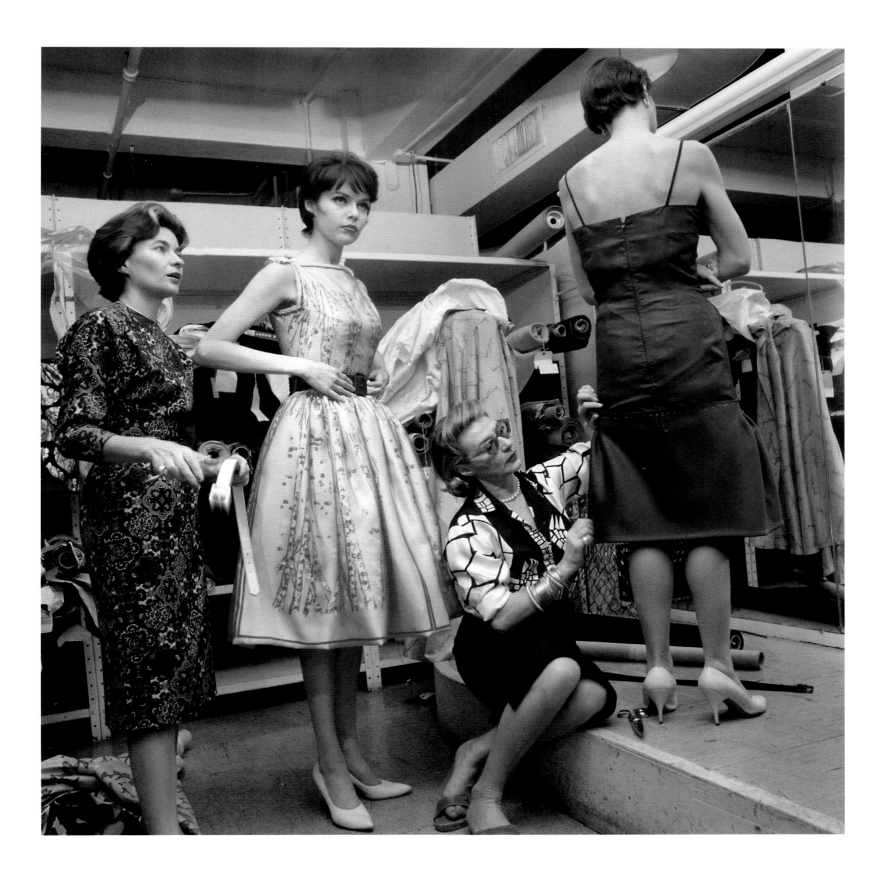

LINCOLN CENTER, NEW YORK STATE
THEATER, FOR *TIME*, 1964

When it was completed, Lincoln Center, the
new home of the New York Philharmonic,
the Metropolitan Opera, and the New York
City Ballet, began presenting symphonies and
concerts, and *Time* asked me to photograph
the New York State Theater on some black-tie
occasion. I decided I was going to light up
the atrium for the photograph. I was working
with remote control so that when I clicked
my camera, the lights flashed and it was
spectacular. People didn't really notice, they
didn't know what was happening. It was like,
first you see it, then you don't. But I got a
great picture. The Magnum photographer
Burt Glinn asked if he could use my sync cord
to take a picture and I said, "Yeah, right."
He laughed.

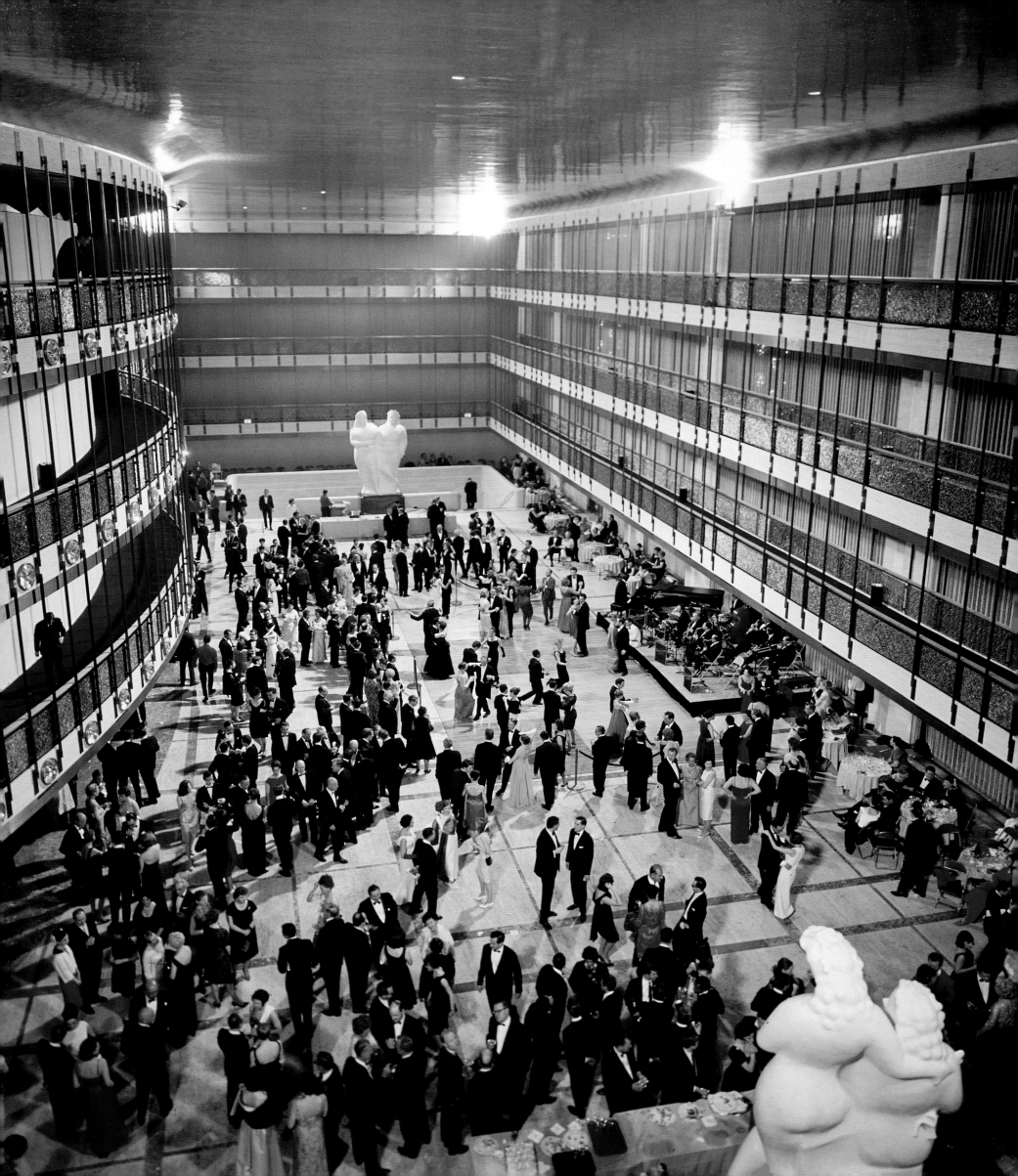

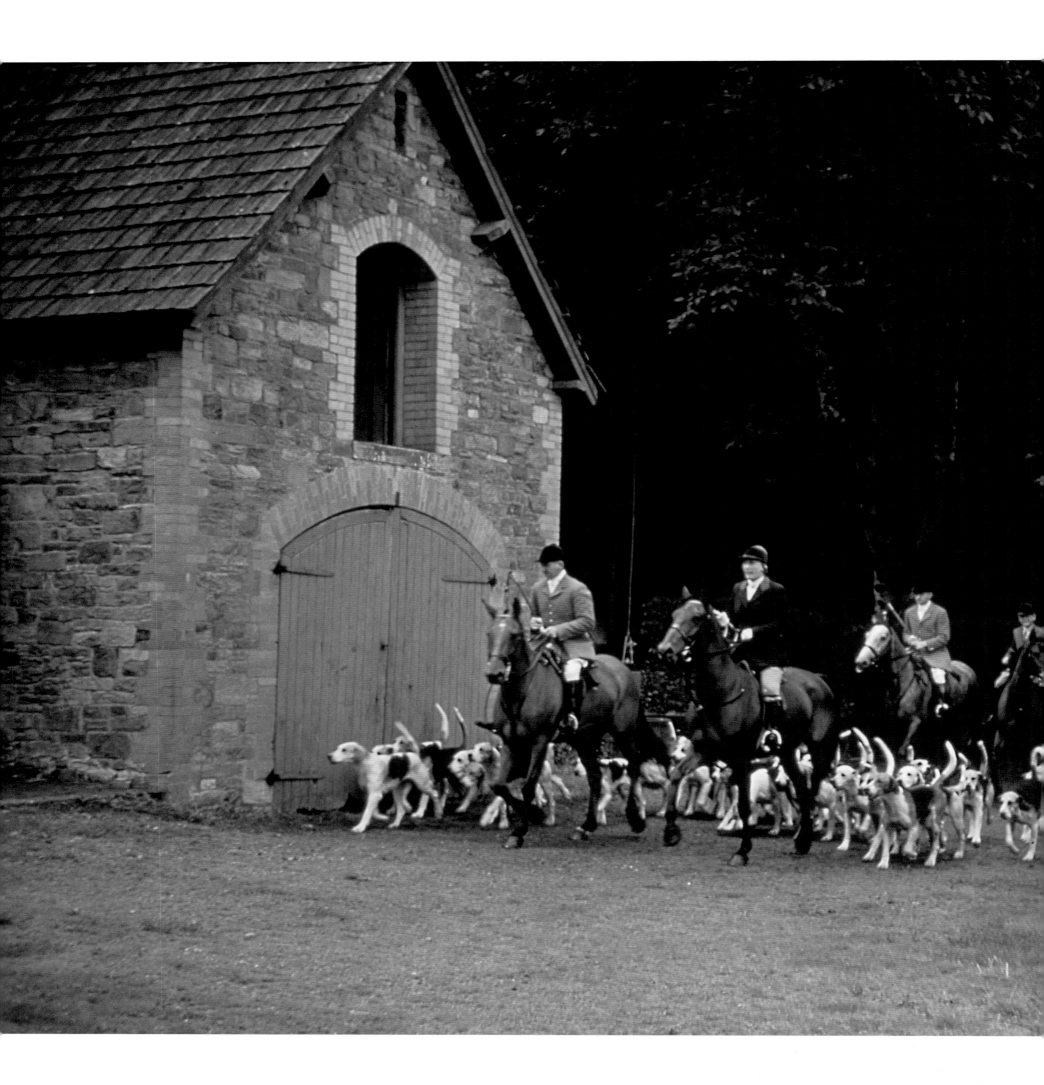

STAG HUNT, ENGLAND, 1955

I had just met my future wife, Sue Ellen Blake, in Rome. She was an actress and I was photographing her for a couple of magazines, first in Rome and then in Venice. The first night we went out together I said I was going to marry her. She said I was crazy. After the shoots were over I invited her to join me in Switzerland where I was taking photographs for a book, which she did. When that came to an end, we parted back in Rome as I had to go on to England for *Sports Illustrated* to shoot a stag hunt. I was there for a week. I never saw a stag. I was way out in the countryside and it was raining and cold and I was miserable and there was no stag. I cabled *Sports Illustrated* and said I was coming home. I got back to New York and went to my apartment and found Sue Ellen had camped out there. She had been flown over to read for a play with Tyrone Power and she thought she would stay in New York for awhile before going back to Italy. We had dinner that night, and she said, "You know, Ormond, I will." I said, "What do you mean, you will?" She says, "I will marry you." We were married three weeks later and we have been together ever since.

MILES DAVIS IN HIS BATHROOM, FOR *TIME*, 1971

Time did a story on new high-end designs for bathrooms, and asked me to photograph some society ladies and some jazz musicians in their bathrooms.

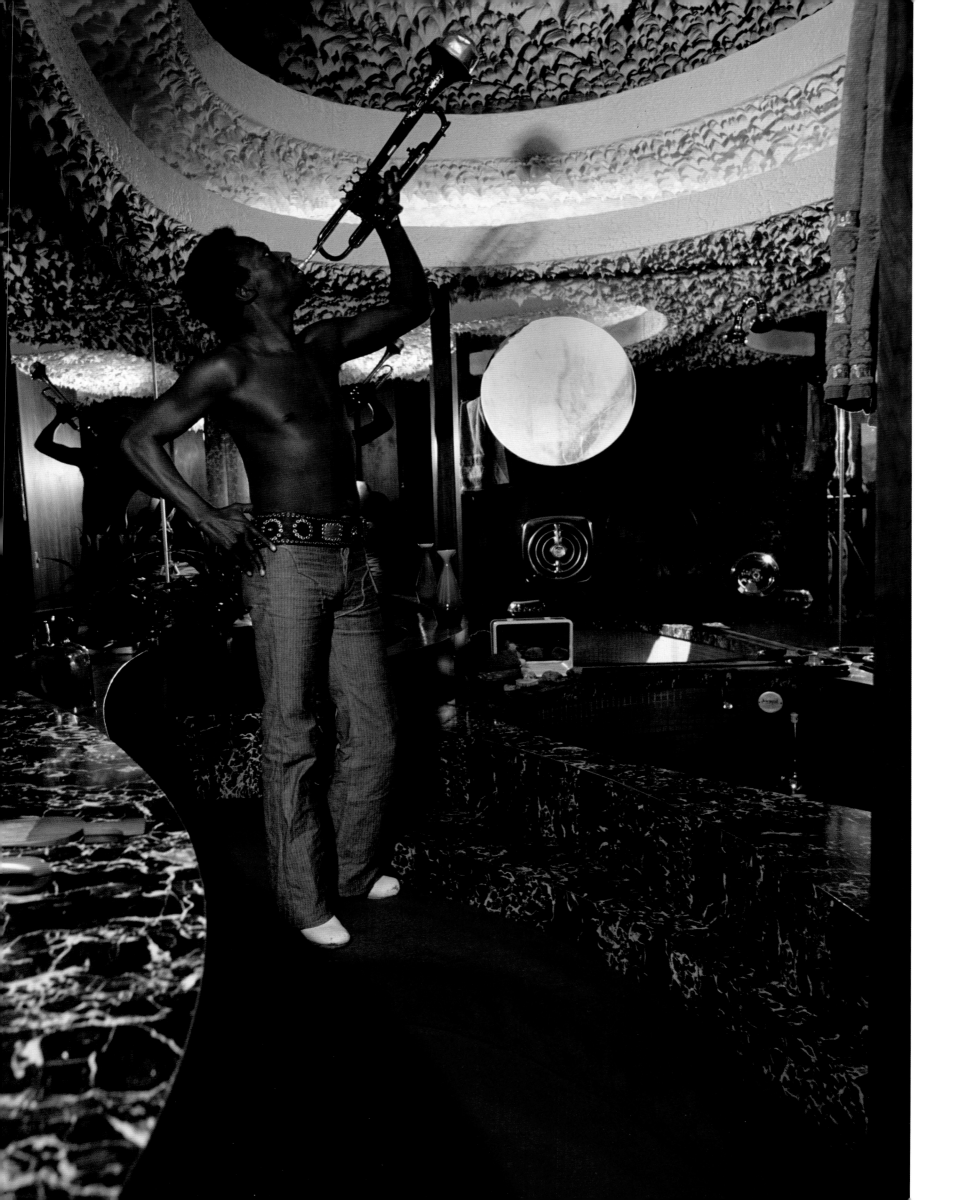

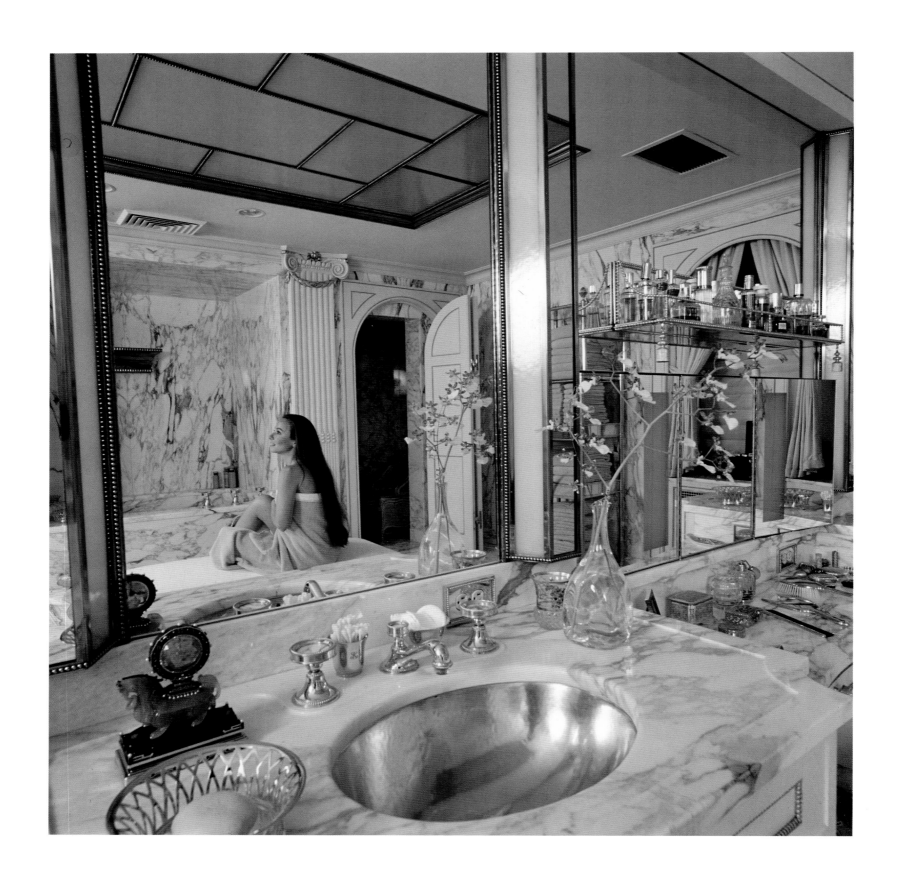

MRS. CHARLES REVSON, FOR "HOW THE OTHER HALF BATHES," *TIME*, 1971

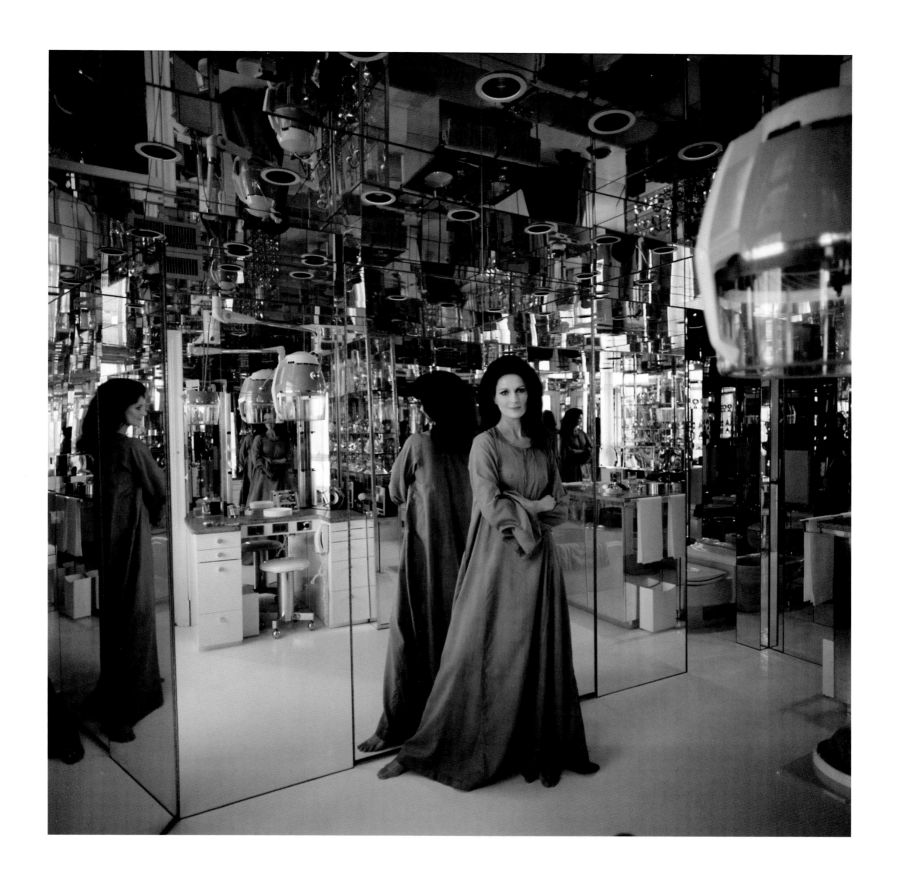

MRS. HARILAOS "BETSY" THEODORACOPULOS, FOR "HOW THE OTHER HALF BATHES," *TIME*, 1971

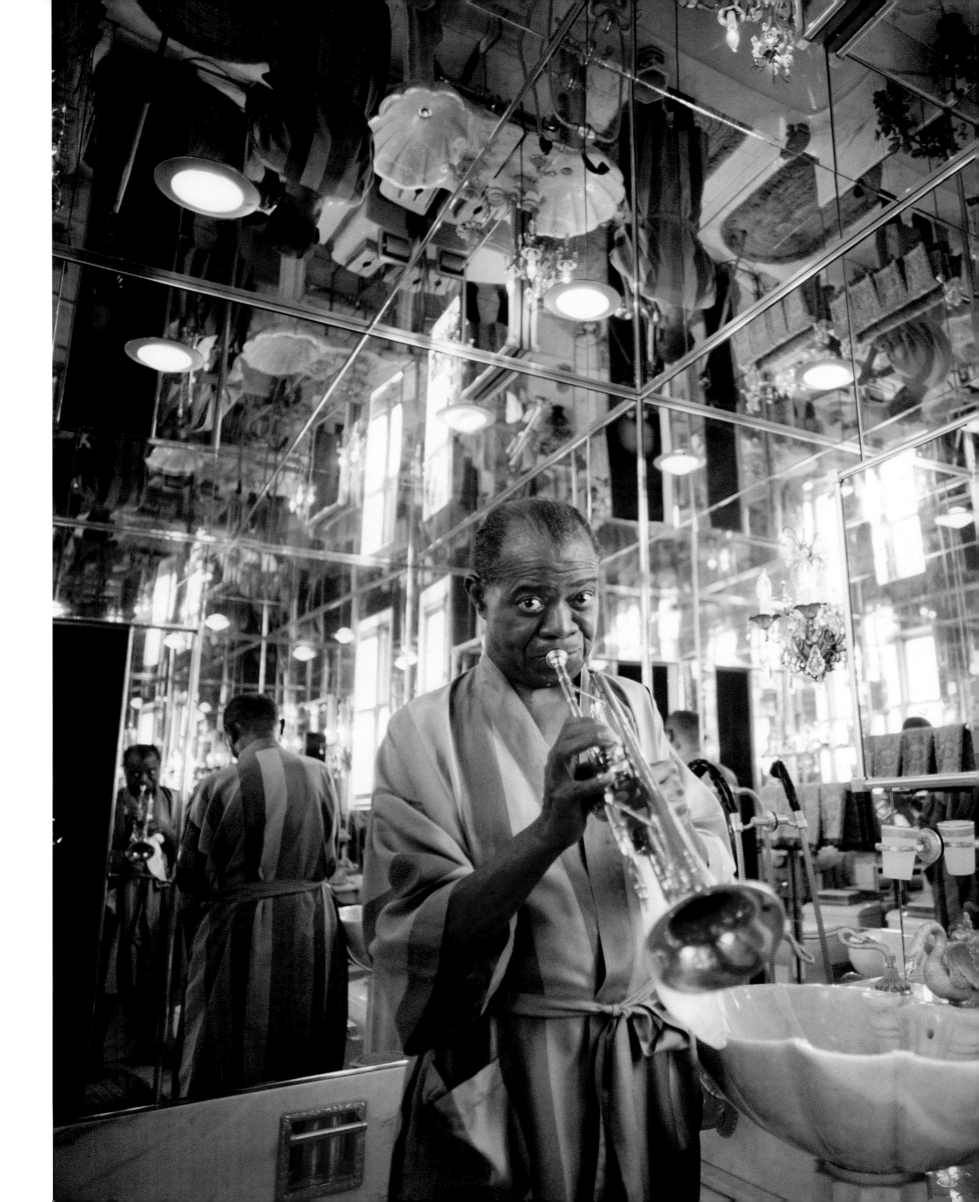

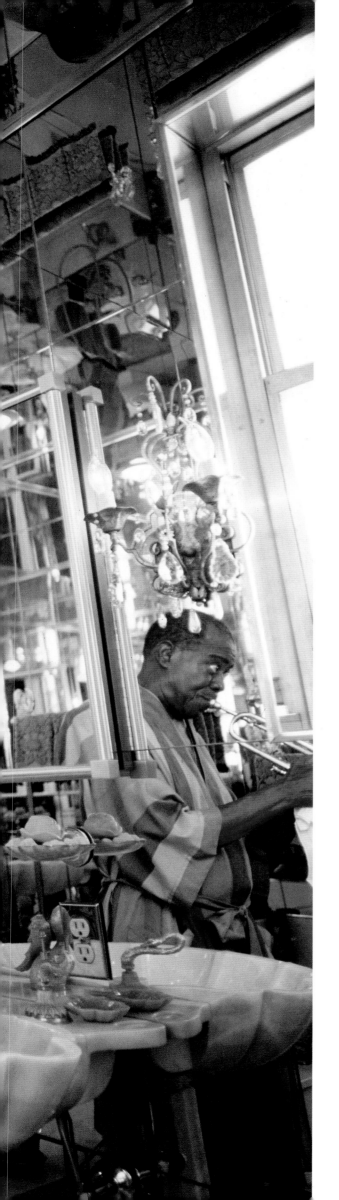

LOUIS ARMSTRONG, FOR "HOW
THE OTHER HALF BATHES," *TIME*, 1971

Mrs. Armstrong said in the article,
"Redecorating this room made the rest of
the house look so shabby that I had to
redecorate everything."

MRS. HOWARD OXENBERG, PRINCESS
ELIZABETH OF YUGOSLAVIA, FOR *TIME*

These photographs were taken for an article
called "Dressing Up for Fun" about people
around the country who were taking pleasure
in dressing well, whether buying French or
American fashions, or both, and living
well, if not a jet-set lifestyle certainly a life
of refinement.

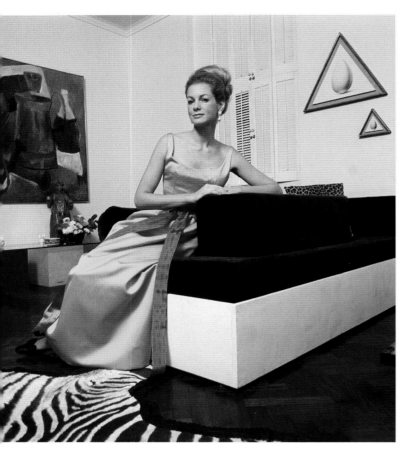

MRS. ROBIN BUTLER

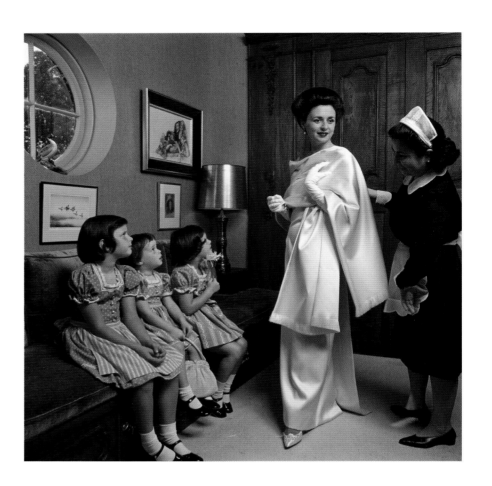

MRS. JOSEPH GARNEAU WERNER

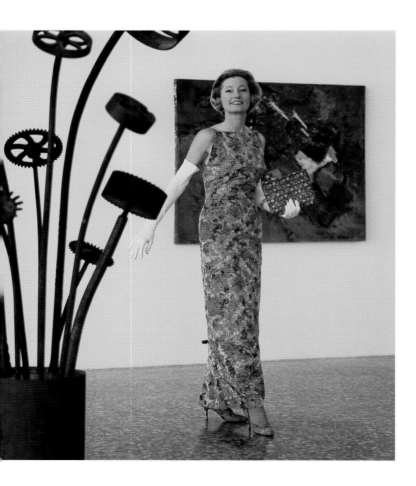

MRS. JOHN H. BLAFFER

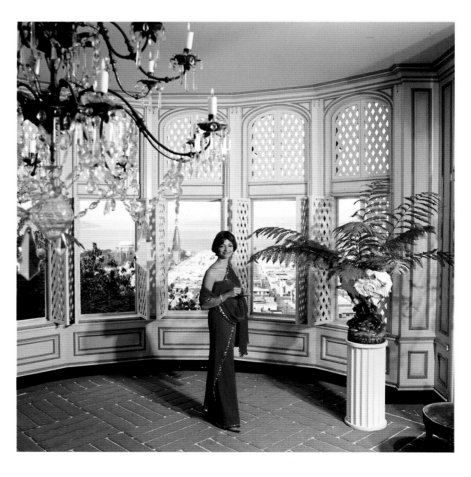

MRS. JOHN ROSEKRANS

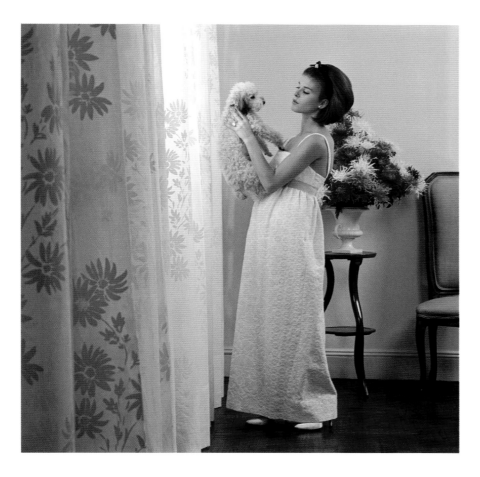

MRS. FREDERICK GUEST

MRS. ROBERT SARNOFF

MRS. CHRISTIAN DE GUIGNÉ III

MRS. SAMUEL PEABODY

FEDERAL RESERVE BANK, NEW YORK, FOR *THE SATURDAY EVENING POST*, 1959

FEDERAL RESERVE BANK, NEW YORK, 1959

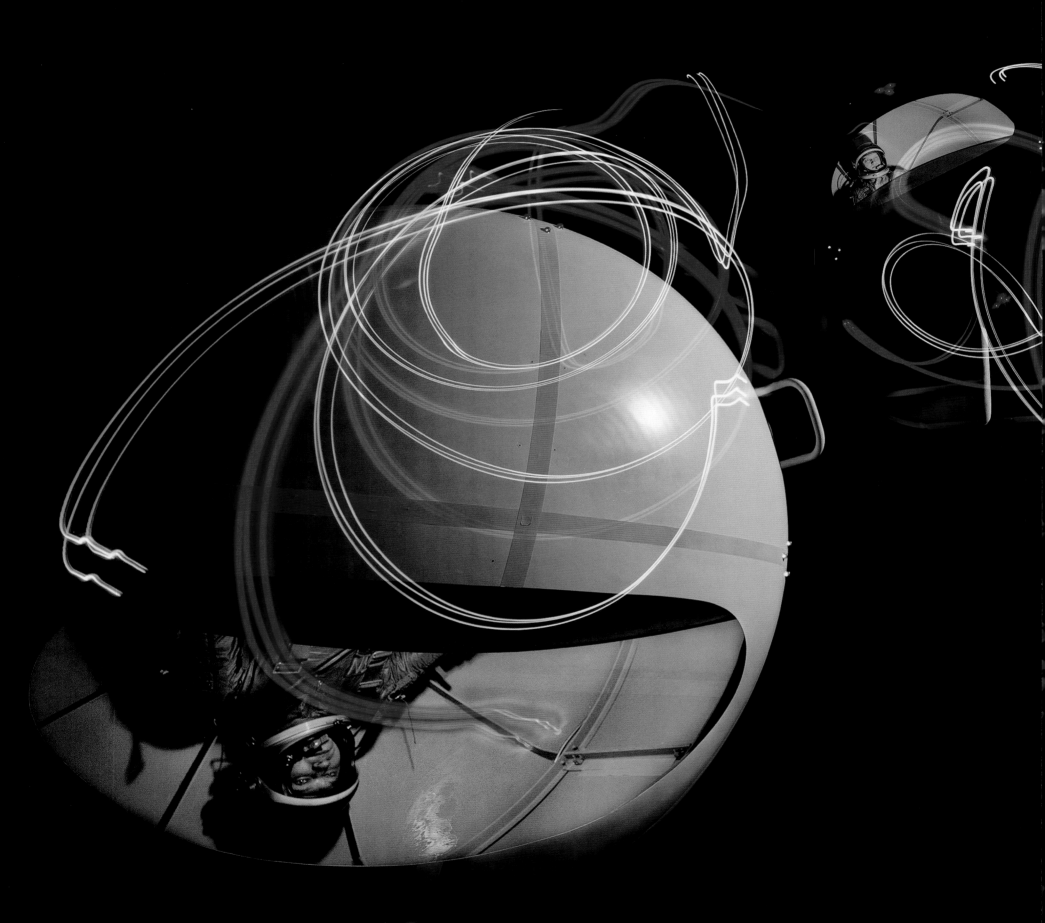

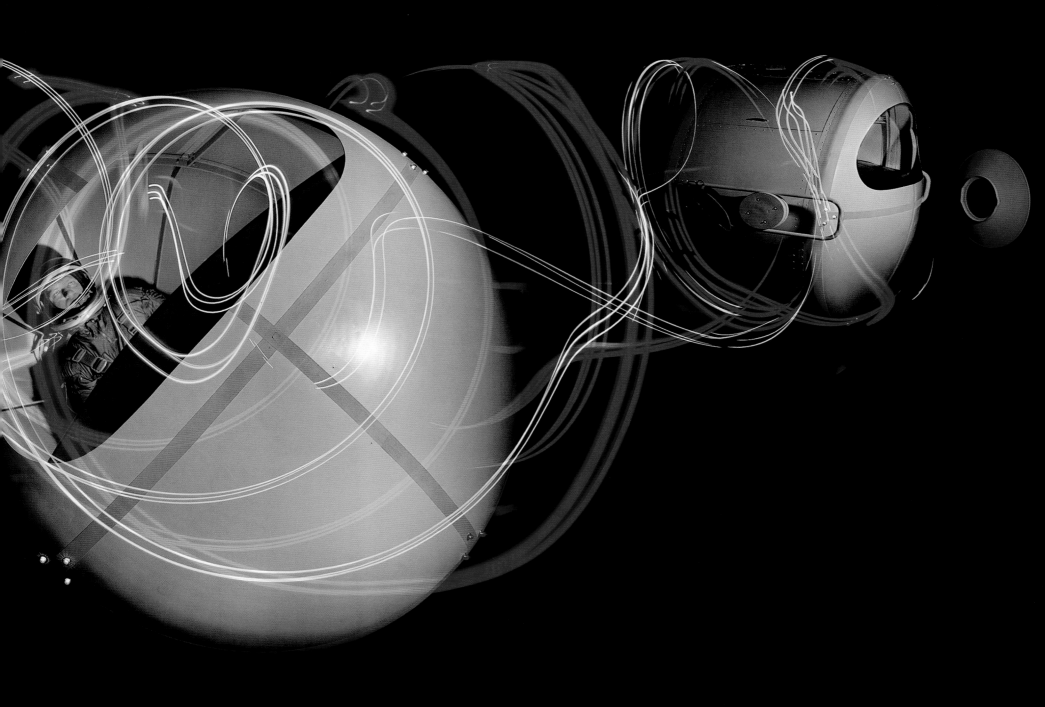

"SPACE SPECTACLES," FOR *THE SATURDAY EVENING POST*, 1962

FACES
& FIGURES

—

—

Ava Gardner had been living in Rome for many years and had not wanted to make movies for a long time. *Life* wanted to have her on a cover. In 1960 she was still big news and a very beautiful woman. The editors were sure they could get me to her through her press people and after that it was up to me. She was not allowing anyone to photograph her.

I flew to Rome and met her public relations people who warned me that she could be difficult. They told me her vocabulary was like that of a drunken sailor. Whether she spoke like that for effect, no one knew except Ava. I was warned to be careful of her. The PR rep took me up to her lovely apartment, just off the Spanish Steps. He introduced me to the star and then ran out, looking like he was afraid of her. So, there we were, one on one. There was no one else but us. She starts speaking to me in the foulest language, flowing from her beautiful mouth. After a few minutes, I said, "Ava, I used to be in the Navy. I know all the words. If this is the way you normally talk, then fine, no problem. If you're doing it to impress me, I've heard it all." She said "Okay," and that was the end of the four-letter words.

I reminded her that I was there because *Life* wanted a cover. She told me that three months before she had been horseback riding and fell and the horse kicked her just under her cheekbone. She was concerned it would show in the photograph. I didn't see anything. She said it was slightly swollen. I thought it was all in her head. I didn't see anything. We had drinks, chatted, and then I went back to my hotel. She told me to call her in the morning and we would talk about photographing. I called her the next morning and I said it was a great day and we should get going. She said, "I don't feel beautiful today." I said, "What do you mean? You're sensational." She said not today, but to come over and have

some lunch. I went to her apartment and didn't take my camera along. I didn't want to upset her. We had lunch, cocktails. We were together the whole day, and she was drinking a lot. We went out shopping, and then we had more drinks. It was a long day.

When I returned to my hotel, she called me and said we should have dinner. So, we had dinner together that night. I got back to the hotel around one in the morning. She told me to call her the next day. It was a courtship. I went to see her the next day, bringing flowers. She knew I liked certain cigarettes and she gave me a couple of cartons. She made a special lunch for us. This went on for six days. We were getting closer and closer, but I could never point a camera at her. Finally, I said, "Ava, I'm a photographer. I love you. You are a great girl, but I have to take some photographs for the magazine. I will photograph you and develop them here, and you can see them. If you don't like them, I will throw them out and do more."

"But I don't feel beautiful."

The following day I informed *Life* of the situation. They said if I wanted to pull the plug, I could do so. I had another assignment in Spain to photograph the making of *El Cid* with Charlton Heston and Sophia Loren. I told Ava I had to go to Spain for an assignment. She said she would see me there. We left it at that. I didn't tell her where I was staying, what I was doing. I didn't say anything. I was very upset at her stubbornness.

I arrived in Spain and was standing in the lobby with Charlton Heston and others in the movie when somebody came up behind me and covered my eyes. "Guess who?" It was Ava, she had managed to track me down. I said I was staying in the hotel and she should call me and we could perhaps take some photographs the next day. She told me to call her and we could arrange it. I didn't call and she didn't call and I never got to see Ava Gardner through my camera lens. It was a fun experience being with her, such a great and beautiful star, but I did not catch the brass ring—and that remained utmost in my mind, getting the photograph. – O.G.

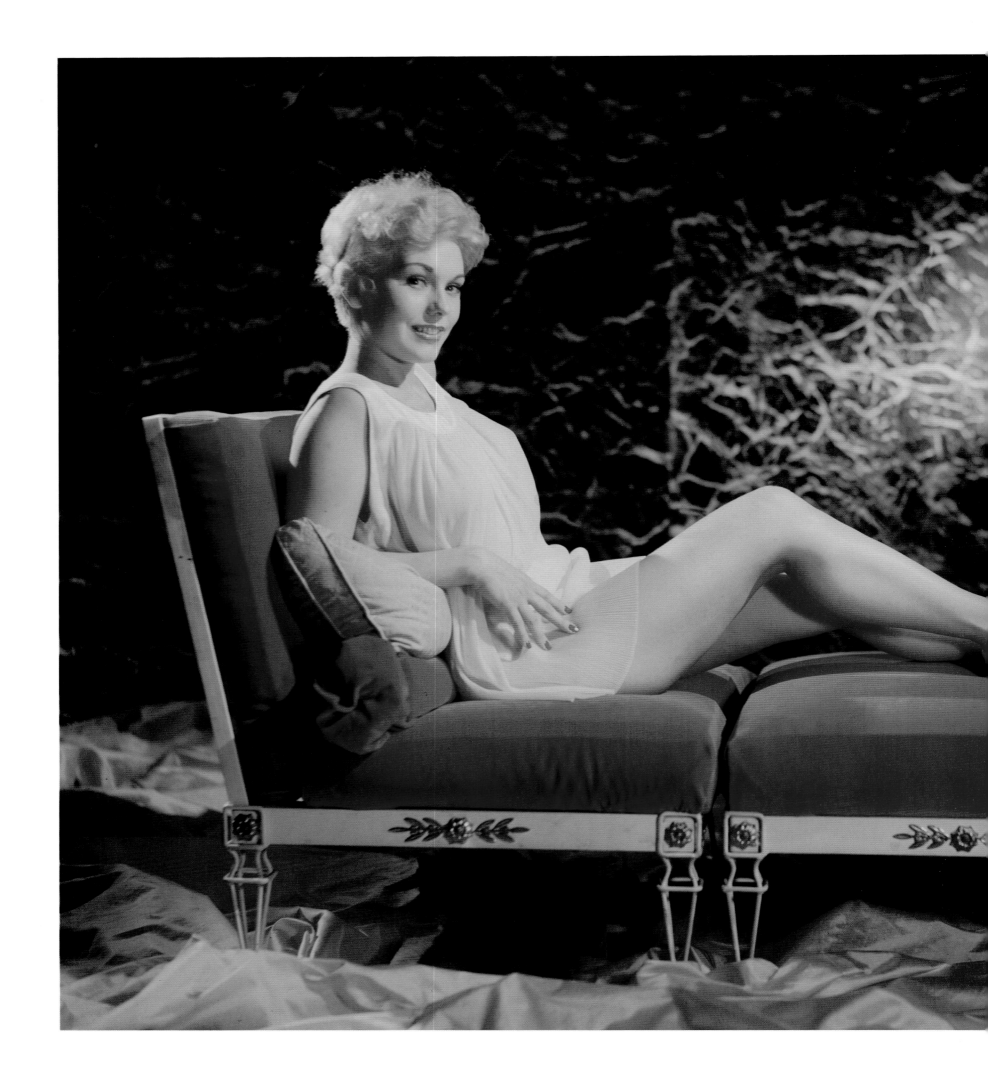

KIM NOVAK, NEW YORK, FOR *ESQUIRE*, 1955

HILDEGARD NEFF, 1955

Hildegard Neff was starring in *Silk Stockings*
with Don Ameche on Broadway. I was
thinking I could do something different with
her for *Collier's*. I went to rehearsals and
met Hildegard and we became good friends.
I photographed her in many different ways,
even in lederhosen and a hat.

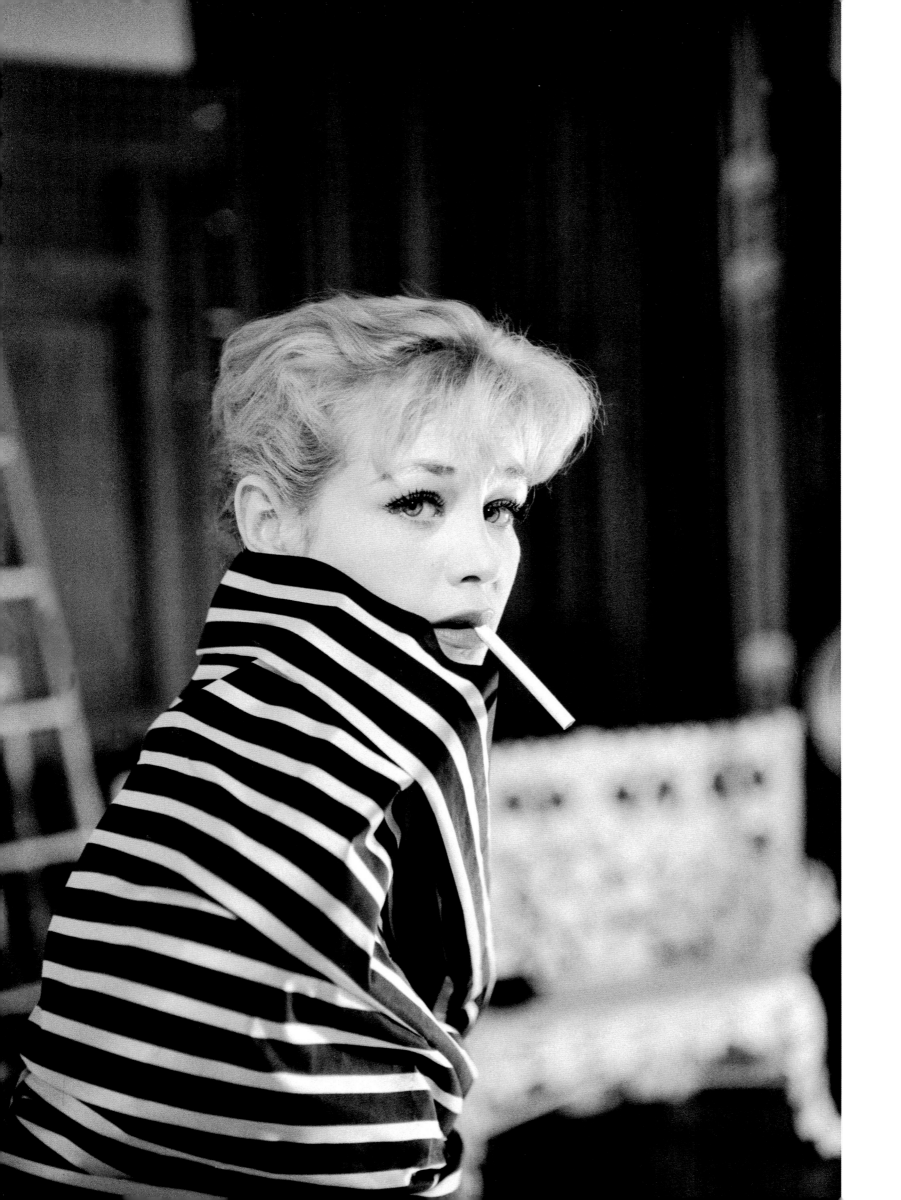

MARLENE DIETRICH, FOR *THIS WEEK*, 1954

This photo ran on the cover of *This Week*, a
newspaper supplement.

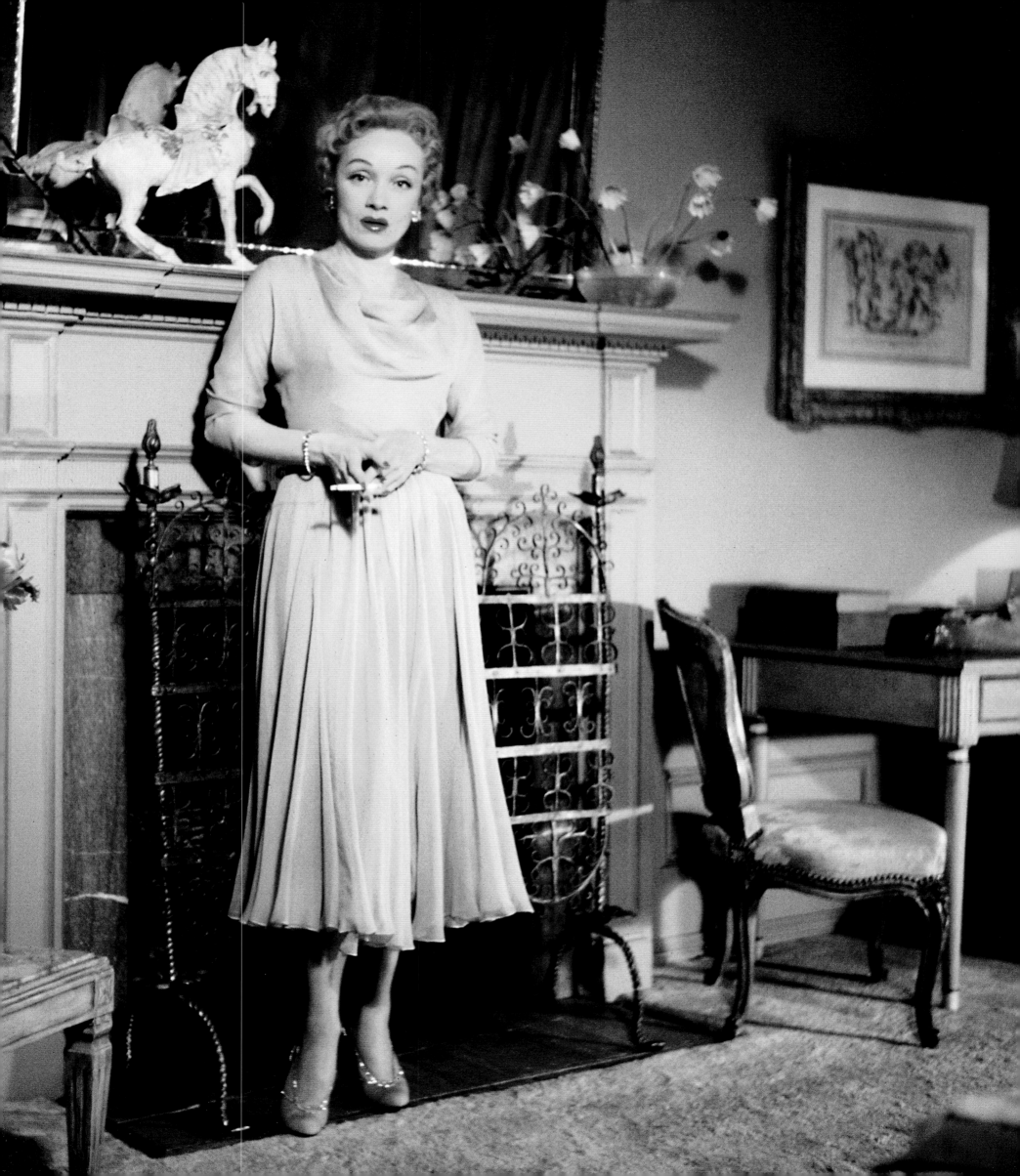

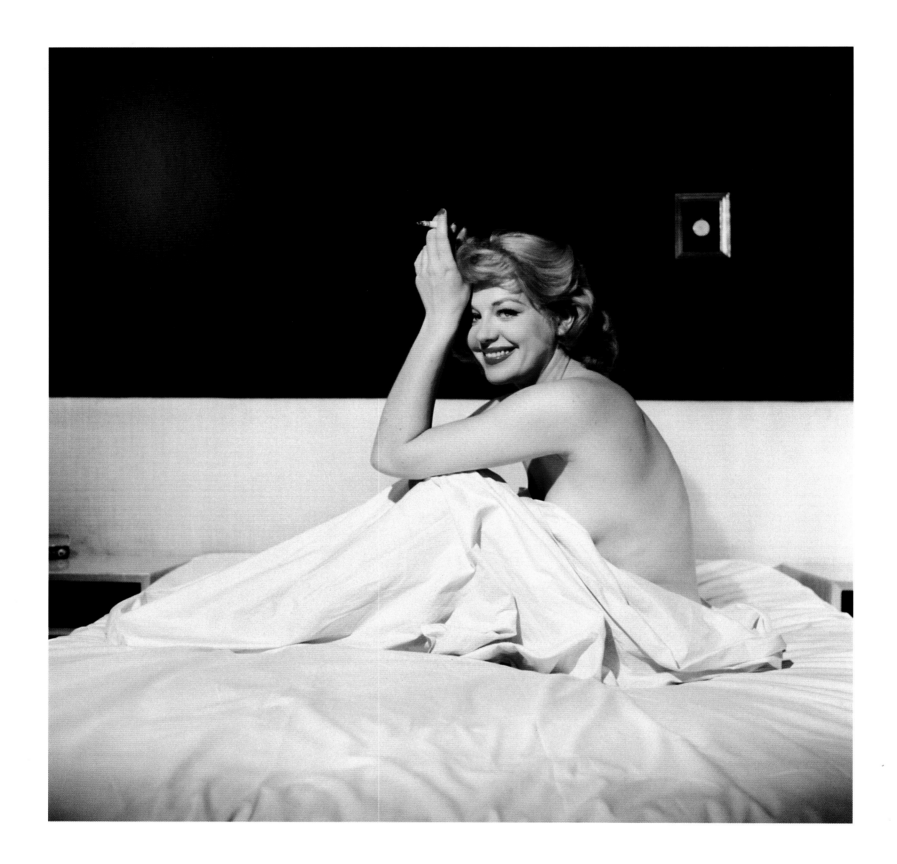

HILDEGARD NEFF, 1955

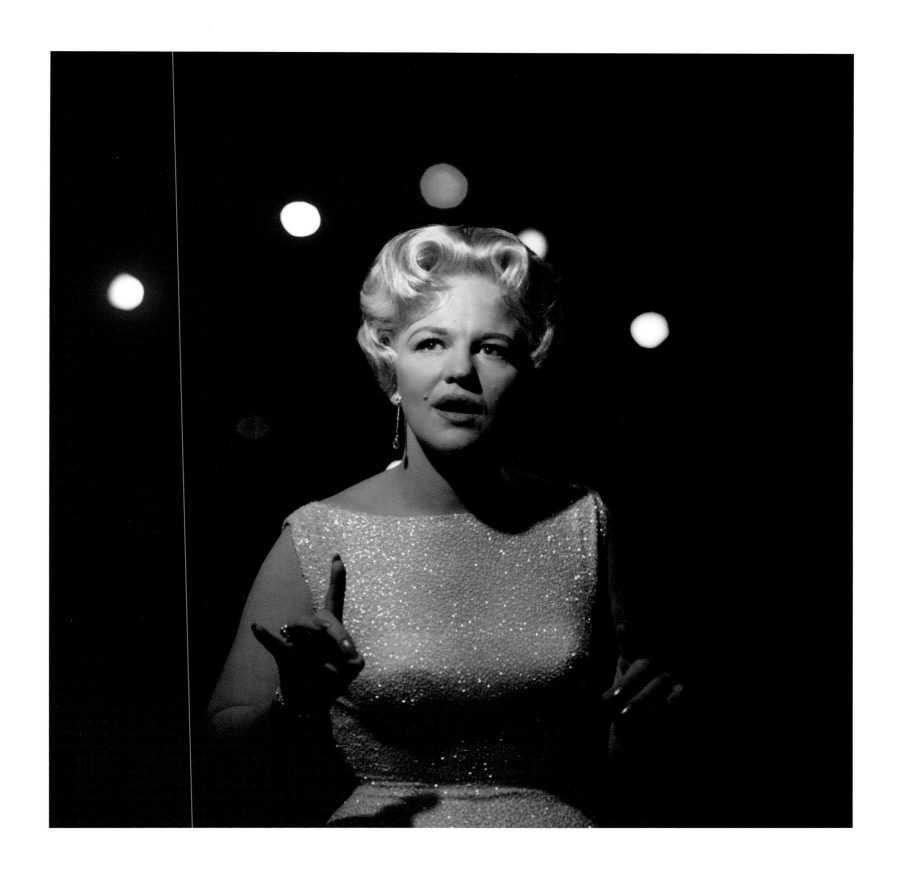

PEGGY LEE, NEW YORK, 1953

I shot her one morning in my studio. I
just raised a paper backdrop behind her,
punched some holes in the paper and shined
lights through using colored gels to get the
nightclub effect.

JANET BLAIR, FOR *LIFE*, 1956

Janet Blair was playing Sid Caesar's wife
on his television show and I photographed
her for the cover of the magazine.

JAYNE MANSFIELD, 1956

148

HELEN PARTELLO, 1958

Helen was a girl of the moment who had
appeared in a couple of Italian movies but
was actually from California. The photographs
ran in *Nugget*, a men's magazine of the time.
The article accompanying the photographs
quoted an unnamed photographer as saying
that she had the face of an innocent schoolgirl,
while the director Vittorio De Sica said she
had the face of a perfect delinquent. She was
pretty alright.

JULIE WILSON, 1957

She was a nightclub singer who performed at the Latin Quarter and the Copacabana and had several Broadway credits, including *The Pajama Game*. In 1957 she was singing with Ray Anthony and his orchestra.

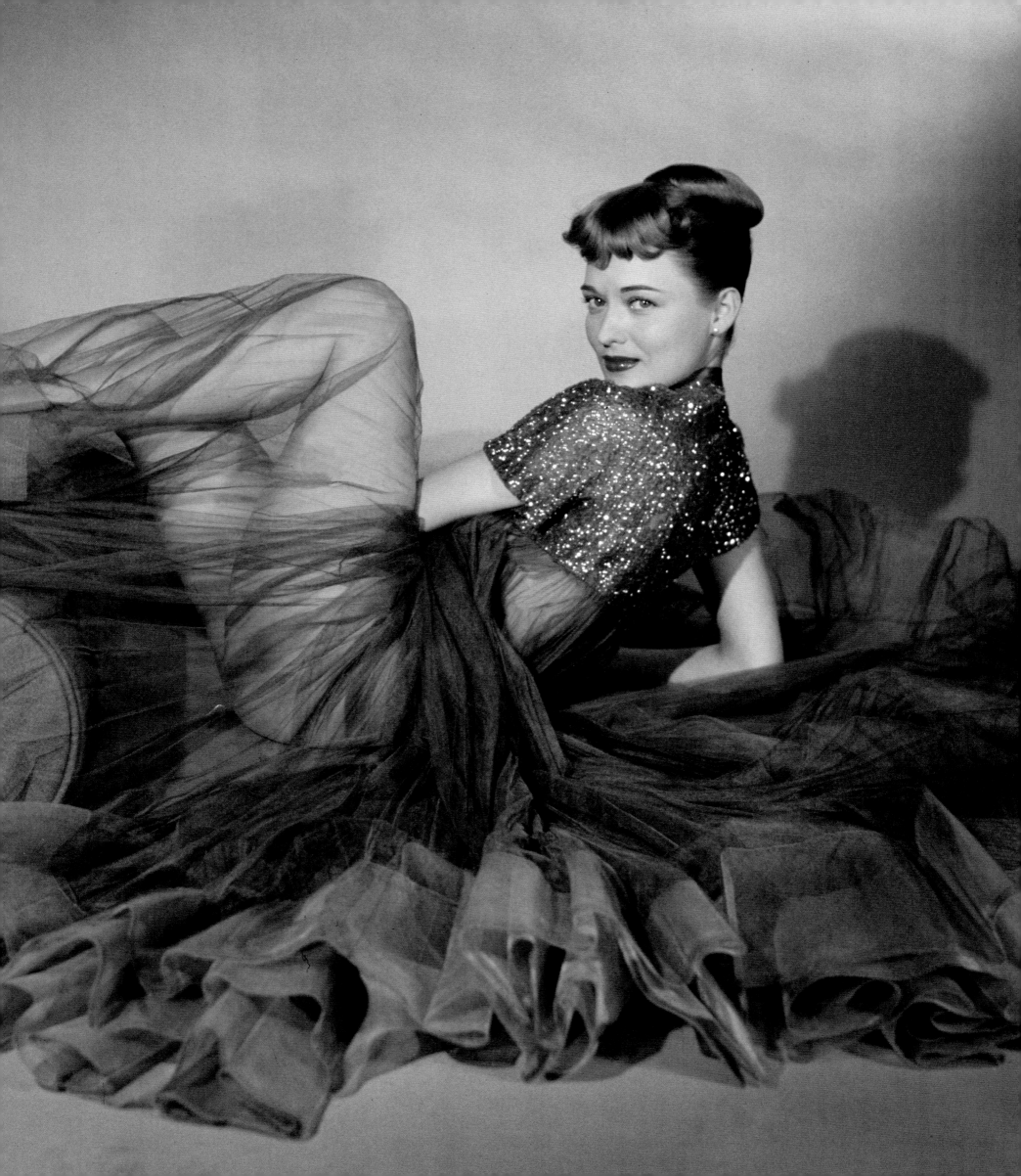

SOPHIA LOREN, ROME, 1955

I was sent to Italy to photograph a beautiful
new film actress who barely spoke any English.
The big Italian star at the time was Gina
Lollobrigida—not Sophia Loren. I had a
ten-thirty a.m. appointment to meet her. She
was living in an apartment with her mother,
Romilda, a piano teacher, who was expecting
me. We had coffee and tried to communicate
with her little bit of English and my little bit of
Italian. But no Sophia appeared. By eleven
o'clock I was getting anxious to start shooting.
It was always hard to photograph in
Mediterranean countries because everything
started very late, even though I wanted to go
out early because of the light. The light,
especially in summer, would be directly
overhead by eleven, making it difficult to
photograph. After I looked at my watch a few
times, the mother said, "The lazy thing. She's
still sleeping. Go in there and throw her out of
bed." I protested, but she insisted, "No, you go.
Throw her out of bed." I said she should do it,
but she insisted I do it.

Romilda led me to the bedroom and then went
back to the kitchen. I went into the bedroom
and Sophia was still sleeping and her beautiful
breasts were exposed. I gingerly sat down on
the edge of her bed. "Sophia. Sophia. Come on.
Ciao, ciao. Let's go." She was lying there asleep
her hair tousled. It wasn't what I expected, for
sure. Finally, I was able to wake her up, but
she insisted on having lunch before we left for
our shoot. It was at least three o'clock by
the time we were out and ready to photograph.
The sun was high, and very hot.

She had made a movie the year before (*The
Gold of Naples*, 1954) in which she played a
street vendor in Naples. I had the idea to put
her in a peasant blouse and skirt. I told her
that she would look great in a large fountain.
She agreed to my plan. I purchased the
oranges and splashed water over the blouse
and pulled it low. She held up her skirt and
washed the oranges in the Trevi Fountain.
I was getting some wonderful photographs.

She had a special way with everyone. Two
carabinieri came by on horseback, wondering
what was going on. I assumed they were going
to throw Sophia out of the fountain. Sophia
said ciao and bent over and lifted her skirt a
little bit. The carabinieri saluted her and rode
off, and I continued shooting. That night we
had dinner together and she said, "I will learn
English. I will learn to speak better English
than Gina and I will be a great star in America
and all over." I said I thought she would make
it. Some years later when she won the
Academy Award for her performance in *Two
Women*, I remembered what she had said that
summer night in Rome.

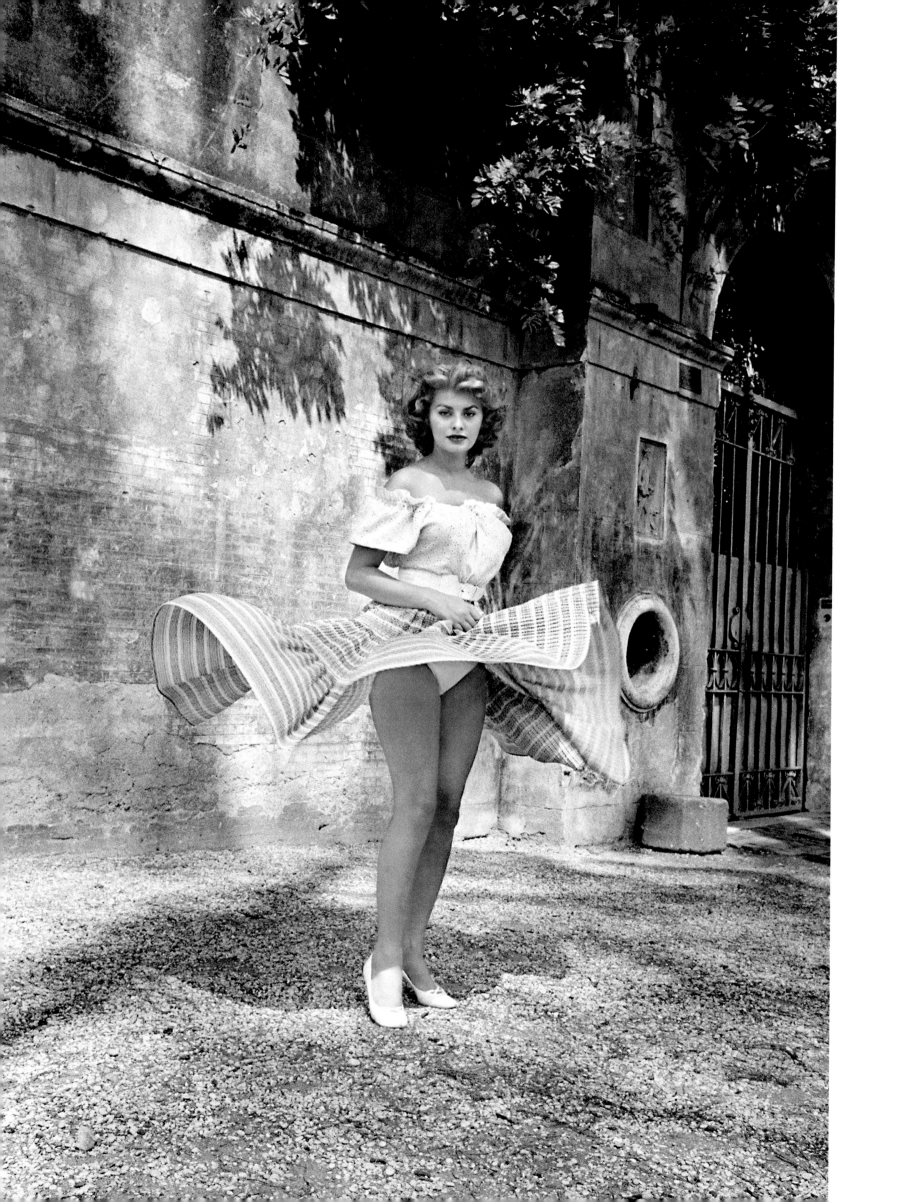

SOPHIA LOREN, ROME, 1955

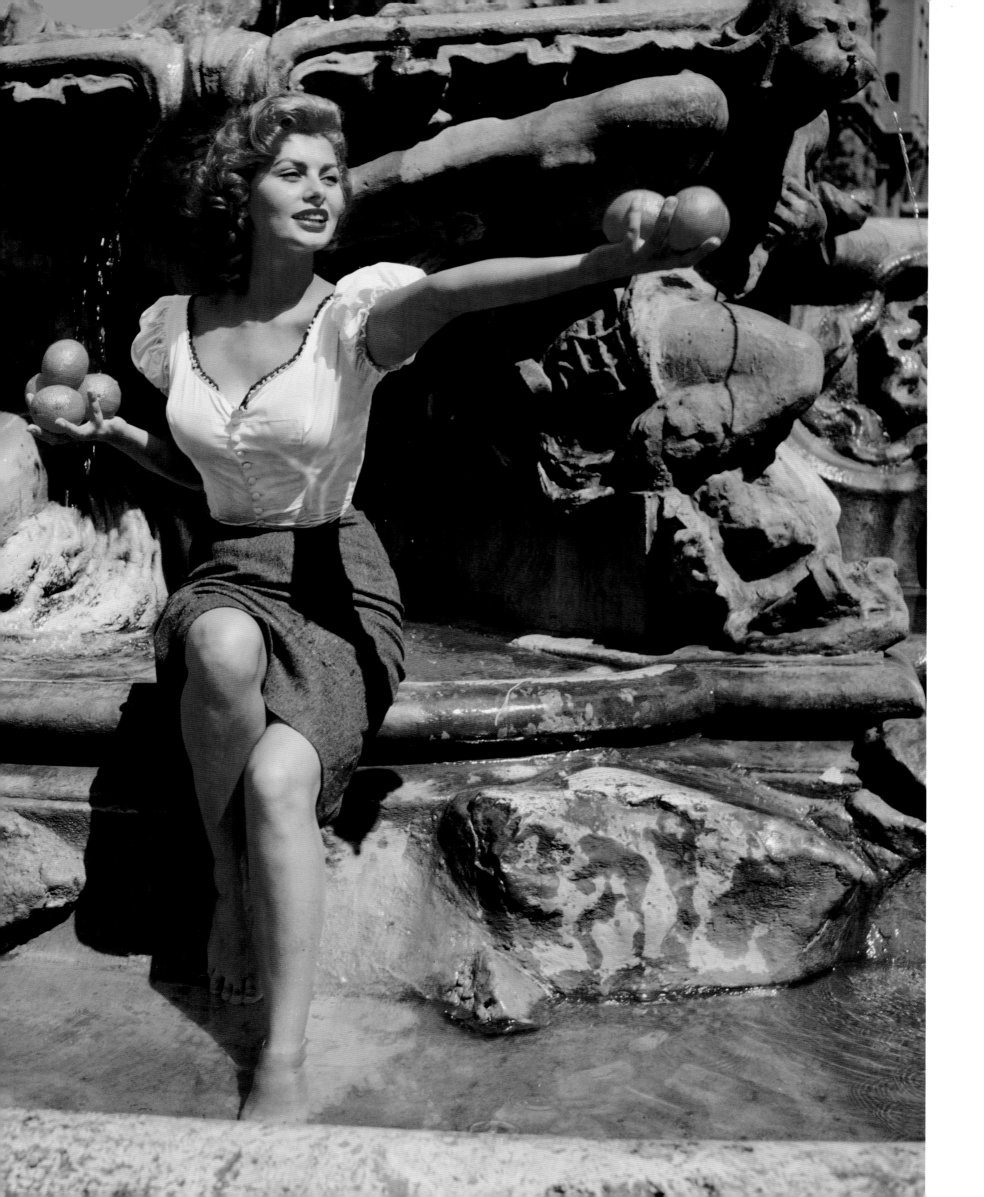

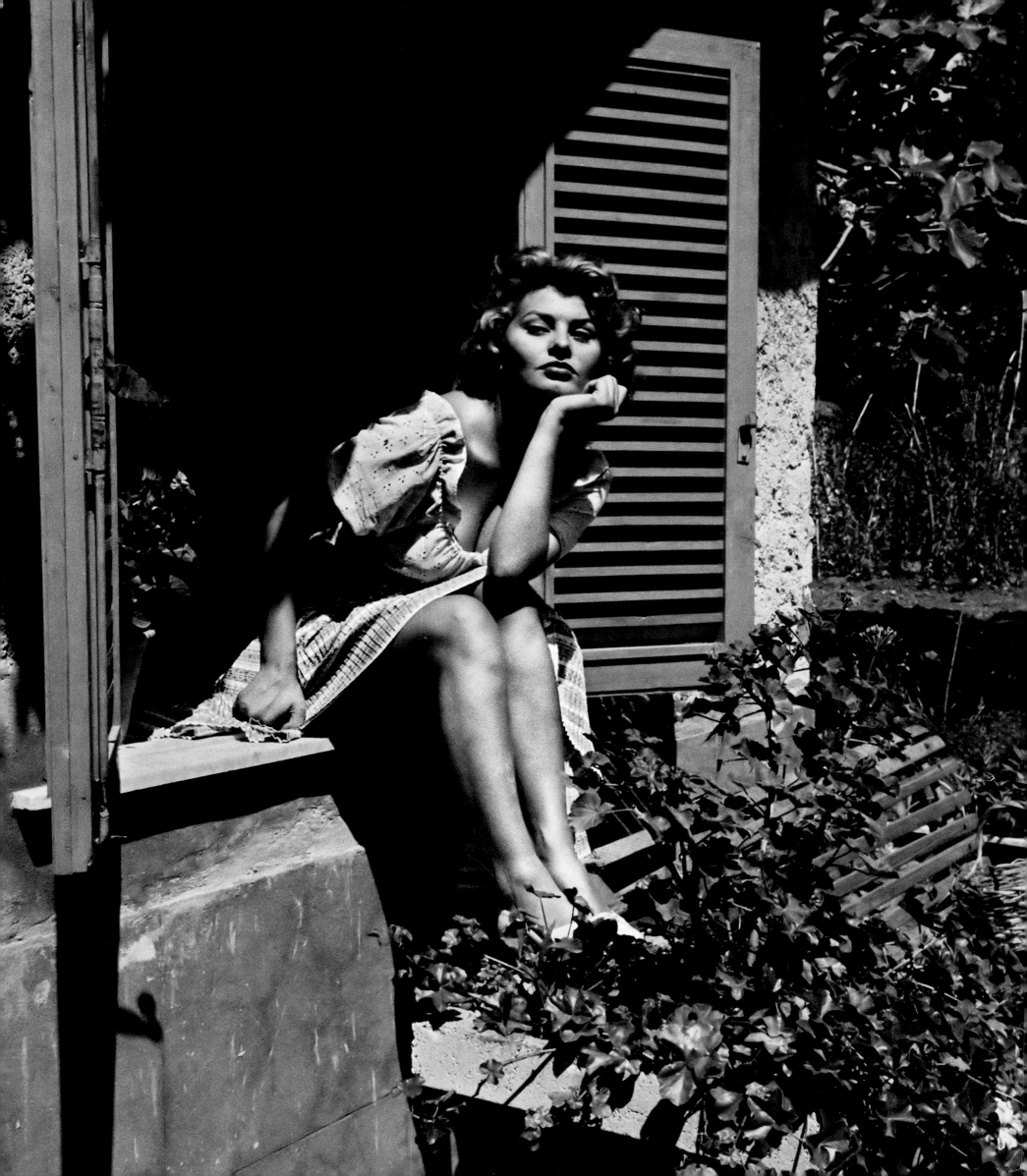

SOPHIA LOREN, ROME, 1955

ERIN O'BRIEN, MADRID, 1960

ANNA MOFFO, ROME, 1959

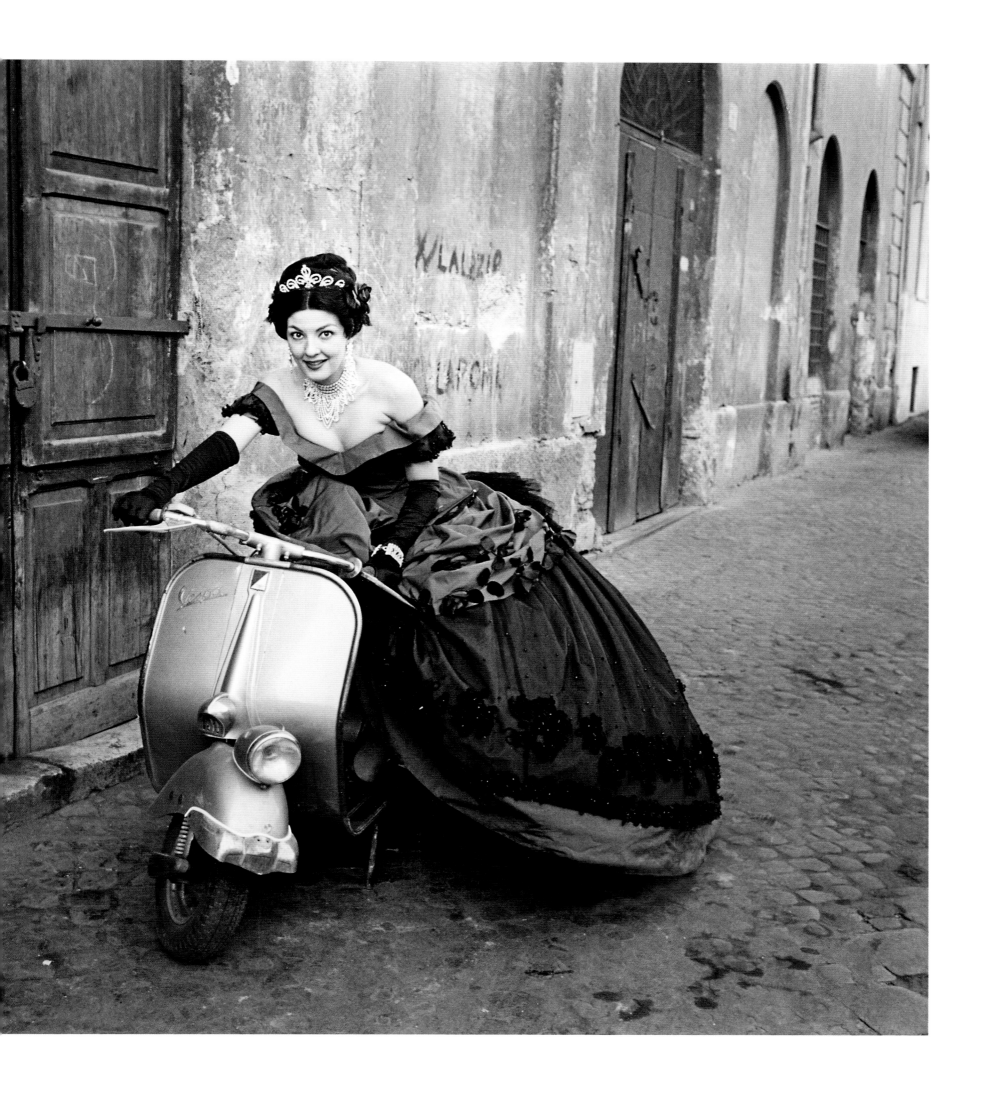

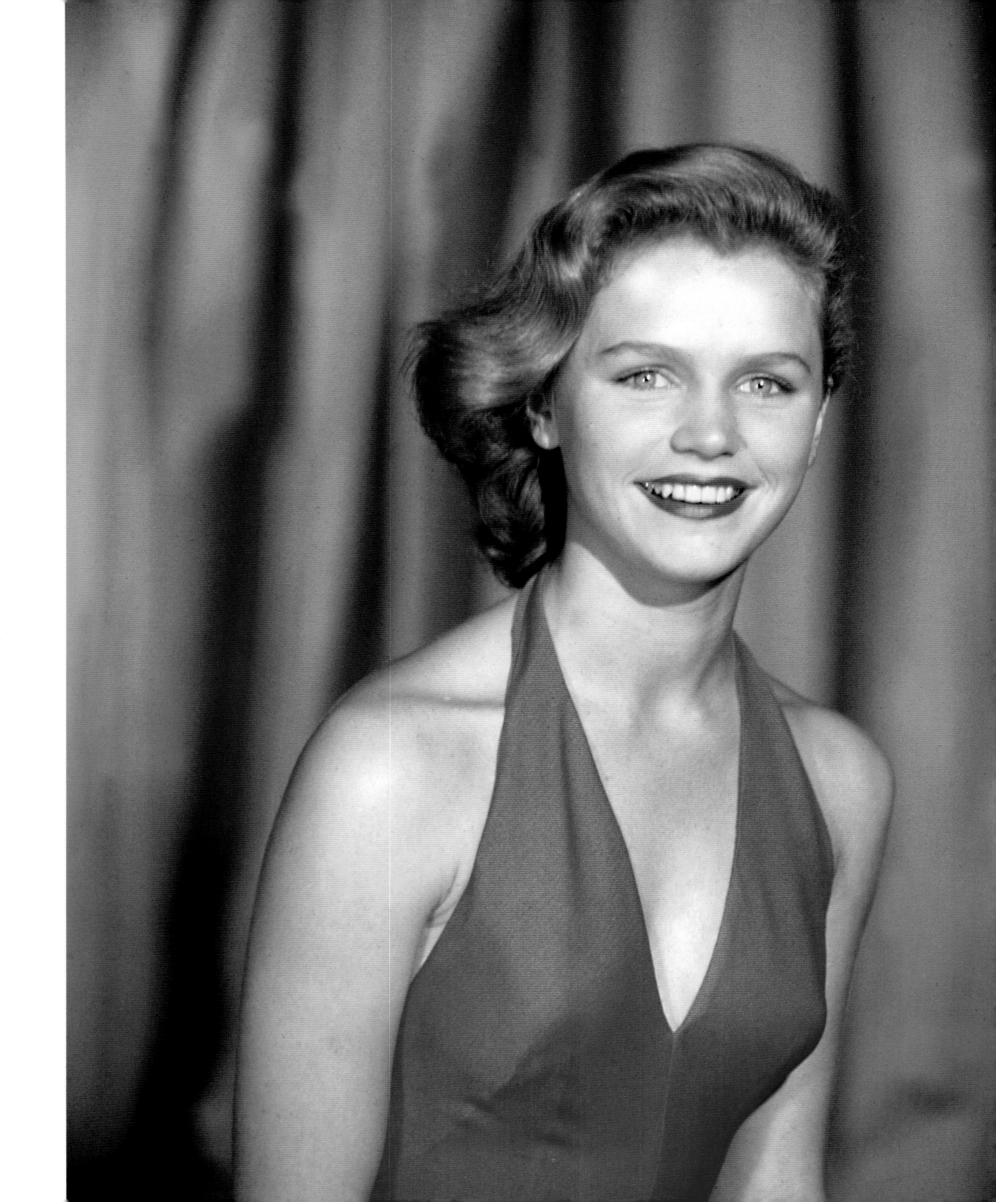

LEE REMICK, NEW YORK, 1957

She had made her first movie playing a drum
majorette in Elia Kazan's *A Face in the Crowd*
with Andy Griffith and Patricia Neal. We
were trying for a cover shot for *Life* magazine,
we even flew to Bermuda to take pictures,
but we didn't manage to get it.

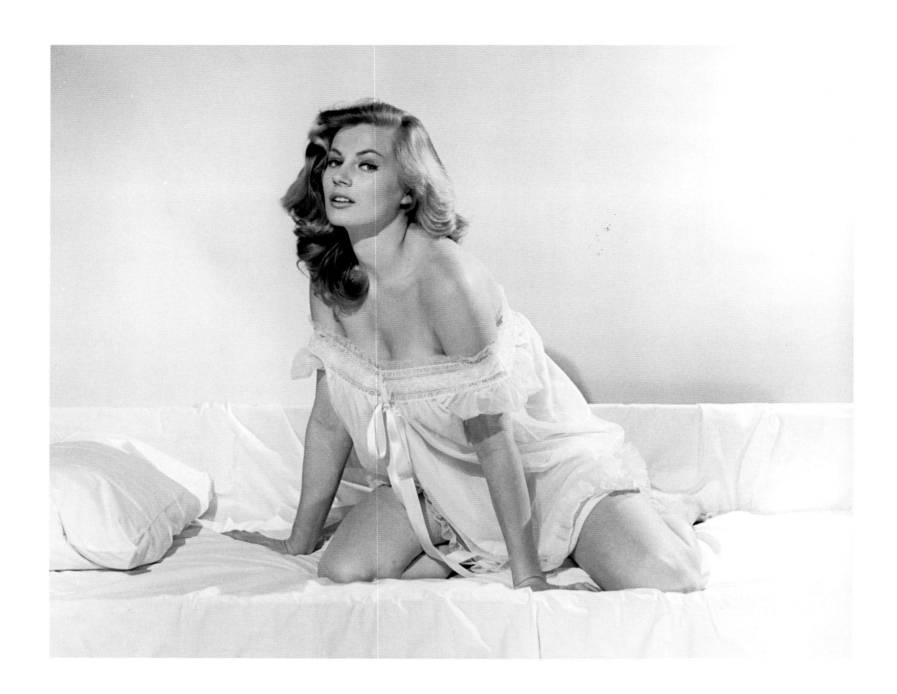

ANITA EKBERG, NEW YORK, FOR *PARADE*, 1954

I had an appointment to photograph Anita Ekberg
one morning around ten o'clock at my studio, which
was then on East 65th Street. I was expecting
her and an art director when the doorbell rang
and in walks this dynamite, sexy, thin young
Swedish lady and she says hi. She went to the
dressing room and saw my bedroom which was just
off the dressing room. We got great photographs
and we were quite friendly while she was in New
York, which was only a couple of days. She was by
far the most beautiful woman I ever photographed.

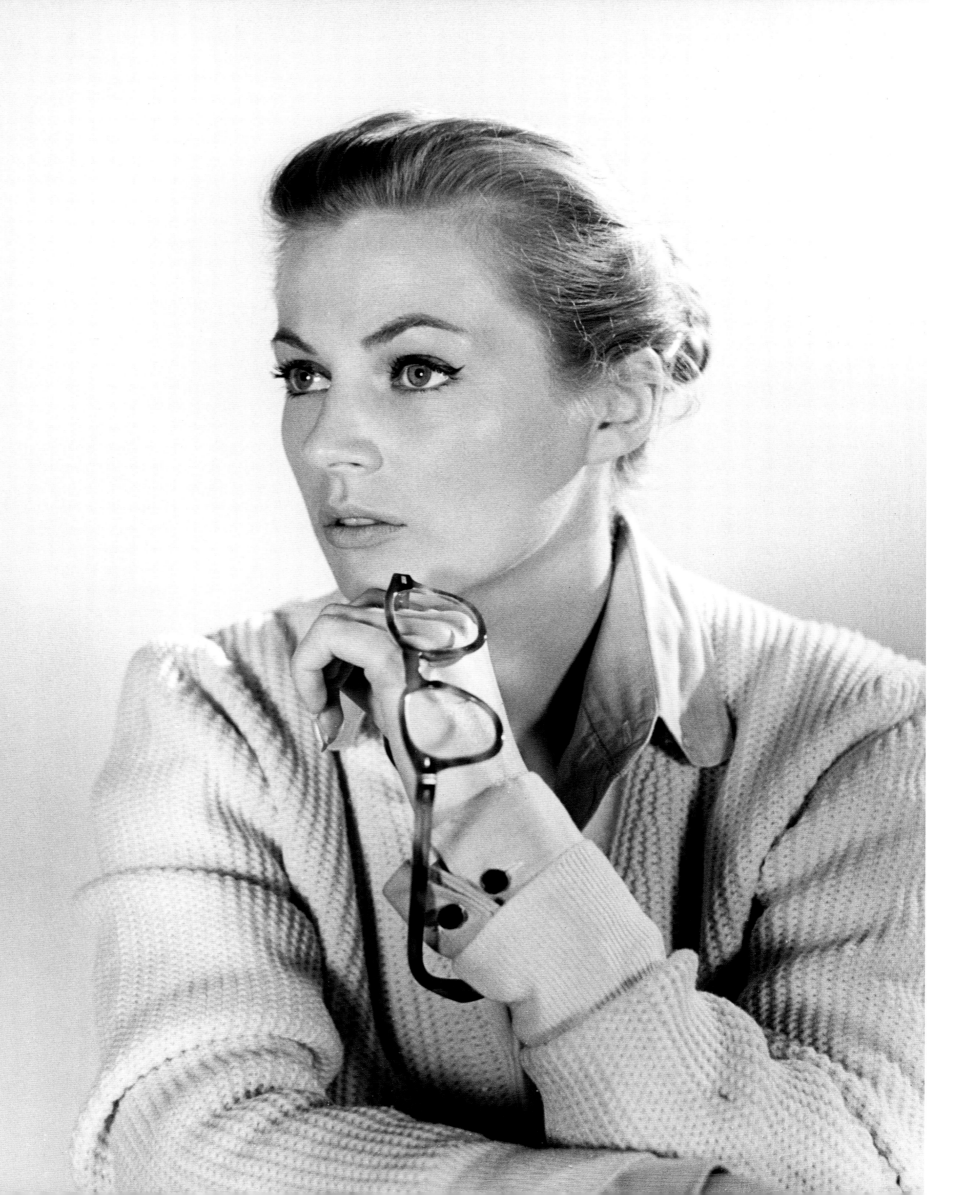

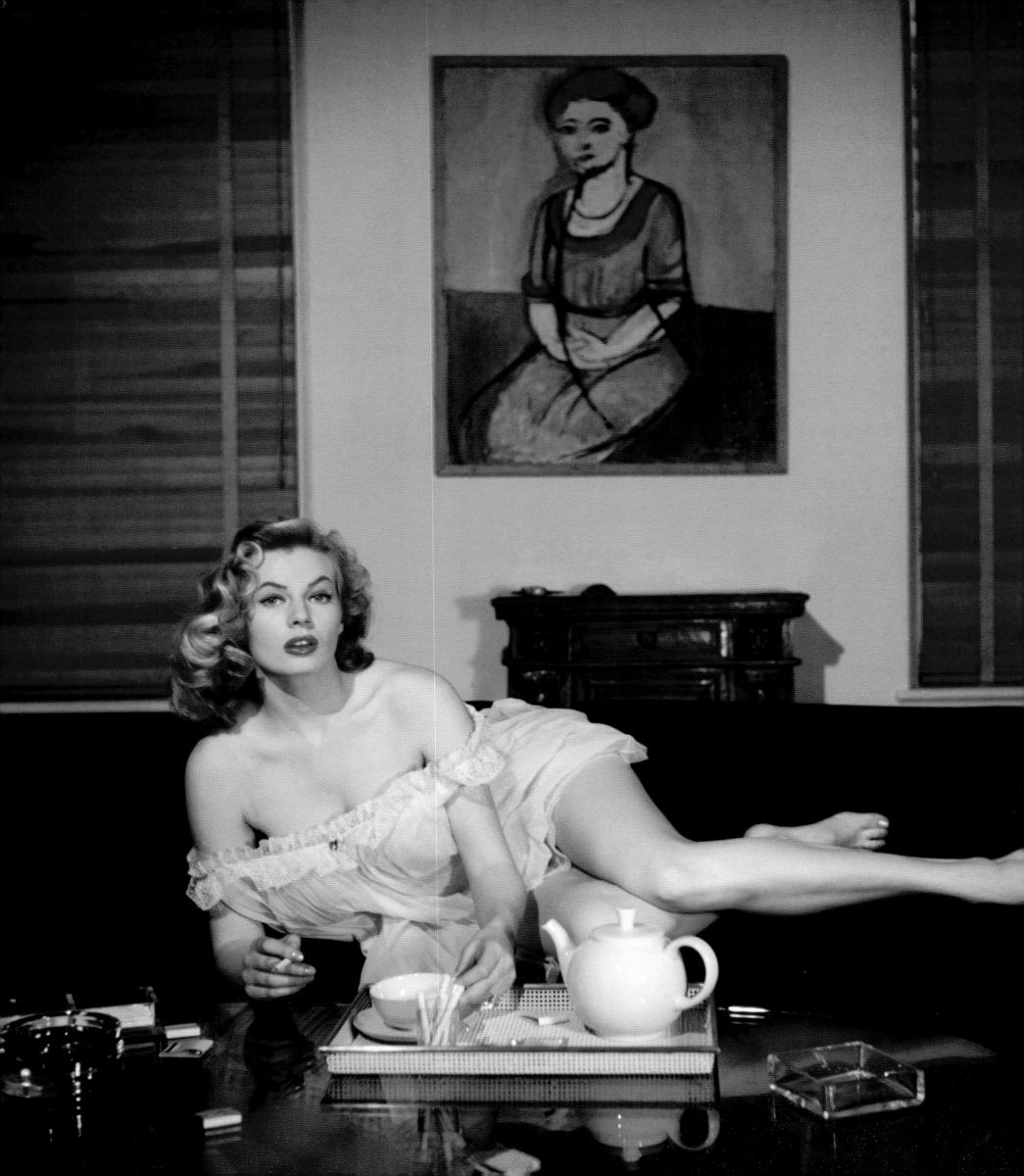

RUDY VALLÉE, 1961

He was performing on Broadway at the
time in the musical *How to Succeed in Business
Without Really Trying.*

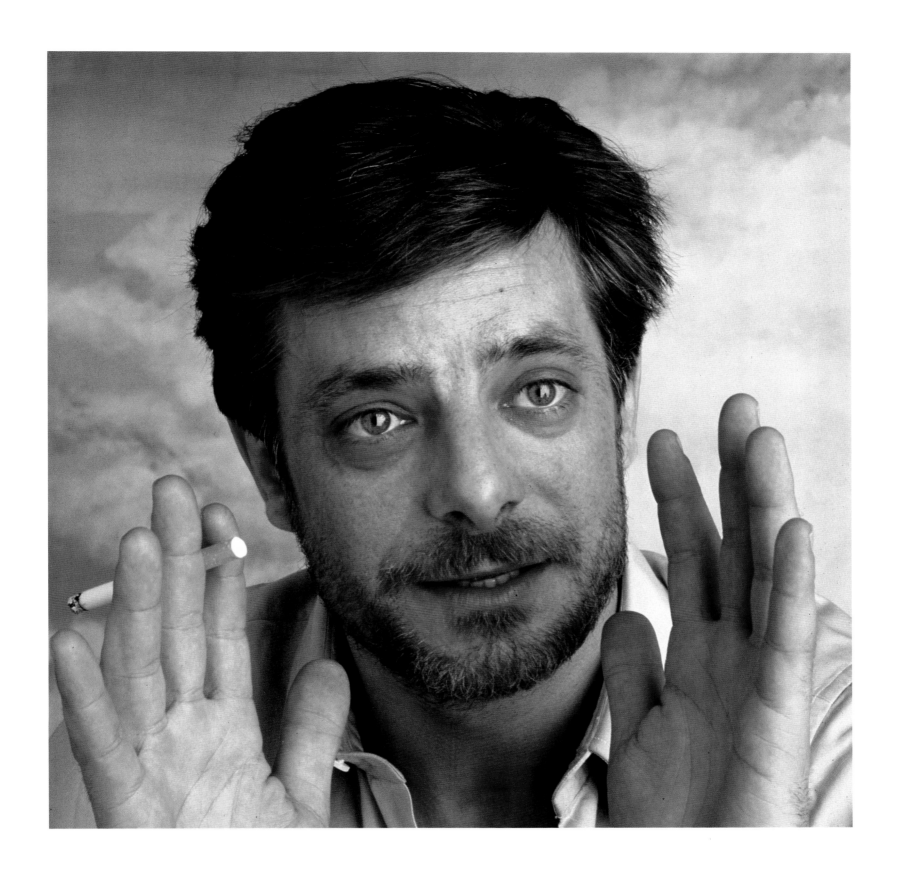

GIANCARLO GIANNINI, NEW YORK, 1976

Time magazine assigned me to photograph the Italian actor Giancarlo Giannini, who was in town with the film director Lina Wertmüller. It was around the time when the movie *Seven Beauties* was out. They came to the studio and I photographed Giancarlo and we became friendly and had dinner together. The next day they show up at ten o'clock in the morning and they want to see the pictures. So we showed them the photographs and we took some more photographs. And it seems for the three or four days they were in New York they were always dropping in the studio. We showed them around the city and we had a good time together. But the magazine didn't run the photographs.

TENNESSEE WILLIAMS, FOR *LIFE*, 1962

Another photograph from this series ran
with a *Life* magazine article on Broadway that
bemoaned the fact that there were no new
dramas that year by seasoned veterans like
Williams and Arthur Miller.

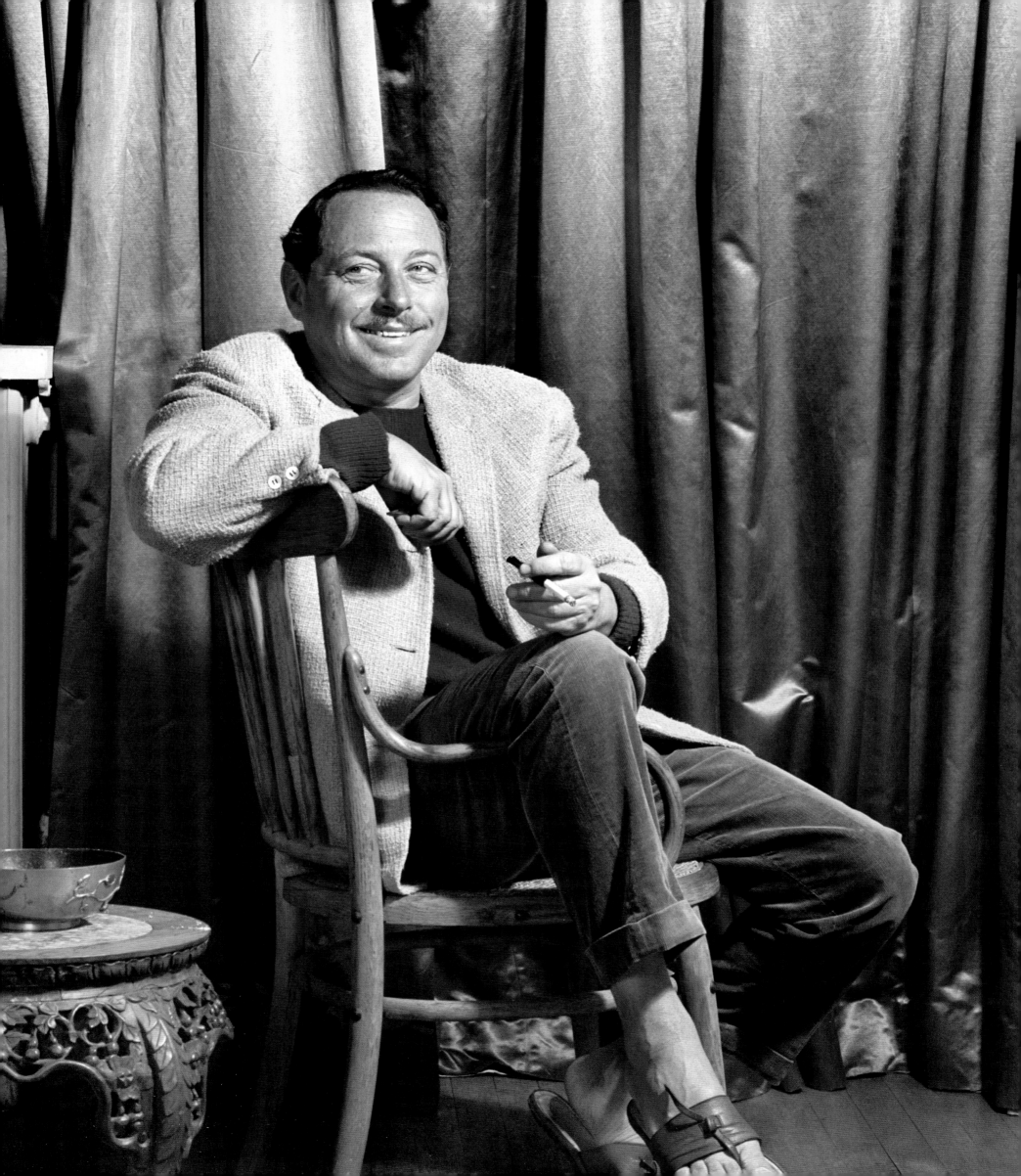

PRINCESS CHRISTINA OF SWEDEN, 1964

Time magazine gave me an assignment to photograph Princess Christina of Denmark. You get a "poop sheet" from the magazine that says who, when, and where and so on. She was attending Radcliffe College in Cambridge, Massachusetts, associated with Harvard. So I get there and I am trying to establish some rapport with the princess. I am thinking of all the Danish things or people I have known or photographed. For example, I knew Victor Borge, who was Danish. So then I meet the princess and she is probably about eighteen years old or so. I get her outside, it's one on one, just the two of us, even though she was very protected. It was only because I was from *Time* magazine that I was allowed to photograph her. So, she had a bike and we went around the campus and I am following after her taking pictures and talking about Victor Borge and other things, but I sense something is wrong, I am not getting through, whatever it may be. We finished the shoot, had a soda and a sandwich and we were chatting and I said, "I have got some nice shots, I would like to send the best ones to you. Where shall I send them?" She said she was going to be home for vacation in a couple of weeks and I could send them to the royal palace. I said, "Gosh, I know you have so many around the country, which one shall I send it to?" She said, "Send it to the one in Stockholm." *Time* had given me the wrong information. The Princess was from Sweden. I should have realized when she saw my Hasselblad and said, "My brother has a Hasselblad; you know Hasselblads are made in Sweden."

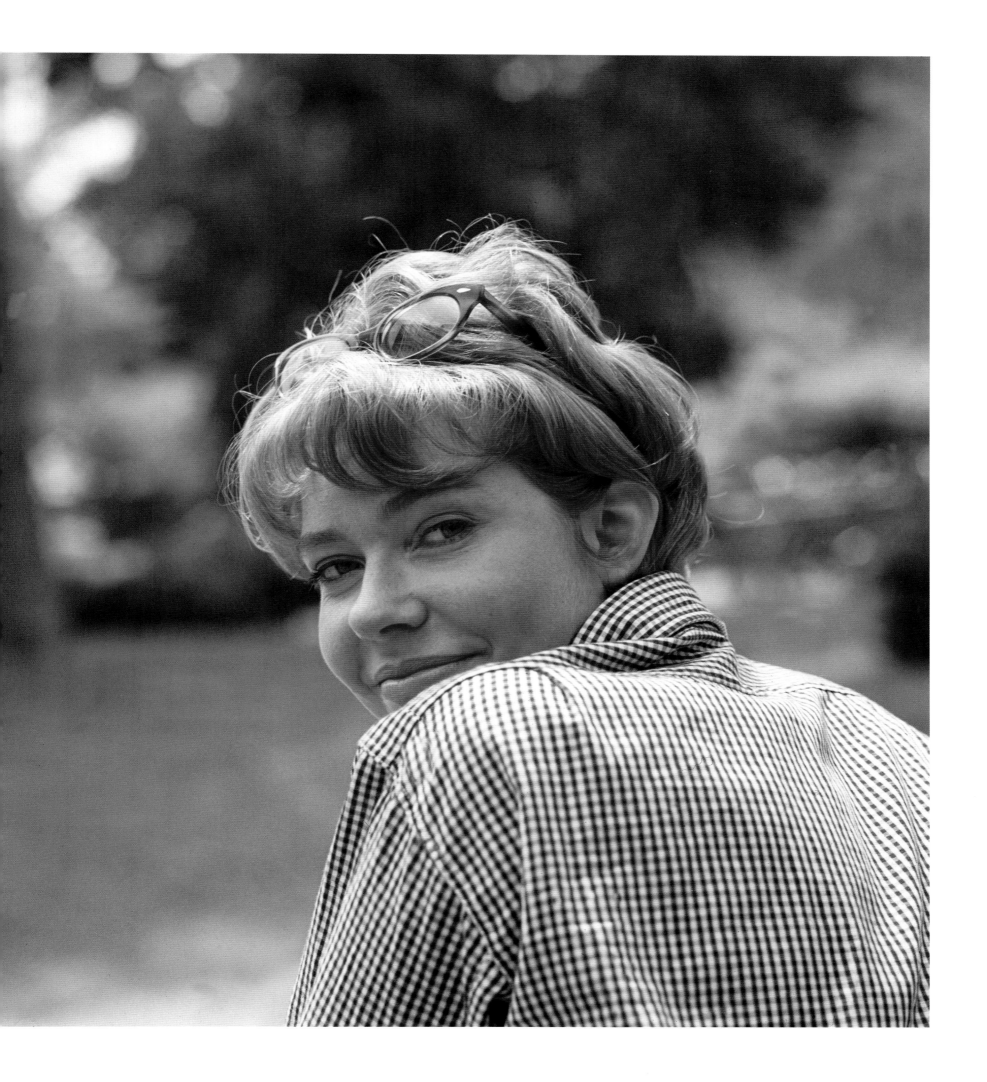

LIZA MINNELLI AT THE HALSTON BOUTIQUE, MADISON AVENUE, NEW YORK, 1968

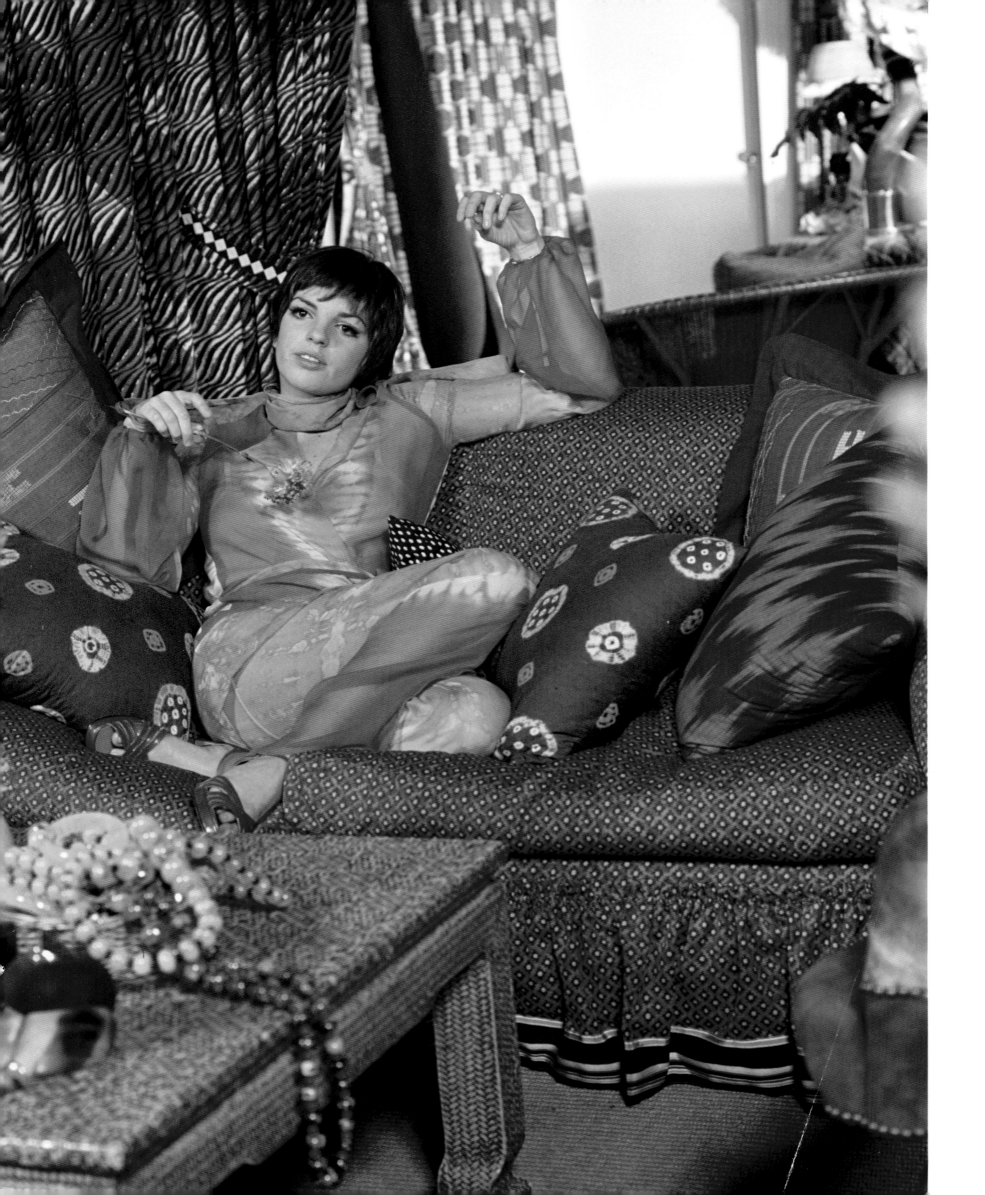

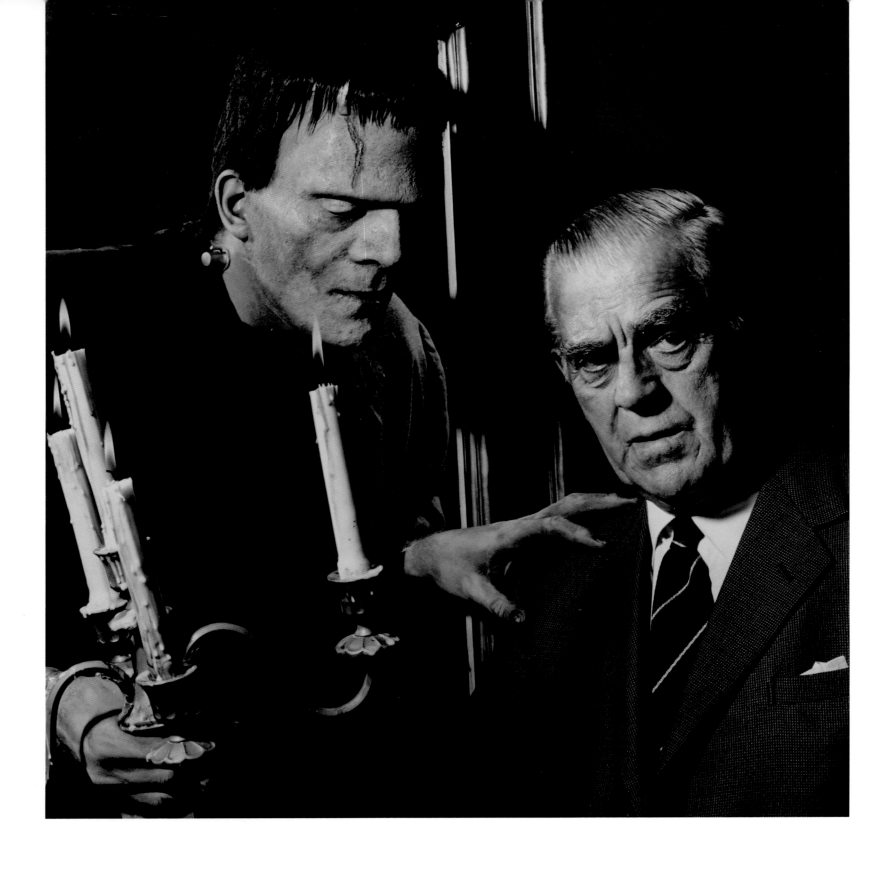

BORIS KARLOFF, 1960s

RIGHT: FRANK LANGELLA IN *DRACULA*, FOR *NEWSWEEK*, 1979

Frank Langella was on Broadway in *Dracula* and the play was a big success and getting a lot of attention. *Newsweek* wanted to do a cover. So we copied the background with the bats in the studio and scheduled an appointment for him to come over. Usually the appointment is made and then costumes are sent over and the subject arrives and is made up and puts on the costume and we take the picture. Well, the doorbell rings and in walks Frank Langella as Dracula. He came over in a taxi in character. So, here is Dracula walking into my studio and he said, "Ormond, Mr. Gigli, please don't make me look so gruesome. I want to look nice. I don't want to look gruesome."

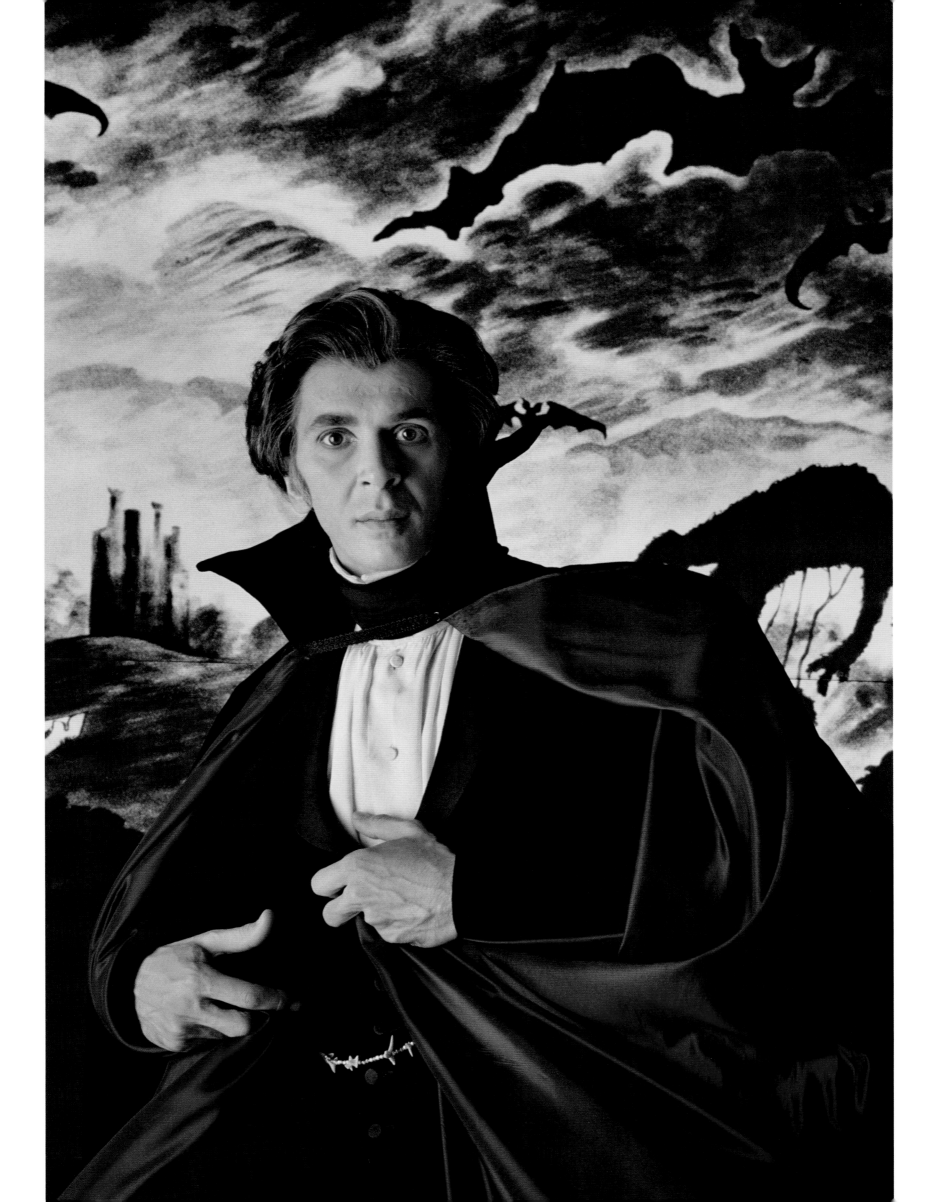

ARNOLD SCHWARZENEGGER, MR. UNIVERSE, 1976

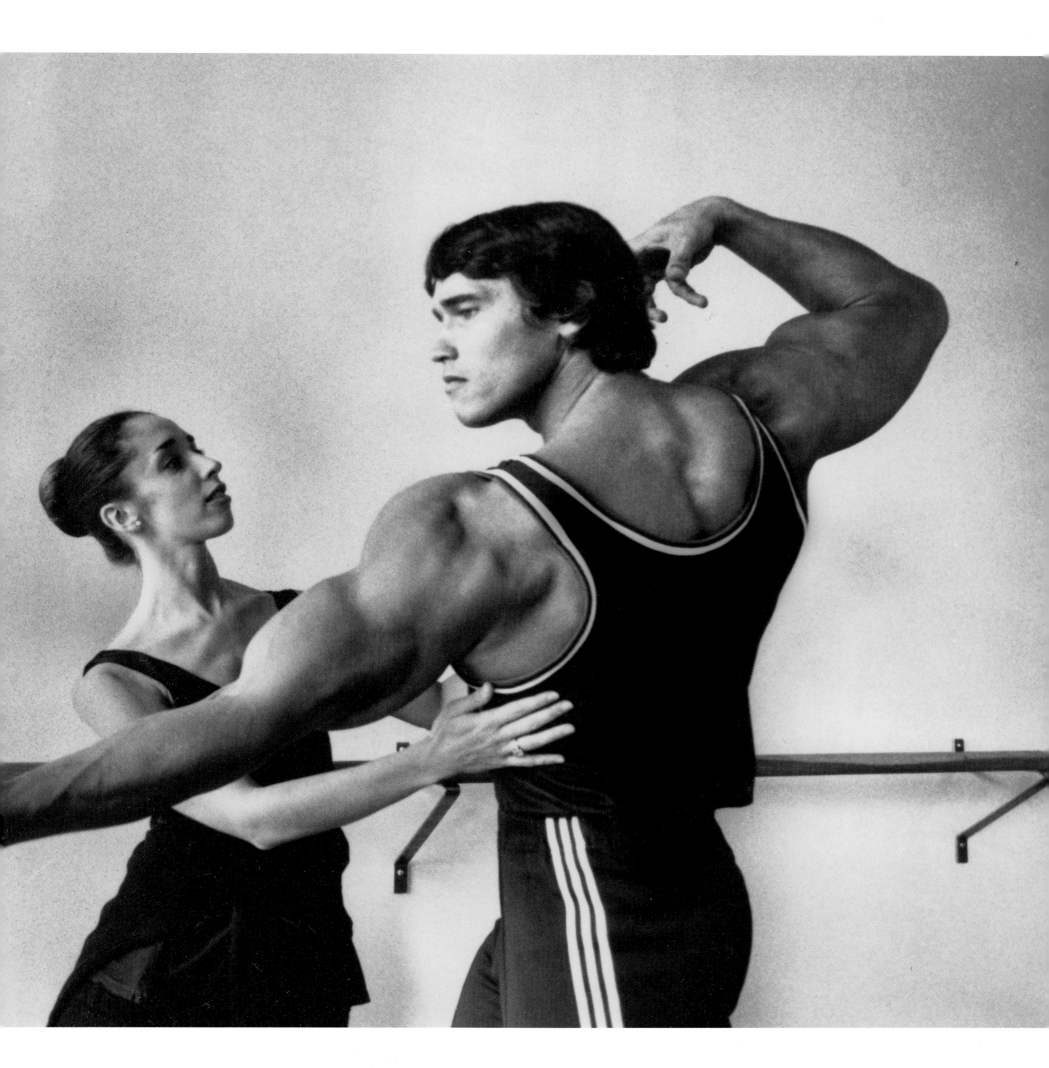

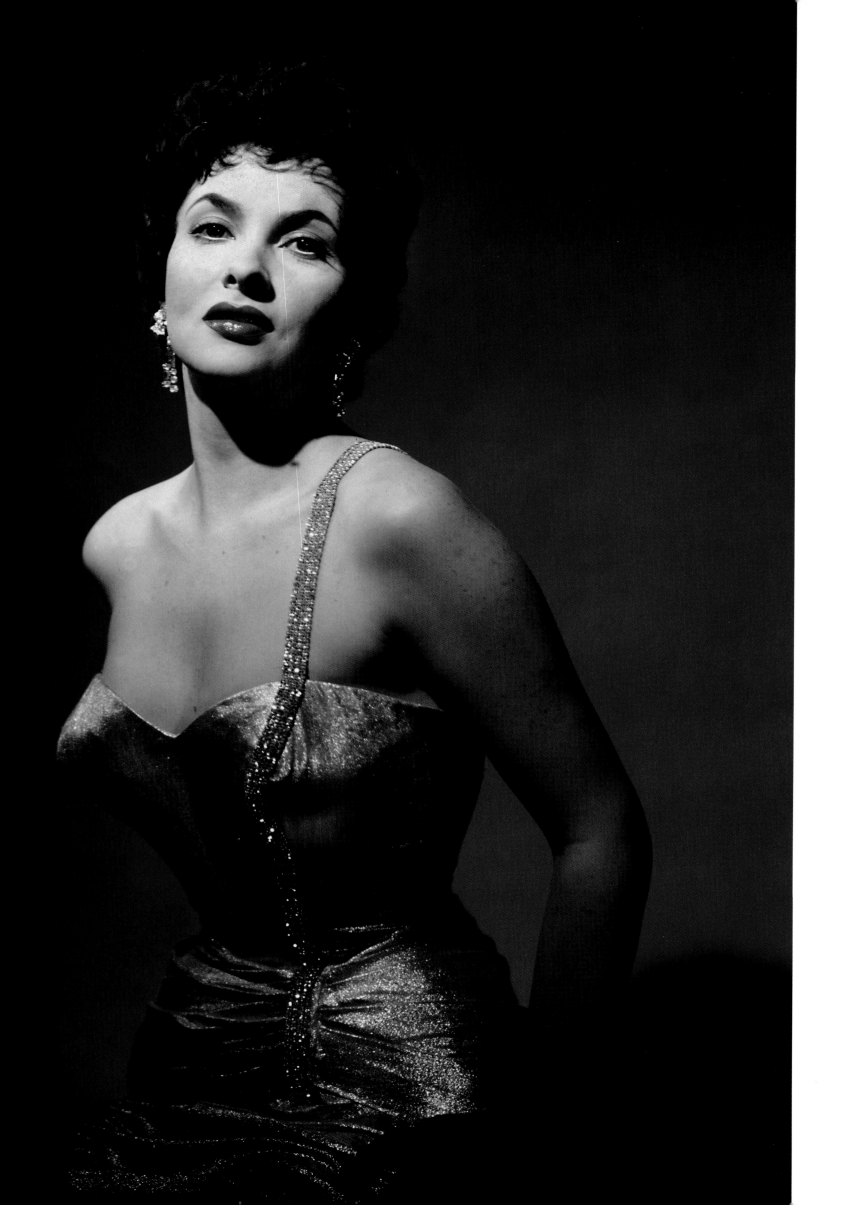

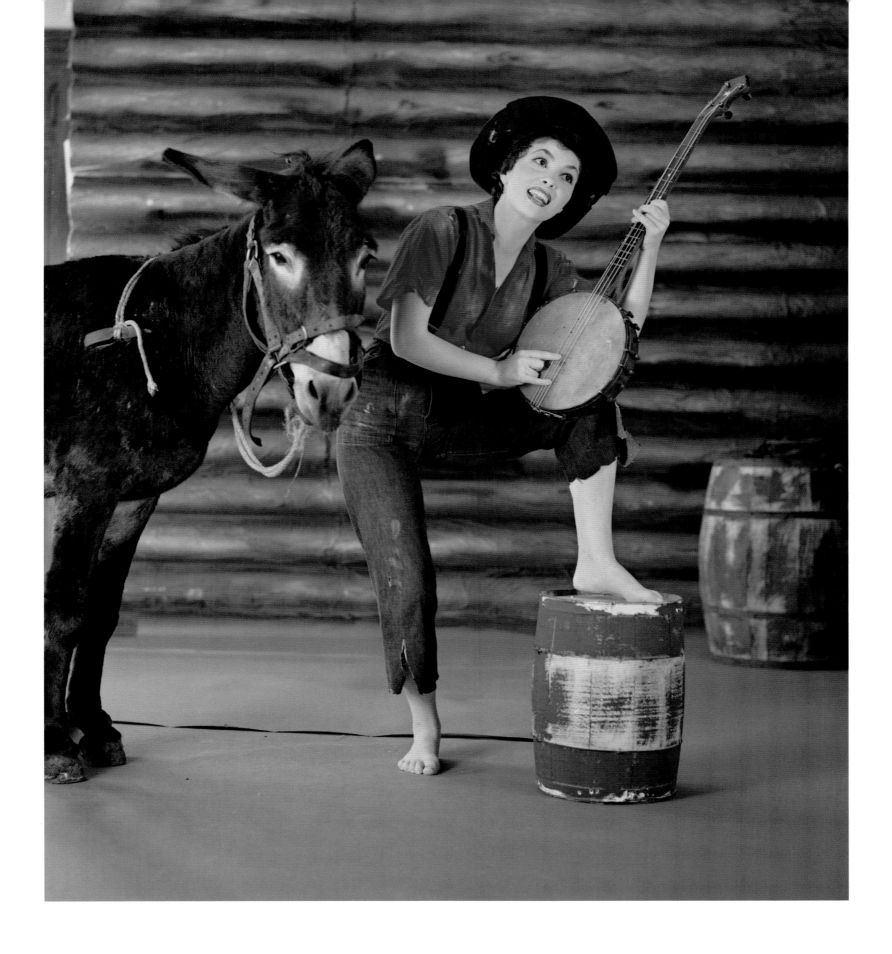

GINA LOLLOBRIGIDA, NEW YORK, 1955

What can you do differently when you have
a beautiful Italian star who has been
photographed innumerable times? I suggested
to *Collier's* that since Gina Lollobrigida was
in New York, I would like to take an original
approach to the sex symbol. *Collier's* was not
at all convinced until they saw the results.

I decided to make Gina into an American
hillbilly. My studio would become a hay-filled
log cabin, and Gina would wear a red blouse,
suspenders, shortened jeans, and play the
banjo. She loved the idea and assisted
with the design. She even posed with a mule
I managed to get up to the studio.

181

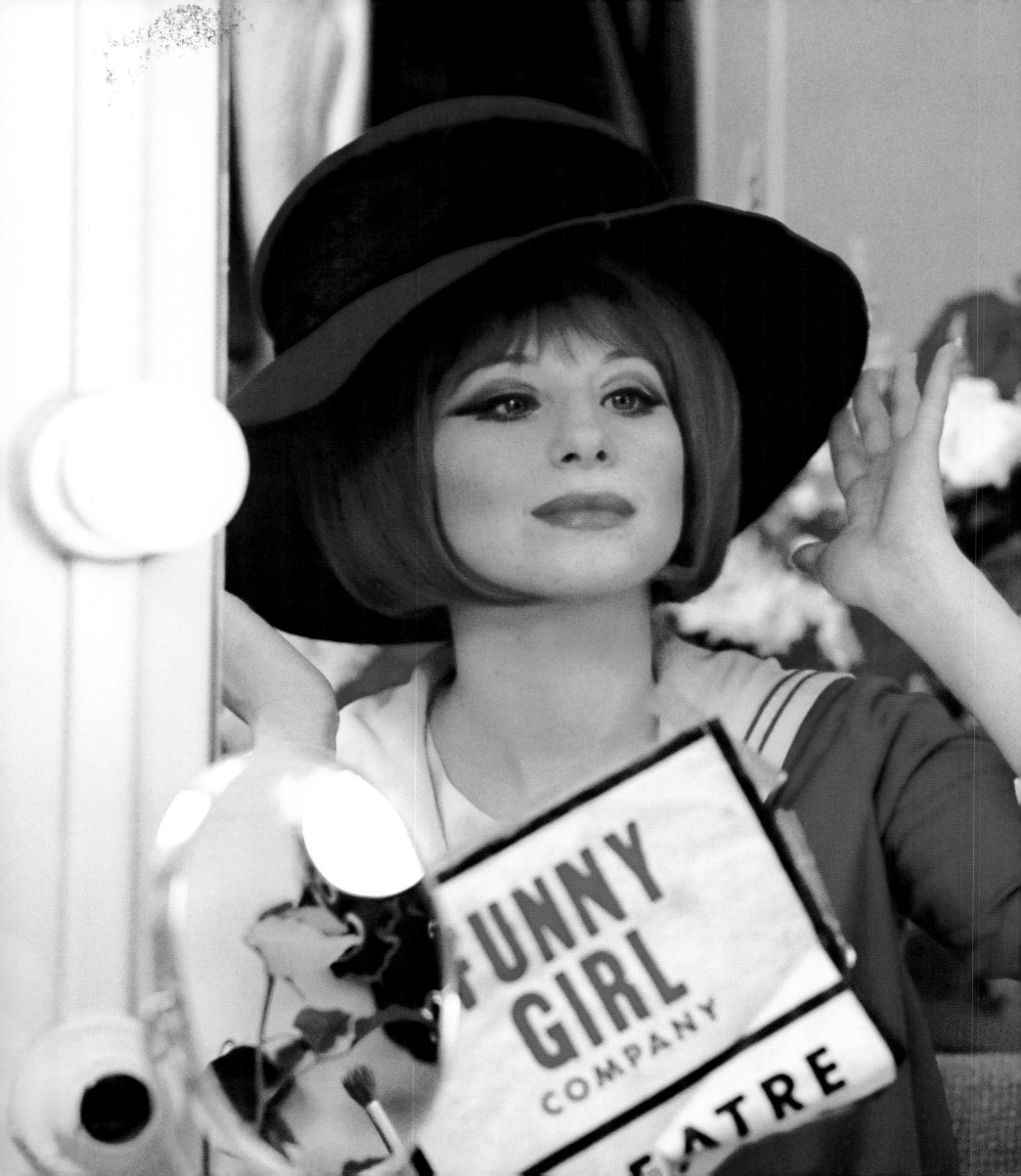

BARBRA STREISAND IN *FUNNY GIRL*, FOR
"THE GIRL," *TIME*, 1964

After photographing Barbra onstage with the
full cast for two hours after the performance–
until one-thirty in the morning–I then
photographed her in her dressing room. When
we finished, she said, "Let's have a bottle of
champagne." Then she announced, "Now I
have to leave for my party, two hundred
people are expecting me." I said, "Do you
think they'll still be there at this hour?" She
said, "They'll be there!"

JOANNE WOODWARD, 1958

I never took paparazzi shots, but I was in
a restaurant or café somewhere and she
was sitting there, and I took her photograph.
I don't know if she was annoyed or lost
in thought.

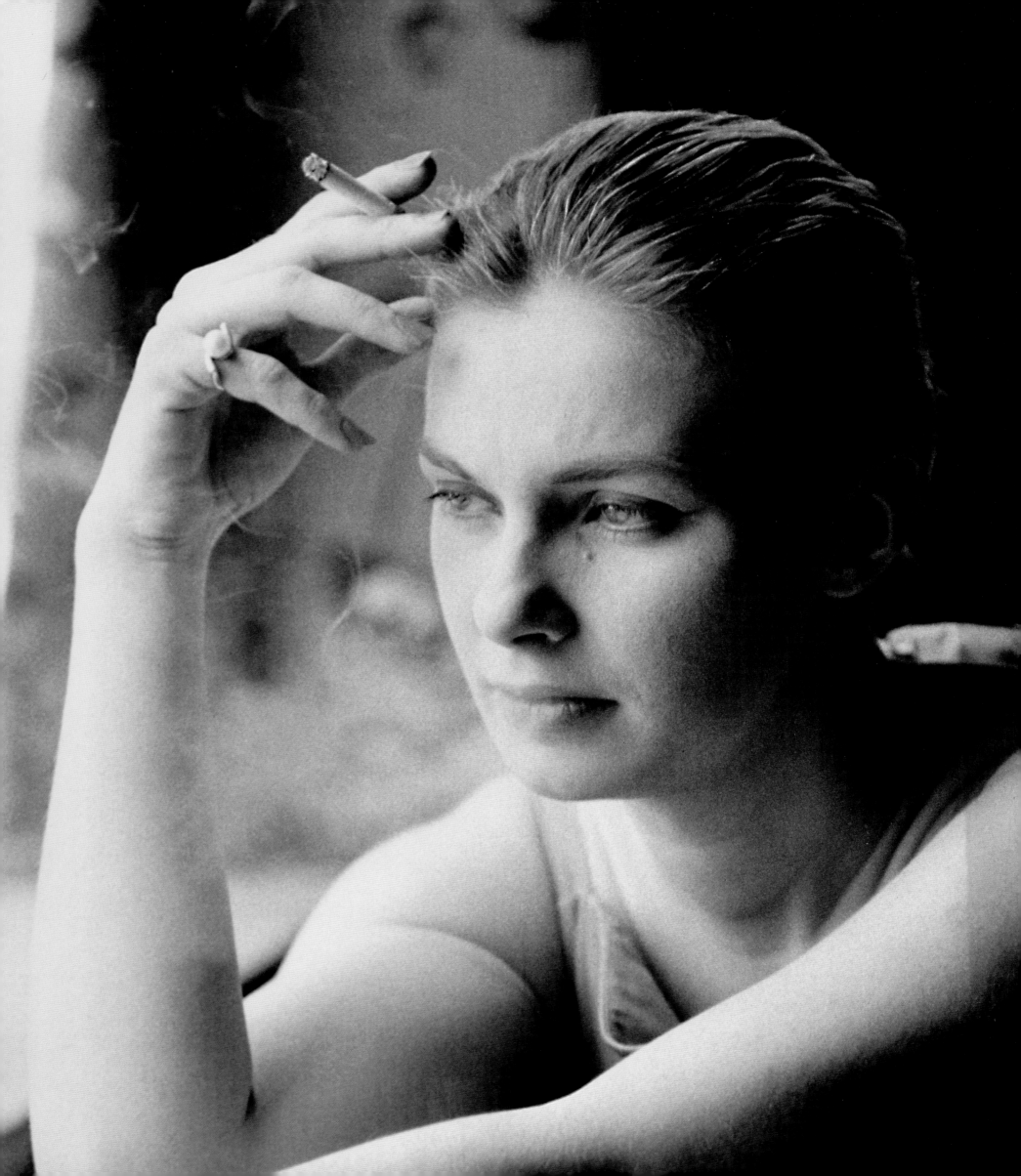

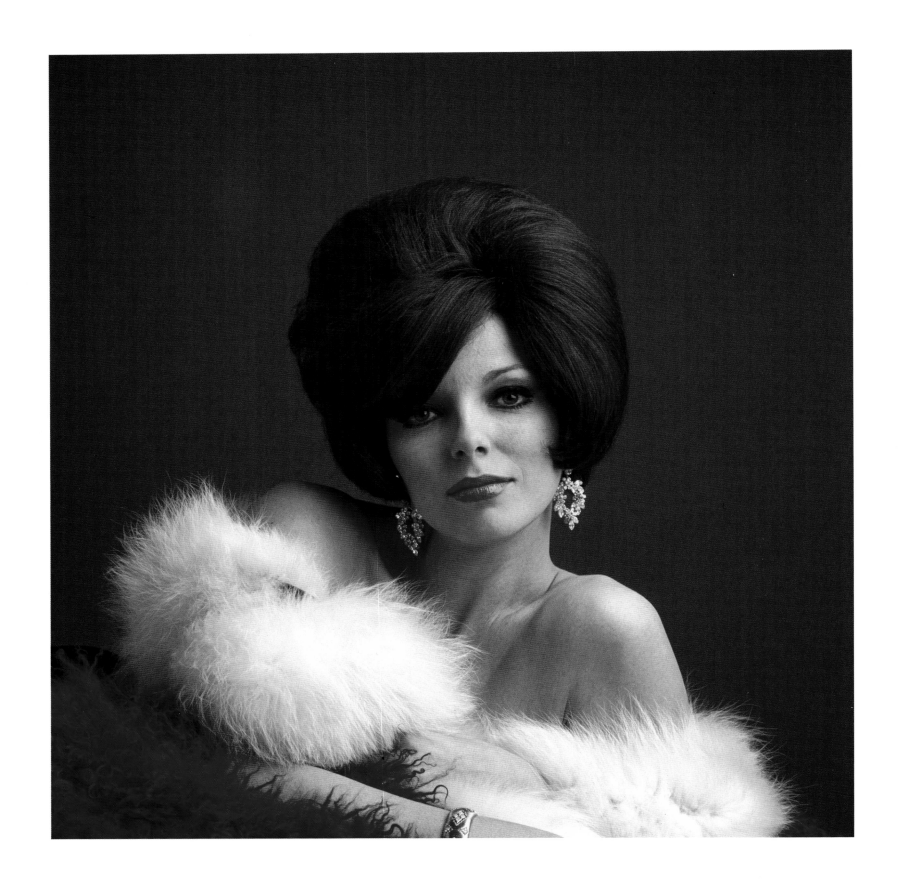

JOAN COLLINS, 1965

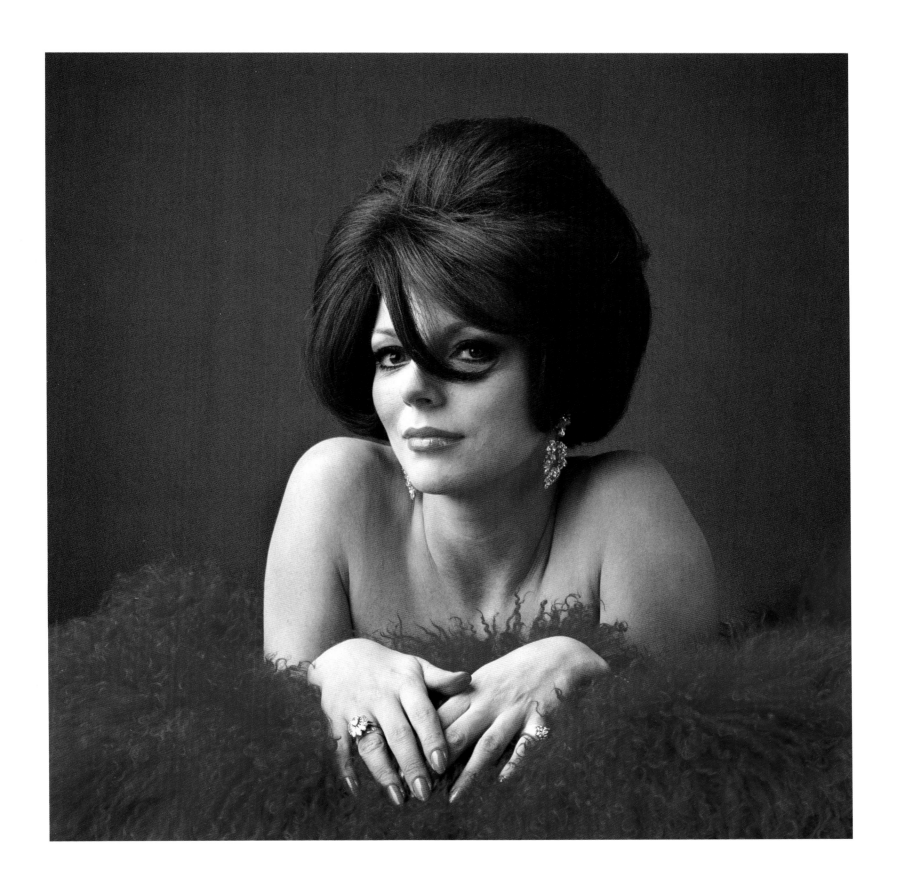

LAURENCE OLIVIER AS TATTLE IN
CONGREVE'S *LOVE FOR LOVE*, LONDON,
FOR "A RICHNESS OF TALENT," *TIME*, 1966

Working in the theater in England just seemed
so much easier than working in the theater in
New York. I'd say I photographed at least three
times at the Old Vic and at film studios,
and there was always 100 percent cooperation
by everyone from the lighting people to stage
managers. Of course, I had very good
credentials by the mid-1960s. When I first met
Sir Laurence Olivier he was working on the
film *Khartoum* opposite Charlton Heston.
Olivier played the Mahdi, the Muslim leader in
the Sudan, and Heston played General Charles
Gordon. I walked into the studio and it was
like I was an expected guest. Olivier was on a
white horse in full makeup and costume, and
the director, Basil Dearden, greeted me by
name and introduced me to Olivier and then
said, "Now, what can we do for you?" It was
very welcoming and they showed me all over
the sets. I took many photographs of Olivier as
the Mahdi. He was very masculine and
intimidating in character. I photographed him
two days later with the National Theatre in the
Old Vic. He was playing a totally different
character. I was in his dressing room
photographing him as he was getting made
up and waving his handkerchief in a foppish
manner. His whole character changed to very
feminine, soft. I was amazed and said, "I
notice your whole demeanor is changing." He
answered, "Well, from knowing the part that
I have to play, as I start to put the makeup on,
I am that character; as the makeup goes on
and the costume, I am speaking in that tongue.
I am playing that role. And even though I
am being interviewed, I am that character."
This and other pictures were for an article
called "The New Elizabethans."

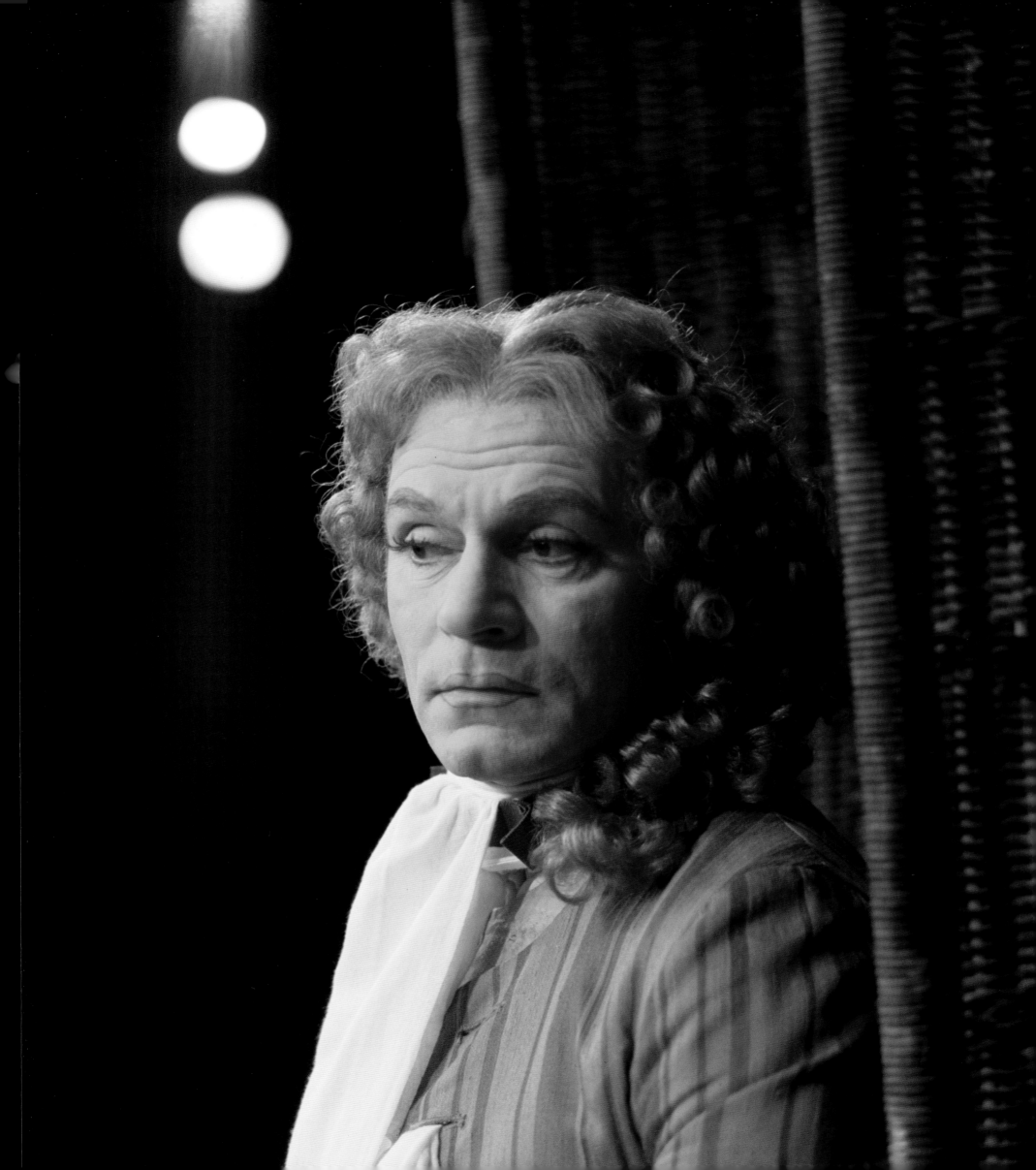

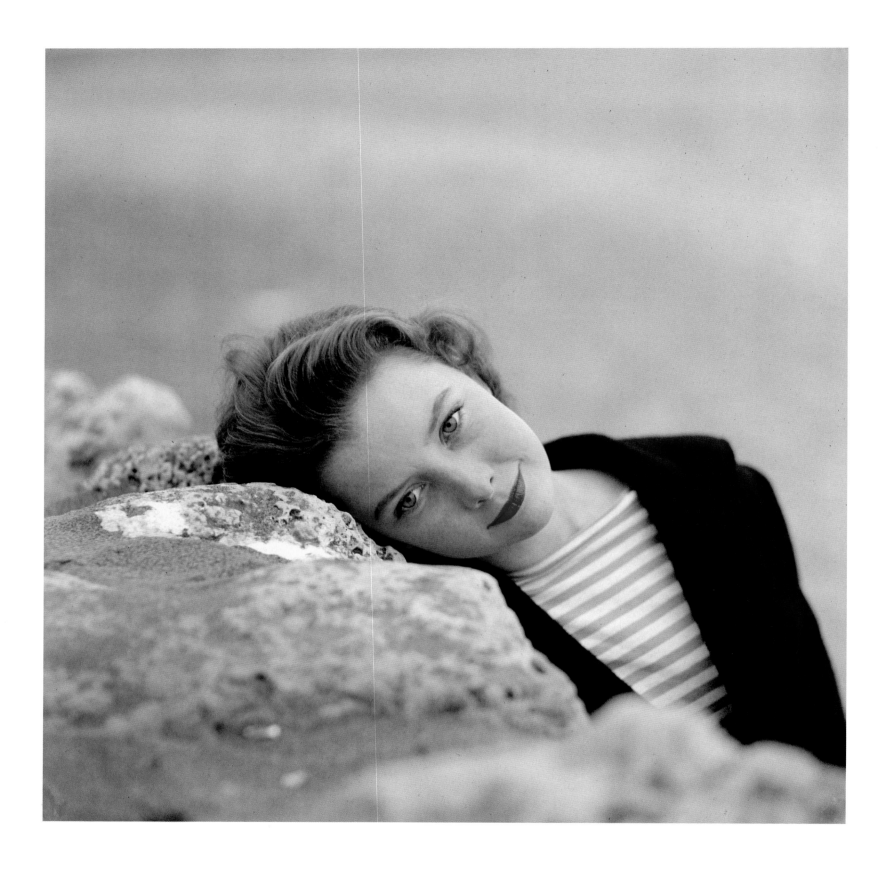

JUNE THORBURN, ISLE OF WIGHT, 1956

She had a peaches and cream complexion. A very attractive young lady. I had photographed her before and we had gotten to know each other. Later I received an assignment to photograph her for a magazine and I thought we should fly over to Ireland for the day to shoot. We left early one morning and came back late that evening. As we took off on the flight in the morning June grabbed my hand and squeezed it so hard and was absolutely terrified. Four or five years later, I was back in the States and read how she died in a plane crash. I wondered if the fear she felt when we flew together was a kind of premonition.

RICHARD HARRIS, LONDON, FOR *TIME*, 1966

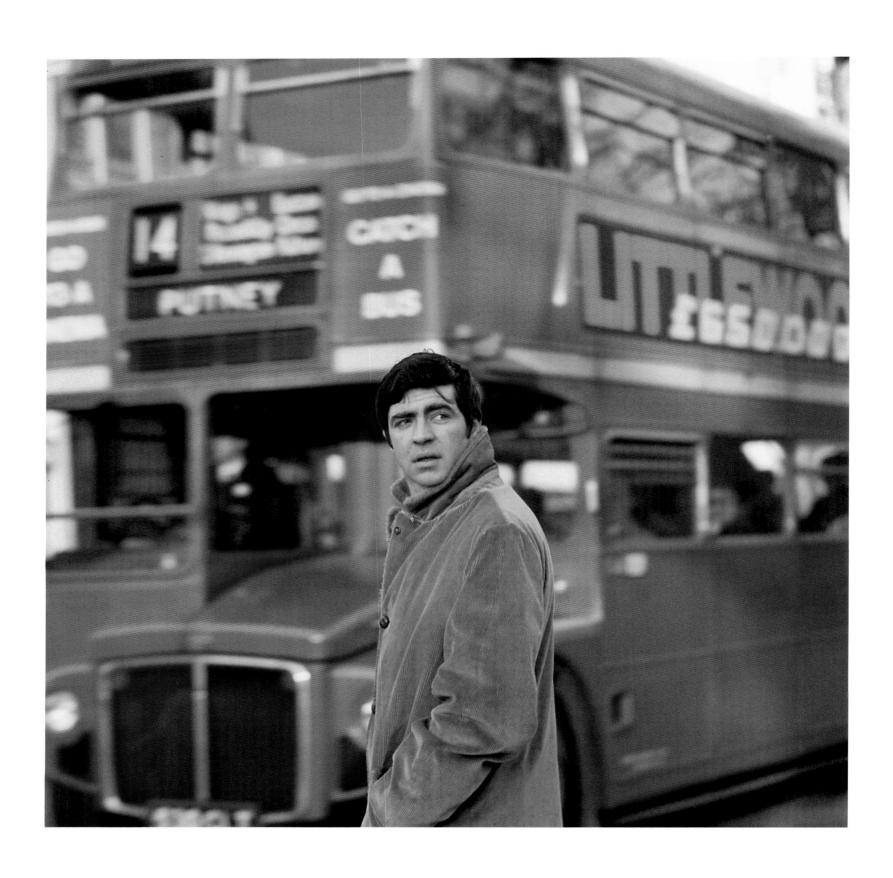

ALAN BATES, LONDON, FOR *TIME*, 1966

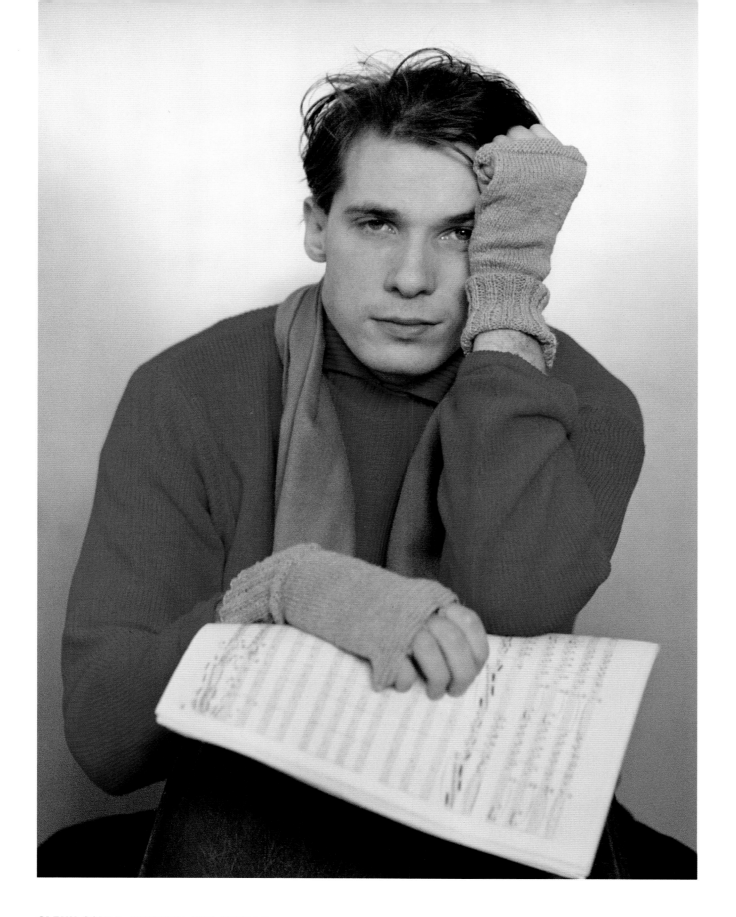

GLENN GOULD, DETROIT, FOR "CHILLY
GENIUS," *THE SATURDAY EVENING POST*, 1959

I photographed Glenn Gould for *The Saturday Evening Post*. I used to do a lot of work for them. They had a series called "The Face of America," which was a two-page spread, one photograph. Sometimes they picked a stock photo, but very often I shot it for them. They sent me to photograph Glenn Gould, the concert pianist, in Detroit one winter performing with the Detroit Symphony Orchestra. I went out there and met him while he was rehearsing. He was playing wearing wool gloves with the fingers cut off. I went to shake his hand and he pulled his hands back. He didn't shake hands with anybody. And his clothes hung from him, too long, too much cloth. It was strange. I photographed him in his tuxedo as well and even that didn't fit him. It seemed he could easily get tangled up in his clothes.

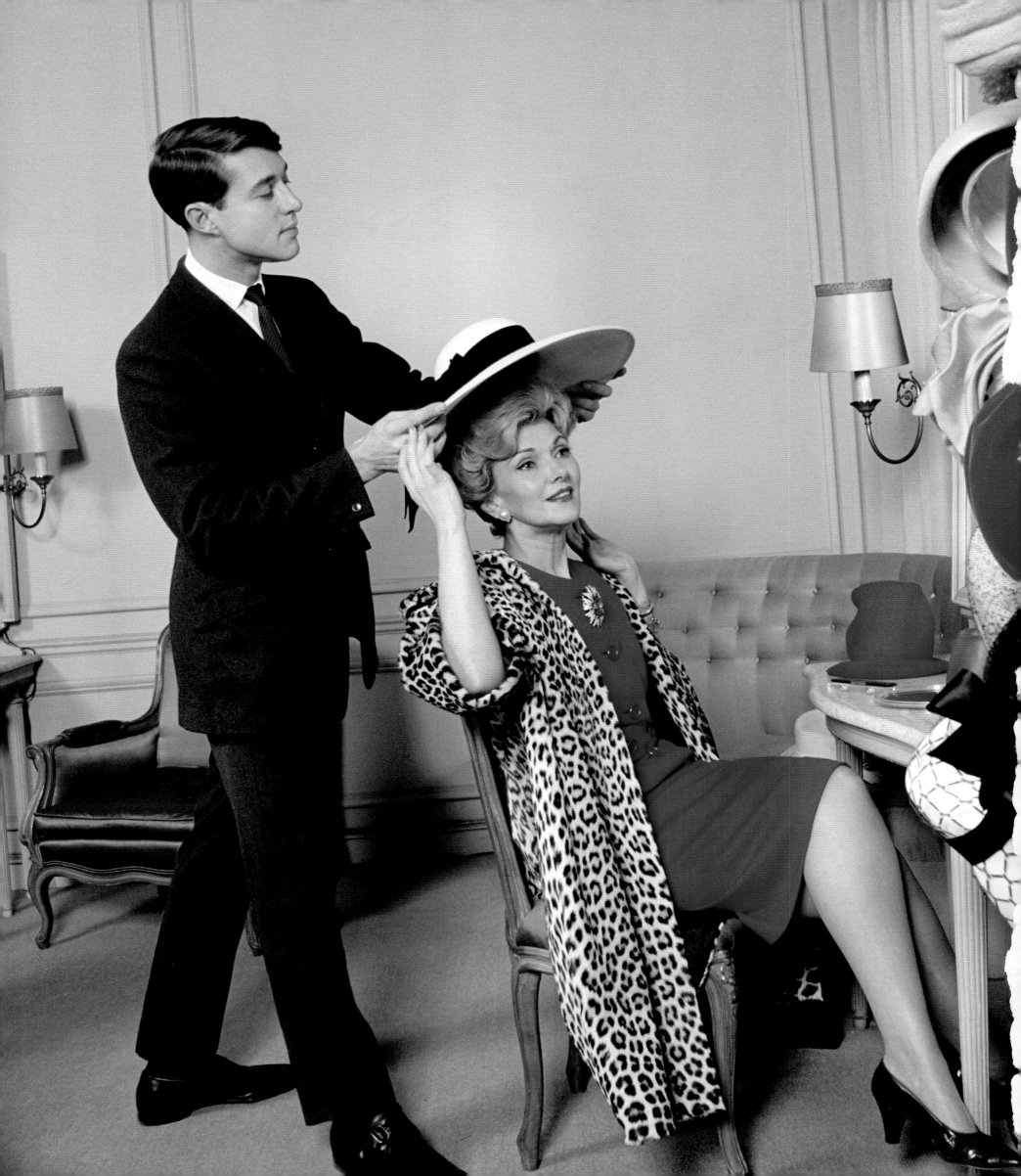

HALSTON AT BERGDORF GOODMAN, FOR "POSH PLACE FOR FASHION," *THE SATURDAY EVENING POST*, 1962

WILLEM DE KOONING, FOR *TIME*, 1960

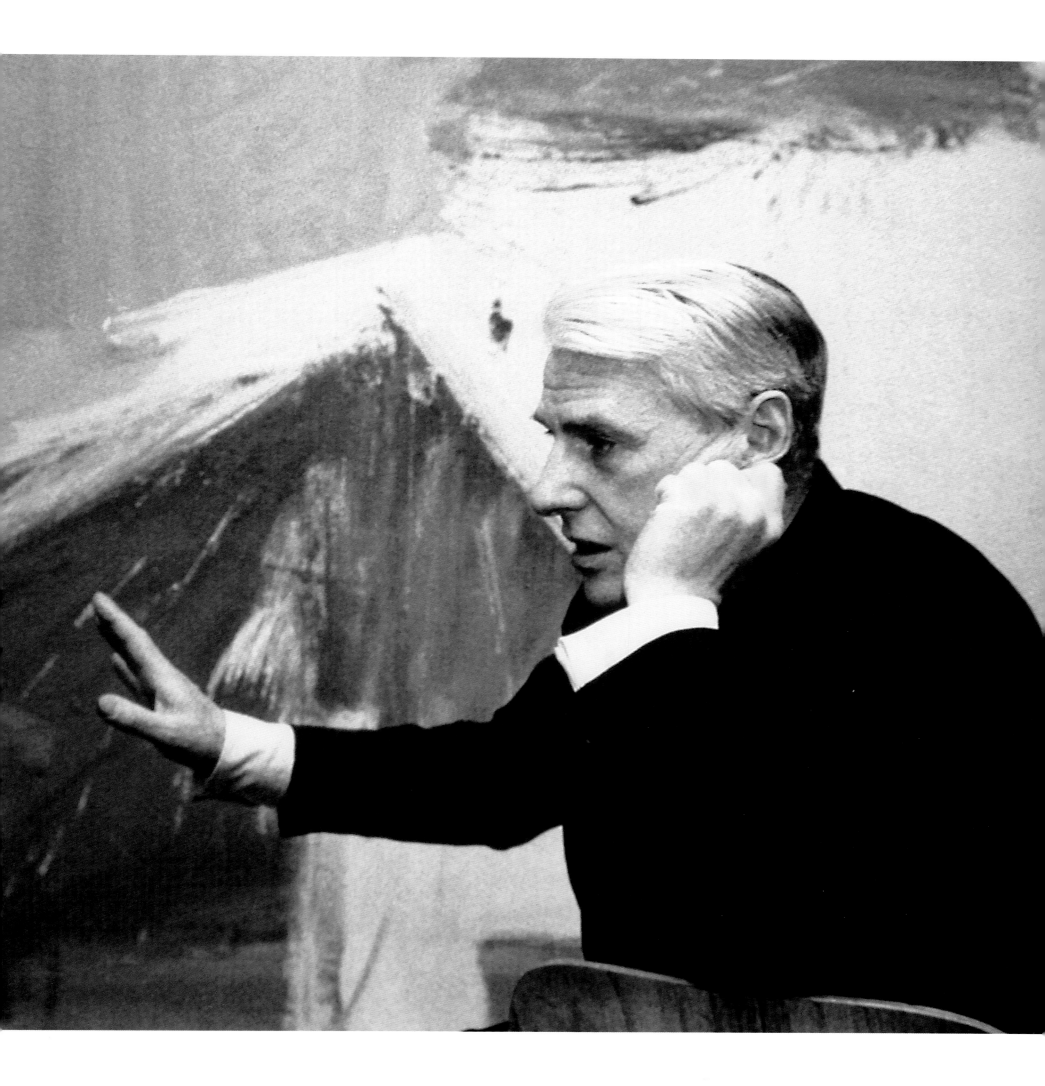

MARCEL DUCHAMP AND XANTI SCHAWINSKY,
NEW YORK, 1961

When I bought my building on East 58th Street
in New York, Marcel Duchamp, the great Dada
artist renowned for his painting *Nude
Descending a Staircase, No. 2,* had the entire top
floor. I had to get him out as I needed to divide
the floor into two apartments in order to get a
mortgage. While he really liked the apartment
and didn't want to leave, once construction
began, he left. Duchamp devoted his life to art
and playing chess. Having given up painting
and sculpture he made a living advising art
collectors, but spent most of his time at the chess
board. He was a good friend of Xanti's and
I took many photographs of the two artists at
their favorite pastime.

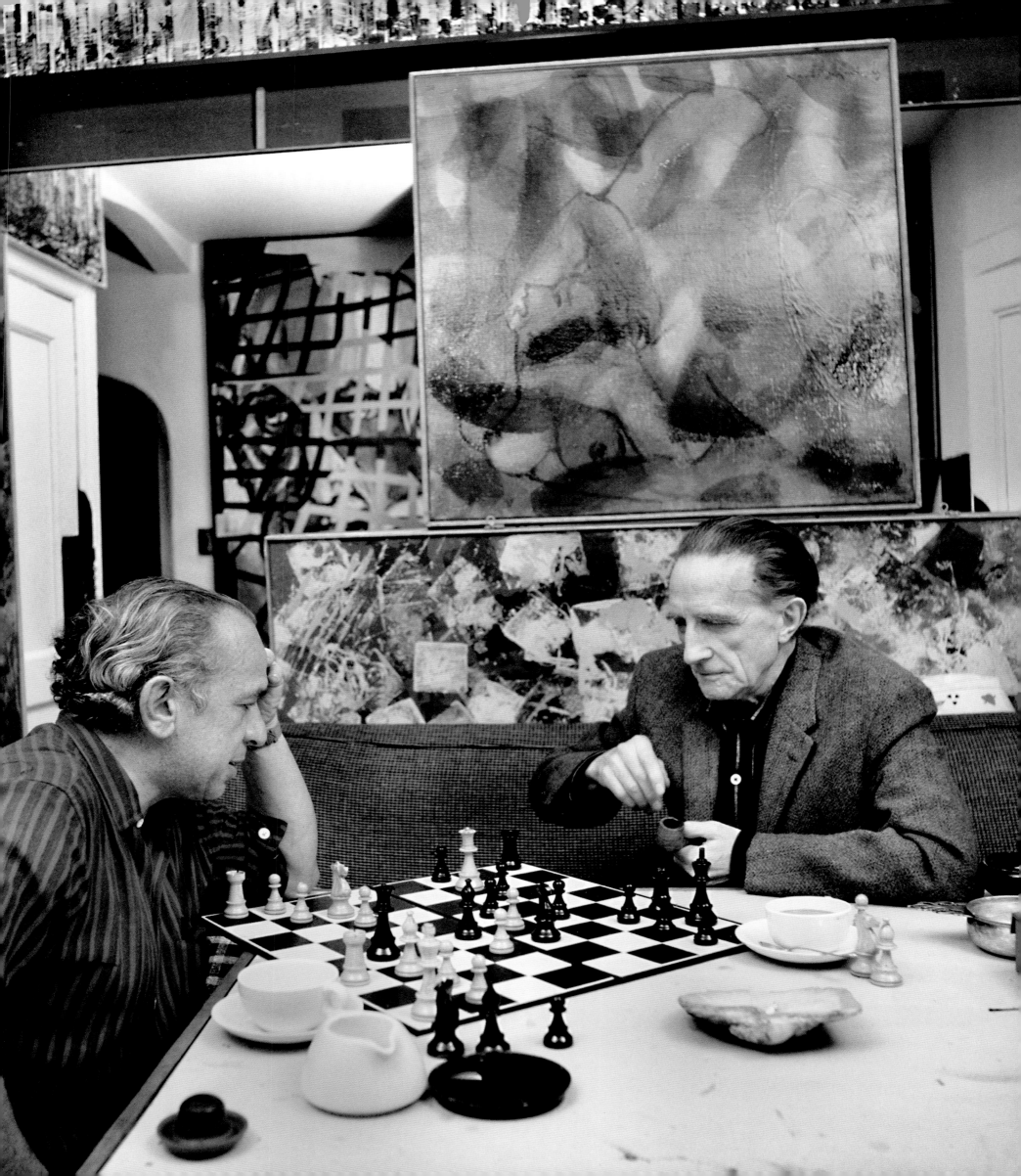

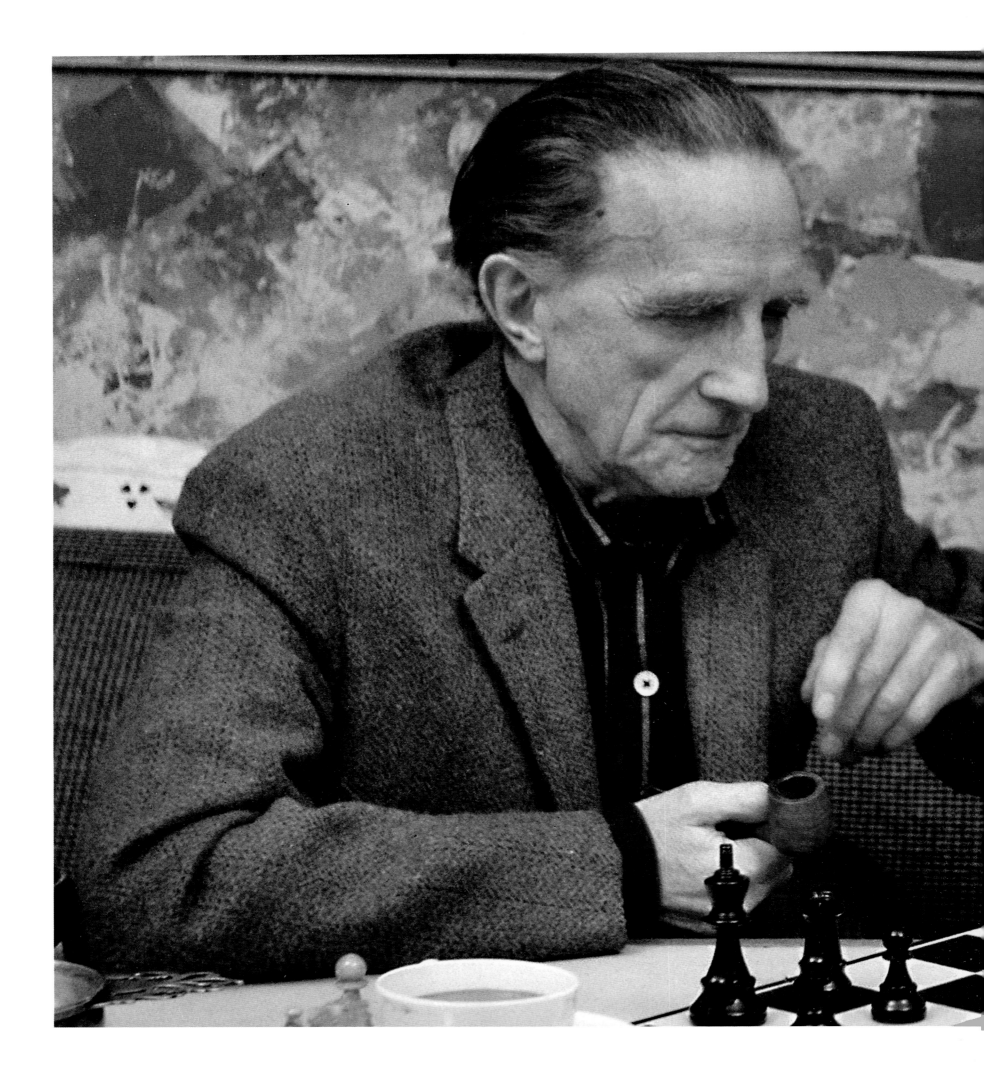

MARCEL DUCHAMP, NEW YORK, 1961

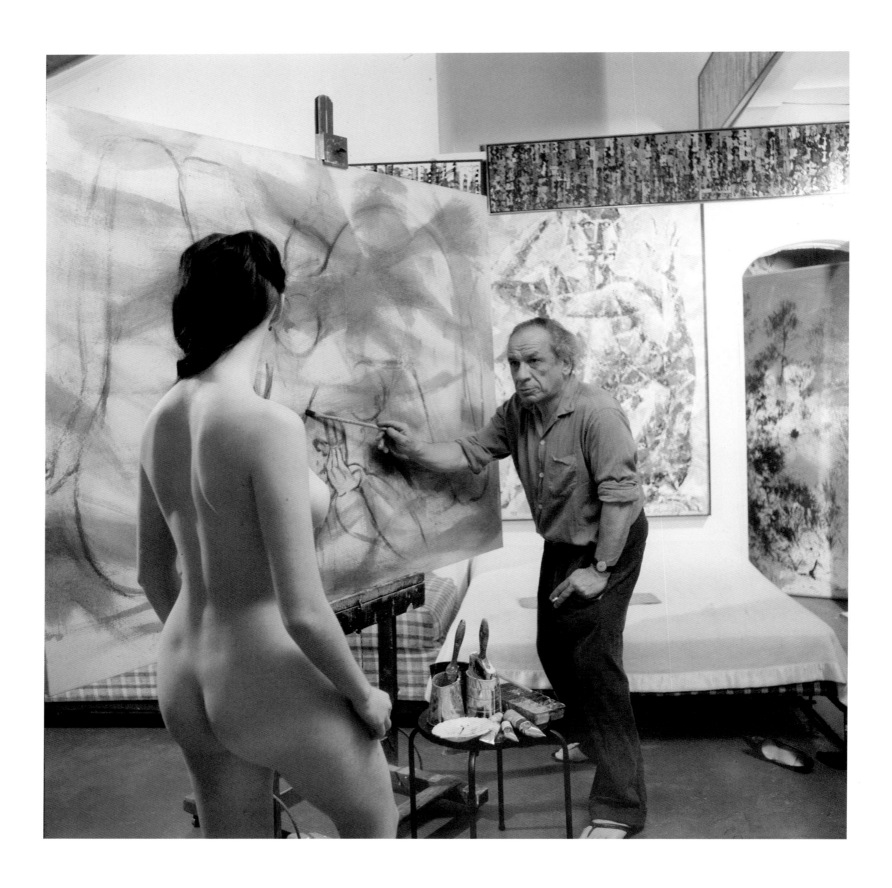

212

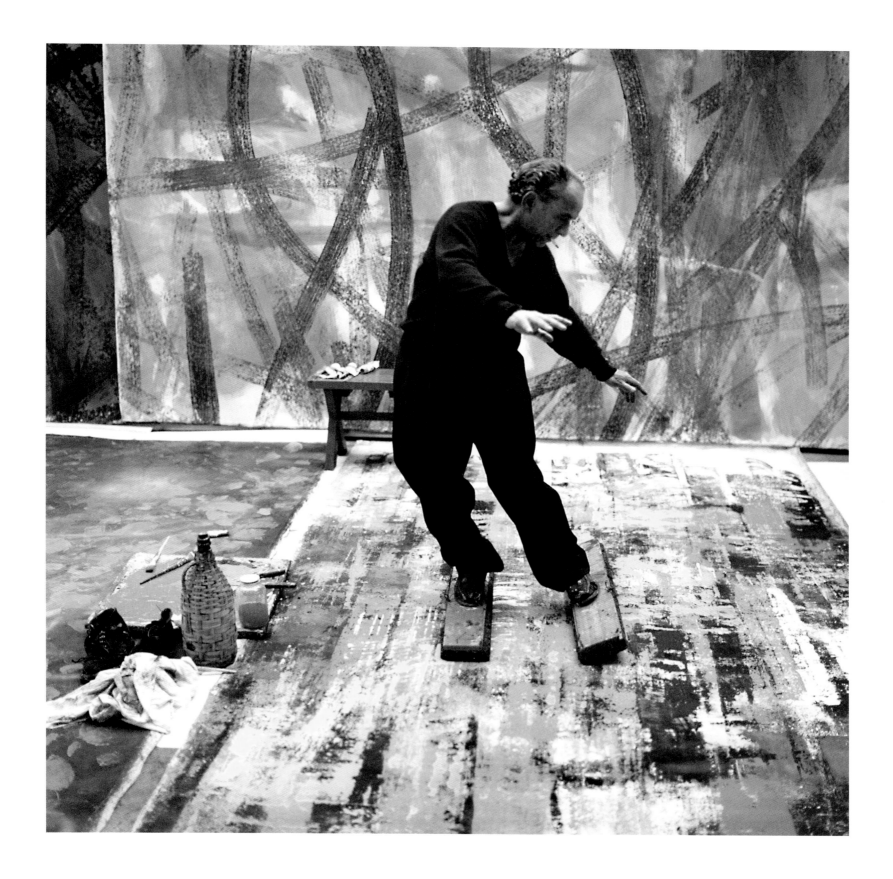

XANTI SCHAWINSKY, NEW YORK, 1961

In the 1960s I came across an artist with the memorable name of Xanti Schawinsky. He was a terrific artist and a bit of a madman; an exciting talent. I approached *The Saturday Evening Post* about a story on this guy making car paintings. He didn't paint cars, he painted using cars, driving over the canvases. He did some paintings with his feet. He was an original. Although in his sixties at the time, he had the vitality of a much younger man. He possessed a rare joie de vivre, finding beauty all around him. Aside from art, his great passion was chess. The *Post* titled the article: "He's Got Artistic Drive."

GIANNI VERSACE, 1978

214

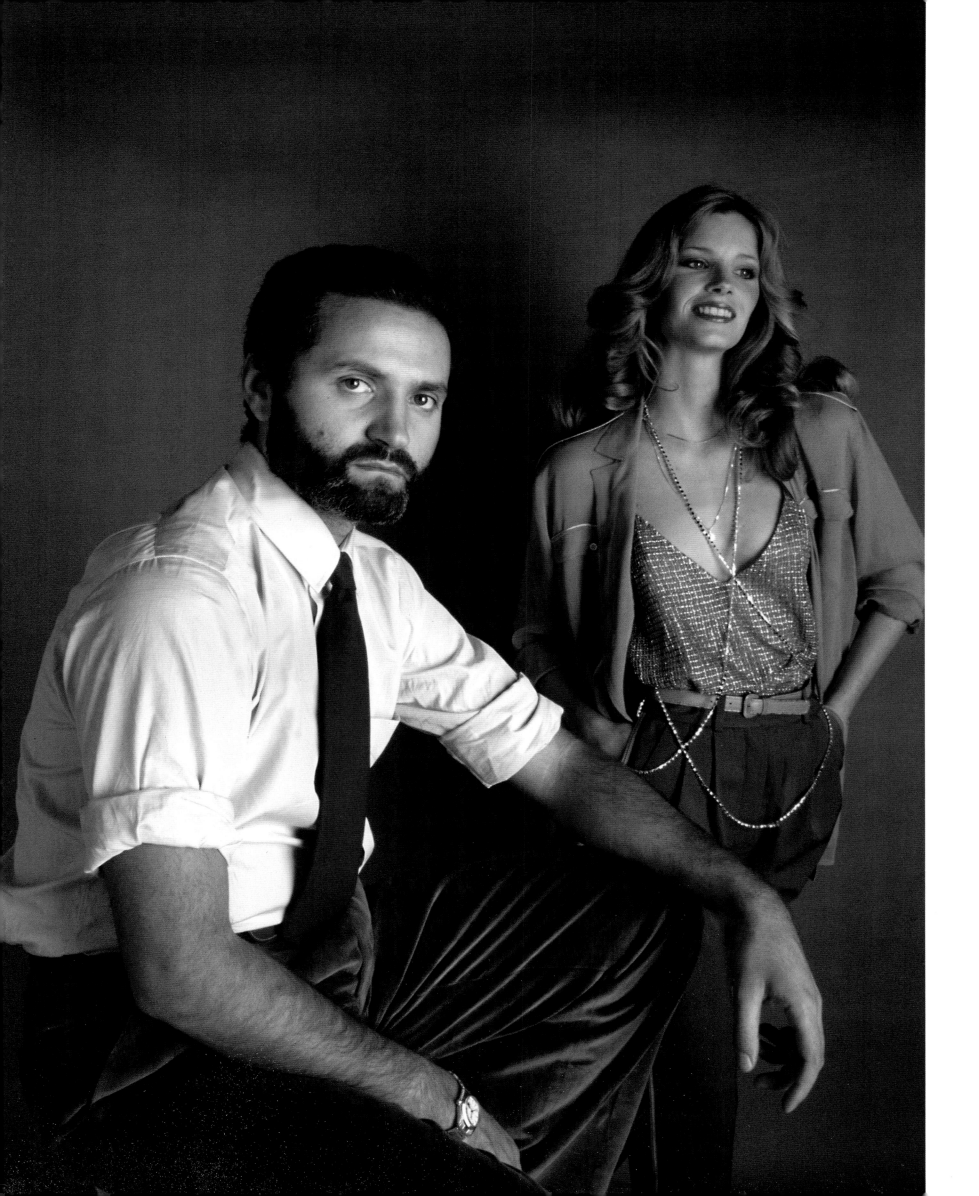

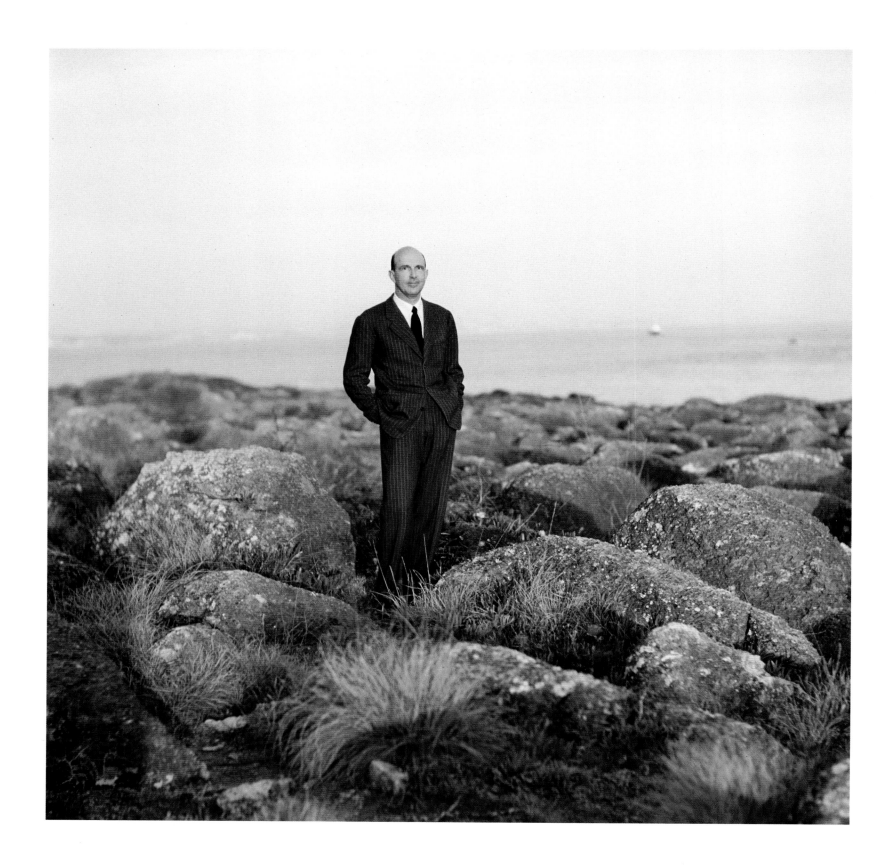

EX-KING UMBERTO II OF ITALY, CASCAIS,
PORTUGAL, 1960

I was in Portugal to photograph the exiled king of Italy. I thought this guy was in line with the Caesars. He had the perfect look, his nose, his features, his profile. A real king. He asked me to join him for dinner that evening. I said, "Your highness, I am pretty certain I can make it, but let me get back to the hotel first and check my messages, and then I will confirm." When I got back to the hotel I got a call from the *Time-Life* stringer asking if I would like to have dinner with two princesses. I said, "Which two princesses?" He said, "The daughters of King Umberto. Two lovely girls, in their twenties." I said, "Fine, just don't let the father know!"

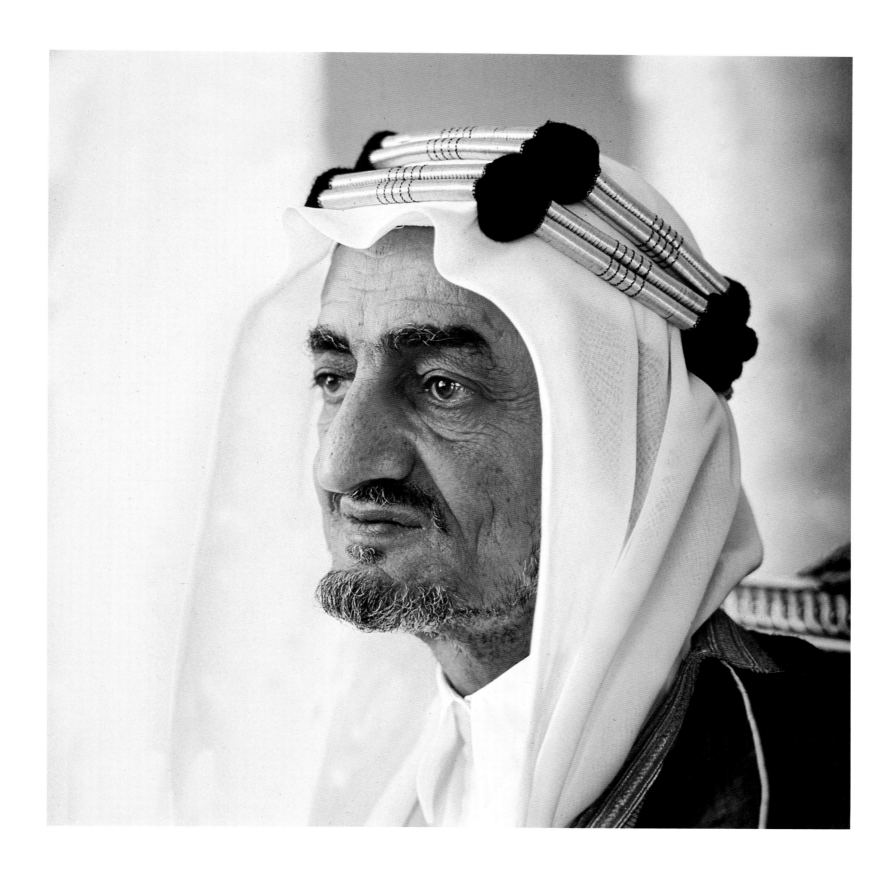

KING FAISAL, SAUDI ARABIA, 1964

Before I could travel to Saudi Arabia, I had to be checked out and was introduced to Prince Mohammed bin Faisal in New York. We had lunch several times at the Plaza Hotel where he stayed and became quite friendly. He came to the studio a few times and loved to see the models. The screening process took about a month. When I finally got to Riyadh, I was at an audience with King Faisal. He was sitting on an elegant chair outside the palace. All communication was through an interpreter, but I knew that Faisal spoke excellent English. It was our first meeting and at one point I walked up to the king taking meter readings and said, "Your highness, I was with Mohammed last week in New York and he sends his love and he said he will see you in a couple of weeks." Faisal says, "Oh good, how is he?" That broke the ice and from then on it was a delight.

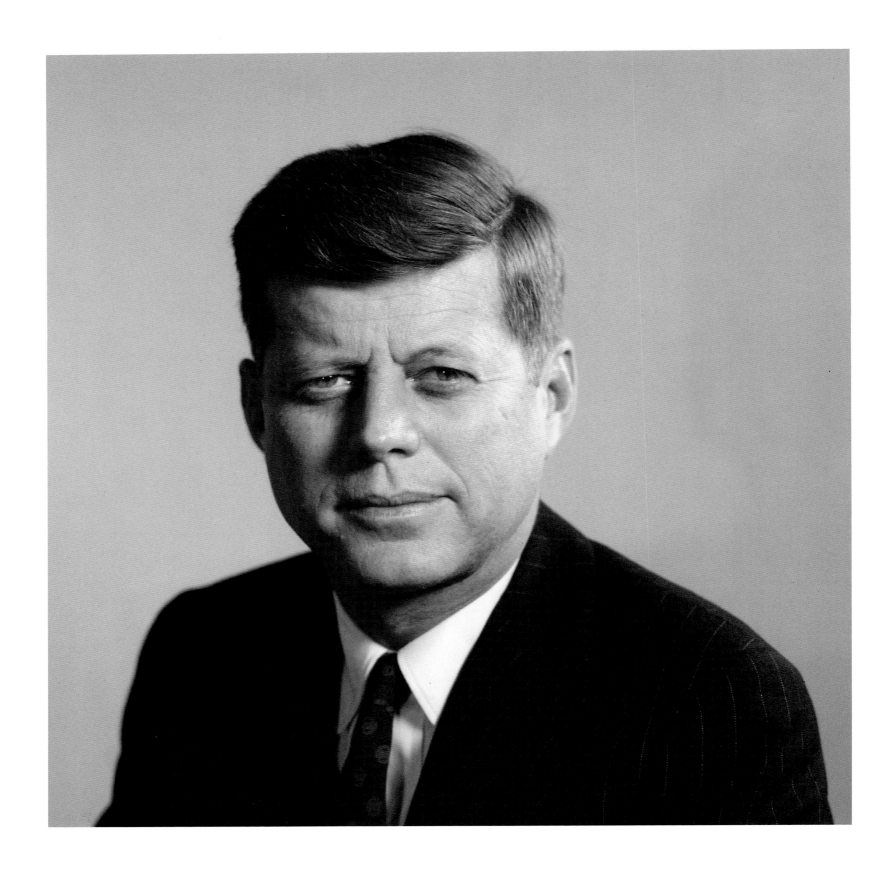

JOHN F. KENNEDY, 1961

I photographed Kennedy a few times. The first time was when he was in Hartford, Connecticut, about to announce the kickoff of his 1960 presidential campaign. Senator Kennedy was in his suite at the hotel trying to put a cabinet together, while I was trying to get some good pictures. I didn't use a flash so as not to disturb him. We had a steak and beer in his suite before he gave his speech. When I photographed him giving his speech I was surprised to see how nervous he was. We said good-bye afterward and then next time I photographed him it was in my studio after he was elected president.

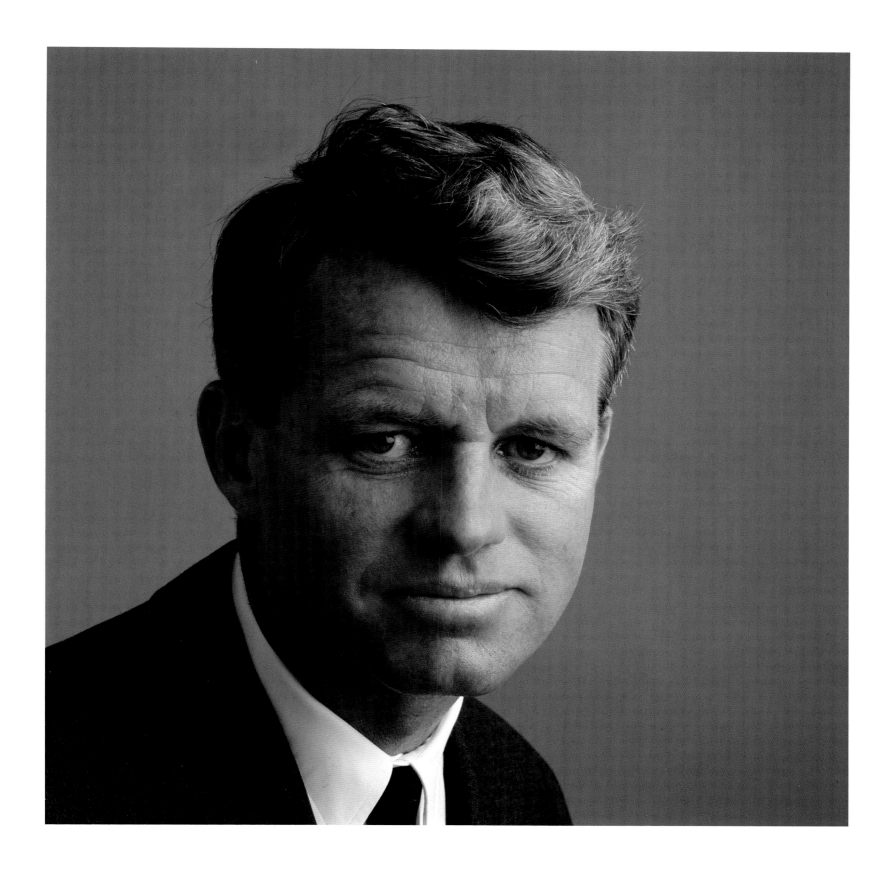

ROBERT F. KENNEDY, FOR *LIFE*, 1964

Life magazine assigned me a job to take some pictures of the attorney general, Robert F. Kennedy. I flew off to Washington on a Friday morning and spent two hours with him. At the end, I was packing my gear and mentioned that I was flying back to New York to go skiing with my family. He said he was going skiing, too. We were both heading for Smuggler's Notch in Vermont. I got there that night with my family, and he arrived with his family the next day. For one week we were skiing together and having dinner with the kids running all around. It was a madhouse, but great fun.

DESIGNERS ON THE UNFINISHED
PAN AM BUILDING, FOR *THE SATURDAY
EVENING POST,* 1962

This was for an article called "Breezy Designs
for the Office," on office design, and featured
various designers. We got permission to go
up in the as yet unfinished Pan Am Building
and arrange some furniture and take the shot.
The designers are, from left to right: Barbara
Dorn of Dorn Associates, Marvin Affrime of
Space Design Group, A.D. Aulicino of W. & J.
Sloane, William Raiser of Loewy Smith, Louis
Beal of Interior Space Design, John Caproni of
Caproni Associates, and Jack Freiden of
Frieden-Studley.

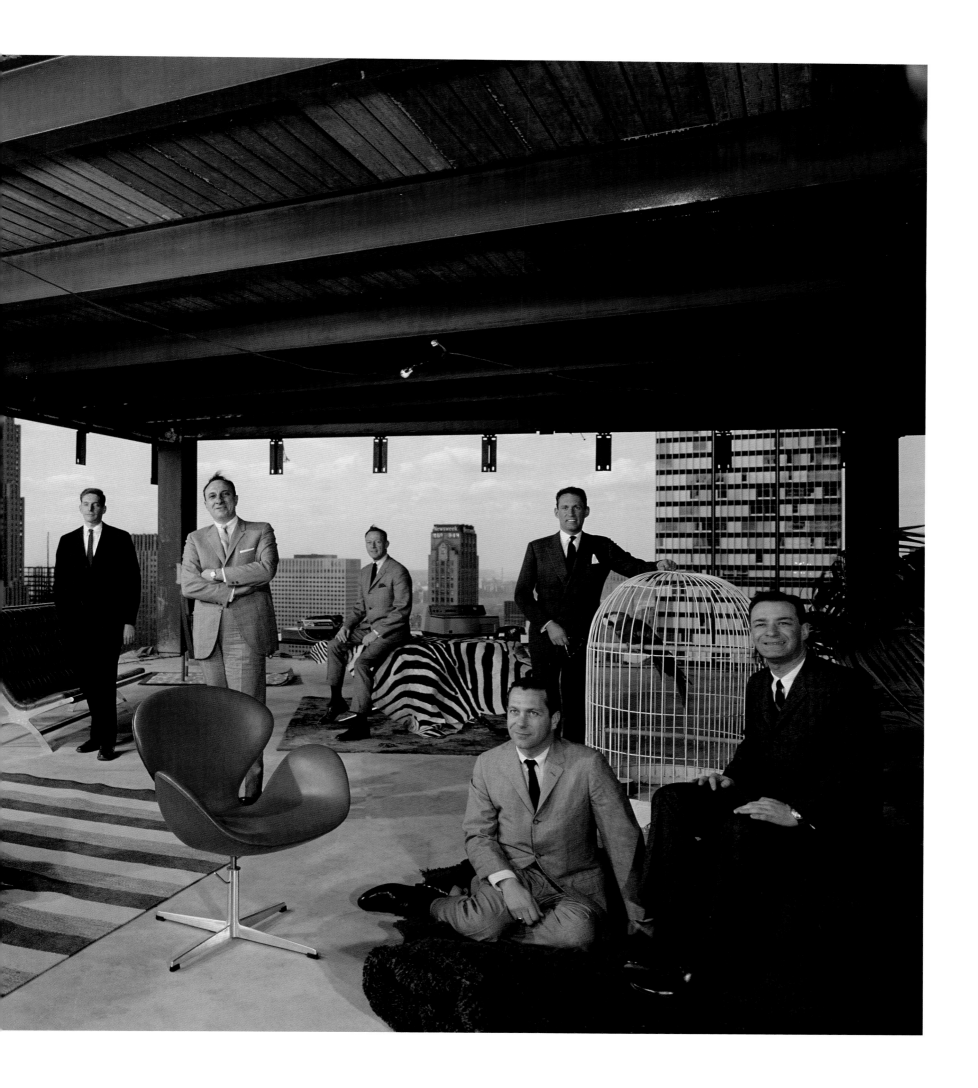

ALL THE WORLD'S
A STAGE

—
—

After I got out of the navy in 1945 and left the *Ladies' Home Journal*, I tried to go into business for myself. I rented a shared studio in Carnegie Hall and was just barely making the rent. I had in it in my mind that I would be doing fashion photography, but I was on the same floor with some ballet schools. A lot of the top ballerinas were in there taking classes and I found myself photographing many of them. It exposed me to the ballet, to dance, and to movement, which was very important.

After my Paris stint, which got my career going, I was back in New York with a lot of work coming in. Many of the assignments I was getting from *Time* and *Life* and *Collier's* were to shoot theater people and celebrities and I gradually became the theater photographer for *Time*. Whenever a new show opened, I was there photographing it. Aside from regular stage photographs, I would do opening nights and photograph in the dressing rooms. I would do separate sittings with the stars in my studio. Whenever I did a show, I would get good publicity. There would often be a photograph of me with the star up front in the magazine telling a little bit of what the story was going to be. At the time, the photo magazines were eating up stories about famous, sexy movie stars and how Ormond Gigli photographed women like Anita Ekberg, Kay Kendall, and Kim Novak.

When a new show opened, I would get a call from the publicity people and they would send me tickets and ask me to have a look at the show and see if there was any new talent that I would like to have over to the studio to do something separate on her. In turn, I would take the pictures and sell them to the magazines. It worked well for everybody. The show and the talent would get publicity, I would make my fee and get published. The world opened up to me in front of my camera. – O.G.

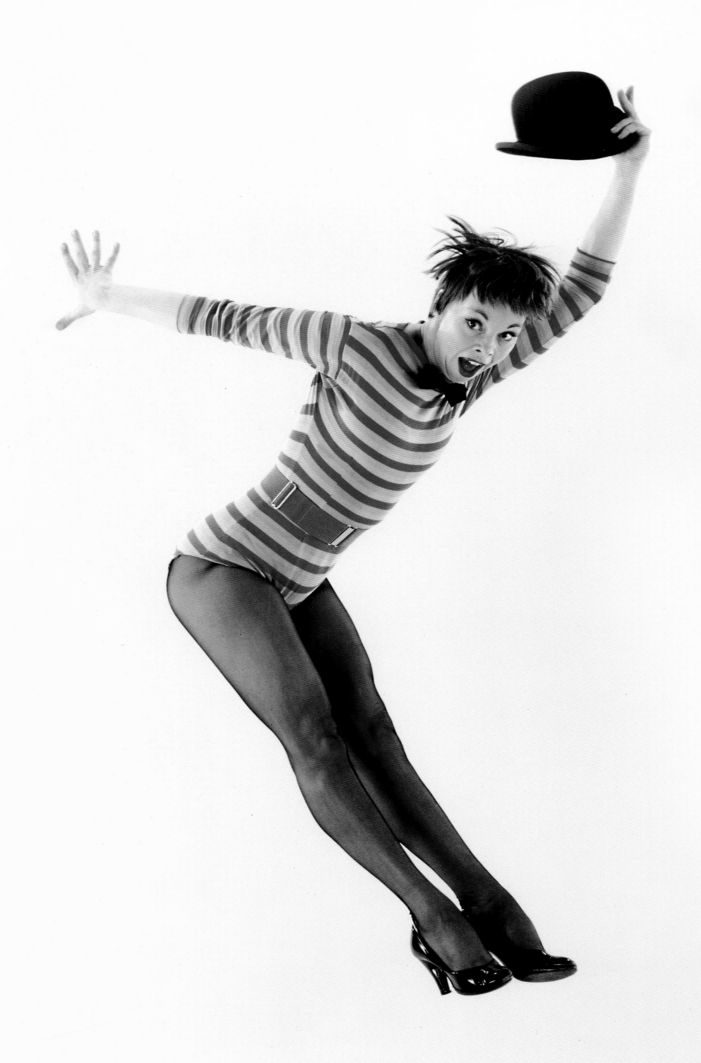

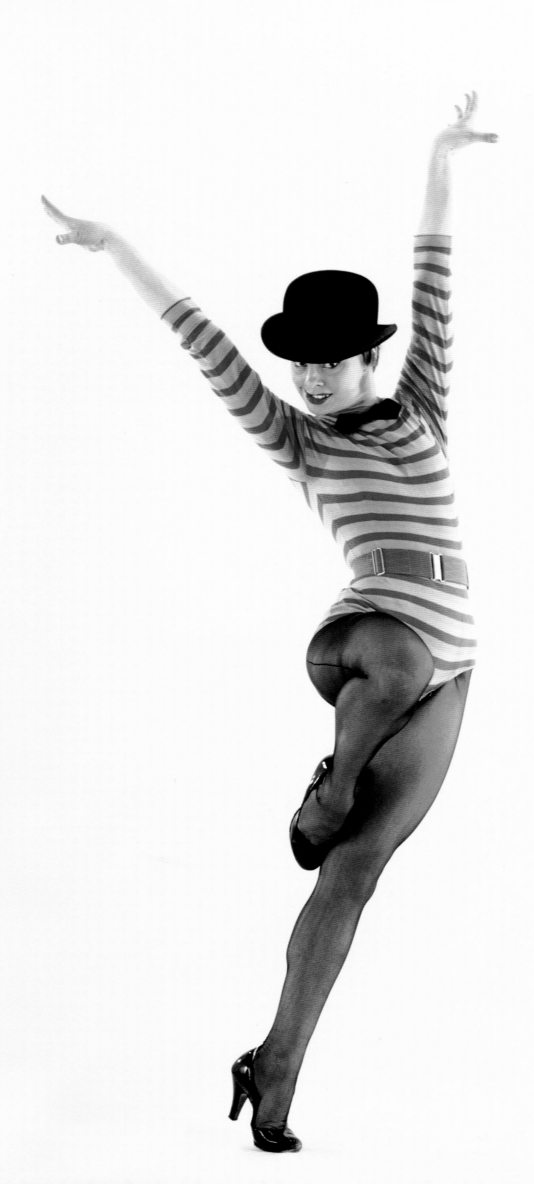

CAROL HANEY, NEW YORK, 1954

The Pajama Game was on Broadway, with a
score co-written by a very close friend of mine,
Dick Adler. I photographed Carol Haney
a lot around that time. She played the role of
Gladys Hotchkiss and wowed everybody,
especially in a number called "Steam Heat,"
and won a Tony Award.

MARLENE DIETRICH AS RING MASTER AT A CIRCUS BENEFIT FOR CEREBRAL PALSY, MADISON SQUARE GARDEN, 1953

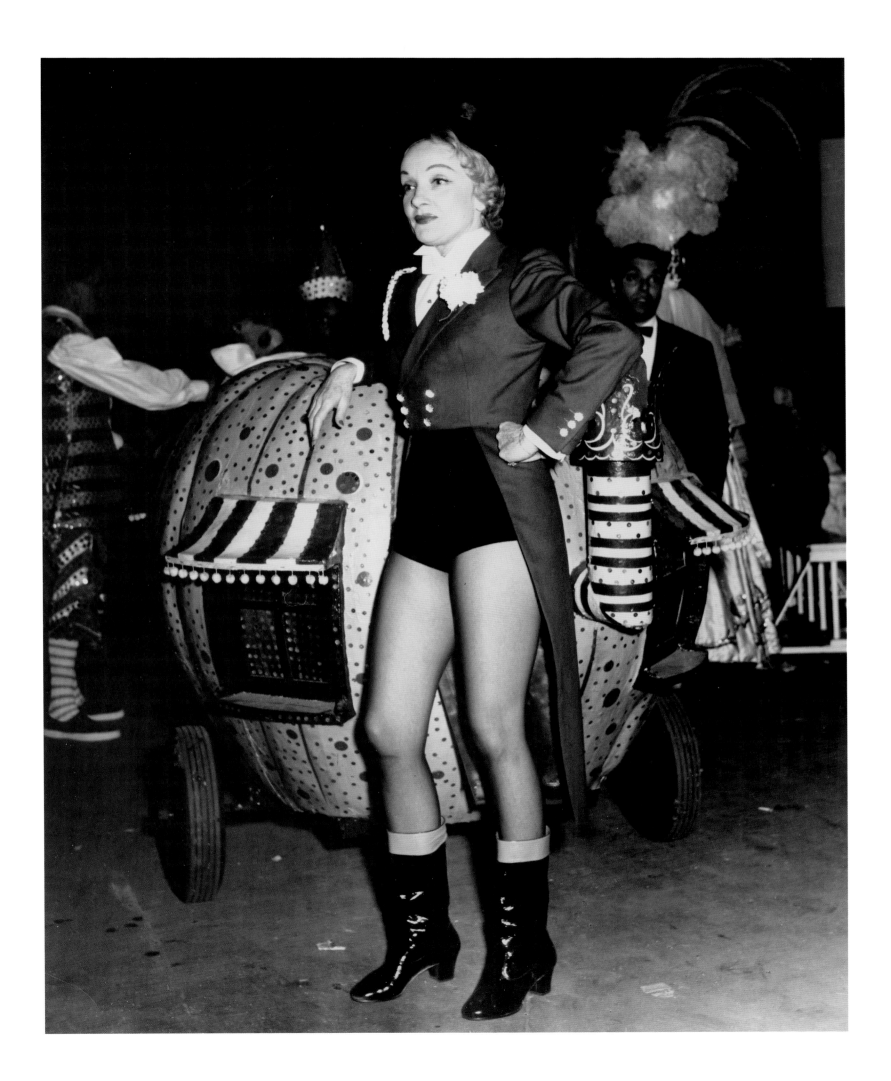

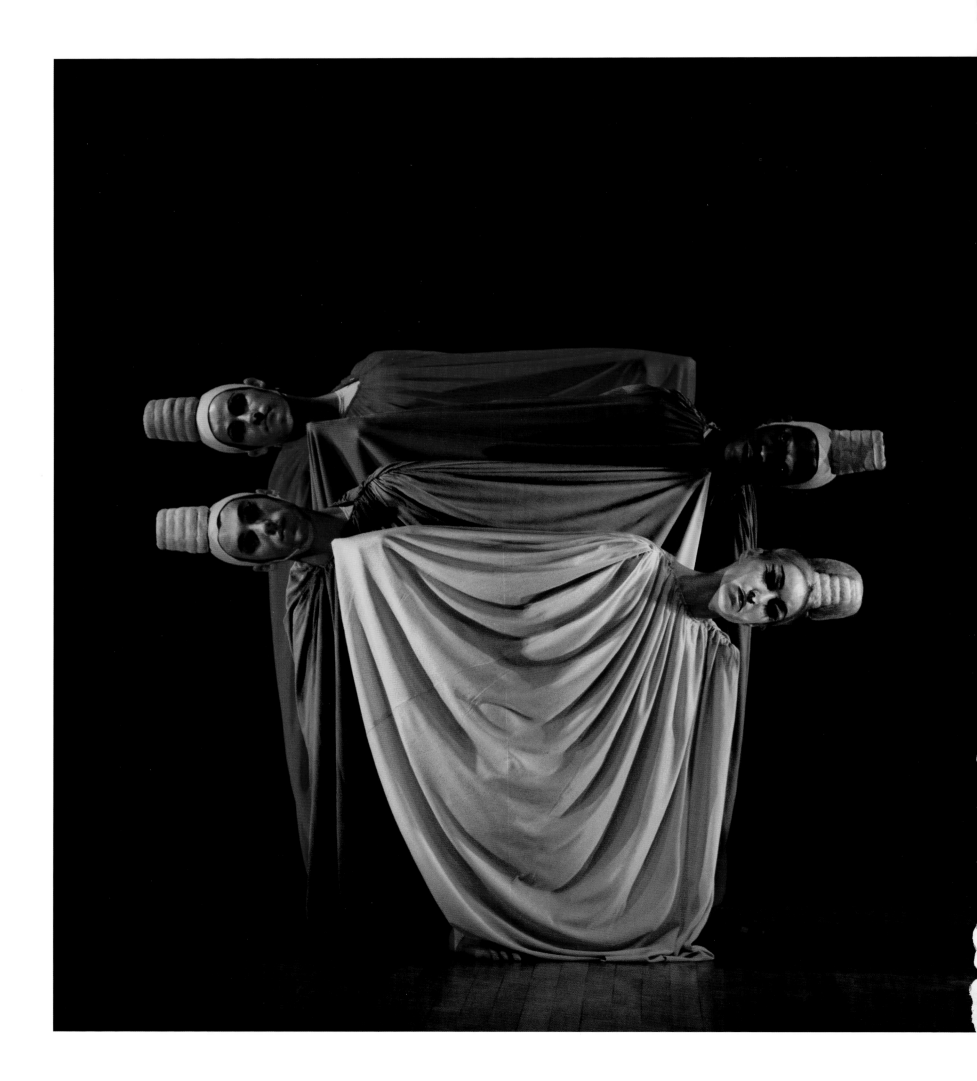

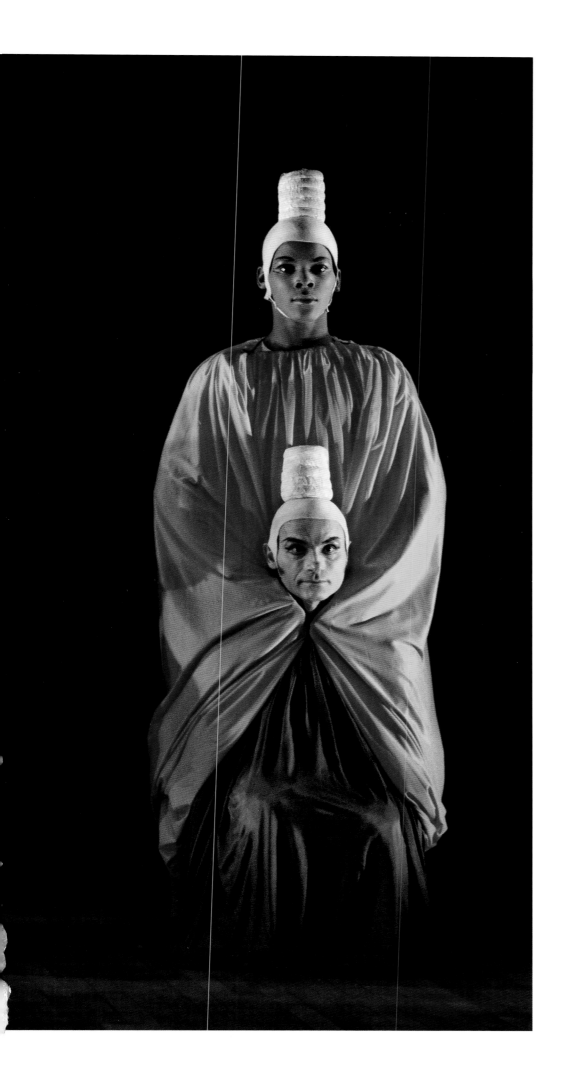

JOFFREY BALLET, FOR *TIME*, 1967

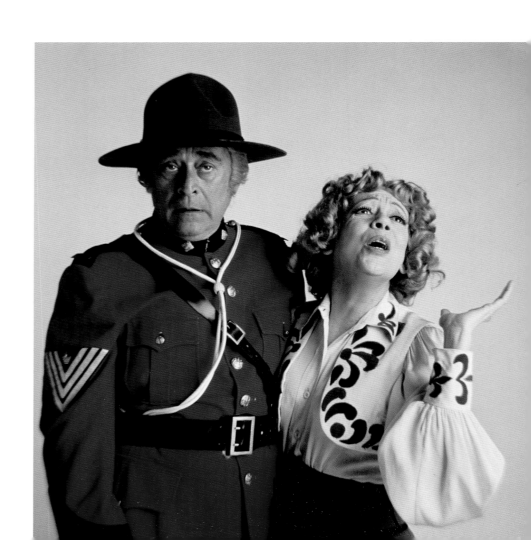

IMOGENE COCA AND LOUIS NYE, IN A TAKEOFF OF OLD MOVIES, FOR AN ADVERTISEMENT FOR CIBA PHARMACEUTICAL COMPANY, 1968

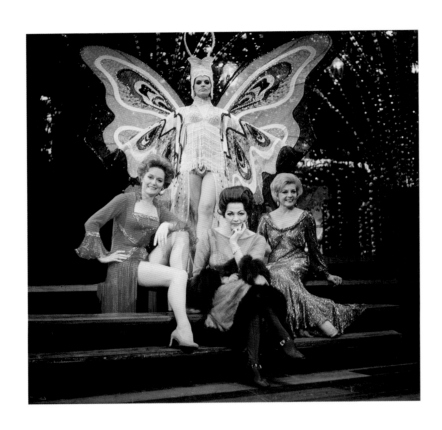

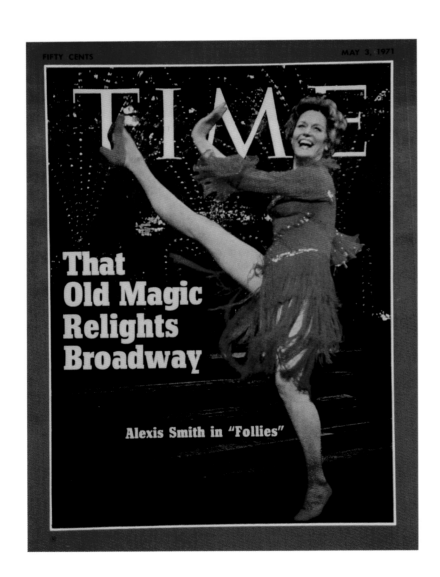

FOLLIES, FOR *TIME*, 1971

CLAMMA DALE IN *PORGY AND BESS*,
FOR "WELCOME TO THE GREAT BLACK WAY,"
TIME, 1976

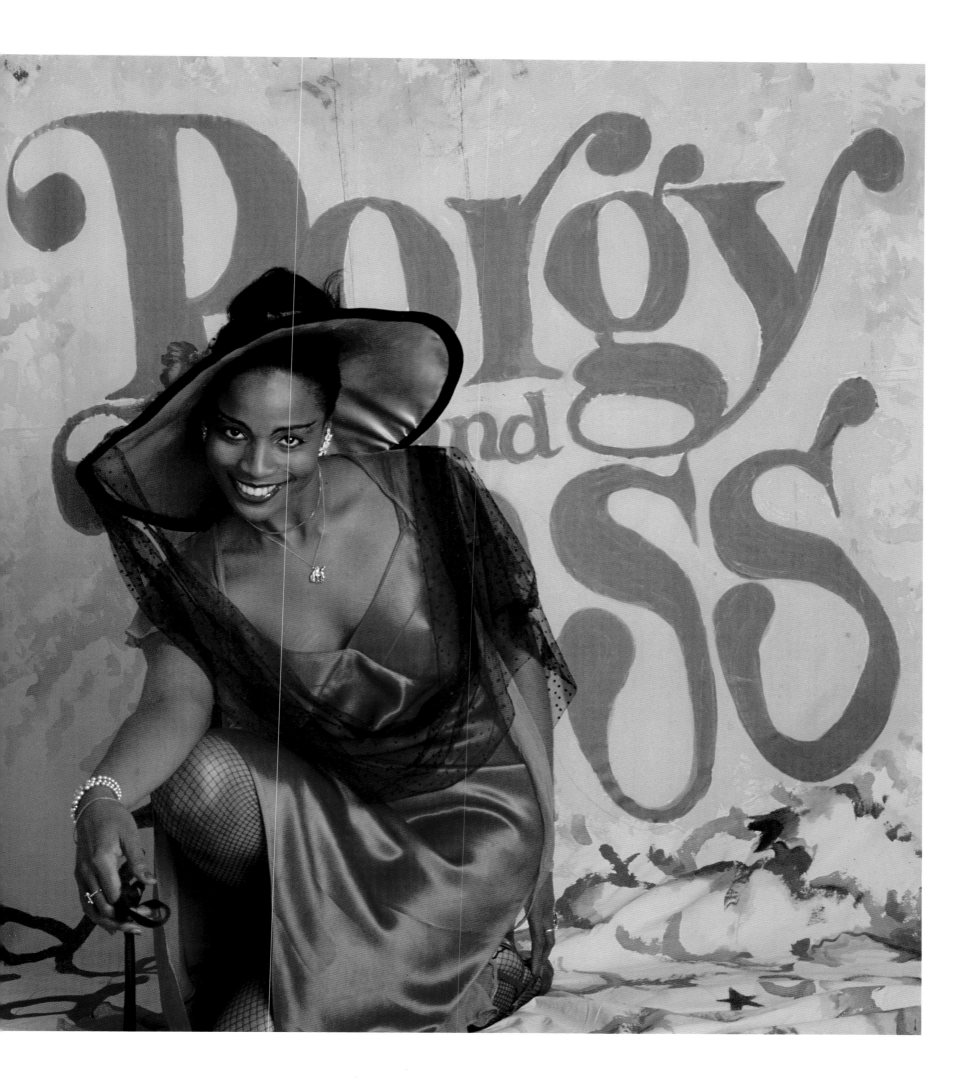

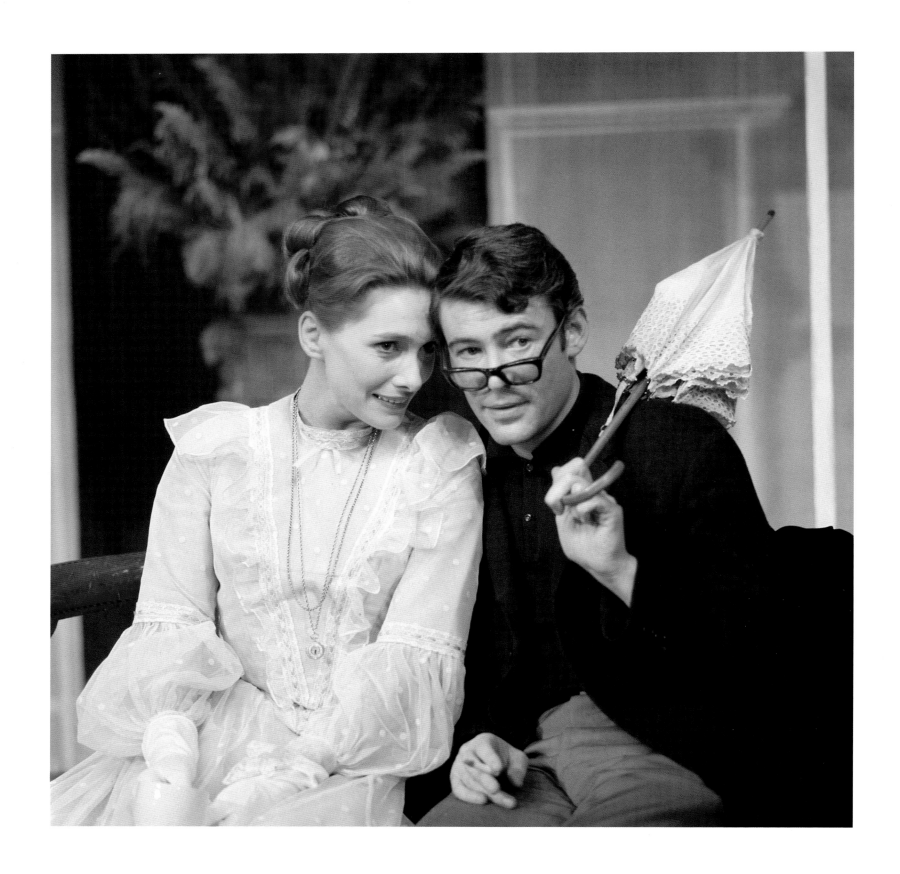

PETER O'TOOLE AND HIS WIFE SIÂN PHILLIPS, 1966

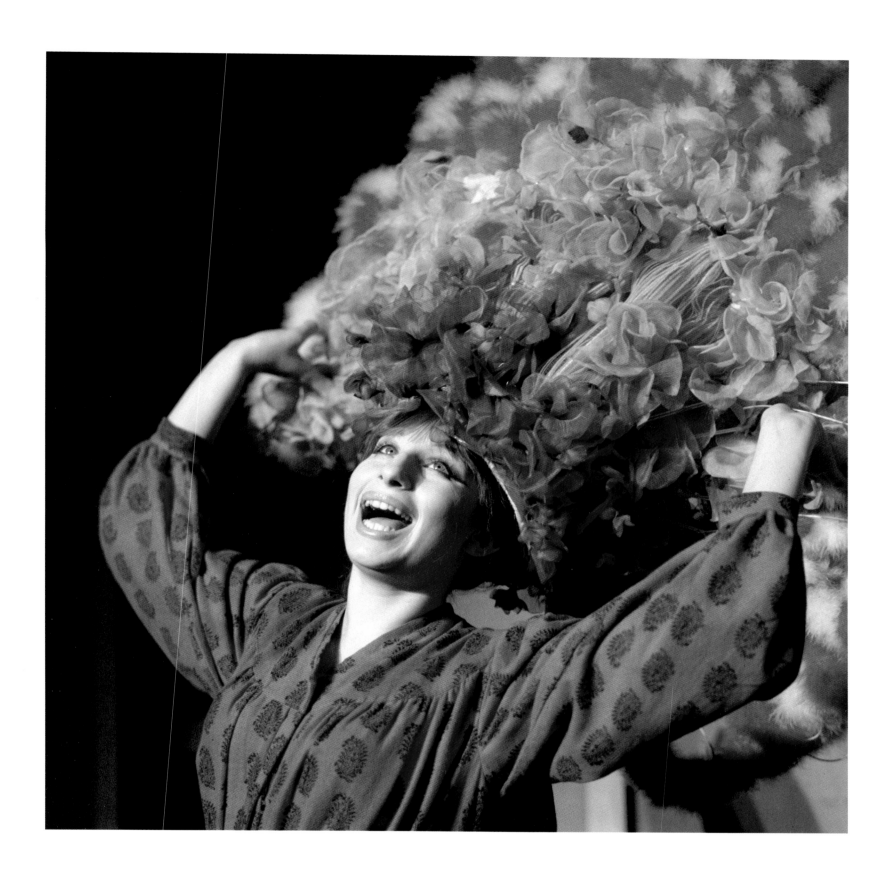

BARBRA STREISAND IN *FUNNY GIRL*, FOR *TIME*, 1964

JUDY GARLAND, PALACE THEATRE,
TIMES SQUARE, NEW YORK, 1956

FOLLOWING SPREAD: LESLIE CARON,
NEW YORK, FOR *COLLIER'S*, 1954

Leslie Caron was doing a one-woman show
on Broadway at the time and I was going
to photograph her for *Collier's* magazine. I
had the idea of shooting her in tights and high
heels with a boa. I would shoot her in both
a black costume and then a red costume
to give a checkerboard effect as she moved.
Behind the red costume would be a black
background, and behind the black costume
would be a red background. I ran my idea by
the *Collier's* people and they approved of my
concept. But when Leslie arrived at my studio,
she was limping slightly. She had sprained
her ankle. She said it would be alright as long
as she didn't stop moving. If she stopped,
the ankle would swell and she wouldn't be able
to continue or go that night. I assured her I
wouldn't let her stop. I put on a jazz record,
Leslie danced, and I shot away. She was
fantastic with the big eyes, and the little girl look
she had in her film *Lili*. It was a terrific session.
A lovely lady. I never saw her again.

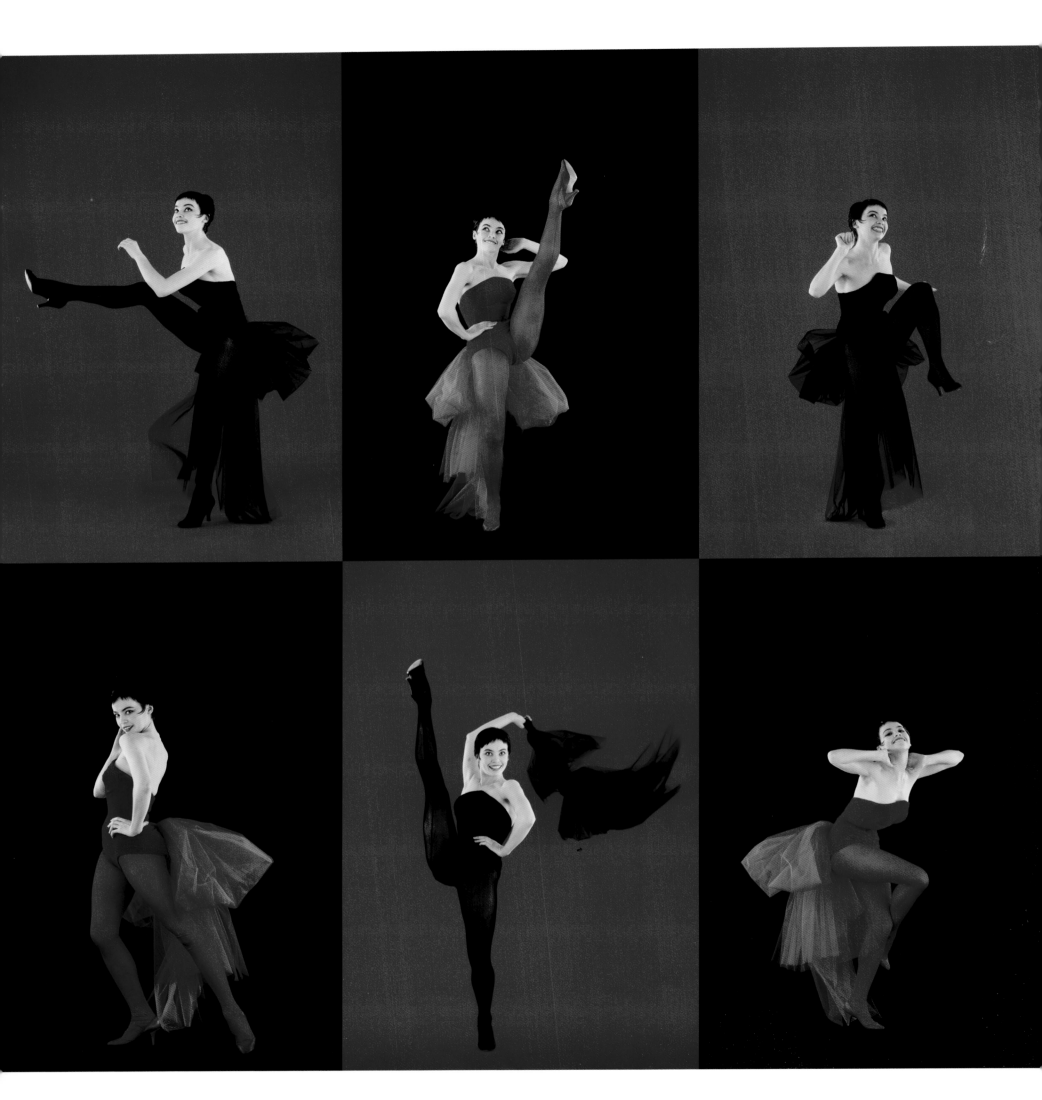

238

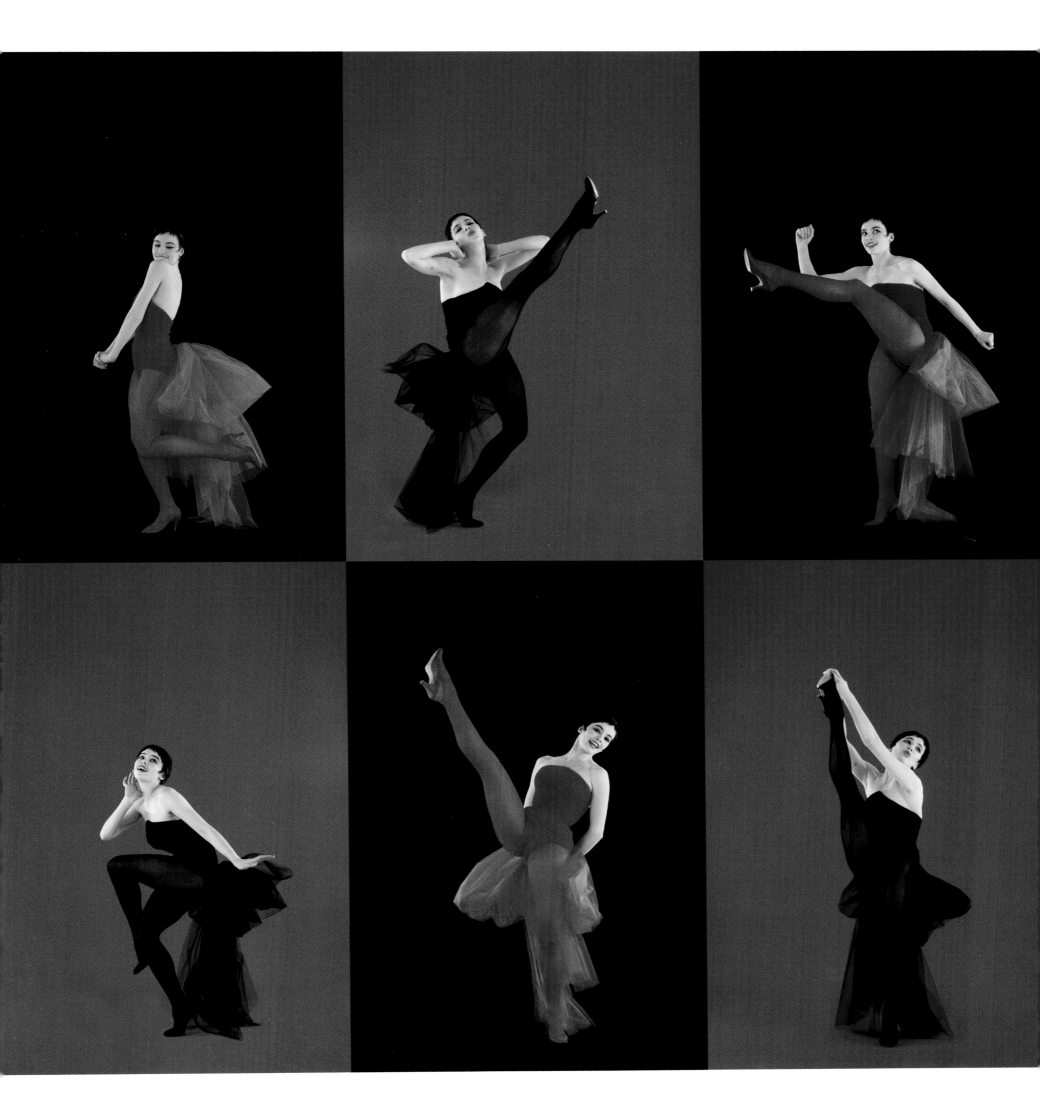

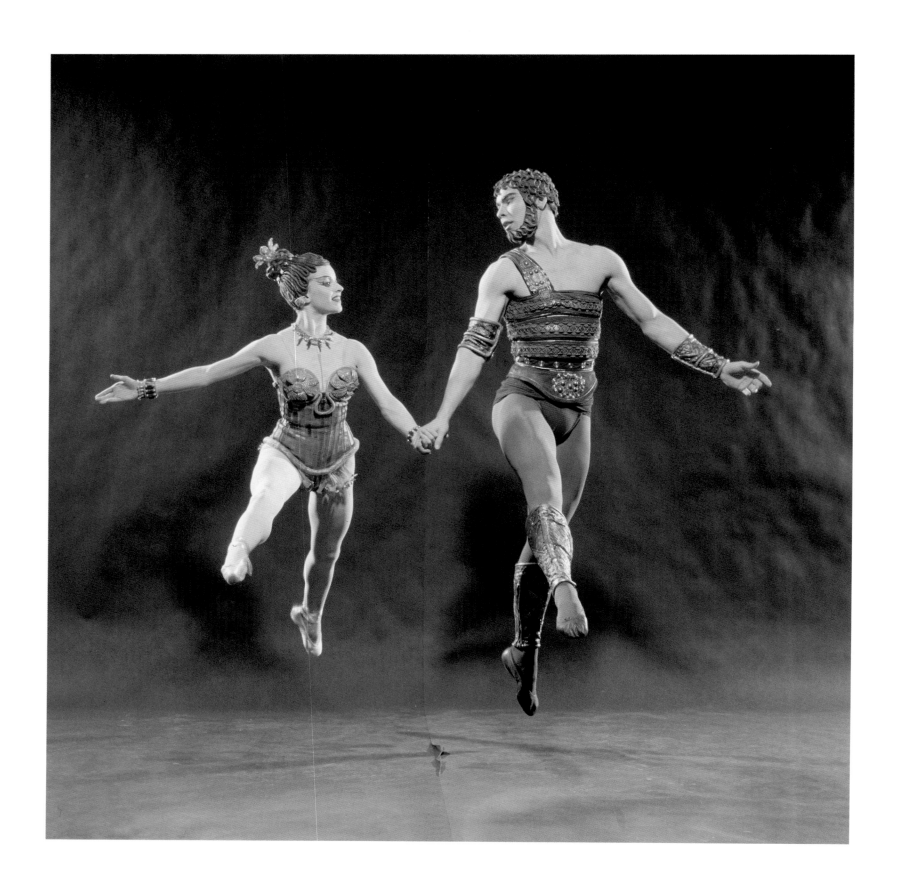

VIOLETTE VERDY AND JACQUES D'AMBOISE, NEW YORK CITY BALLET, FOR *LIFE*, 1959

VIOLETTE VERDY, FOR *LIFE*, 1959

241

VERA ZORINA, FOR *COLLIER'S*, 1955

She was a Norwegian dancer who performed
in ballets and musical theater. She was the
choreographer George Balanchine's second wife.
This was shot for *Collier's* in my studio.

RIGHT: ROBERT STEPHENS PLAYS
ATAHUALPA IN THE OLD VIC PRODUCTION
OF PETER SHAFFER'S *THE ROYAL HUNT
OF THE SUN*, LONDON, FOR *TIME*, 1964

FOLLOWING SPREAD:
OH! CALCUTTA!, FOR *TIME*, 1969

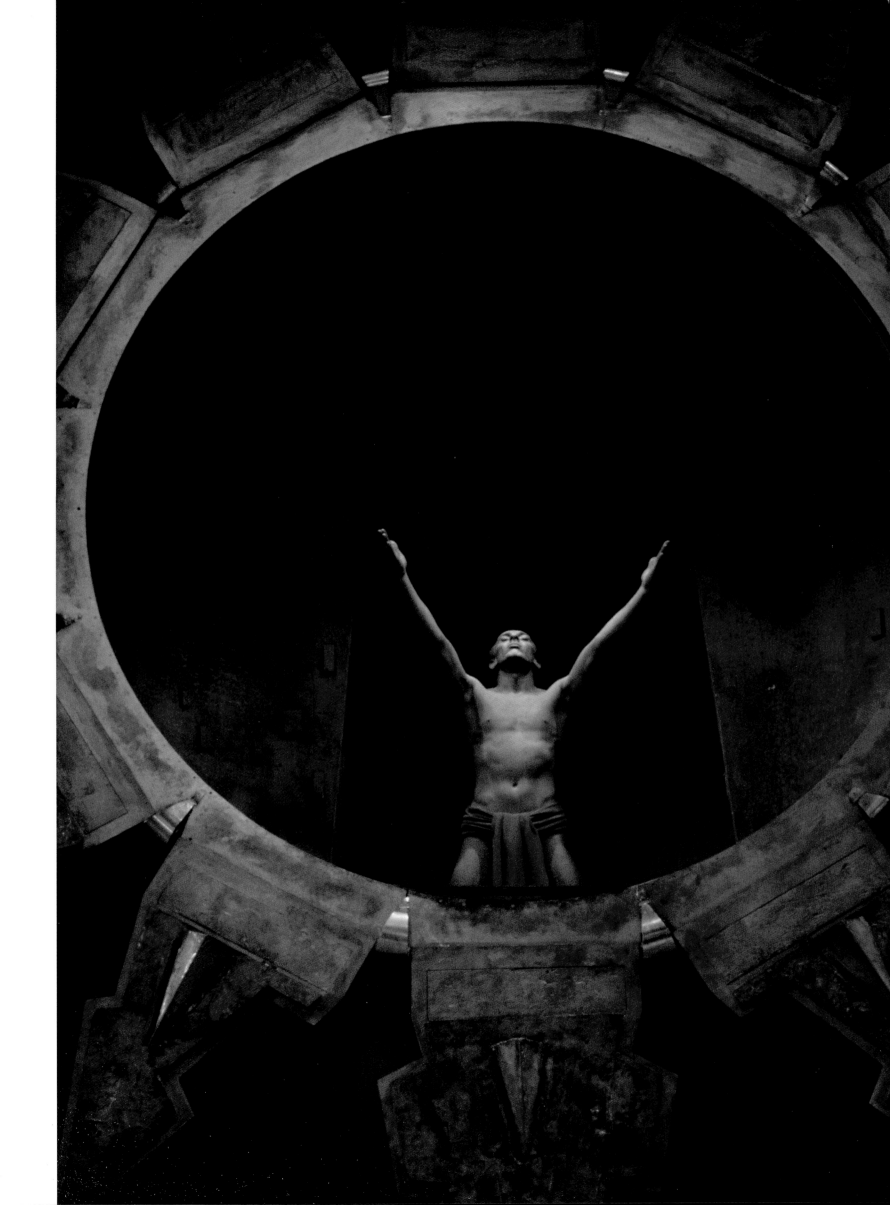

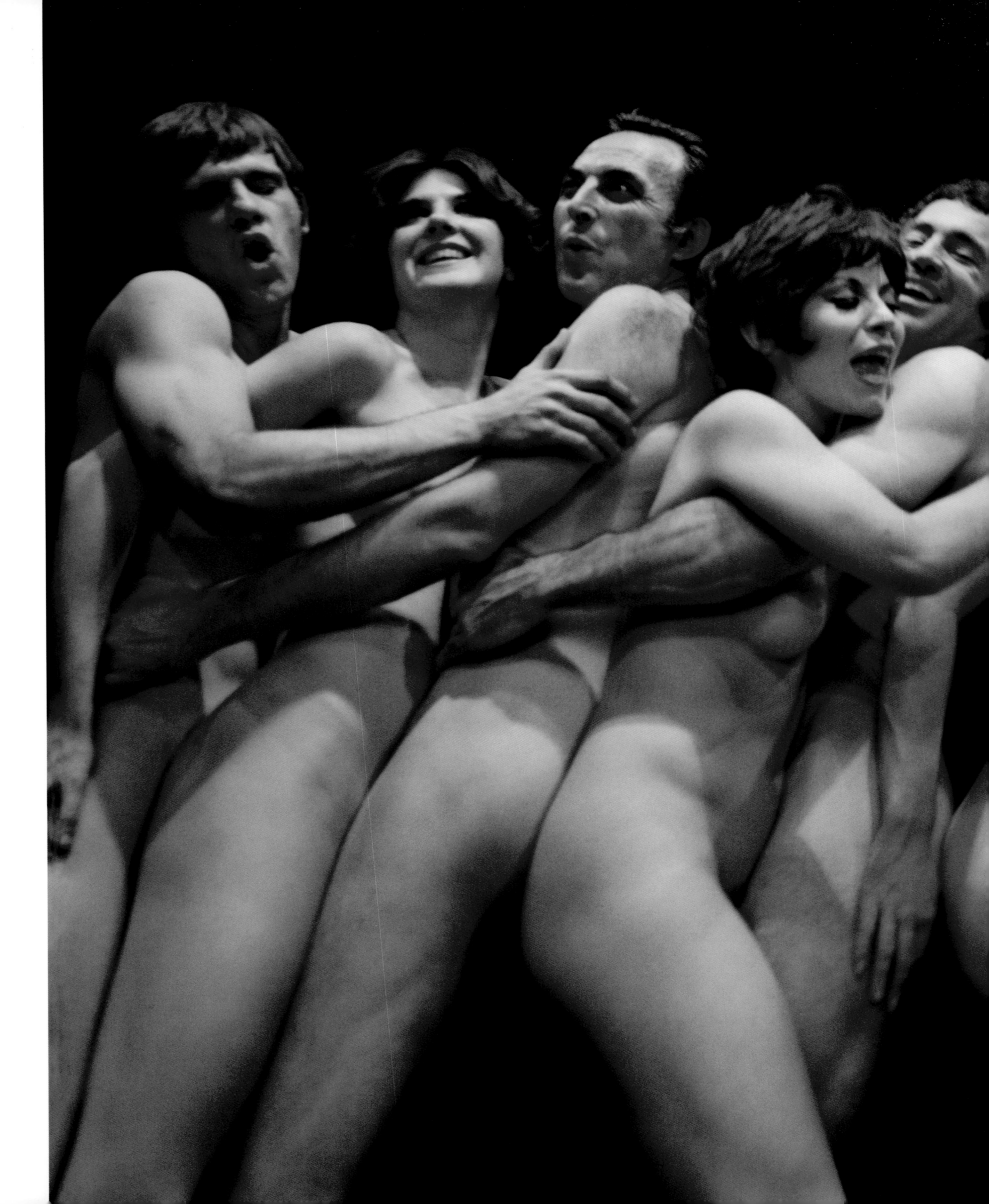

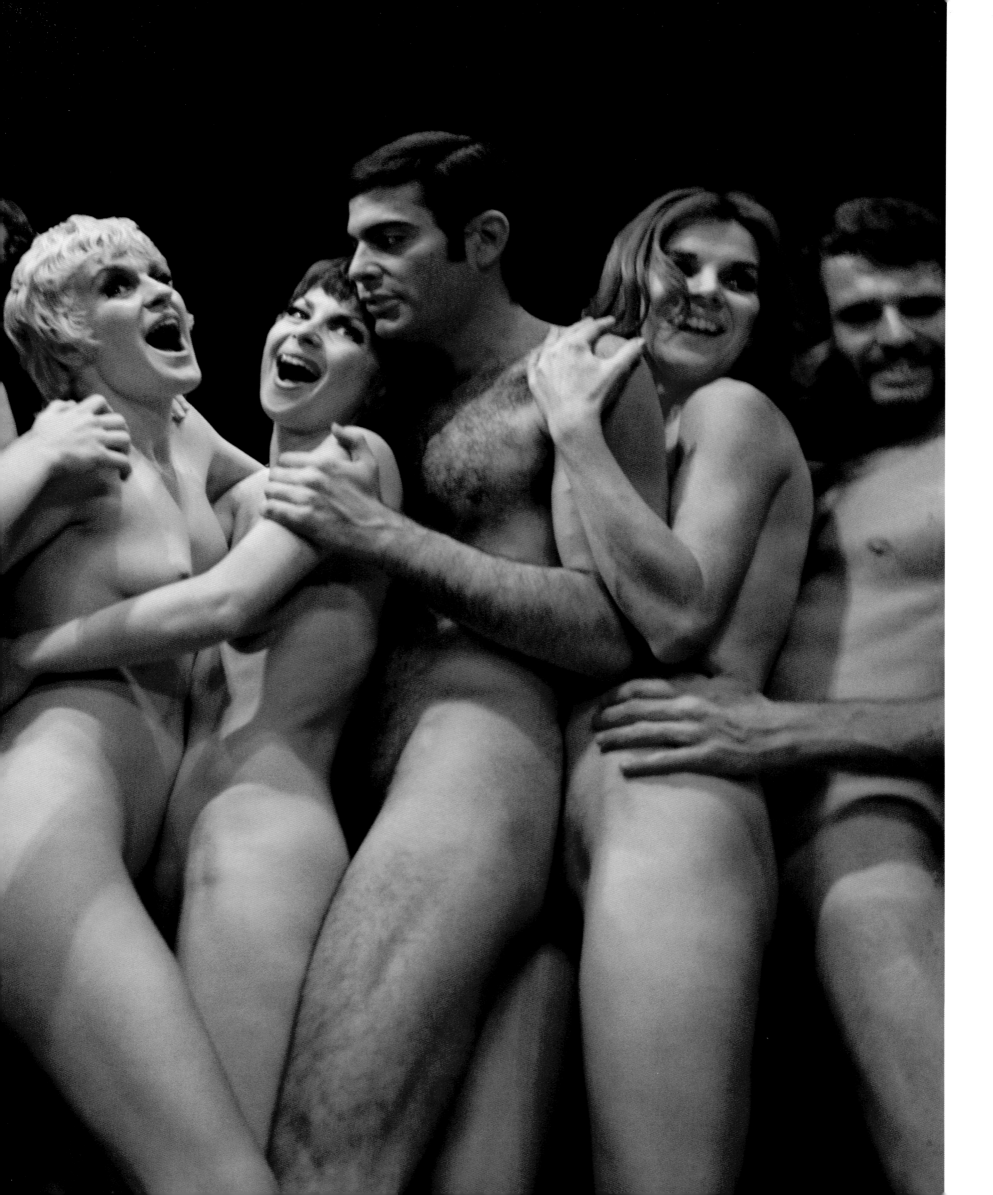

246

GWEN VERDON, NEW YORK, 1953

When I first photographed Gwen Verdon,
she was performing on Broadway in *Can-Can*.
She was the lead dancer and was absolutely
incredible to watch. I had her come to
the studio and would shoot her kicking and
engaging in all kinds of dancing. Later, I used
Gwen for a *Collier's* spread called "Mixing the
Mambo." The idea was to trace in dance
the evolution of the mambo from its origins in
Africa to Latin America. We had nine costume
changes and Gwen was shown in a different
attitude in each dance.

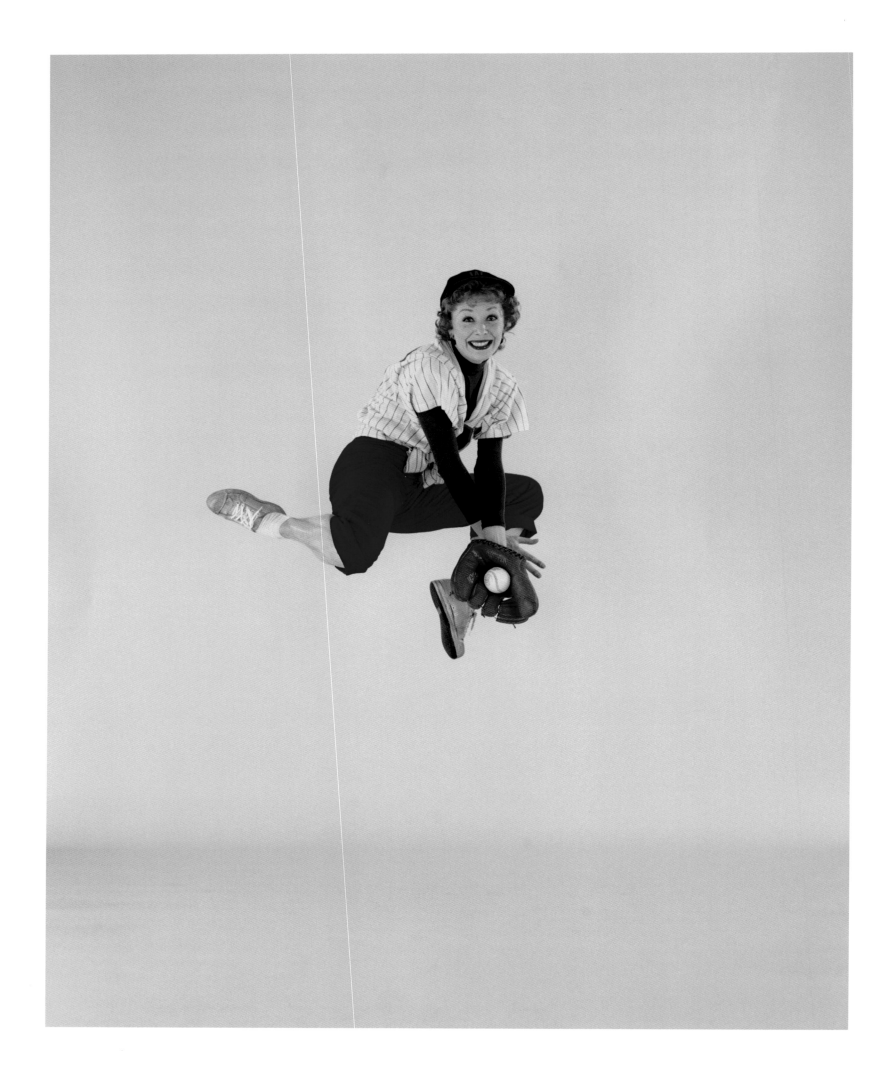

GWEN VERDON, 1955

In 1955 Gwen Verdon's star was rising. She was the lead in *Damn Yankees*, the musical based on the novel *The Year the Yankees Lost the Pennant*. I had the idea of doing Gwen as a baseball player for *Sports Illustrated*. I got a baseball uniform for her, and with her red hair and freckles she looked just great. I handed her a baseball glove and she was absolutely sensational, jumping around, swinging a bat, sliding into base, playing all the positions. *Sports Illustrated* gave my photographs of Gwen three pages.

AFTERWORD BY MARLA HAMBURG KENNEDY

—
—

I don't quite recall the first time I saw *Girls in the Windows*. I can say, however, that this rich and evocative image has played an important role in my life as a photography collector, curator, and dealer. I'm fortunate in having sold the work many times to a variety of collectors. On a more personal level, I can say that the work exerts a unique kind of magnetism, always drawing me closer, and always revealing new layers of meaning and beauty. On a cultural level, *Girls in the Windows* is now recognized as one of the iconic fashion images of the twentieth century. Like all seminal works, *Girls in the Windows* reveals much about its time and place–in this case, that time and place being New York City at the apex of its influence as a fashion and art capital.

The story behind *Girls in the Window*, as brilliantly examined by Christopher Sweet in his introduction, is as fascinating as the image itself. On a technical level, this was a complex and challenging image to stage and capture. And, in the "Mad Men" era of its creation, digital technology wasn't even on the horizon. Therefore, the brilliance of this work was achieved in the old- fashioned way–as a product of sublime skill and inspiration, supported by the best analog technology available at the time.

Over the years that I have dealt with *Girls in the Windows*, I became increasingly curious about the artist, Ormond Gigli. I was fortunate to become acquainted with Ormond through phone conversations and then emails. As it turned out, this dialogue paid all sorts of inspirational dividends, because Ormond began sharing many more of his astonishing images. I was awestruck by the range and quality of his work, which spanned several decades and genres. Indeed, it was the richness and variety of this oeuvre that spawned the idea of producing the artist's first major monograph, which you hold in your hands.

The team that orchestrated this project has been nothing short of inspiring in its own right. My thanks and appreciation go to Christopher Sweet, and Craig Cohen of powerHouse for doing such a masterful job. And, of course, my greatest thanks go to Ormond Gigli for being the sublime artist–and human being–that he is.

MARLA HAMBURG KENNEDY
Hamburg Kennedy Gallery

To my wife, Sue Ellen, who has been at my side for fifty-six years, who gave me two wonderful sons, Blake and Ogden, a great home, and who has been my partner in running my studio, doing all the things necessary to help me create my images.

I want to thank my son, Ogden Gigli. When I decided to do a book, I knew Ogden would be there every step of the way to assist me in every way that he could. He knew my images and where they were. He handled all the difficult technical aspects of this project. Organizing images, helping to edit, and restoring them to their original beauty was a huge job that he did with endless enthusiasm. Ogden grew up in my East 58th Street studio. He was around many of the famous people that I photographed. It was an everyday thing, being around these people. He later became my assistant and traveled the world with me working on many of my assignments. Currently, Ogden has his own commercial photography studio working on all kinds of interesting assignments.

I also want to thank Christopher Sweet for finding my publisher and for helping me with my texts and for his introduction; Craig Cohen, executive publisher of powerHouse Books, for his enthusiastic response to my book proposal, for his wonderful photo edit, and for the manner in which he brought the book to fruition on an accelerated schedule; Triboro for the handsome design; and everyone at powerHouse who contributed to the publication of my book. Finally, I want to thank Marla Hamburg Kennedy for encouraging me to actively pursue my idea of doing a book. I had been thinking about it for years and made recordings of the stories behind the scenes that guests loved to hear about, but I never did anything about it. It took Marla's love of my images to put everything into motion. She brought just the right people together to make this book happen.